"**I like to see a man proud of the place in which he lives. I like to see a man live so that his place will be proud of him.**"

— **ABRAHAM LINCOLN**

For my partner, Nick Barletta.
You are the love of my life.

GAY IN AMERICA

SCOTT PASFIELD

Introduction by
TERRENCE McNALLY & TOM KIRDAHY

WELCOME BOOKS / NEW YORK

PREFACE
Scott Pasfield

with his partner Nick

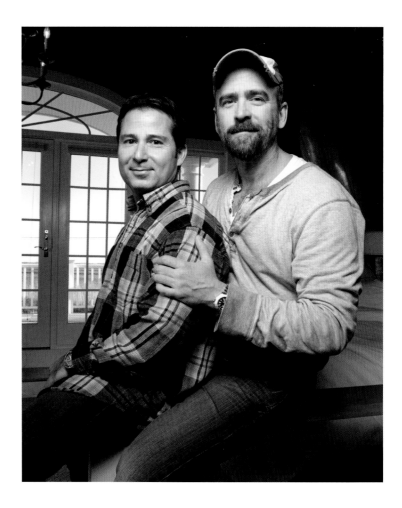

Ever since I can remember, I've known I was more interested in boys than girls. It has always been a part of who I am—it was never a decision or choice that I made. I also believed from a young age that it was entirely unacceptable. So I hid those feelings and tried my best to be straight. Nothing is worse than the self-hatred you feel when you are taught that something so integral to who you are is wrong.

We'd never had an out gay person in our family, so I was breaking new ground when I came out at twenty-five. For the most part, everyone was accepting. The only person I didn't tell right away was my father—I waited two more long years. Our relationship was so complicated and stressed, I feared his response. Dad spent his whole life searching for some elusive feeling of happiness, trying many different religions, philosophies, partners, and drugs along the way. At the time I came out to him, he was on his third marriage, to a woman who was a born-again fundamentalist, and he'd converted to her religion. When I first told him, he said he'd

need time to process and think about it. The following day he sat me down in my living room, turned on the TV, and left. He had made a video of himself talking to me—he couldn't bring himself to do it in person. On the video, he told me that he disapproved and that it was wrong to be gay. He said his associating with a known sinner would be problematic. But there was hope, he added: if I gave myself over to the Lord, salvation was possible. After watching the whole tape, I was devastated. We didn't discuss it again for many years.

I learned so much about how not to live by my father's examples. He beat himself up constantly for his addictions and desires. He believed deep down that he might go to hell for all he had done, and in the end, it seemed to me that religion brought him more fear than peace. I have such great memories of my father when I was young—he was so smart, creative, and talented before he allowed his self-hatred to chew him up. The man who I had known and admired was long gone, his hopes and dreams along with him. I would not make the same mistakes.

Dad was diagnosed with lung cancer at fifty-seven; it took him down in a matter of months. His wife wanted to put him in live-in hospice care. He would have no part of that—he wanted to die at home. So, I flew down to Florida and spent the last three weeks of his life by his side. It was one of the most difficult things I've ever had to do, but I wouldn't trade the experience and the time we had together for anything in the world. His opinions didn't change in the end, but mine did. He wanted to be forgiven for all the ways he felt he'd let me down. And I forgave him. It brought us both a lot of peace.

A year before my father's death, I had started going to a regular group-therapy session for gay men in New York City. That is where I met my partner, Nick. When I was struggling through my father's illness, he was there for me, calling me in Florida, making sure I was okay. When I came back to New York, we both realized that we had fallen in love over the past months and we couldn't ignore it anymore. The hard part was, Nick was with someone, and he still wasn't out to his family. He had two major hurdles to jump before our relationship could begin, and he did so, with grace and courage. This year we celebrate our thirteenth anniversary together.

People always tell you to shoot photos of what you love, and that objective is what led me to this project. I knew I wanted to photograph a subject that I cared deeply about, and to create a body of work that would make a positive difference in people's lives. Focusing my lens on gay men also meant looking more closely at myself, and I was finally ready to do that. I decided that I would find and meet a gay man from every state, listen to their stories, and photograph them in the hope that I could turn the material into a book that would change opinions and educate—the book I wished had existed when I was a kid. I wanted to produce a profound collection of ordinary, proud, out, gay men who would otherwise never find the spotlight. My idea soon became an obsession, and I set out to see the country though their eyes.

I placed ads and plotted out small trips, no more than two weeks at a time. The ads went something like this: "Looking for great out men, happily living their life where they choose, who are willing to share their stories for the greater good and ultimately for a book that will make a difference." I asked them to write me stories about themselves for consideration and was amazed at the number of wonderful responses, far more than I could ever possibly hope to shoot.

The men I met and photographed taught me a great deal. Through their stories of love and heartache, pride and shame, courage and regret, I was able to reconcile my own lingering struggles with self-acceptance. My hope and belief is that others will find the same healing and love in these deeply honest words and images. This book speaks for the gay community, not through any one story or portrait, but through its collection of diverse and varied experiences and faces. I want it to educate people about the realities of what it feels like to be gay. I want young people to have it as a constant resource as they move forward in their lives, comforting, inspiring, and reminding them that they are just as normal and precious as any straight kid.

Gay rights are human rights, and if we focus less on general concepts like gay pride and more on the personal story of each individual, it becomes instantly clear that our similarities as human beings far outweigh our superficial differences. Our cultural views about sexual preference are evolving, but there's still a long way to go before we are all treated equally and fairly. By highlighting these great, complex, humble men who defy clichés and stereotypes, I am making my contribution to the slow process of positive change.

Up until this last year, having a uniformed gay soldier on the cover would not have been possible. In the president's State of the Union Address, he said, "Starting this year, no American will be forbidden from serving the country they love because of who they love." How powerful and moving to finally hear these words. And we owe thanks to people like Dan for making that possible. His stand against Don't Ask Don't Tell and its injustice is admirable. He helped right a wrong that was the basis for so much hatred. When I photographed him on that snow-covered street in Cambridge, I saw a man who was proud of all he was and had accomplished, and who just happened to be gay. That is true of every man in this book.

INTRODUCTION

Terrence McNally & Tom Kirdahy

The best thing I've done in my long life is marry Tom Kirdahy. It was that moment, just a year ago, in the shadow of the Kennedy Center in our nation's capital when I understood who I was and all I still could be. The total commitment of two lives to each other is a profound moment for anyone, but for a gay man born in 1938 it was an overwhelming one.

Many of the men in *Gay in America* are younger than me, but we have shared many of the same years of furtiveness, fractured relationships with our families, and the feeling of exclusion from those most basic of constitutional tenets: life, liberty, and the pursuit of happiness.

I wish I could remember how old I was when I first knew I was gay. I remember the sun on my back, the living room rug, the hard floor beneath, and the boy I was thinking of. I wish I knew the year now, because it feels like forever. It felt good down there and it felt right, I remember that. There was some remorse, of course (I wasn't a parochial school boy for nothing) but there was never enough of it to deeply scar and it was always trumped by the erotic longing I felt for my classmates. My church was strong; Eros was stronger.

The emotional attraction to men came later, in high school. It was another man's love and approval I needed. It was a man I wanted to share my life with. Both attractions,

physical and emotional, defined me as gay. I liked women; I loved men.

I'd seen enough movies to know that New York City was the only place to be for someone like me. I went to college, I had lovers, I began a career as a playwright. We went to all the out of the way gay bars, down dark stairs to rank basements to meet our kind. We let our hair down completely for three months every summer at Fire Island. Some of us even got into long-term relationships. Life was good. Well, it was good enough. After all, we were gay.

We would manage a life for ourselves. We would cope with the status quo. We would improvise. But we would never really belong. Words like "husband" would never be in our vocabulary except as a lame joke. We could go to church but knew to keep a low profile at God's table. We would probably never be parents. We were free to love but not to be legal. As I said, we managed. Some of us got very good at it.

But first Stonewall, then AIDS changed everything. The former showed us that we could fight back, that hiding out in our traditionally safe places—the bars and summer resorts— was not the only alternative. We had voices and we began to use them. AIDS taught us that our very lives depended on it. If we did not stand up now and take our rightful places in the world, we never would. Being gay became being serious.

It still is. Homophobia is shrinking like the malignant tumor that it is, but total remission is at least one generation away. When the battle of Stonewall finally ends it won't be with a bang but probably with a grateful whimper as an exhausted mentality accepts what is has known all along: good will among men, not hate, is the meaning of life.

To say "I do" to a man like Tom Kirdahy, my activist lawyer/producer/hero husband is a very long, very successful journey to this kid from Texas who spent half his life thinking being gay always meant coming in second. I write this as a happy man, approaching the end of my life. The stories of the men in *Gay in America* are part of my story, too, and why these last years are, truly, going to be the best. **—Terrence**

Terrence and I have a twenty-five-year age difference. He came to New York City via Corpus Christi, Texas, in the mid '50s. I came in 1981 for college when I was eighteen. It seemed there were gay bars on every corner and gay characters were even beginning to make appearances on television. Gay pride was celebrated on the anniversary of Stonewall. The parade had become one of the biggest in the city. Progress was in the air. The landscape was shifting for anyone who was gay in America.

But shortly after I arrived it seemed that all of New York was talking about a new disease decimating the gay community. Suddenly all of our progress was being challenged by a health crisis. It only made us stronger. The LGBT community of Terrence's generation taught my generation a lot about courage in the face of adversity. In what seemed like a flash, groups like ACT UP, Queer Nation, and Lesbian Avengers were taking to the streets, demanding the government take action. We made headlines everyday. We lost heroes but we developed leaders.

When I began law school in 1985 I was convinced I'd become a gay rights lawyer. Atticus Finch was my hero in literature and as a young boy I fell in love with Gregory Peck's portrayal in the film of *To Kill a Mockingbird*, so it seemed fitting that I'd try to become a gay Atticus Finch (okay, maybe I was also a little in love with Gregory Peck the handsome actor).

But AIDS altered the course of my dreams. Civil rights took a back seat to survival. I found myself representing people with HIV/AIDS with bread and butter issues: access to health care, housing, nutrition, and disability entitlements. Those issues took priority over laws that concerned themselves exclusively with sexual orientation.

Over time the landscape shifted once again. HIV meds improved dramatically. What was once a death sentence became a manageable chronic illness. And as the urgency of our needs surrounding HIV/AIDS receded to the background, our political demands brought other issues to the forefront. Nondiscrimination laws began to sprout up everywhere, more and more openly gay officials were being elected to office, the gay baby boom came into full flower, and same sex marriage became part of a national dialogue. In the '80s we read the obituaries first to see which luminaries we had lost. Now we go straight to the Styles section to see who got hitched. It is a testament to the resilience of our community that the narrative shifted from a health crisis to family planning.

In 2003, Terrence and I registered as domestic partners in both Southampton and East Hampton on Long Island. Later that year we were civilly united in Vermont by a justice of the peace. In 2010, we were married in the District of Columbia. We've been chasing marriage in New York for a very long time, and as soon as it's legal we'll once again exchange rings as we get hitched in our home state. Neither of our early lives could have prepared us for what we experienced on the banks of the Potomac last year. It's an exhilarating time to be gay in America.

Scott Pasfield's epic book is testament to the complexity, challenges, and joys of being gay in America. From cities like San Francisco to rural environments like Delta Junction, Alaska, and suburban locales such as Spartanburg, South Carolina, Pasfield has documented the lives of gay men who have found homes for themselves all over the country. It's a personal, funny, surprising, inspiring work that probably raises more questions than it answers. What does it mean to be gay in America? I think it's an unanswerable question. But after meeting the men of this book, I'm reminded that I'm sure glad I am. **—Tom**

WILLIAM Gulf Shores Alabama

I grew up in a very straight world. I had straight friends, played sports, had girlfriends. I was an Eagle Scout and was involved in all sorts of outdoor activities. Growing up gay in my Alabama town wasn't an option.

I moved to Spain when I was twenty-three for work with a Fortune 500 company. It was the perfect opportunity to come out and begin my life as a gay man. When I returned to the States fourteen years later, I could have reestablished myself in a larger, more cosmopolitan city like Dallas or Miami, but as a native Alabamian, I was drawn to the sugar-white sands and turquoise Gulf Coast waters of my childhood. This was where I learned to swim, fish, and crab, and spent many hot, humid days with family and friends—the loved ones I rarely saw during my years in Europe. After living in Madrid and Barcelona, I decided to trade in the fast-paced city life for the one Jimmy Buffett writes about.

As one might imagine, stereotypical gay life here is limited to a few bars and clubs and an occasional pride celebration, but I was positively surprised regarding the social advancements and the acceptance of the gay community, especially here along the coast. I travel frequently for work and do enjoy my time in whichever big city I happen to find myself, but it always feels good to come home to Alabama.

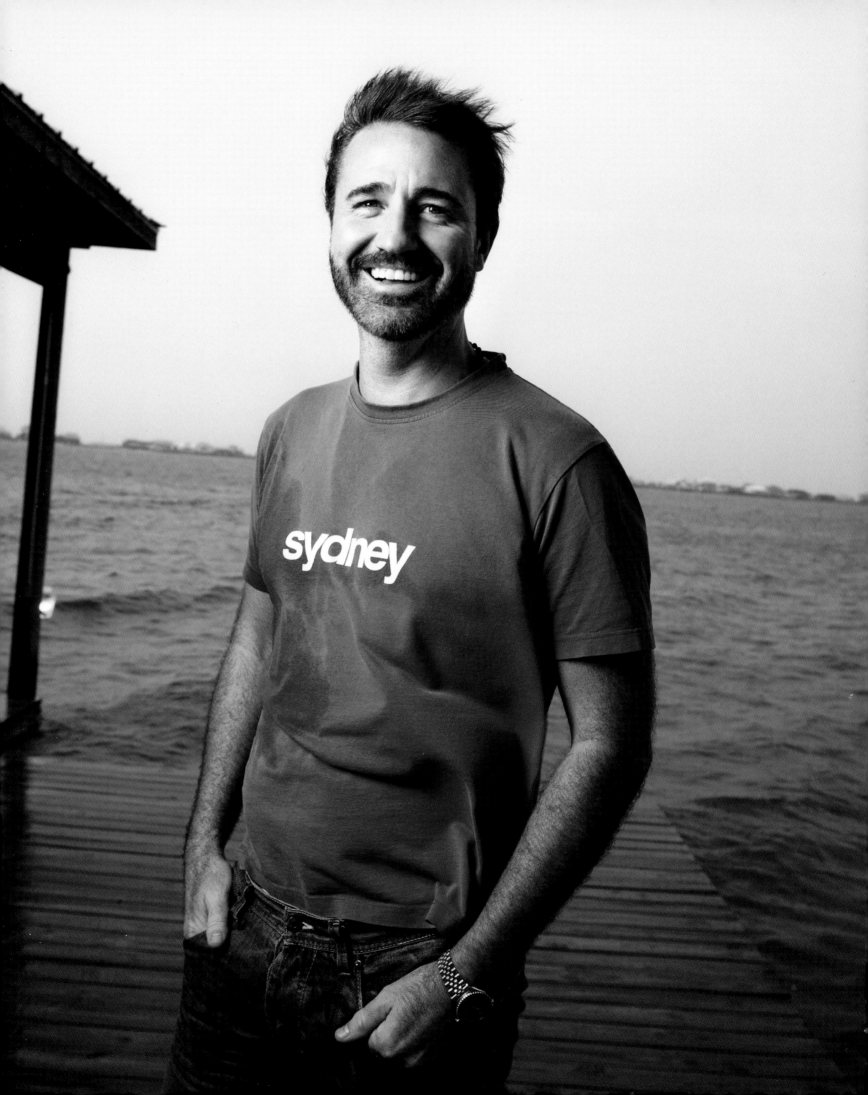

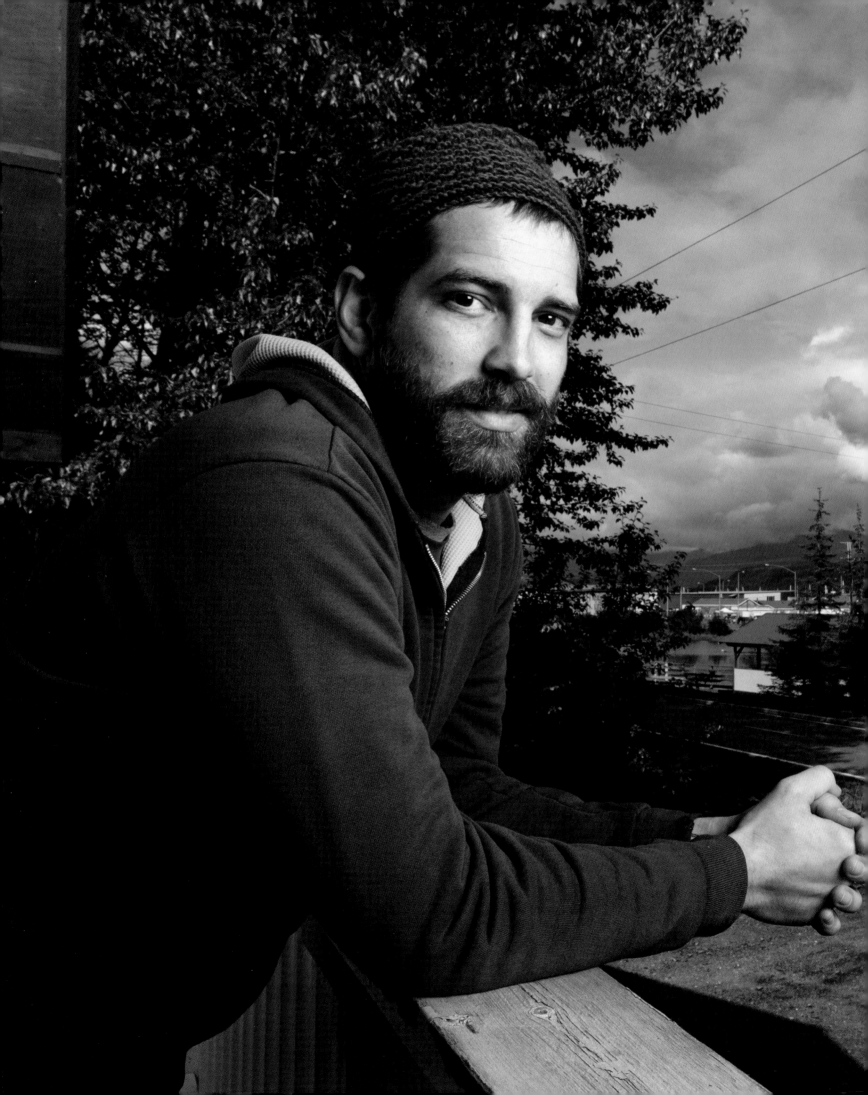

ALEX Seward Alaska

Growing up in Oklahoma will teach a kid to be on his best behavior, respect his elders, use the words "sir" and "ma'am." I went to church, did what I was told and had a pretty set schedule with school, sports, and family. All that has stayed with me, and now that I'm here in Alaska, it's grand to say that Oklahoma has never left me. But man, did I sure as shit leave Oklahoma. I am twenty-seven years old now. I left home when I was eighteen to see what else was out there, and I'm still looking. The world is one fascinating place, and I intend to cover as much of it as I can. I've lived in five different states and been to all fifty; I've visited ten countries and lived in three of them. I came to Alaska on a whim, and six years later, here I am.

I have no home to call my own. I'm a traveler. I've got a place to lay my head, make food, shit, shower, and shave, and hell, I even have free Internet and laundry, but it's not mine. I work hard, very hard, just as everyone does up here. I live here in Seward, a town of no more than 1,700 people. No stop lights. A beautiful bay that never freezes in the winter, so the fishing's always good. Mountains completely surround the whole town, it's almost like they're giving us one huge hug.

It was the first real friend I made up here whom I finally came out to. Turned out she already knew, and was of course very happy for me. What really got me was when she asked me if I felt better now that I'd told someone. And you know what? I sure as hell did. I felt better than I ever had in my whole life. Up until that moment, I never realized what a heavy weight I'd been carrying.

I would be lying if I said that I didn't want to settle down somewhere in Alaska and live the rest of my life with the one I know I will find. But for right now, I am still on that mission to see all that the world has to offer. A word of advice to anyone else who is doing the same thing, gay or straight: Be careful if you come up here to Alaska, you just might never leave again.

MICHAEL & ALLEN Delta Junction Alaska

My partner and I have been in Alaska for ten years. We own an eighty-acre ex-dairy farm that we are trying to resurrect. We've been building a large (some would say huge) two-story house right in the middle of it. We're finally getting siding on this month!

We've begun collecting milk cows; two are currently being milked, and two heifers were born this year. We're also raising hogs and one of our sows had her second litter two weeks ago. The goats kept eating my garden, so I insisted they had to go. The farm looks out on the glorious Alaska Range, as well as the White Mountains and the Granites. Living here brings us closer to our dream of self-sufficiency.

I work as an environmental specialist for the Army. I am also chief of the Delta Junction Rescue Squad, an unpaid volunteer position that takes up many hours. Allen works for the state during the summer as a park ranger and is the true farmer between the two of us.

We're two Southerners who moved here for my job. We were curious how such a small town would greet us, and discovered that everyone knew pretty much everything before we even got here. Small towns have no secrets—even if you want to keep them, which we did not. There was a week of polite but curious gossip and questions, and then nothing. Our lives as gay men here have been completely uneventful. In fact, it's more like the movie *Big Eden*, where good-hearted, loving people have pushed us to share our lives with them in a way that completely surprised and overwhelmed me. For this reason alone, we are home.

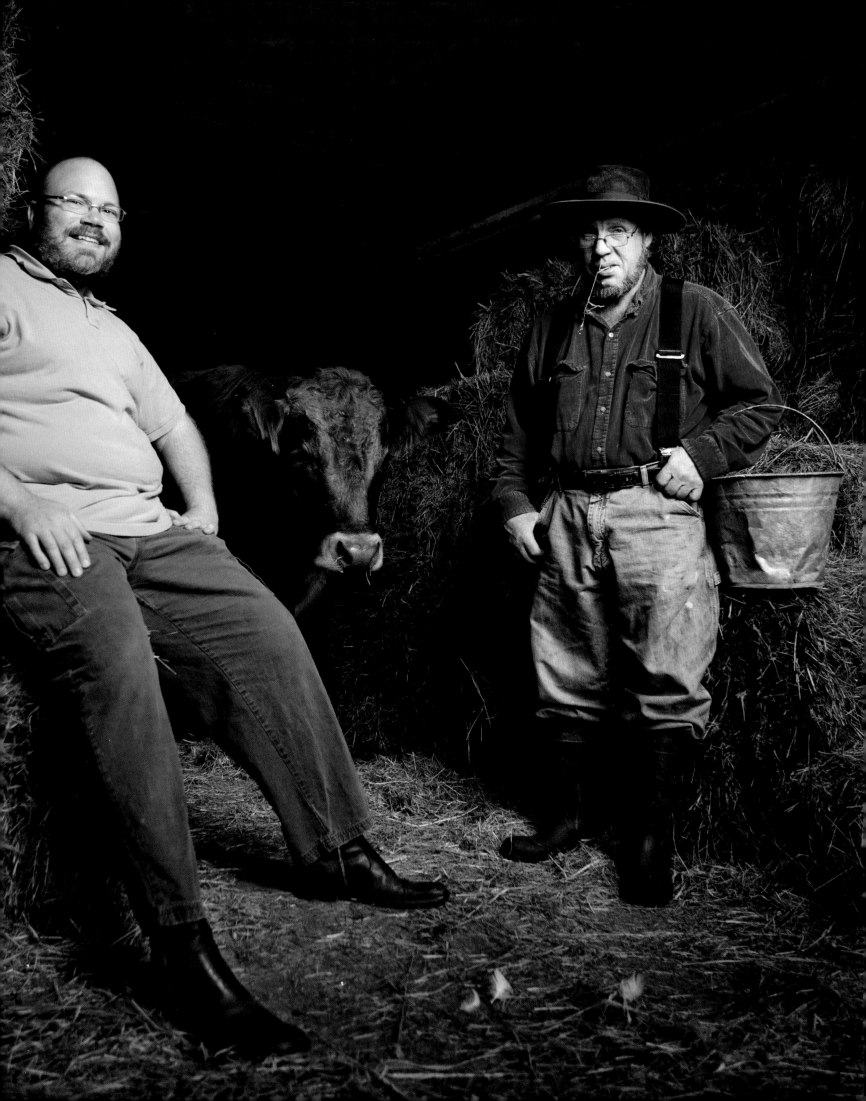

TOM Palmer Alaska

I am an openly gay man with a pioneering spirit and I'm living the life I've always wanted to lead. As a young man in Michigan I dreamed of coming to Alaska. I wanted to be Jeremiah Johnson. I was just this odd gay man who felt stuck in the wrong time; I wished I were born a hundred years ago. Everything in me wanted to be a pioneer, live off the land, and find a simpler life. About twenty-five years ago I opened myself up to the Alaskan dream, and now I can say that dream has come true. I could write a book about my adventures in this great land.

New to Alaska at age twenty-two, I was determined to become a wildlife photographer. I spent months in the National Parks backcountry of Katmai, Denali, Wrangle, and St. Elias photographing bears, wolves, moose, caribou, and the auroras. Two years later I homesteaded in the Wrangle Mountains seventy miles from the nearest town. At age thirty I started a tour company and discovered that sharing the love of my life—Alaska—with people was my true passion.

One of my best memories in Alaska is of me and my two adopted wolf pups howling to a wild pack under a brilliant red aurora. I'm passionate about the auroras and have been photographing the amazing light shows of the northern skies since I moved here. I've built two homes through the years; the second, where I currently live, is the Alaskan dream: a log home built from the ground up with a draw knife, chainsaw, and a chisel.

Ten years ago, Hollywood came knocking. They built a set for the movie *Avalanche* on my property, and I appeared in a couple bit parts. Since then I've had the opportunity to work with three major motion pictures, four reality television shows, Discovery, Animal Planet, and National Geographic. I've also provided locations and scouting for many commercials and hosted the Marlboro Cowboys for two still photo shoots. A gay man's dream come true! I couldn't help but think, here are these men—the epitome of masculinity and ruggedness in our society—doing a photo shoot in a gay man's camp. Go figure!

I had a life-defining moment about a year ago while hosting a group from Korea at my glacier camp. Only one person in the group spoke a little English. We sat in a circle dining on awesome Korean food, taking in Alaska's incredible scenery. Upon leaving, the guide that spoke English said the group wanted to tell me something: they pointed to the incredible landscape and said, "We think this is you!" A tear came to my eye when I realized they were right. I have made a life of loving this land, breathing it in, and living the Alaskan dream.

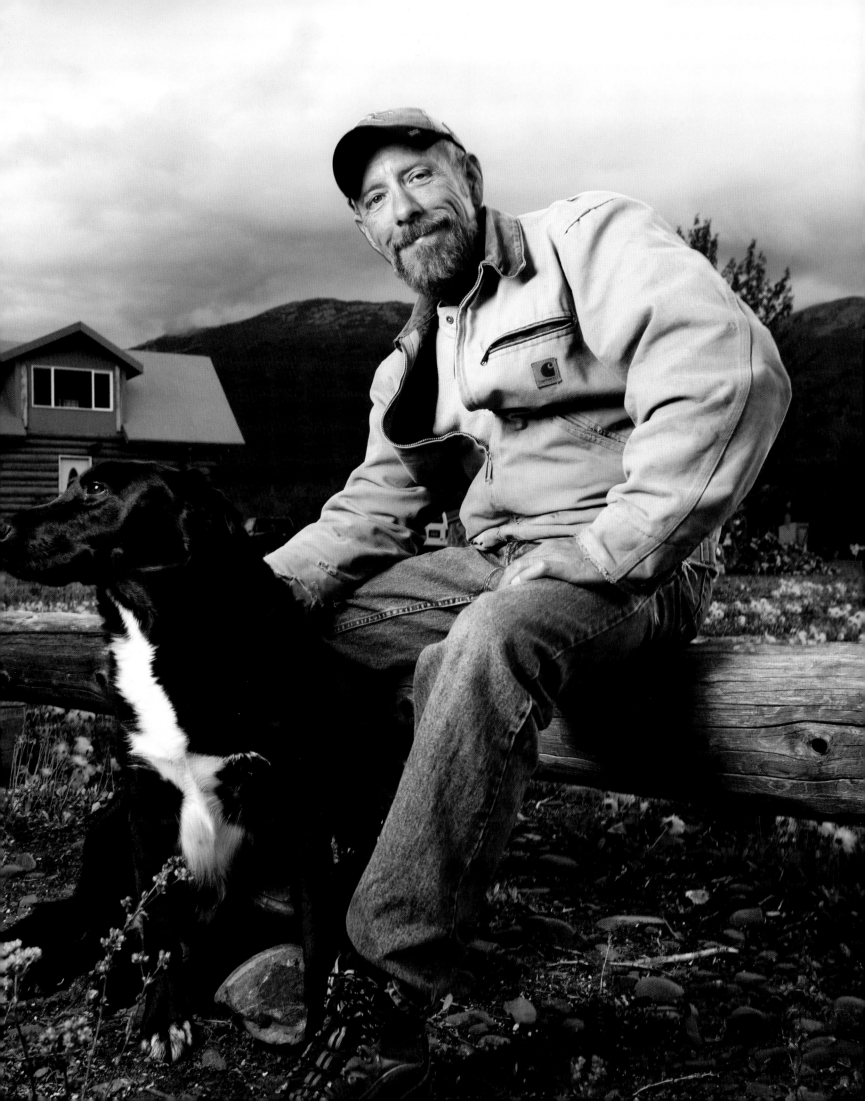

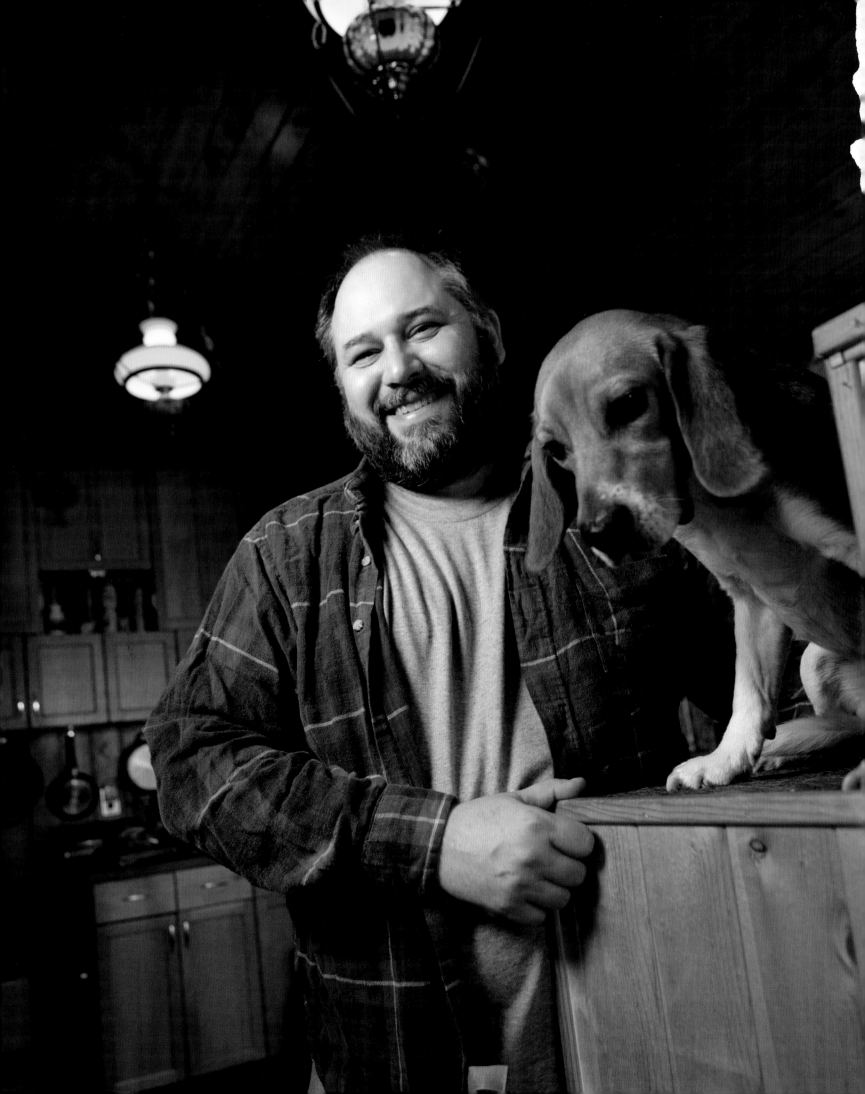

TERRY Tok Alaska

I have lived happily without running water for over ten years, in a hamlet of 1,400 people, 110 miles from the next village, 200 miles from the closest city, and 330 miles from the nearest gay bar.

While living in a small, remote town certainly doesn't offer a shooting-fish-in-the-barrel approach to finding available gay men, Alaska is a place of extremes, and in a way, that applies to the people here as well. This is one of the last states with a majority of men, hence bisexuality seems to be rampant, and being gay certainly isn't rare (in fact, in the last census Alaska had the fifth-highest rate of people identifying themselves as being in same-sex unmarried partner relationships). But on the other hand, most Alaskans closely guard their privacy. So while the overall attitude of the state is "live and let live," it's often drowned out by the loud and dominating voices of those with a religious or military background.

I wouldn't trade the ease of finding companionship or playmates of city life for what I have here. I live in a place where locking doors is not a requirement, people scarcely ever burgle vehicles even if the keys are left in the ignition, and since everyone is bound to know most everyone else, the ability to anonymously hate someone is almost non-existent. Sure, you can't blow into town riding a gay pride float, but over time people get to know a whole person here, which makes it much harder to simply dismiss someone based on a few differences.

VICTOR & SCOTT
Tucson Arizona

I **was born and raised in San Diego.** I like to think I was misplaced at birth, but lucky that it was with a loving family. My parents are from Mexico. I have an older brother and a younger sister. My whole family was into sports; I was into books. I'd always wanted to be a writer, but my parents didn't view this as practical, so I was pushed to become an educator like my siblings.

During college I was an instructional aide for an elementary school because it was credit toward my degree. That was a tough time for me. I had come out to myself a couple of years prior to the job, and then to friends and my siblings while I was working at the school. There were a couple of other closeted gays on the staff and faculty, and they were bitter and miserable. One day I came to work and there was a flyer posted in the break room about a seminar the district was giving on sensitivity training regarding lesbians and gays in the school system. I wasn't out at work yet, and the school secretary came up to me, pointed to the flyer and said: "Can you believe that? Isn't that sick?" I froze. Also in the room was one of the other closeted teachers. I turned to him to see what he would say and he just gathered his things and left the room. I looked at her and said, "Everyone has a right to work," and I turned around and walked out. I've always regretted not coming out to that woman. She could have learned a valuable lesson about judgment that day. I've never held my tongue since.

I live in Tucson now with my partner of six years, Scott. When we moved out here, I started focusing on my writing ambitions—I write screenplays and poetry.

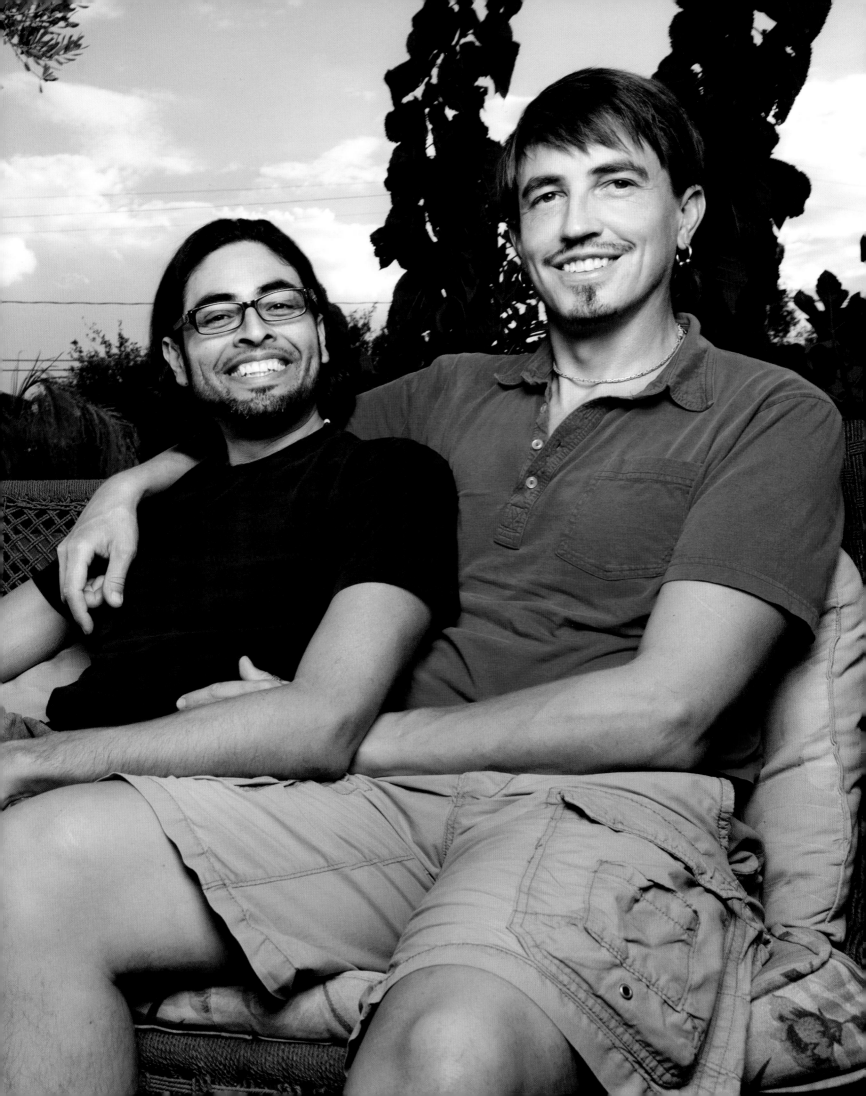

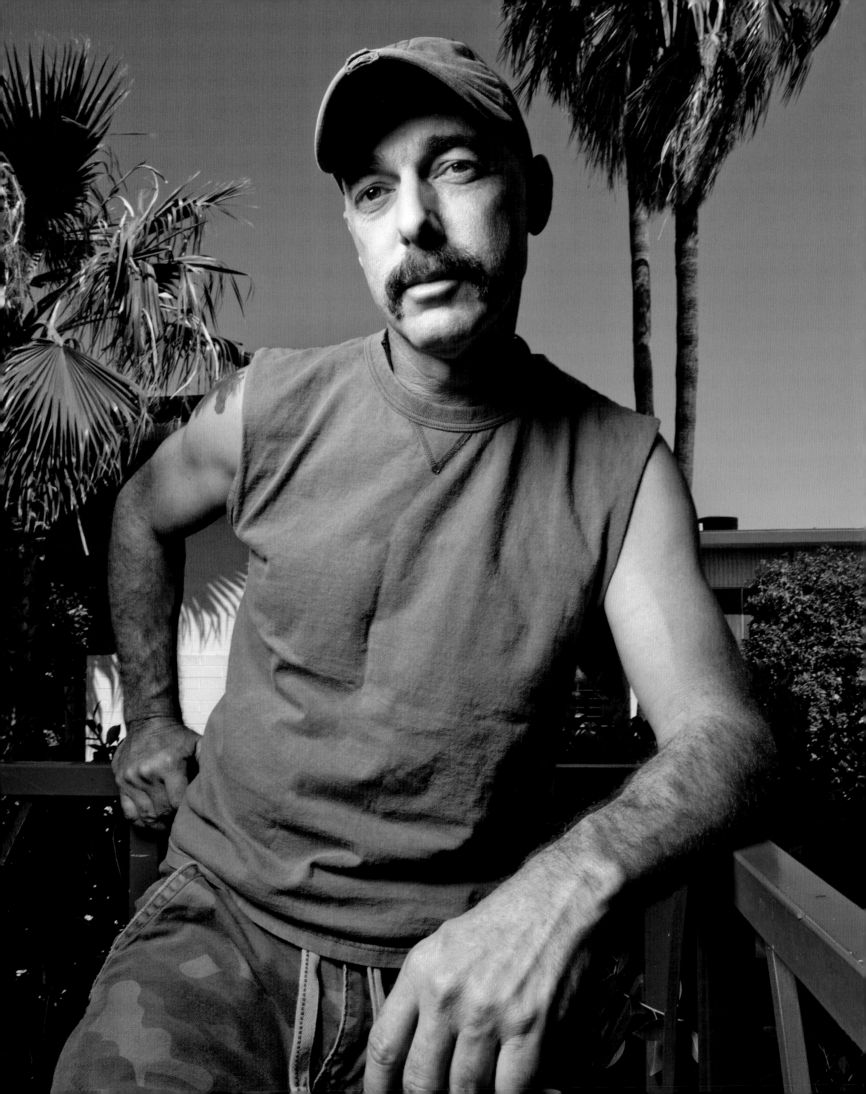

PAUL Phoenix Arizona

I have HIV; it doesn't have me. Ironically, I owe HIV a debt of gratitude, because it could have very well saved my life—from me. As a young gay man I lived the fast life. I was always told I could go anywhere, do anything—the sky is the limit. In fact it was. I had no boundaries, no commitments, no requirements, and after coming out, no expectations. It started to seem as if I no longer existed. My quest to find acceptance brought me to havens at night that would never be associated with my life by day. Two lives, one person.

By day I was an achiever, friendly, funny, entertainer, cowboy, horseman, trainer, instructor, corporate climber and, more interestingly, I worked for the medical examiner's office on the humanities clean up crew, collecting dead bodies off the highway after accidents. Talk about coming face to face with your own mortality! But the higher I flew by day, the further I fell by night. HIV is humbling. It made me aware of who I am and how precious life, love, and longevity really are.

My favorite quote and most important message is: "You can never touch someone so lightly as to not leave a mark."

BOB Scottsdale Arizona

I was raised in the Midwest and there was no choice but to be straight and married. It was just the way things were. I married the girl of my dreams in 1970. By the time I was twenty-six I had two sons and owned my own business and a farm. Although financially successful, there was always something missing. At thirty-one, I told my wife I was gay. She didn't believe me. So instead of rocking the boat, I stayed in a unhappy situation.

As the years went on I grew to become one of the top horsemen in the country, as well as one of the most award-winning hair stylists. Finally the anger and guilt took over and I knew I had to be true to myself. I gave my wife our business and our home and moved to Scottsdale, Arizona to start over.

It was tough at first, but now I have many great gay friends and my straight horse show friends realize I'm still the same guy I've always been. My sons have accepted the fact that they have a gay father and my ex-wife is actually speaking to me again. Life is good. My dog Tater and I travel a lot and the horses are still a huge part of our lives. All in all, I'm a happy cowboy.

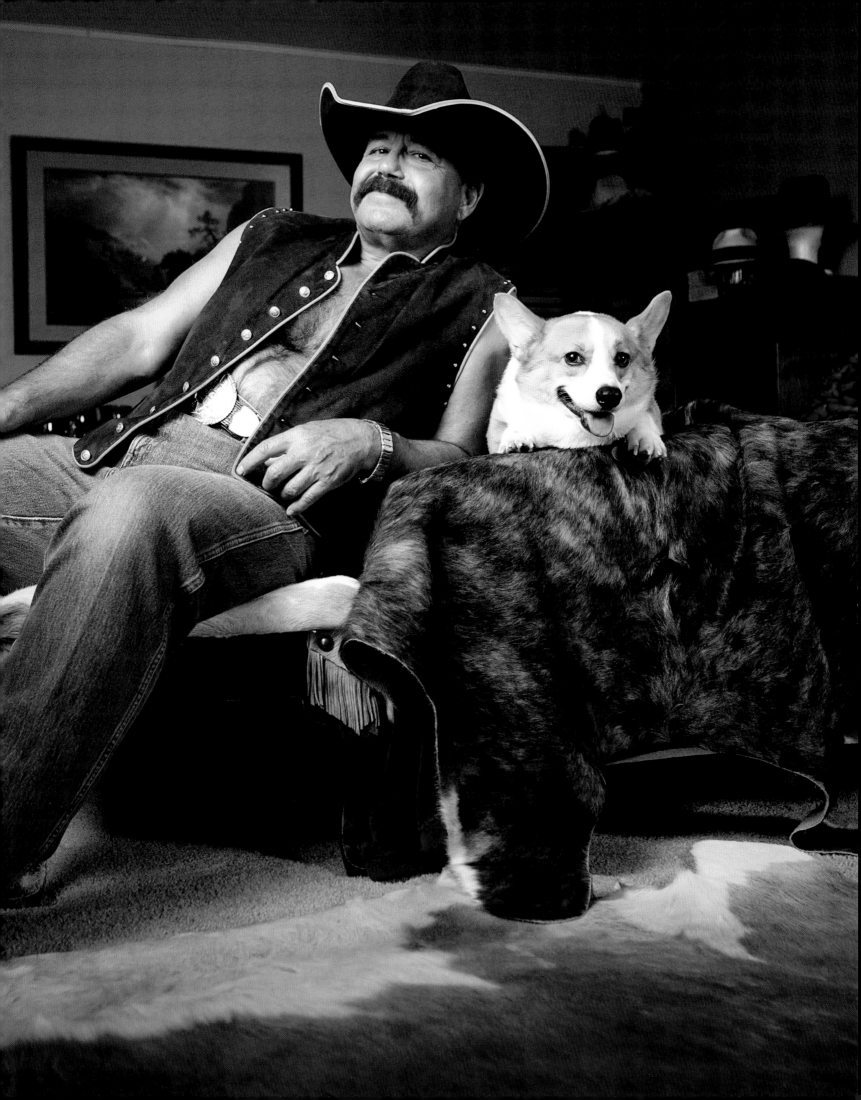

AMOS Little Rock Arkansas

I **relocated to Arkansas from New Orleans after Hurricane Katrina.** I was living in what is now notoriously known as the Ninth Ward, the area hardest hit by the storm. I lost everything. It is such a rude awakening to realize that the books and the movies you love, your favorite shirt, your diplomas, and your credentials are gone forever. It is not easy to be yanked away from your memories, from your material possessions, from everything you know and be brought to a strange place and have to start all over again. I spent a couple of months living at a Red Cross shelter in Arkansas and then came to Little Rock, which I now call home.

I have always been somewhat of an activist, marching for civil rights and helping to integrate the faculty of the New Orleans public schools by being the first white teacher in a black school. Speaking up for what I believe in has always been a part of me. I cannot look at intolerance and stand by quietly.

I am also somewhat of a religious Jew. I was fortunate to live in Israel for many years and my ultimate goal is to go back. I have reconciled my faith with my sexuality; both are very important to me. I was surprised by the reaction of the Jewish community here to the fact that I am gay. Most said, "So what?" I am overwhelmed by their acceptance. There will always be one or two detractors, but that is their problem. I must say that the people of Arkansas have been wonderful and after a year of not really knowing who I was, I'm living my life as an openly gay Jew and I finally feel at home.

I love Arkansas but I am puzzled by the lack of unity in the gay population here. Because of that I founded Literary Pride, a gay reading group that has been successful beyond my wildest dreams. It is so good to spend an evening with a group of like-minded men and just talk about whatever comes to mind. My other group is Cinema Pride, a group that brings people together and gives us a chance to watch gay-themed films that we otherwise wouldn't have a chance to see here in the Bible Belt. I also worked very hard to have gay literature included in the Arkansas Literary Festival. For the last two years we have had the pleasure of having gay authors as part of the event.

As a teacher, my students are my life. My fields are gay studies and existential philosophy. I am currently working on two projects. One is an existential view on the raising of gay consciousness, and the other is a book on growing up gay and Jewish in the South. I love to teach writing, and nothing pleases me more than discovering new talent and helping students find their hidden voices.

I wear a lot of pink simply because I've always loved the color. My students began bringing me flamingos of every kind, and it just caught on, so they nicknamed me Dr. Mingo.

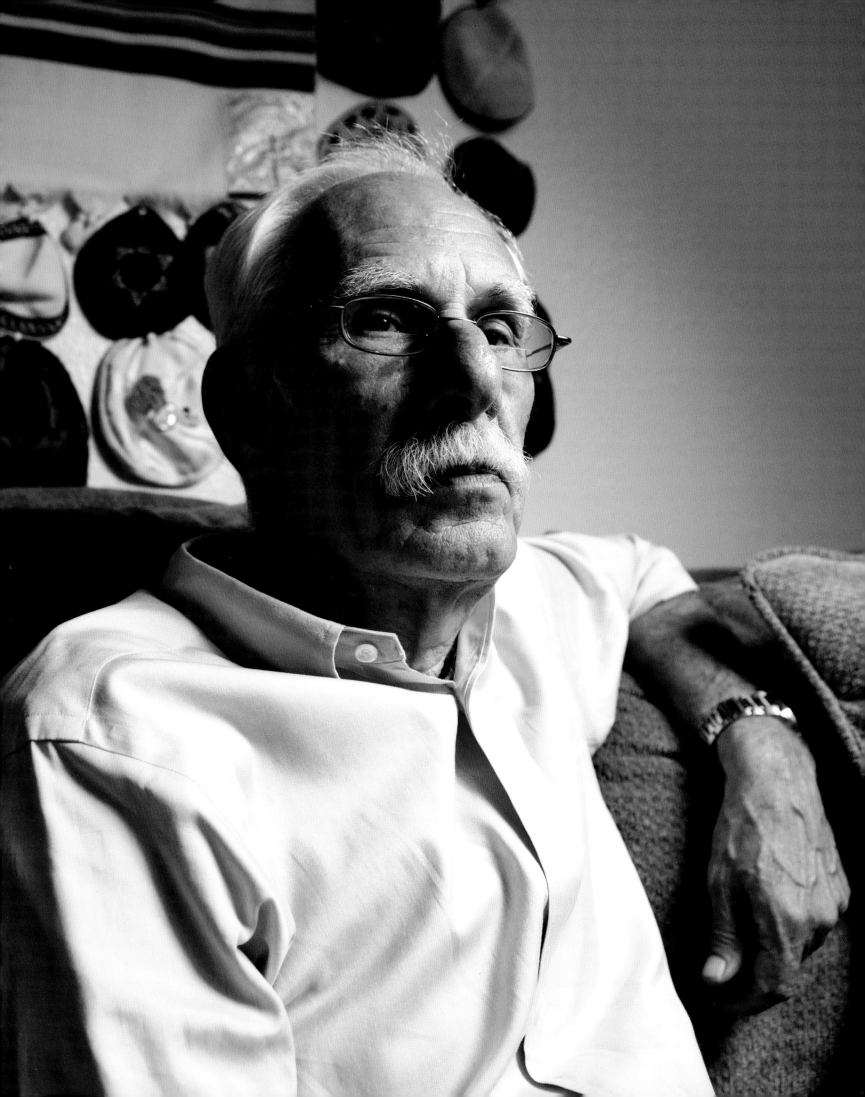

NILE & JIM
Palm Springs California

We are products of what we call the ignorant **generation,** the generation that could not even talk about sex, much less sexual orientation. We are also products of rural environments; I was raised in Montana and Jim in Kansas. We both followed the dictates of societal mores and married and had children. Jim, the furry one, was married for twenty-seven years; I was married for twenty-one. We have pretty cool relationships with our respective families. We've been together for fourteen years, eight as registered partners in the state of California.

As gay men, our philosophy is that we neither flaunt nor apologize for who we are. We have always lived as the minority gay couple in all-American communities. We proudly fly our pride colors, but at the same time we go out of our way to connect with people. Maybe we're just lucky, but we've never been put down in any way. We have had neighbors flat out tell us how much they appreciate us being here. As gay men, no other joy makes our hearts leap more than that. We choose to live quiet, orderly lives, being sensitive to those beside and around us, and we feel we have earned their sincere respect and affirmation in return. We are committed to being positive role models, helping by example to bring down the myths and stereotypes.

Our life's hope is that we touch people's lives in a way that they might reach acceptance and understanding of the reality of being a gay man, and realize that embracing diversity really is fine.

We're just pretty plain, low-key men.

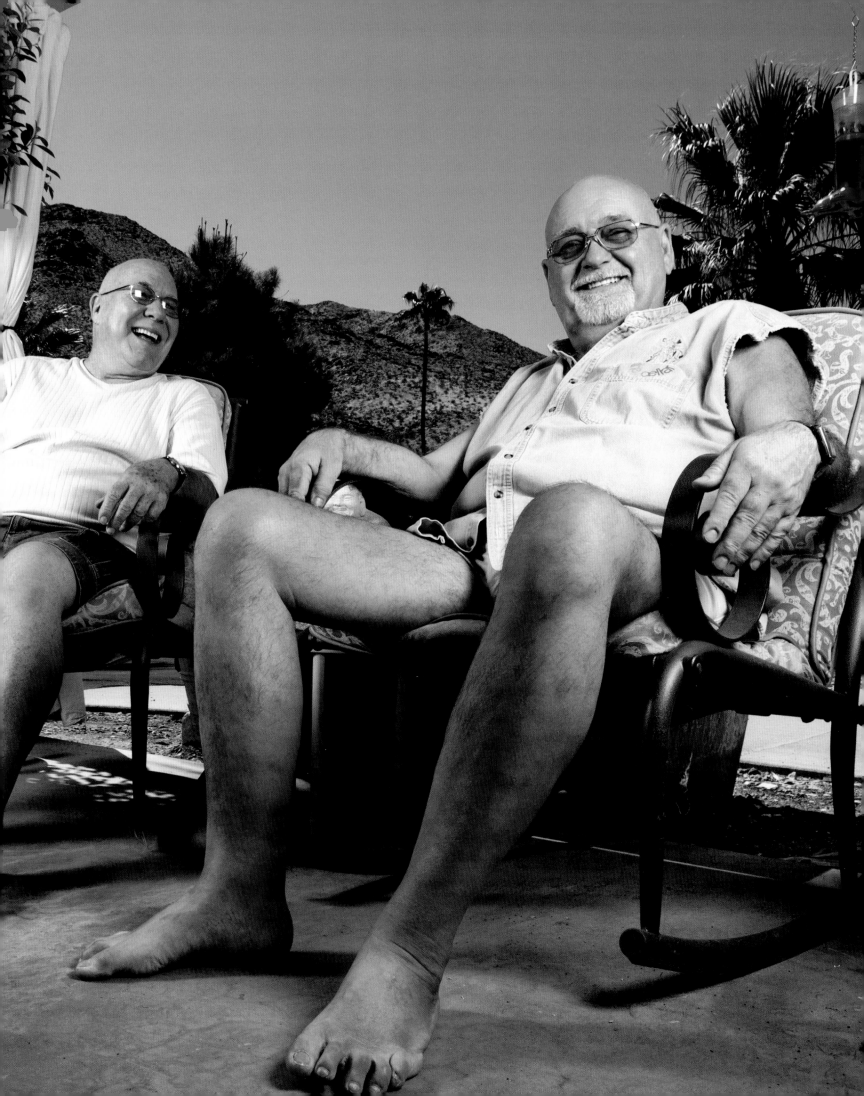

PHILIP Palm Springs California

I **started working in the adult film industry in my early thirties.** On paper that's a little too old to begin, but I looked like a twenty-year-old kid. In retrospect, I'm really lucky I didn't get involved when I was ten years younger—the amount of drugs and pressure in that world is absolutely lethal. It is sad, too, because today I am regularly contacted by young guys who want to be porn stars. I tell them not to go there.

I am from a macho Italian family based in Buffalo, New York. Growing up, there were no gay people around me. Or if there were, I didn't see them. I hid my sexuality from myself. I married an older woman when I was twenty and pretended everything was fine. When I decided to lead a second life in porn, I was allowing myself into places I normally wouldn't go.

I was being courted by one of the biggest agents in that arena. I became a bit of a star. When I was trying to act in regular films, I had never felt that special. Meanwhile, my wife and family had no idea this was a part of my life—I kept it very hush-hush. I never thought it would explode the way it did. I took a random trip to England and people there recognized my face! It scared me and I tried to retire, but the industry flatly told me, "*We* decide when your time here is up." When I didn't take that seriously, I was proven otherwise—they threatened to reveal me.

My father had just had quadruple bypass surgery the night I was featured on *Entertainment Tonight* as the person who "outed Tom Cruise." A Spanish magazine had claimed that I'd given an interview in France admitting that Cruise and I were lovers. This wasn't true, but I still faced a lawsuit—and, with that, complete exposure of my secret life. I knew my father was in bed that night watching television while recovering. After it aired, I thought, "Oh God, I hope I didn't just give my father a heart attack."

Then, as if events couldn't get more shocking, my parents were completely loving and understanding. My father, the patriarch of my tough Italian clan, even asked me why I hadn't felt comfortable telling them sooner. His parental instinct to be there for me during a tough time dominated any judgmental impulse he may have had. In retrospect, coming out was the best thing that ever happened to me. My family and I became much closer, and I am no longer living a lie.

Being a porn actor brought people into my life who were interested in me for the wrong reasons. It taught me to be a good judge of character. I believe that if you live through a career in porn, you become a very strong person. Sometimes people ask me, "Aren't you that guy?" I don't deny it, but I tell them that "used to be me." Now I am a happy forty-year-old gay man in America—still figuring things out.

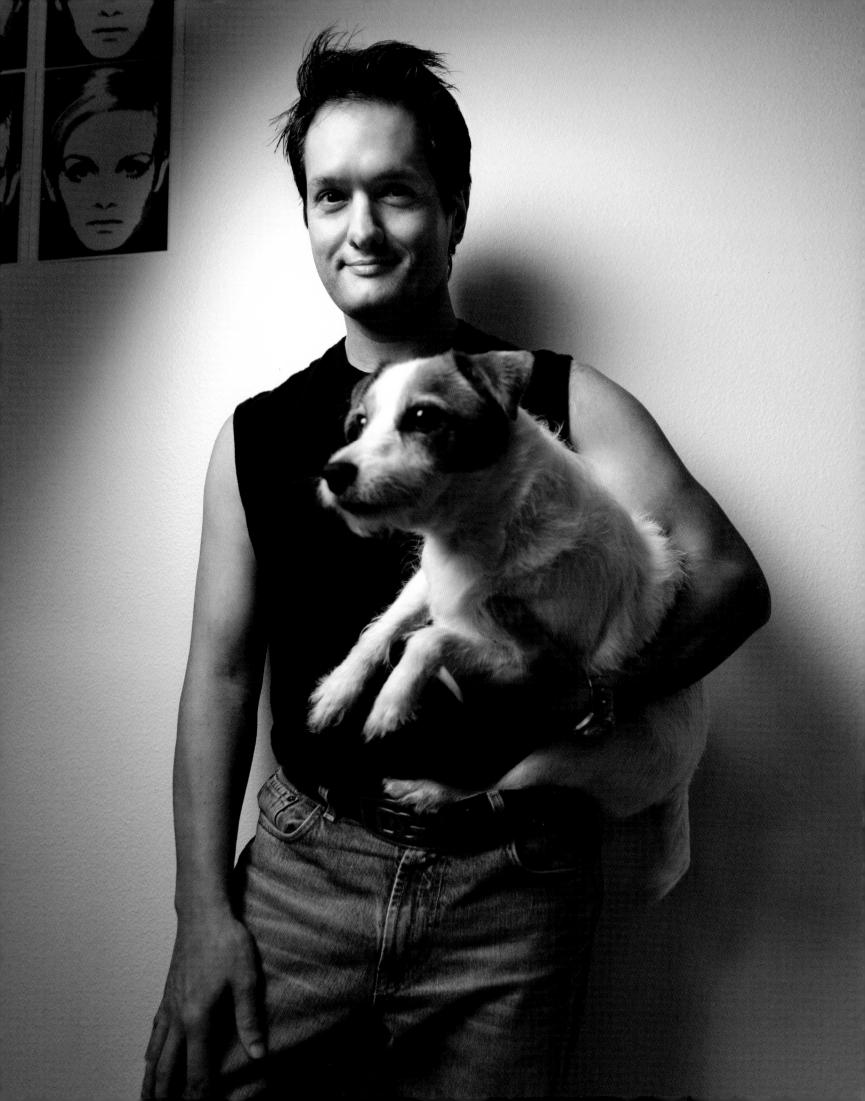

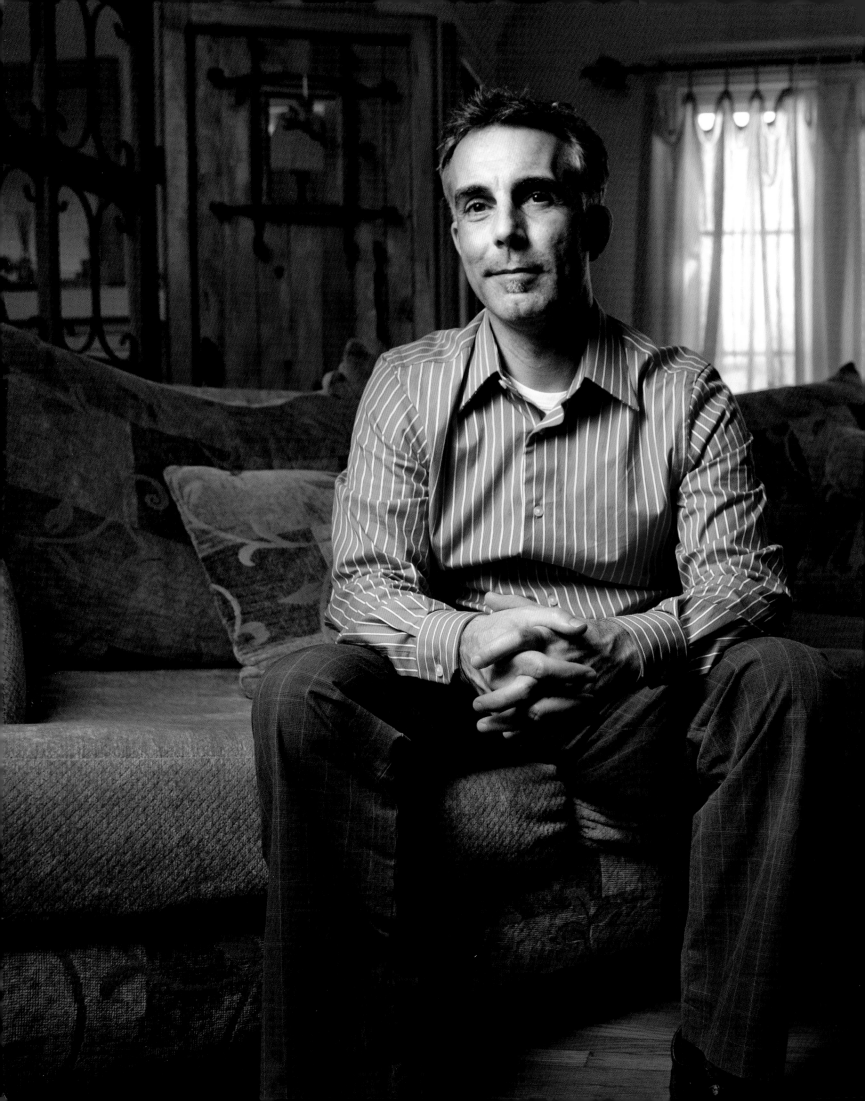

SCOTT Oxnard California

I'm a quiet, fairly conservative (using the term to define my existence, not my politics) forty-six-year-old gay man with a slight edge, living in the town I grew up in. I am fortunate enough to own a humble slice of real estate here: an old Spanish chateau that one of my friends and I spent almost two years restoring on our own. I live the peaceful, atypical life of a homosexual homebody, enjoying the company of my birds and the serenity of the little oases I've created in my front and back yards. I am not a big fan of the bar or club scene and have no addictive habits or traits. I do date, periodically, but am not driven by it. I tend to be more of a relationship-oriented guy and am not real good at the casual sex thing. Boring? Probably to some.

While I don't feel as though I'm defined by my sexuality, I'm not ashamed of it either, and I don't try to hide it. I am very happy and at peace in my skin and very comfortable with my unobtrusive existence. I try to step lightly on the Earth and tend to subscribe to somewhat of a pagan belief system (the pure pagan philosophies, not the occultish Christian bastardizations): respecting the power of nature and the energies in everyone and everything around us. I don't feel as though my sexuality has ever held me back at all. Lucky? Nah, just a light treader.

That all said, I do have a slight obsession with high-quality clothing, and I can be a bit of a perfectionist. Diametric opposition? Perhaps.

ERNESTO Los Angeles California

was born in NYC, grew up in NYC, lost my virginity in NYC. I thought I'd never leave. But it turned out that to pursue my dream I'd have to.

Since I was a little kid, all I've ever wanted to do was design beautiful clothes for movie stars. I remember being ten years old and watching old films from the thirties and forties, and telling my mother that I wanted to make the dress Myrna Loy was wearing. I finally got my opportunity when I moved to San Francisco to go to college and study at the Fashion Institute.

I landed in Los Angeles and never looked back. I began working with costume designers and am now a successful costume designer in my own right. Los Angeles is the best possible place to do what I love. I get to work with talented and wonderful people.

I'll always love NYC and visit there often, but LA is home now. There's room to breathe.

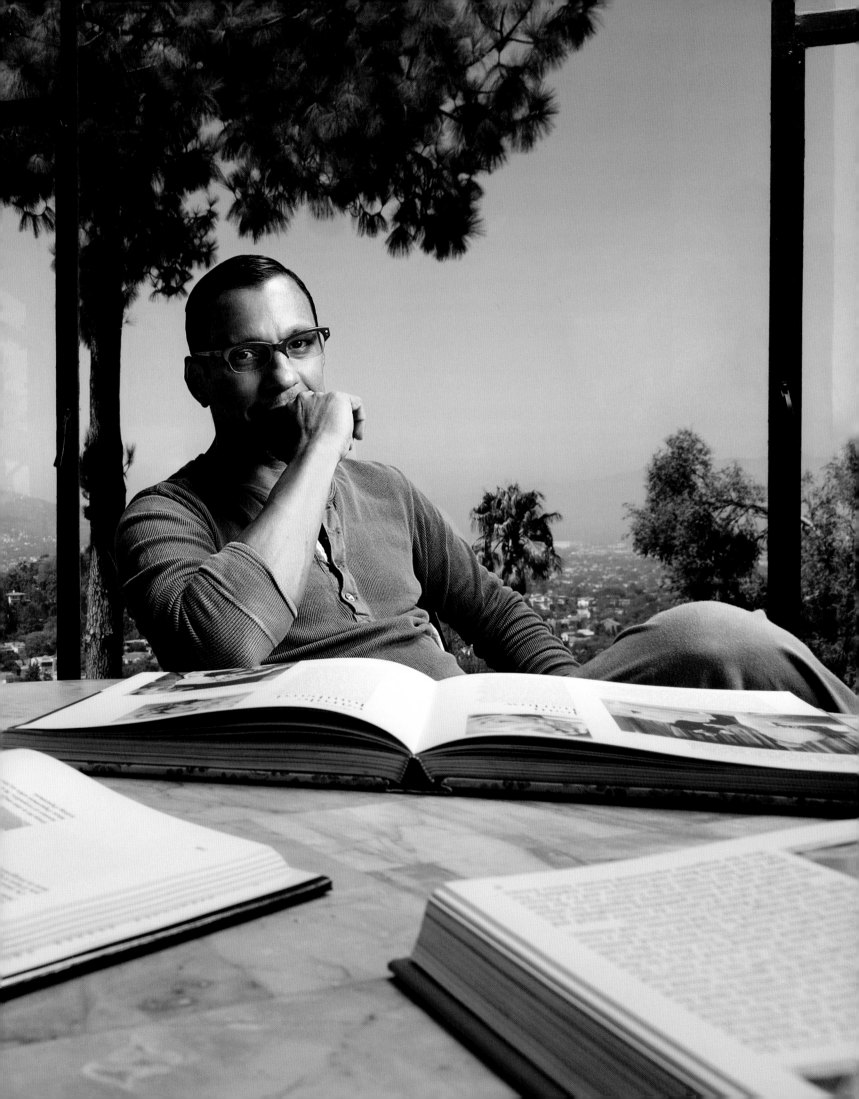

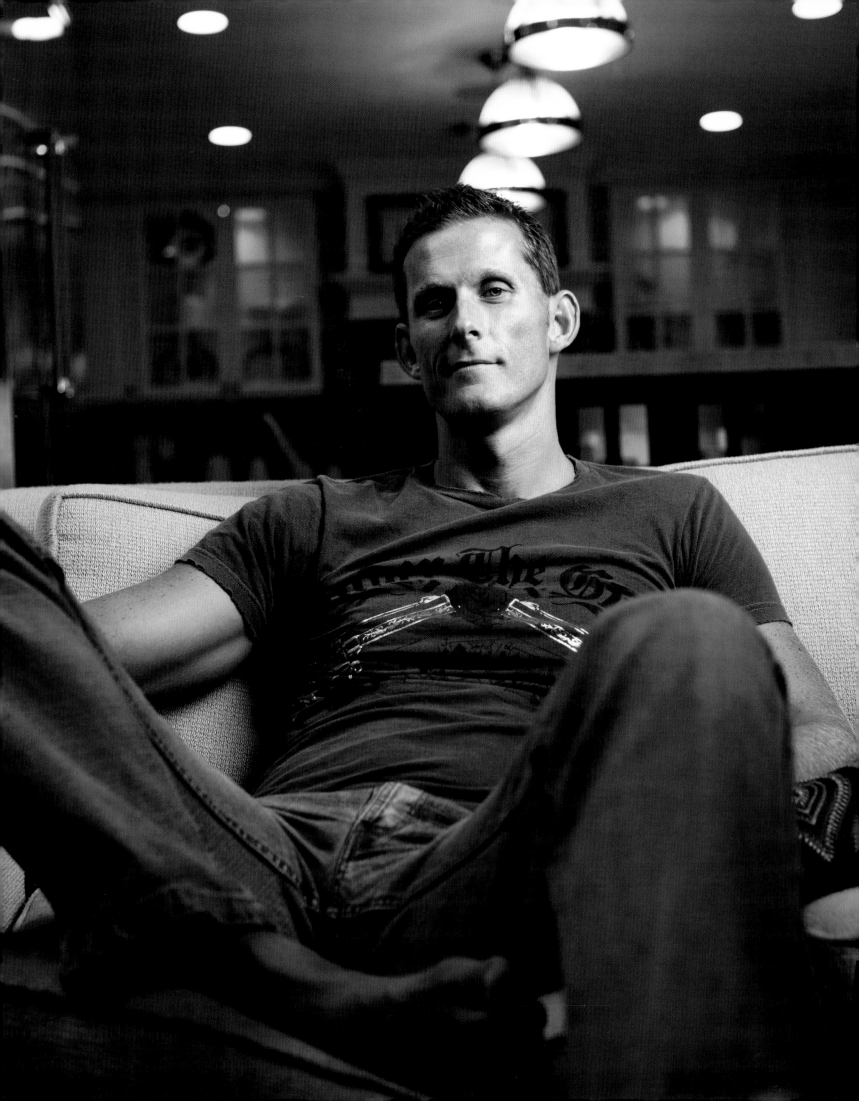

STEVE Studio City California

I knew from the age of sixteen that I wanted to work on Wall Street. I started my career as a bond analyst for Salomon Brothers. I was one of a group of young, hard-working, driven professionals; it was the first time in my life when I really felt that I was a part of something special and unique. I think I was always aware of my homosexuality but always put those thoughts in the back of my mind and focused on building my career and reputation. Since I was young and working hard like my fellow associates, no one ever questioned my orientation or why I was not actively dating.

Many people might not know this, but Wall Street trading floors are a very homophobic environment, much like the world of professional sports. They do not, for the most part, welcome individuals who don't fit into the stereotype of the white, privileged, aggressive, heterosexual male. That's not to say that gays don't exist on Wall Street, but if you're on the trading desk risking firm capital and you're queer, you'd better be pretty good at living a double life. Because as soon as you're outed, the probability of you being treated "differently" by your professional peers and your career heading south jumps pretty high. I was very closeted during my years on Wall Street.

This all changed for me ten years later, when I was courted and seduced by a very prestigious mortgage company based in Los Angeles. I had started dating men during my last few years in New York and met some fantastic people, but there was no one who I felt I would be with forever. I was a late bloomer and didn't have my first date with a man until I was almost thirty. Living life as a gay man for me was one of the most natural progressions of my life. For the first time in my personal life, I felt that I belonged to something. I was starved to learn more about the gay community and make new gay friends. So when I moved to LA as a young, successful bond trader and recently single gay man, I felt like I had the world by the balls.

When it came to dating, I always found myself drawn to other guys who loved to be athletic and lived a healthy lifestyle. I always left the door open to participating in a strong, long-term, committed, monogamous relationship. However, as a result of a demanding work schedule, training and participating in triathlons, and building three homes in the eleven years I lived in LA, I guess there wasn't much time left for finding a partner. Then, ten years ago, at the age of thirty-five, I was diagnosed with an advanced case of Lyme Disease. My illness was one of the most difficult battles I have ever had to confront, but I am fortunate enough to have been able to overcome the grasp of this disease and now live a very healthy life.

In the midst of the upheaval we have witnessed on Wall Street, like many fellow Americans, I find myself trying to reinvent who I am on a professional front. I am too young to retire now, and too active and driven to just give up on pursuing a passionate career path. I acquired my real estate license a few years ago, and am currently acquiring my general contractor's license. I will be opening up my own residential construction and home remodeling company, tailored toward assisting gay men and women in building their dream homes.

I am still single, yet remain very hopeful that one day, regardless of how old I may be, I will find my lifetime partner. I hope I live to see the day when gay marriage and gay families are both legalized across our entire country and are as easily accepted in our communities as every other minority class. Until those days come to be, I will continue to try to be the best person I know how to be, and I will try my damnedest to embrace life as an openly proud gay man and never live in shame of it.

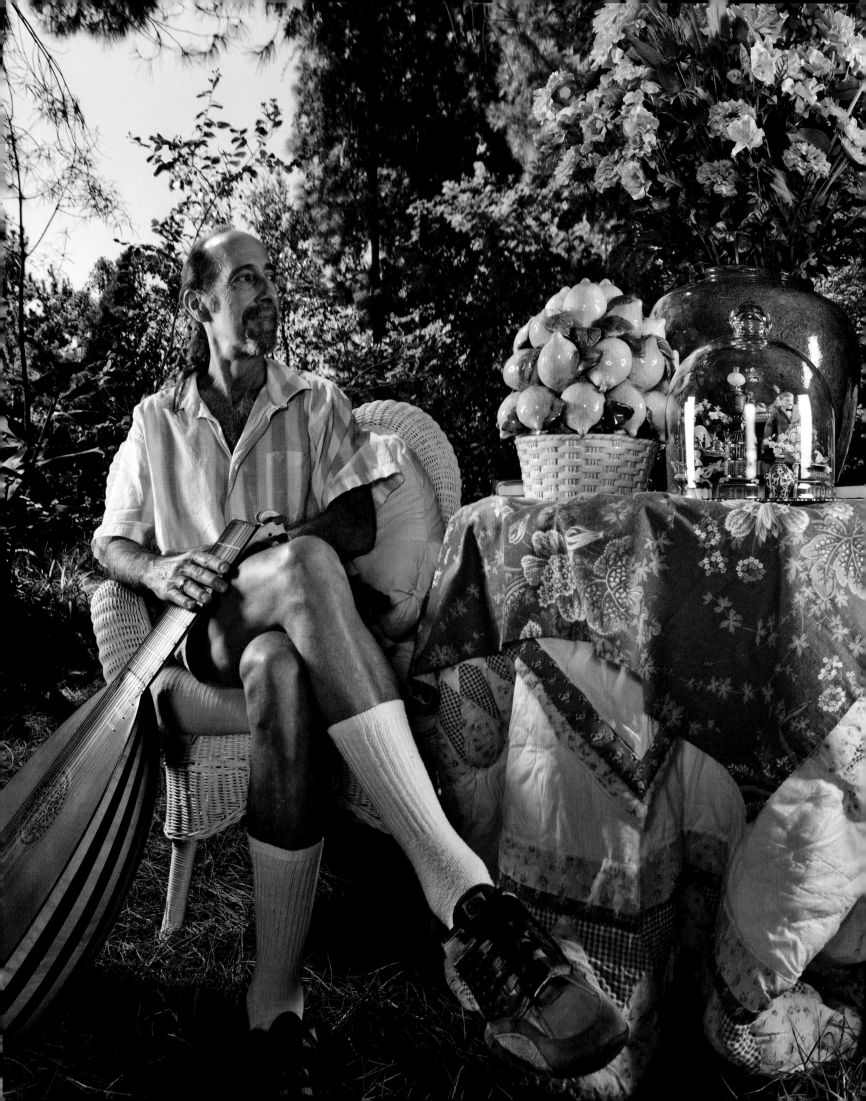

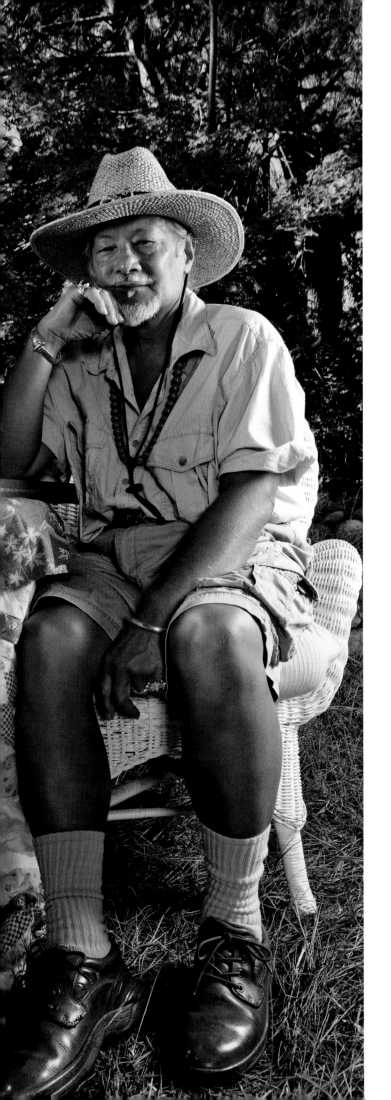

JACQUES & ABI
Sacramento California

I live in Sacramento with Abi, my partner of more than thirty years. We recently married in front of twenty of our closest friends.

Abi is very fond of telling me how he first observed me, long before we actually met, paddling my kayak upstream on the American River, which flows through the community where we currently reside. We have lived together since we met on the disco dance floor in 1976, where we were both inventing our own moves and steps.

Abi moved to Sacramento from Detroit in 1973, and enjoys a semi-retirement as an antiques dealer. He collects antique miniatures and dollhouses and has an intense passion for finding and arranging furnishings for our home, which is dramatically filled with our shared interests.

My hobby is riding and restoring antique bicycles. Using a bicycle built in 1886, I have set a two-hundred-mile distance and time record in Europe, and a one-hundred-mile distance and time record in Australia.

When I can pull him away, Abi and I enjoy traveling together to warm, exotic places.

DANIEL San Francisco California

I'm an Englishman living in America with my partner. In Britain I was a professional stage actor, but since moving to the States two years ago, I've been training in massage therapy and holistic health. I hope to go to UCLA soon to begin a master's in nursing.

My perspective on being gay in this country is tainted by my immigration issue and wanting the right to stay with my partner—a hot green-card-holding Spaniard! Like any straight couple, we chose to live together. But unlike any straight couple, our relationship is not validated by state or federal law. This leaves me jumping through hoops to be here. But would I choose a different way of being? Hell no! Have the suits in Washington tell me how I should live my life? No way! So I will continue to work to be happy and legal, move in the direction that leads me to stay with the man and the country I love. If I step down—they win.

Change is happening whether our opponents want to acknowledge it or not. Gay marriage is on the radar, and immigration will have to eventually follow suit. Spain already has it. So does England.

California and being gay—I love both! And endeavor to have both!

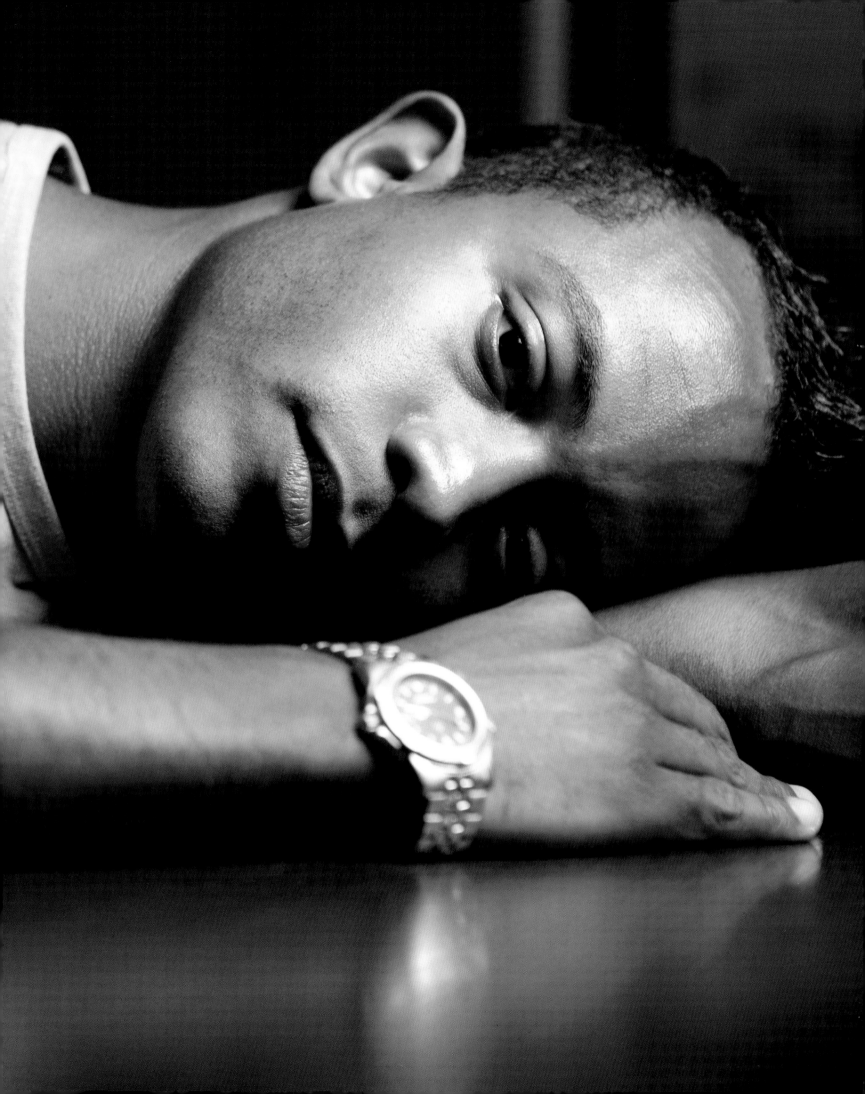

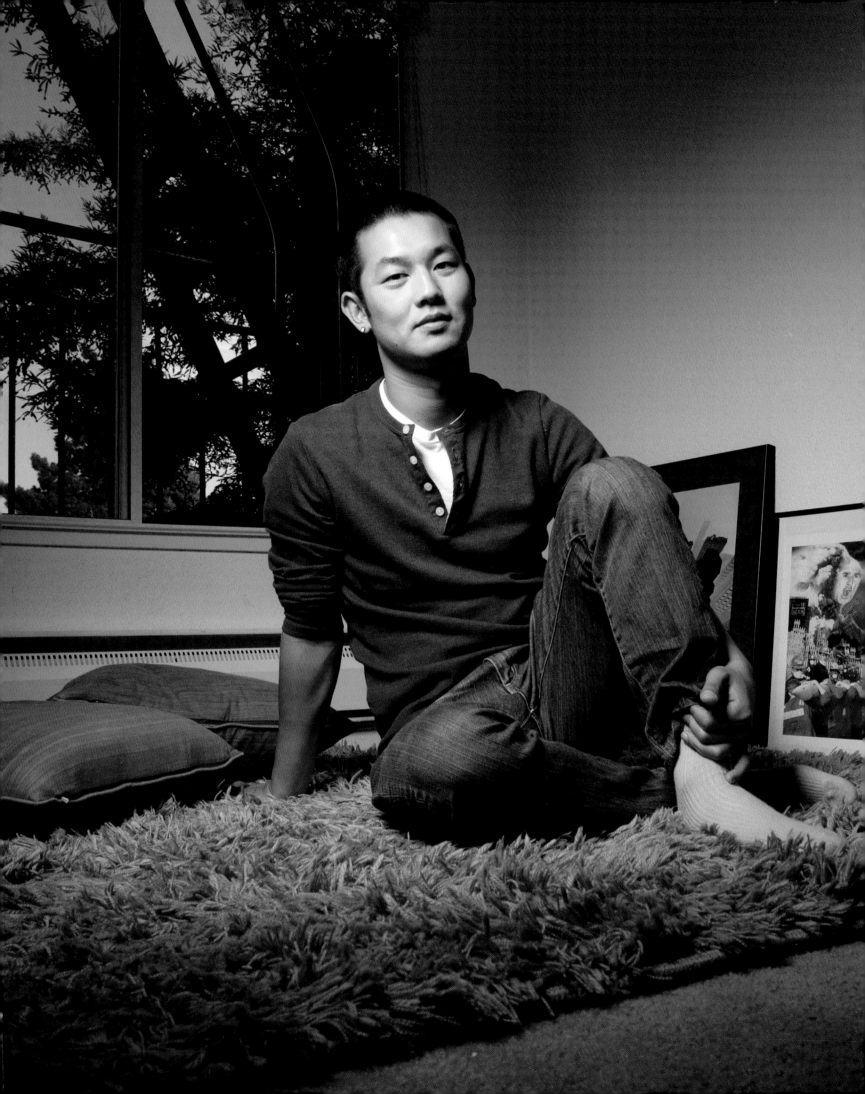

BRYANT San Francisco California

'm a twenty-eight-year-old San Francisco native who recently finished grad school—the first in my family to do so. I got my bachelor's degree in ethnic studies and public policy, and my master's degree in urban planning. I attribute these paths largely to the great fortune of being a San Francisco native. I love it for so many reasons: how beautiful it is, how gay it is, how diverse and Asian it is, how progressive it is. I was able to take women's studies and ethnic studies in high school; my teachers engaged me politically in middle school; we learned about organic farming, numerology, and flower power when I was in elementary school. I don't know where else you could grow up with all these influences.

I guess it has instilled an altruistic sense in me. I now work for the city of San Francisco, allocating money to youth programs. I specifically run a fund that helps young people develop campaigns around issues they care about and create business plans to press those issues forward. It's really incredible helping to enable youths to take an active part in all sorts of issues going on in the city.

My parents emigrated here from Burma, and I grew up in one of the poorer parts of the city. I came out right after high school to one of my closest friends, and to my family after college. Everyone's been great about it—my best friends still love me (one of them actually came out to me a few years later), my brother said he thought it was cool and that being gay made me unique, and my sister said something like, "So what?" and didn't think it was a big deal because she'd had a good friend come out to her when she was twelve. They all have gone out with me to gay clubs and events.

Unfortunately, it's taken my parents longer to come terms with it, and it's still a pretty unspoken thing among them. I think Asian cultures just tend to sweep it under the rug. I have a couple of queer relatives, and whenever they bring their partners to family events, we always refer to them as their "friends."

Considering all of that, I think I'm a pretty regular guy with everyday interests. It's funny though—it wasn't until I left San Francisco to go to college in Los Angeles and the East Coast that I realized what a bubble I live in here, and just how lucky I am!

NANDI Red Feather Lakes Colorado

've had a very rich and full life so far. Part of that comes from authenticity and honesty, just being who I am in my day-to-day life. I've been a cook, a bus driver, a sex educator, a massage therapist, a barista. I've lived in a Radical Faerie sanctuary and a Buddhist meditation center. I am enmeshed with many different parts of humanity.

I can identify with certain situations or behaviors, but the moment I identify *as* them, the trouble begins. My relationship to both Radical Faeries and Buddhists remains placid, but I think that's because I'm not trying to be either. I'm a Lukumi. I'm a Santeria practitioner. My heart and soul belong to the Orishas and to my ancestors, the spiritual totem that supports and raises me up to be walking on the Earth. They are the beings who nudged me past my apprehension of both Buddhists and Radical Faeries in order to explore what each offers, and that's been a great deal. I have made a complete metamorphosis in the last seven years of my life because of my experiences in both of those intentional, spiritual communities.

I started losing my hair at twenty-one, so the shaved head is masculine by default. I can't deny my anatomy, but gender has always been a very gray thing for me. At this point in my life, and really, toward the end of my living at the Buddhist center, I felt like living through a feminine lens. If I had to pick a gender expression that fits my entire identity, it would be a tomboy. I love Doc Marten boots and punk rock and motorcycles and camping and tattoos, but I also really love to look fierce and female and strut my stuff!

Living in those communities forced me to ask important questions about myself and about what kind of world I live in, and what I can contribute to that world. The answer might not be about high heels, but it will probably be delivered in them. All things considered, that's not so bad.

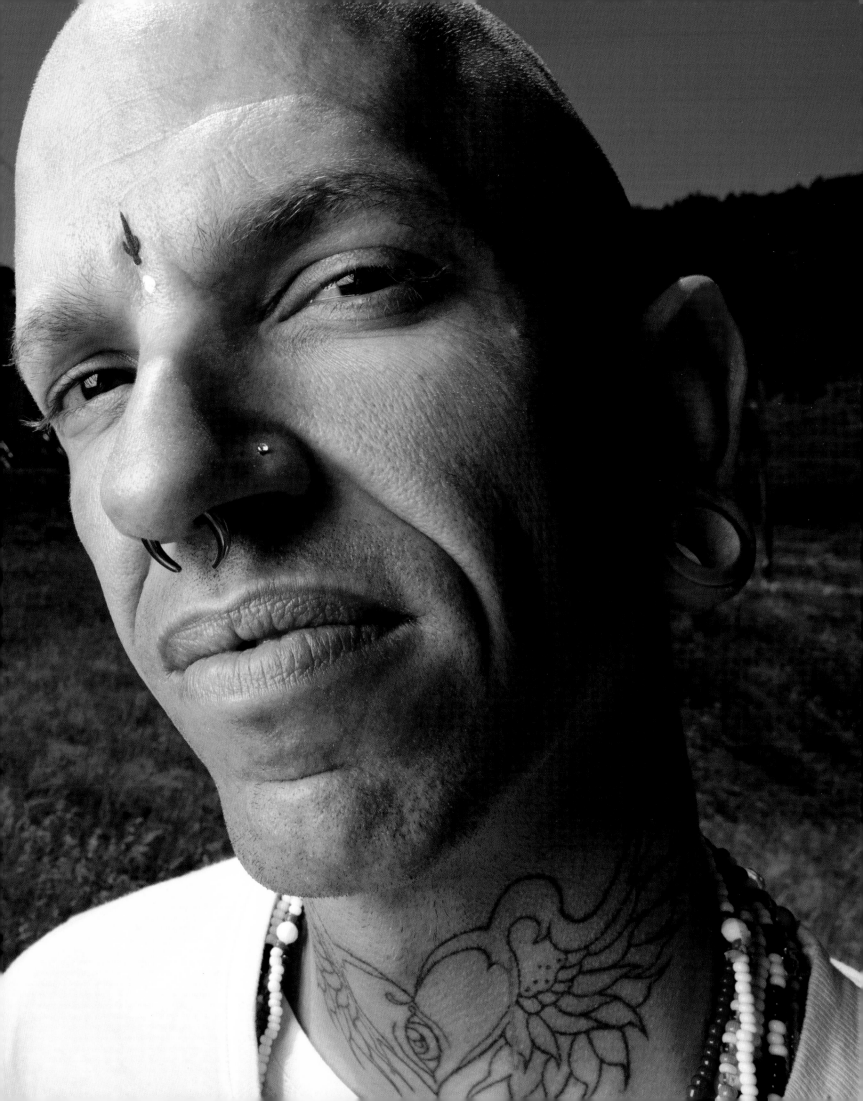

JIM & LARRY Longmont Colorado

I live in "America's coolest neighborhood," Prospect New Town, which is situated alongside the front range of the Rocky Mountains outside of Boulder. It can best be described as Whoville—home to a physically active, artistic, wine-drinking, porch-lounging, new urbanist community. The second you enter Prospect you feel its vibe. It emits happiness and openness with its quirkily named streets, like 100-Year Party Court and Confidence Drive, and its variety of homes and buildings, each uniquely designed and built with mixed materials. I have always been passionate about architecture (Mike Brady from *The Brady Bunch* was my idol), and Prospect New Town is an architectural dream. Upon Jim and me moving into our funky mineshaft house, life became several notches more kick-ass.

I grew up in the economically depressed small town of Antonito in southern Colorado. It is the kind of place where two men dancing together or holding hands instantly turns heads. I am from a Mexican American family with nine other siblings. I honestly believe I am the luckiest of them all, given the fact that I am gay. I tell them this all the time and some even agree! The best thing about being gay in America is that we are *free* to show people how fantastic we truly are.

Jim and I met in 1996 when online dating wasn't nearly as sophisticated as it is today. This was before you could even exchange photos! Jim and I had a commitment ceremony several years into our relationship; my parents refused to attend. To this day, they regret not being there. Besides it being out-of-this-world fun, and missing out on that, they soon realized our love for one another was authentic and deep. As a reflection of their shifted attitudes, they included us in their 60th anniversary vow-renewing ceremony in the oldest Catholic church in Colorado—a mile down the dirt road from our ranch. Each of their ten children walked down the aisle behind them, holding their respective partner's hand. My mom even cleared it with the priest beforehand, and he gracefully allowed it. Not bad for a typically narrow minded community.

Boulder County has been without a gay bar for many years, and there's no special designation for social hubs. Acceptance and blending in seems to come more naturally around here. Some people see that as a good thing, others don't. As it turns out most friends in our social circle are straight, and many of our gay friends feel threatened by this. Some even misinterpret it as us turning against the gay community—something we find difficult to understand. From our perspective, we both expand awareness simply through the outward expression of our love. We have never tried to hide who we are. Accommodating the limitations of others isn't our style.

REGGIE New Haven Connecticut

I was born in Mississippi, but I grew up in Southern Georgia. I always knew I was gay and I also knew I had to get out of the Bible Belt as soon as possible. I searched every college guide and periodical I could find to determine what the best school in the country was for gay students. I discovered that Yale was a really supportive place, and I was lucky enough to get in. Even so, I stayed in the closet until a month after college graduation when my bursar bill had been completely paid, as I feared my parents would pull me out of liberal Yale if they knew I was gay. I came out in July of 1998, and went on to graduate school that fall to study public policy at Harvard's Kennedy School.

I've lived in New Haven for ten years and I love it. In 2005 I bought a two-family house that was built in 1867, and spent a year renovating it. I like to garden, and for fun I also enjoy learning about wine.

I don't think about the fact that I'm gay so much anymore. Most people know I'm gay (since I appeared on the front page of the local newspaper's business section wearing a "Marriage Is So Gay" t-shirt). It hasn't changed anything. I am who I am.

I've only had three serious boyfriends in my life—including my current boyfriend of two years. At this point in my life, getting married and having kids like my other friends (who happen to mostly be straight) are the main goals on which I'm focused.

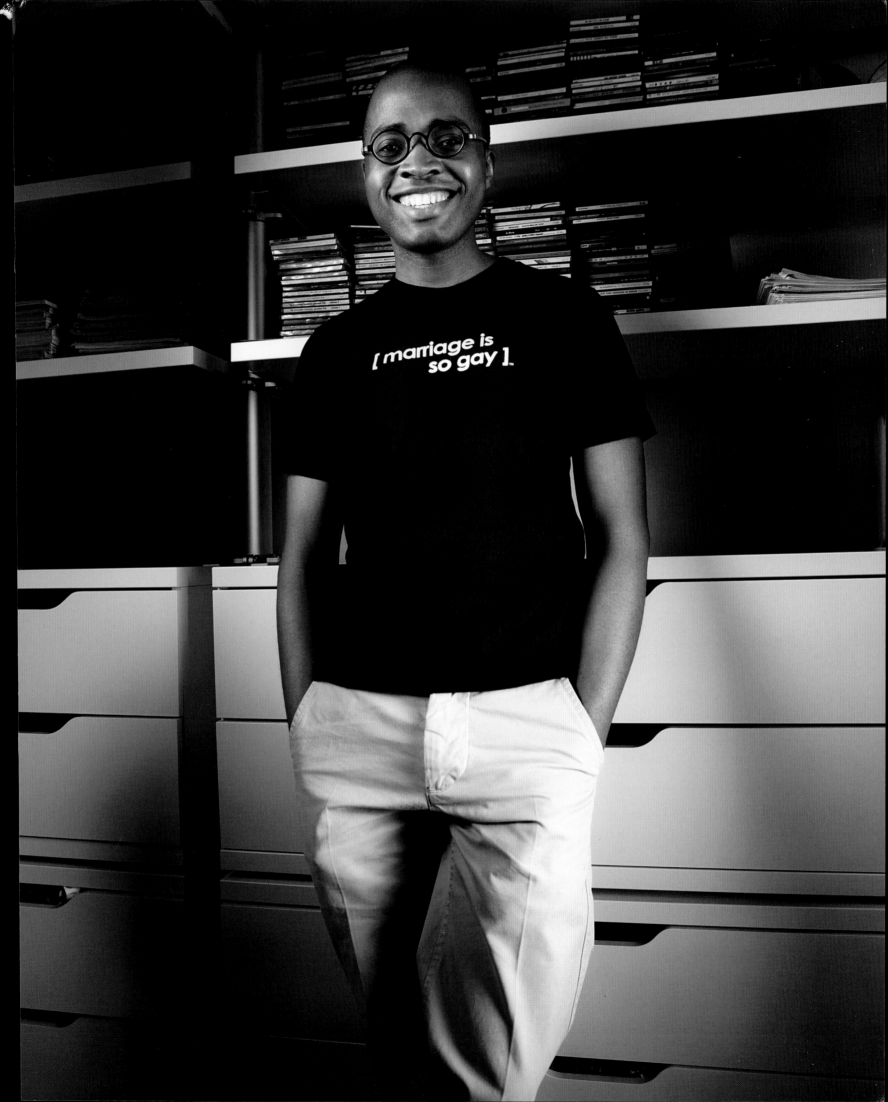

PAUL Bloomfield Connecticut

I **lost my partner of thirty-four years, Marty, in November 2007.** During all those years we were an openly gay couple. We bought our first home together in Bloomfield in 1983 and both felt that living in a community brought with it a certain responsibility to become active and contribute whatever talents we had to various organizations, socially as well as civically. It wasn't long before we found ourselves becoming involved in the political scene, working for elections, whether they were national, state, or local. Our home became the scene of many campaign fundraisers.

Marty was tapped to run for the Board of Education because of his many years as an administrator in the Hartford school system. He was overwhelmingly elected and became the chair of the Board of Education for two years and then sat on the Town Council. I myself served on the Zoning Board of Appeals for three terms. Marty was also a deacon in the Congregational Church, while I sang in the choir and served on the Board of Christian Missions. During all this time, the fact that we were a gay couple was never an issue. We were viewed as "doers," committed to advancing the quality of life for the residents of Bloomfield.

I received a note from a woman I really didn't know very well after my Marty passed away, and in it she said, "Because of you and Martin, Bloomfield is a better place to live. Thank you for all you have done." I like to believe that in some way Marty and I have changed people's views of gay men, and now that I am alone, I will continue to try to do that. Gay pride, to me, isn't just all about parades and festivals. Gay pride is about who you are and what you contribute to the community in which you live. A year ago, the Civitan Club of Bloomfield voted me "Citizen of the Year." I've never been prouder.

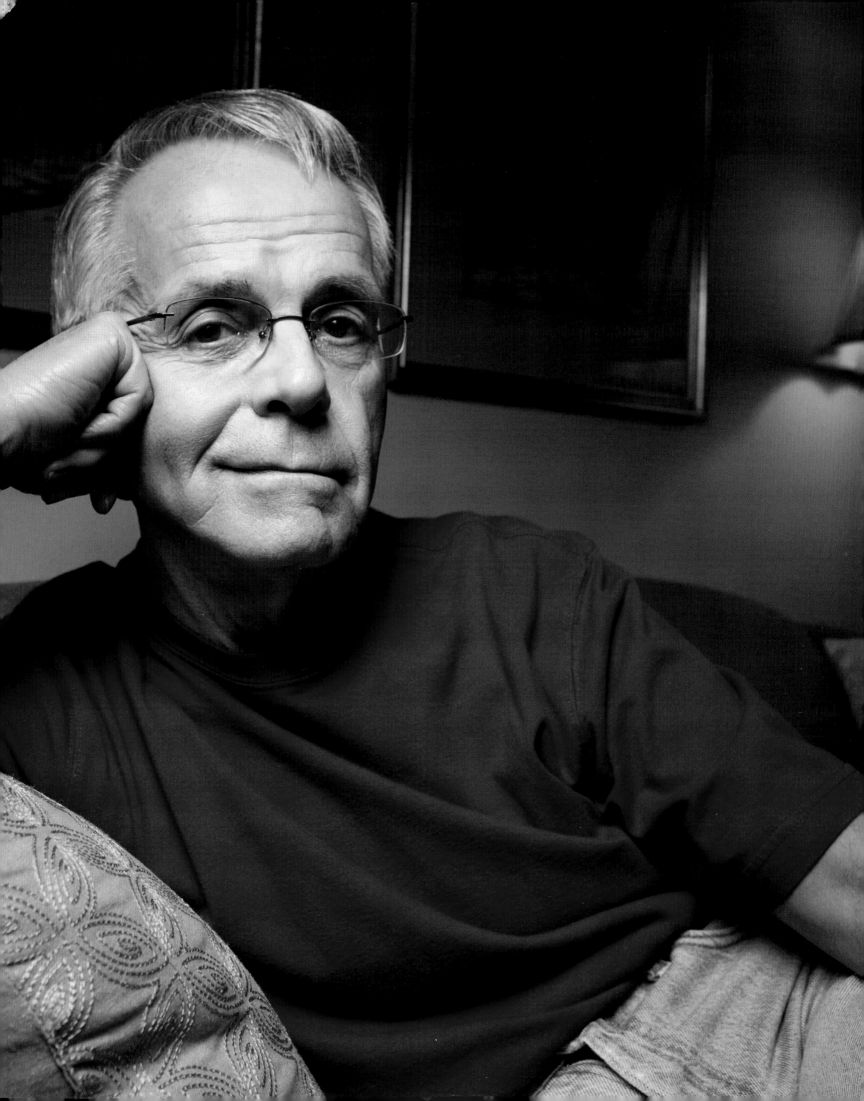

MUDHILLUN Newark Delaware

We didn't really talk much about issues like homosexuality when I was growing up in the eighties and the nineties. . . except when Ellen Degeneres came out of the closet on ABC in 1997. Her show was a shared indulgence for my parents and me (which was an important niche to find in an Islamic family of more than ten kids). This media milestone inspired my polygamist father to start referring to her derisively as Ellen "Degenerate." However, if there's one thing I'd learned from my parents about religion and matters of identity, it was that people must have the freedom of conscience to live as they see fit with dignity and respect—so Dad's jab really got under my skin. [My sensitivity on the matter was probably the beginning of my own gay self-recognition.] Partially for this reason, it took some work to get used to the idea that I might be gay and still remain moored in my faith.

Curiously, right AFTER my father's death in 1999, my third year in college, was when I started actively working to recognize myself as gay. Open from the start but apprehensive about being gay, I prayed. I fasted. I reread the Qur'an closely for both homophobic and queer-friendly messages. I studied the historical context of queer sexuality in Islam. I tried integrating into the local mosque and Muslim Student Association at my university. At times, this cerebral approach felt like an impossible task until I remembered that my parents, even in matters of religion, had always marched to the beat of their own drum. So, as my journey progressed, I started reflecting on a series of themes within my faith and my parents' approach to teaching it: community, honesty, and, above all else, mercy. Ultimately, I reconciled the pieces of myself more with my parents' teachings and with the Qur'an than in the actual community of Muslims on campus or in the trap-

pings of religious rituals. So I gave up on trying to fit into that community (or pray the gay away for that matter). Instead, a more solitary spiritual habit became the little corner of faith I found that, to this day, has sustained me and assured me that God loves me as I am, and wants me to learn and grow from the challenge of accepting and being my whole myself.

In a brisk two years, I tackled coming out pretty forcefully: sharing with close friends and family, joining a coming-out support group, seeking counseling for the less-than-positive responses I got, volunteering at the campus LGBT office, and so on. All this exposure and experience helped me integrate the multiple facets of my identity with little upset to my outlook, my life, or my relationships with others. It also helped me get outside of my head and into the real world. However, it took another two years before I went on my first date in 2001. Still, that didn't stop me from being an activist while at school or from becoming a community organizer after I graduated.

These days, I find that establishing deep and meaningful intimate relationships is the most fundamental and challenging aspect of "being" gay (considering how we, in practice, construct identity so often around action, rather than any state of being). Discussing my work as a community organizer on gay issues and volunteering on gay causes made the continued process of coming out a bit easier, especially when I was single (my "being" active on gay issues as my enactment of gay identity, rather than "being" in any intimate/coupled relationship). Whatever the questions and issues the journey involves, it will surely require continued remembrance and reflection, self-recognition, and religious reconciliation.

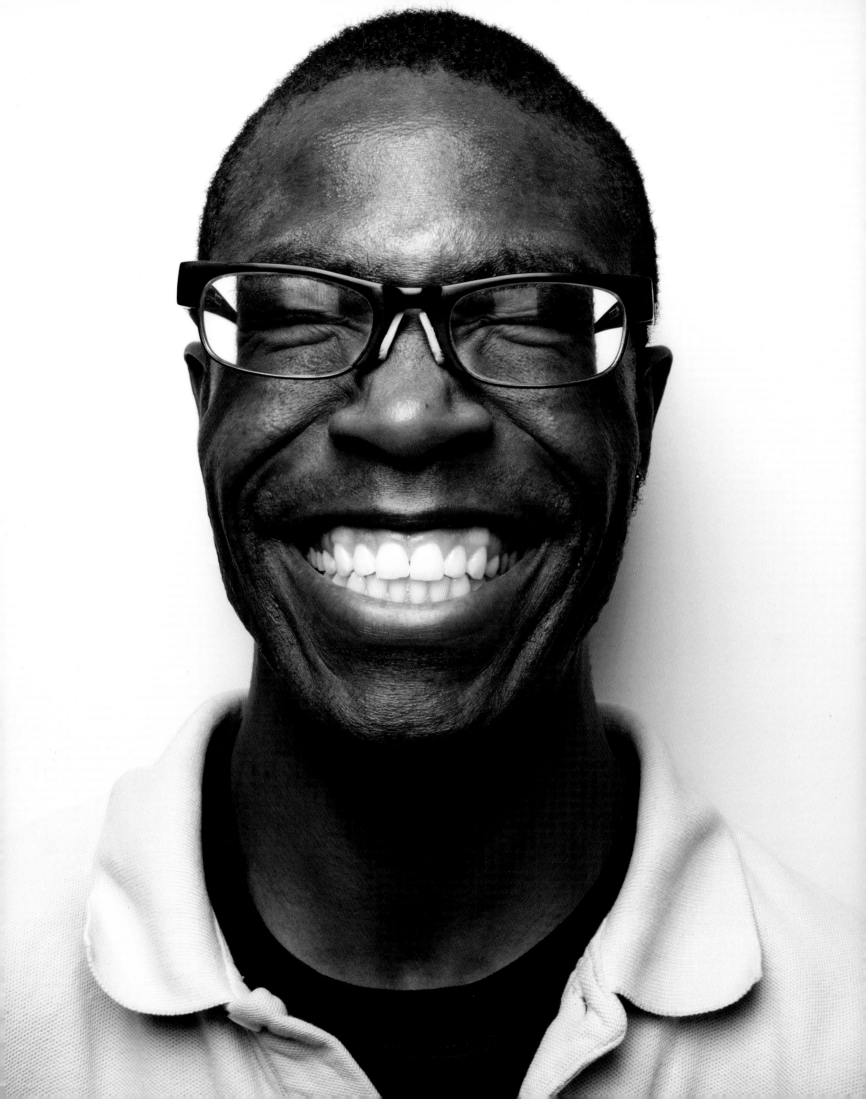

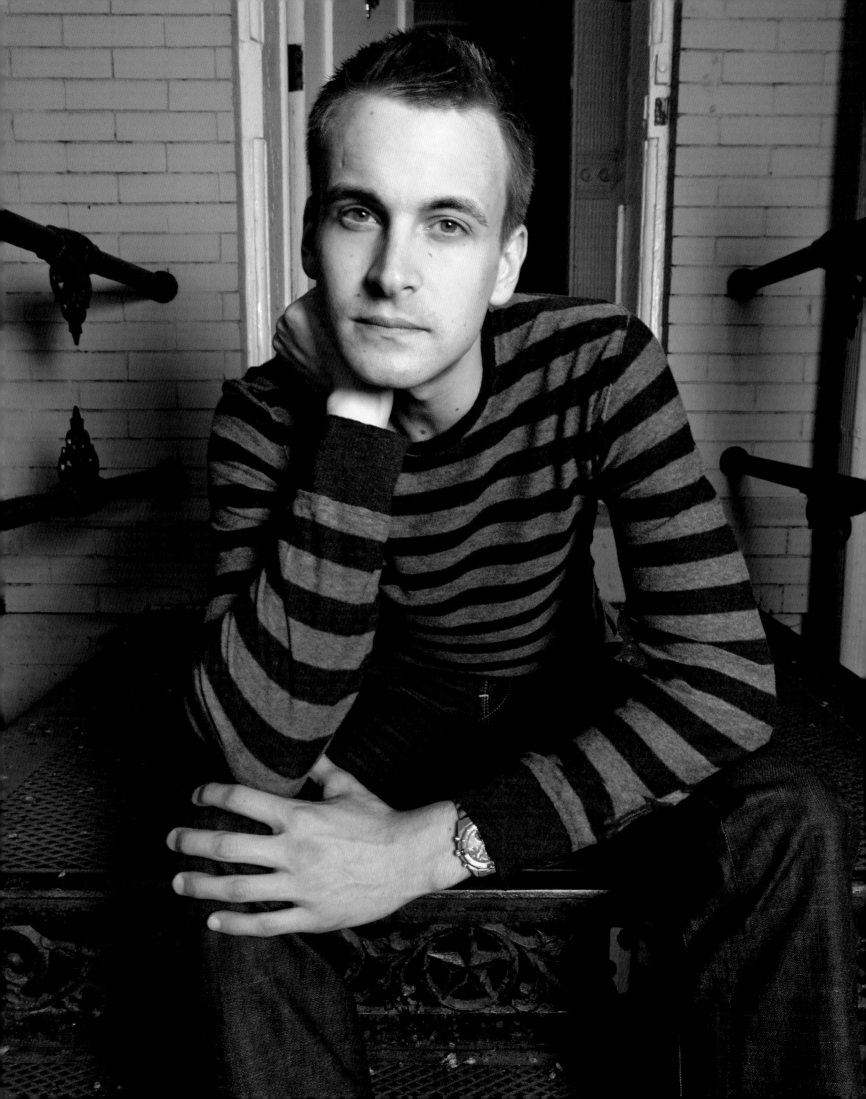

BRIAN Washington D.C.

When I was eight years old, while watching the television show *MacGyver*, I felt an overwhelming attraction to a man for the first time. I wasn't sure what this physical response was, where it came from or what it meant. I only knew that I was curious, and found this attraction compelling.

I was born in Kansas City, Missouri, into what some might call a perfect family: stay-at-home mother, involved father, private schools, etc. However, there was a downside, namely a deeply conservative, mandatory religious faith. In the early years, I was a very happy child. It wasn't until I was nine that things took a turn for the worse. My mother had an affair with my father's best friend, our minister, which led to divorce and physical, mental, and emotional abuse by my mother and stepfather. As a result, my father's world fell apart; he began dating, and after a brief courtship, married again. This marriage quickly took precedence over his obligations as a father and protector. The resulting estrangement from both of my parents affected me socially and academically, which eventually led to boarding school. Emotionally I felt completely abandoned by my father and mother and realized, at the age of twelve, that I was all that I really had. After graduating from high school I decided to follow in the footsteps of my parents and became very active in the church, which in turn caused great discord with my sexuality.

Eventually, I decided to step away from the church and my family, and take a job in south Texas. While this move was very liberating for me on many levels, it was also the beginning of challenges of a different sort. In my early sexual experiences, I took uneducated risks and contracted HIV. Church friends, as well as the closeted gay friends I'd made in Texas, disappeared when they learned of my status. I felt alone and despondent, as though my life would amount to nothing. For the second time in my life, I was faced with the conclusion that I was all I had.

A few years later, in Washington, D.C., I encountered a vibrant, thriving (and quite attractive) gay community where I felt for the first time ever that being gay was not something to be ashamed of. Now was the time for a change; if I was all I had then it was up to me to free myself. That was a few years ago, and since then I have embraced being an openly gay man and have a deeply rooted personal faith that goes beyond religion. I have built lasting personal and professional relationships. I have made great strides in my career, including becoming the cofounder and cochair for the LGBT employee network at the financial institution where I work.

Being true to yourself and your identity is far more important than trying to fulfill someone else's expectations of you. I know now that I have the power to overcome life's many challenges to become the person I am meant to be.

STEPHEN Miami Florida

I must have been around ten or so. I had always known I was attracted to men and never felt anything negative about it, other than the fact that the other boys in my crowd didn't share my feelings—at least outwardly. One day, as my mother and I were doing the dishes after a family lunch, she began to have "the talk" with me. She did the "birds and bees" thing as she washed and I wiped plates. Then she said that there were women who were attracted to other women and men who were attracted to other men. "They are called 'homosexuals,'" she said. And I remember as clearly as if it was this morning, gazing out the window into our small backyard and thinking, "Well, if there's a name for it, then I can't be the only one." It was that simple, that clear, that undramatic.

I came out to my family when I was sixteen. They, of course, hauled me off to the psychiatrist. I went in first and had a lovely fifteen-minute conversation with him about me, my feelings, my fears, my sexuality, etc. Then he asked me to sit in the waiting room while he spoke privately with my parents. I went out; they went in. After about thirty minutes, they emerged—he strolling, she storming—and home we went. Silence in the car, so after about ten minutes I asked what the good doctor had said. Pause. "He said that he wanted to see us every week for at least six months, but that you didn't have to go back," my father said.

The following day I called the office and asked to speak to the doctor. He took my call. Asking him what had transpired, and telling him that when we arrived home Mother had taken to her bed and not another word had been spoken about it, he said, "Well, Stephen, I told your parents that you were the most well-adjusted teenager and homosexual I've ever met, and that it was they who needed therapy to address and resolve their own conflicts about it."

And ever since, wherever, whenever, with whomever, I've been myself. Solid. Confident. Frightened. Unsure. Definite. Strong. Kind. Lover. Fuck buddy. Son. Brother. Friend. Never thinking it was necessary to be "proud," since I am myself. It is all I've ever known and been and, with luck, all I will continue to be for a long, long time.

There are a million tales I could tell you, but they all funnel back to the above. Early knowledge, early assurance, early truth, and a lifetime of being honest and true to the only one who I can and must be: myself.

At fifty-five, I feel younger, stronger, and more confident (prouder?) than ever. Maybe I've managed to find a drop of wisdom somewhere along this crooked road.

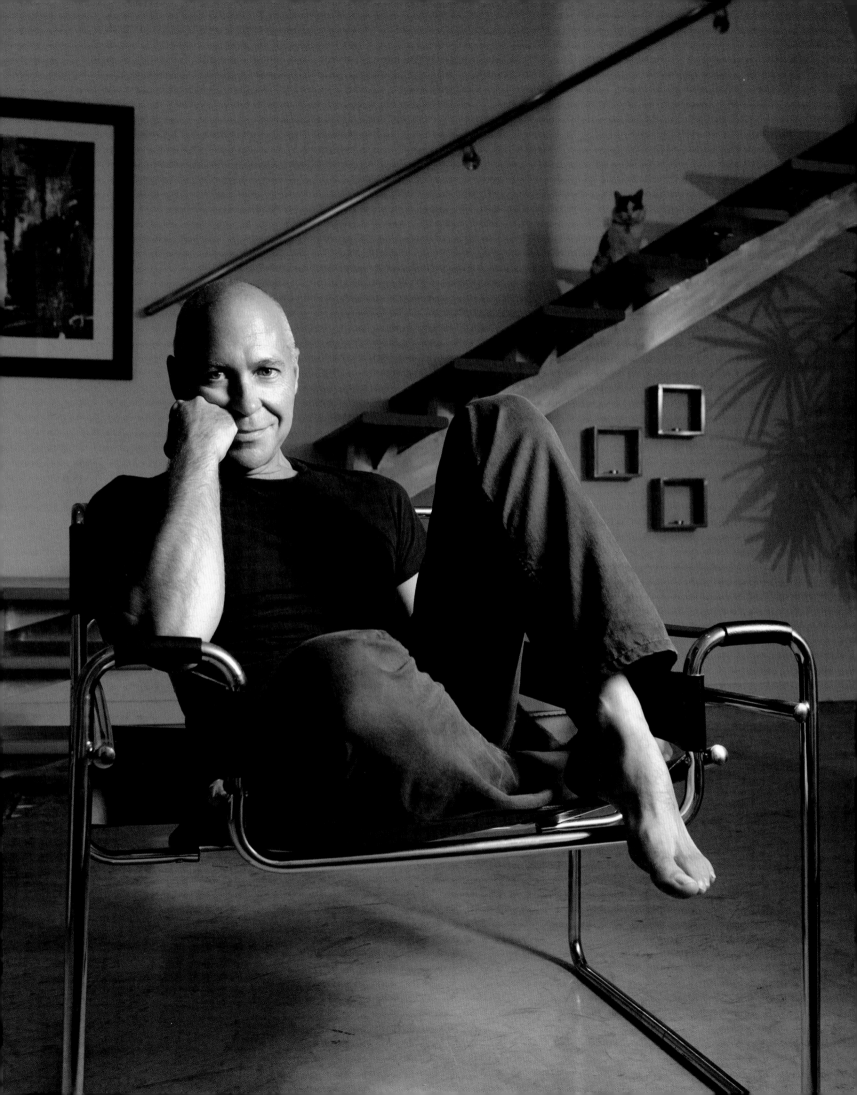

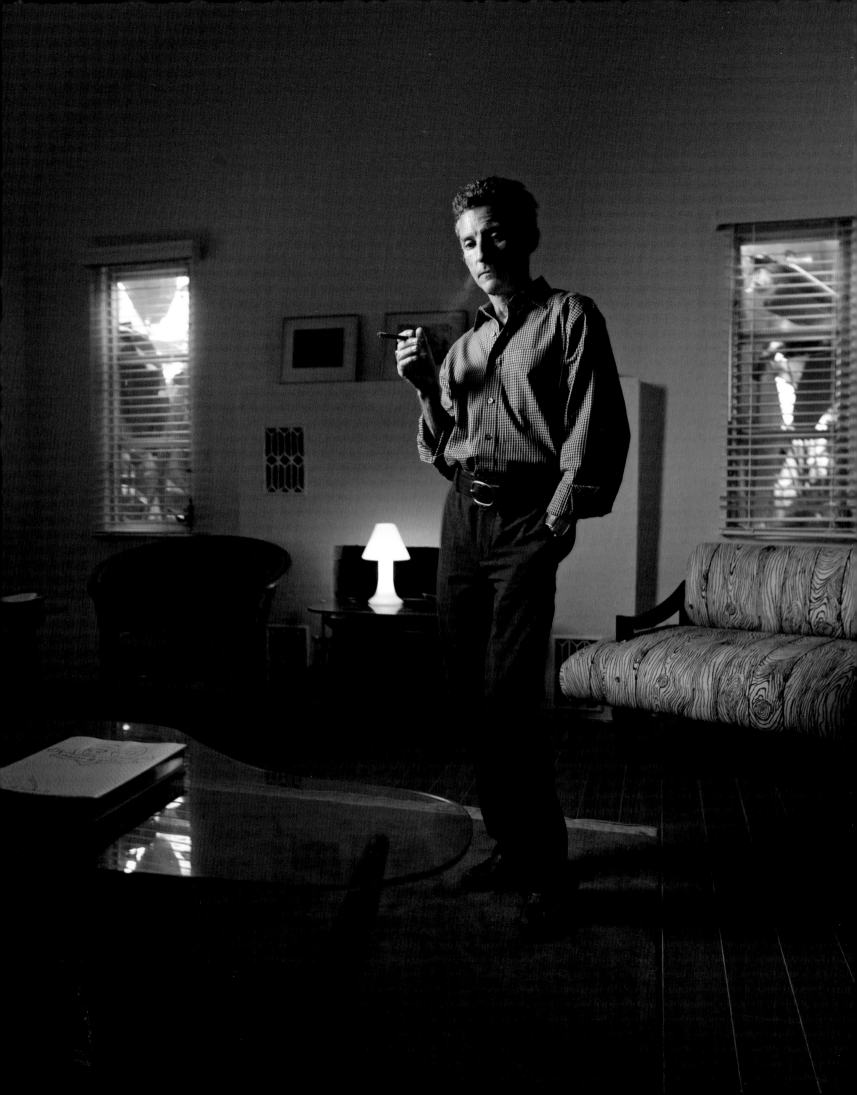

WILLIAM West Palm Beach Florida

I live in West Palm Beach. I'm quiet, suburban, sober, and have been HIV-positive for about twenty-five years. I work for an architect and live alone, quite happily, I might add. Most of my free time is spent helping others in Alcoholics Anonymous. Life is rich but not terribly complicated.

I came to West Palm Beach after spending about thirteen years in New York City. I was born in Hartford, Connecticut, and raised here in North Palm Beach. I went to college in Florida and then Columbia University for graduate study.

I was out by the time I arrived in New York. I believe I became HIV-positive within the first two years of being there. Like many others, I became depressed over the years from seeing so many friends and lovers die. Unfortunately, I couldn't seem to cope with anything except booze. Life became increasingly difficult, as my self-esteem slipped away. Totally defeated, I moved back to Florida in 1995 and got sober a couple months later.

It turned out to be a good move. Through going to meetings I have met the large and varied friends that I have today. My family is all here. Life is low-key, and while I was away West Palm Beach grew into a lovely town.

Today, I don't modify my behavior to meet someone else's expectations. This positive attitude always keeps me in good stead—I'm grateful for the life I live.

TRACE Orlando Florida

'm from the Deep South. I always knew I was gay. It was never a big issue for me. It didn't affect the way I thought about myself or make me feel like any less of a man than the other guys at my school or the friends I grew up with. It never occurred to me that I had some need or desire to come out. Over time my family and friends realized I was gay, but there was no need to talk about that, any more than who my brother was dating, or the private lives of other family members.

If someone feels the need to ask me directly about my sexual preference, I have a few responses. If you're an important person in my life, I'll say yes of course I'm gay. If I'm asked in connection to a civil rights issue, I'm happy to stand up and be counted as gay and fight for our rights, as I do for all civil liberties. If you're a relative stranger and are prying, I take the Southerner's approach by politely saying that it's my personal business and has nothing to do with you.

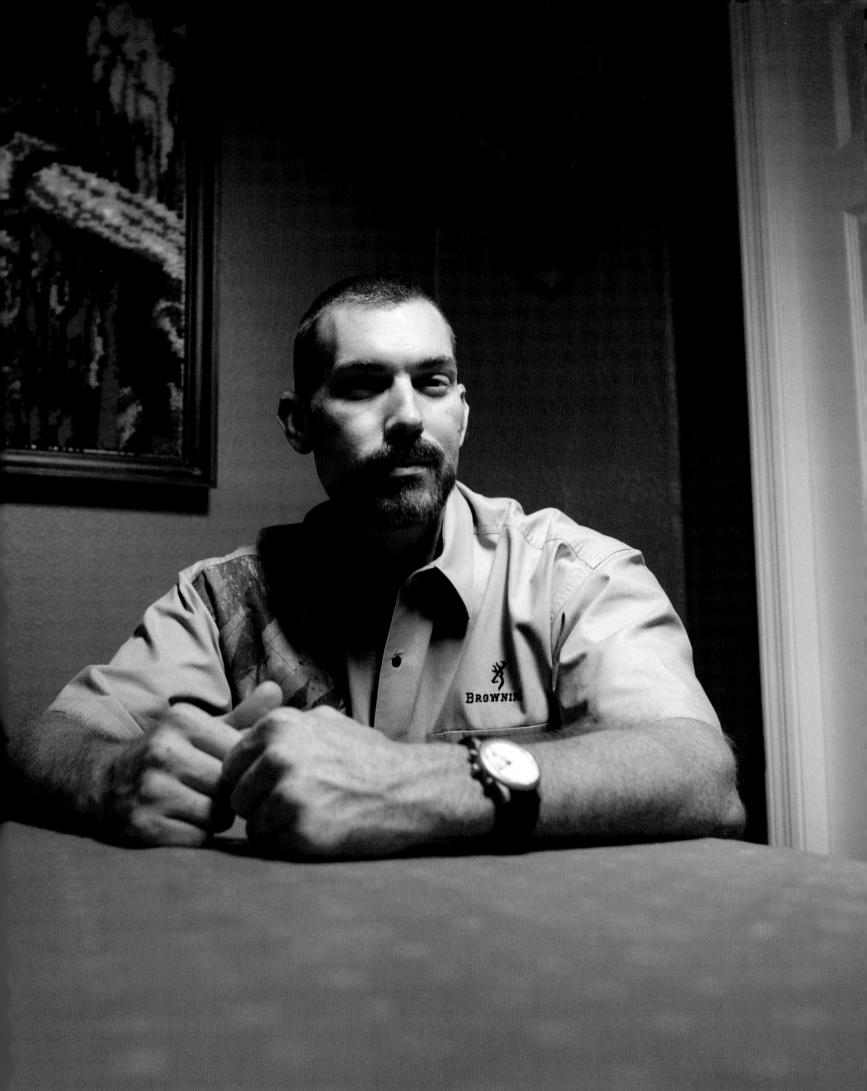

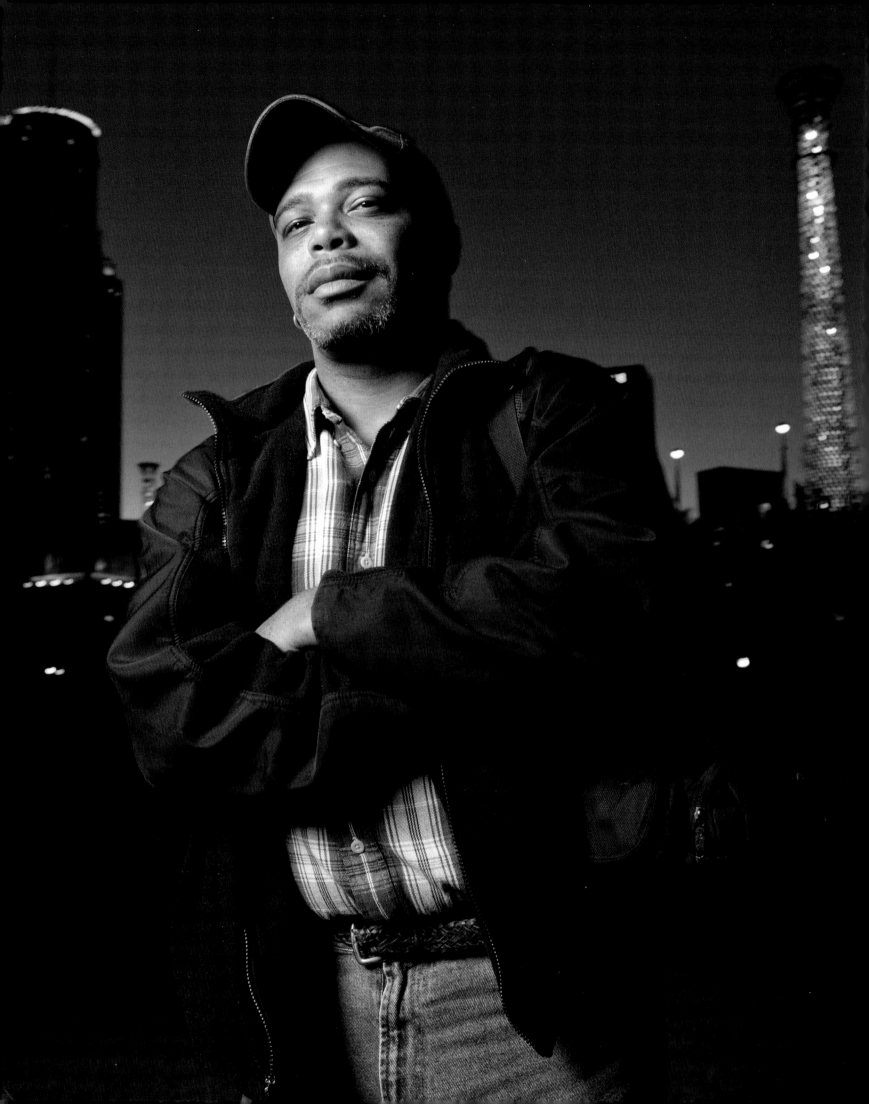

MICHAEL Atlanta Georgia

My parents were sixteen when I was born and I was unwanted. My mother sent me to live with my maternal grandmother when I was nine years old. She physically attacked and mentally abused me for two years. Then my uncle, who was deaf and drug addicted, threw me down a flight of stairs and locked me out of the house. I roamed the streets of Charleston, South Carolina that stormy summer day until late at night, when I was picked up by the police. They pressed neglect charges on my grandmother.

Just a week before this happened I met the woman who would become a rock in my life until her death: Hazel Faniel. She was my father's mother and for years I never even seen my father or knew that I had another grandmother. When child protective services asked me if I had any other family I told them of meeting her and the story behind it. They contacted her and thus began my relationship with Grandma. My grandma was a kind, religious, sweet and loving individual without a mean or judgmental bone in her body. People loved her the minute they met her and she had many long-standing friendships. She taught me to love my fellow man no matter what, and never forget where you come from in life. She had high hopes for me in life and gave me my first camera when I was eleven years old.

By the time I went to live with my grandmother, my father had made a new family that included two young half brothers. My father and I clashed often when he would visit from Virginia after my grandma got custody of me. It wasn't until high school that our relationship turned around a little. He told me he saw too much of my mother in me.

After being in and out of college for six years, I got into debt from credit cards and never graduated. I left South Carolina for Florida and worked jobs in retail and gay establishments but couldn't seem to move up the ladder.

After losing yet another job I found myself struggling and wondering what life had in store for me. It was at this time my grandma got sick and begged me to come home to regroup and be with her. I went back to South Carolina and made sure my grandma didn't have to lift a finger for anything. I told her I wanted to go back to school for photography and try to make it in this world, and she said she would help me as much as she could. The following spring, I started at the International Academy of Design and Technology in Tampa, Florida.

Grandma died just two weeks after I started school. I went through her death alone and realized that I had to fend for myself for the first time since I was thirteen. I had no money and no one to ask for help, but I managed to finish school. Then things went from bad to worse and I was bouncing from place to place, staying on people's couches, and finally ended up in a homeless shelter in Atlanta.

I called my father by phone to ask for help some time ago, and he told me to go to a shelter. He has a four-bedroom home in Virginia and he tells his son to go to a shelter. Since then, I have cut all ties with my father.

I got in a job attainment program that allowed me to do seasonal work for Macy's and Barnes & Noble. From there I got a got a job at W Hotels Worldwide, where I was nominated for employee of the month. I plan on putting in a transfer for the W Ft. Lauderdale and spend the rest of my life in sunny southern Florida.

I will never give up on my photography. I still want to do fashion pictures and portraits. I wish I could get a job as a photographer's assistant but I don't know how that will happen. My idol is Herb Ritts and he inspired me even more when I was in school. Having that degree means so much to me. I have learned not to give up and I continue to have faith and be a fighter, but I am also humble. I am a survivor.

ROB & KEITH Atlanta Georgia

'm sure there are many out there who have never met a pair like us: a gay couple in the Deep South—one African American, a military brat and computer geek hailing from a liberal western state; the other of strong British descent, a roaming scholar with dual citizenship originating from the U.K.; both sharing similar interests in techno, gadgets, and *Project Runway*. A more perfect alignment could not have been made.

The discussion of marriage has been tossed around on numerous occasions, but since it's not yet a legal option in Georgia, instead of adorning shiny bands of commitment, we share personalized military dog tags around our necks to symbolically represent our union.

We collided into one another without the intent of ever letting go.

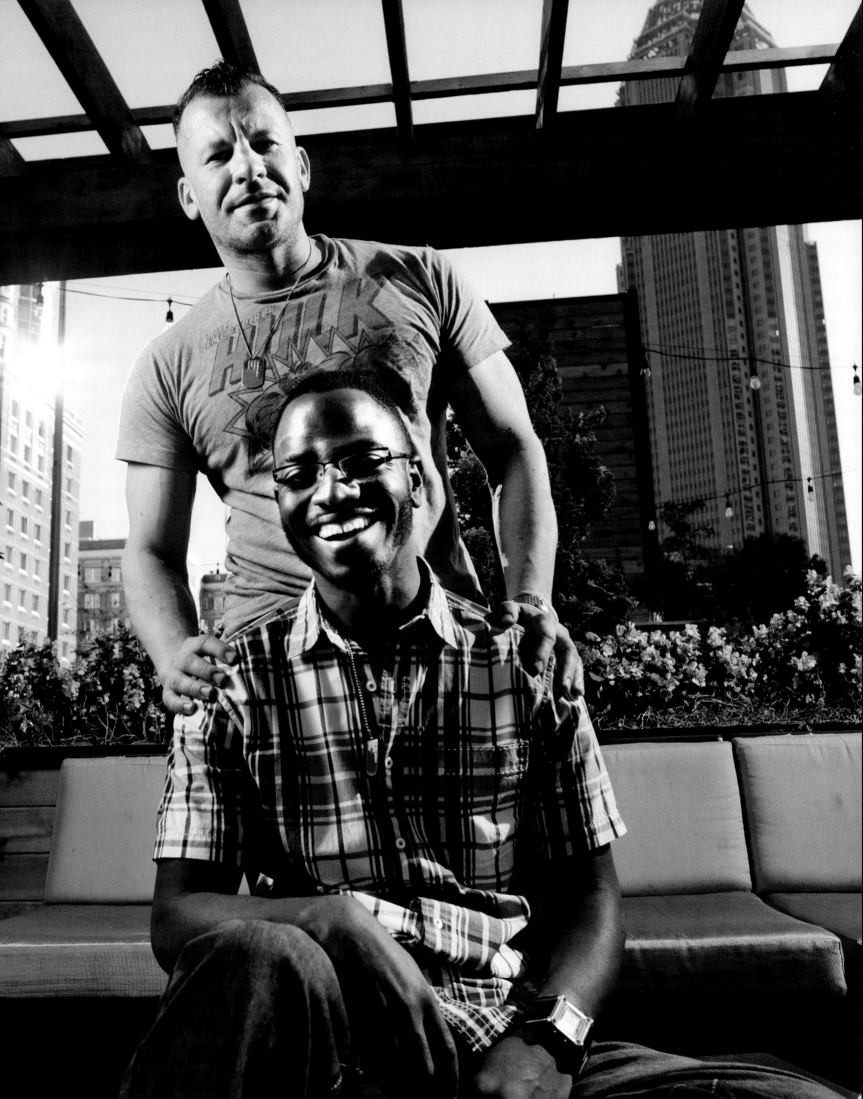

TODD & JASON Atlanta Georgia

Todd and I both grew up in very conservative Christian families. I was raised just outside Chattanooga, Tennessee, in an Evangelical household with loving, affectionate, supportive parents—except when it came to my homosexuality. I came out to my family when I was fifteen, then went back in the closet for a few years when it didn't go well. I came out again after turning eighteen and graduating high school. My parents didn't react any better the second time around, so I packed my belongings and moved to Atlanta.

I chose Atlanta because I had visited for a couple days a month earlier and it just happened to be gay pride weekend. This small-town country boy's jaw hit the ground when he saw Peachtree Street lined with rainbow flags, men holding hands, pride banners, and welcome signs. People accepted me for who I was, treated me with respect, and didn't think twice about the fact that I was gay. It was the first time in my life that I could hold hands with another man in public and not worry about being seen. Needless to say, I fell in love. I created a good life for myself here, started a career in banking, bought a home, got a dog, made friends, had a few relationships. Ever since I got here, I've never attempted to hide any aspect of my life.

Todd grew up in the western suburbs of Detroit, Michigan, and was raised as a Jehovah's Witness. His family situation was very similar to mine: he had a great relationship with his parents, aside from the whole "gay thing." Todd came out to his parents at twenty-one when he moved out into his first apartment, and after that initial conversation it was something that just wasn't ever discussed again. Like my family, Todd's parents thought it was something that could be fixed with therapy and religion. Todd went on to finish school, obtain his MBA, and start a career in finance. He was lucky to have a gay uncle in Chicago who, with his longtime partner, provided Todd with love, support, advice, and a "family" atmosphere. Eventually, Todd left Detroit for Chicago.

Todd and I met six years ago in Atlanta when Todd accepted a new job that required him to move here. The plan was for him to work in this position for twelve months, learn the new skills that would help him build his career, and then head back to his life in Chicago. I was recently out of a relationship at the time, and back in the dating scene with no thought of getting into anything serious. We met online and decided to get together one night for dinner. It was an instant connection. We had so much in common—we liked the same TV shows, movies, entertainers, etc. The obvious physical attraction didn't hurt either. We continued to date, fell in love, moved in together, and eventually started wearing rings to signify our love and commitment to each other. Needless to say, Todd didn't make it back to Chicago after his year was up.

In the course of our relationship, we both realized that we were living in a very exciting time for the gay rights movement. People's opinions were beginning to evolve, state and local laws were starting to change, courts were stepping in to protect the rights of gays and lesbians. When the California Supreme Court legalized gay marriage in that state, we knew that we had to participate, even though it wouldn't mean any more than the paper it was printed on in our home state of Georgia. We wanted to be a part of history and show the rest of the country that our relationship was no different than that of opposite-sex couples. We wanted to be an example of a model relationship to our friends and family, for them to see that we weren't any different than them and that gay marriage wasn't something they needed to be afraid of—it wasn't going to make the skies fall. So, in September of 2008 we were in San Francisco with some of our closest friends getting married in the City Hall rotunda with a statue of Harvey Milk looking over our shoulders. It was amazing. Nothing else in this life has ever felt so right for either of us. And here we are now with three years of marriage under our belts, still in love, building a loving home and life together, and seeing where the road takes us.

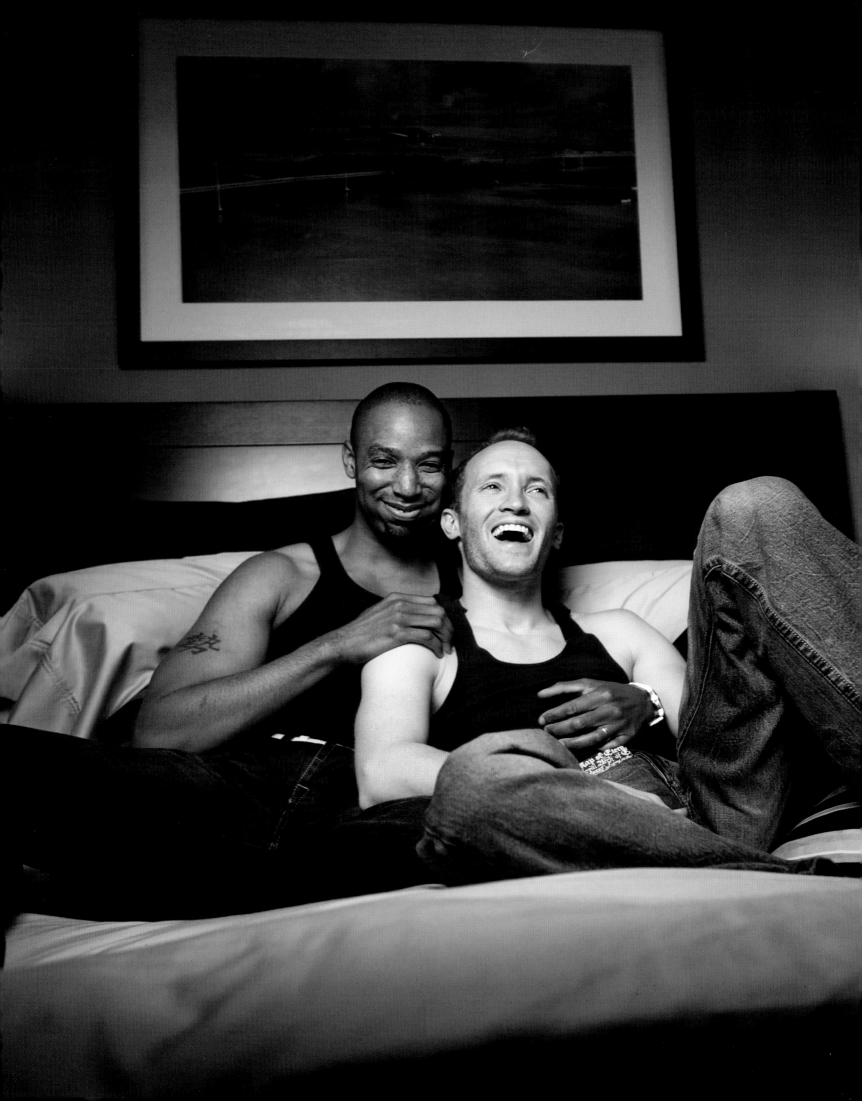

DAVID Snellville Georgia

I'm profoundly deaf, but I can read lips and speak fairly well. I have two kids—my ex-partner, who is also deaf, is their biological father. They are both hearing.

When we were together, we decided to call my ex-partner "Daddy" and me "Daddie." But our children said that wouldn't work because the words "Daddy" and "Daddie" sounded exactly the same. Since we're both deaf, we didn't know that. So we decided to let the kids choose what to call me. They discussed it with each other and settled on "Mommy with a beard," because I stayed home and took care of them.

I'm single now and enjoying my time with friends and family. I haven't dated anyone as of yet. If it happens, it was meant to happen. If it doesn't happen, that's fine too. My priorities have changed a lot over the past few years. I was the titleholder of International Mr. Deaf Leather in 1995, but I'm more interested in being a dad these days. I'm blessed to have a relationship with my son and daughter even though things with their father didn't pan out well.

There was a time in my life when I didn't think I could have kids. When I was in college, I took an HIV test and it came back positive. I had to learn how to live my life as an HIV-positive person, recreate my identity, educate myself about the disease, and start using safer sex to prevent from spreading the virus. After attending AIDS support group meetings for eight years, I decided to take another HIV test in a different state. It came back negative. I retested a bunch of times. They all came back negative. It finally convinced me that I'd gotten a false positive result the first time.

When I was diagnosed positive, my hopes of having children were completely crushed. Now I'm HIV-negative and the "Mommy with a beard" to two incredible kids.

RICK Lexington Georgia

The majority of my life as a gay man has been nothing but a gracious blessing. I realized my sexual desires toward men when I was sixteen, and I lost my virginity to a man twice my age a year later. I went off to college not long after that, but then took a few years off before going back to get my degree at the University of Georgia. I was handsome young man, content with myself, pursuing a good education. Then, the most wonderful thing happened to me: I met and fell in love with the sweetest, most handsome, charming, loving, giving, passionate, and driven man God ever graced this world with. To have such a man love me was the greatest gift of my life.

Marc and I met in a calculus class in the fall of 1976. I had been "out" for five years; Marc had never had sex with a man before. We became friends, but not intimately at first. We courted platonically for months until just before Valentine's Day, when our relationship turned physical. I realized almost right away that Marc was not the type of person who was interested in a casual affair. I knew that a relationship with him would mean a deep commitment. I understood I had to be ready for that. Thank God that I was. I recognized him as an angel sent to me. How could I be so lucky? I always told him he was the most adorable cherub ever on Earth.

We had a beautiful chemical and sexual attraction and were always honest and true to each other. We were very fortunate as well to both have loving families and be surrounded by very dear friends. We also shared a common religious faith. Our hearts and souls were bound together not by any institution but by love, passion, and commitment. We fed off of each other's energy and even started a business together in the spring of 1977. We channeled all of our common interests into an enthusiastic, passionate machine that could make us a shared life and living. Marc was the fuel and I was his spark. We accomplished a lot of things as partners, both personally and professionally. We had a storybook life together, which is not to say we didn't have our tough times. You can't be around someone 24/7 for thirty-one years and not have a few hurdles to jump.

Marc's battle with cancer became the final and most difficult challenge of our life together. When he died in 2008, I hit the ground hard. I was devastated, and alone for the first time in three decades. It was overwhelming. I had lost the love of my life, my very best friend, and my business partner all at the very same moment. Somehow I managed to pick myself up, and have stumbled along for the past year. I am still devastated emotionally, very tired, sad, and lonely. I am, however, a strong person. And I am reminded every day that I am still very much alive. I know that Marc made me a better man than I ever would have been without him. I know I will always have him in my heart and in my soul. I will forever treasure the memories of our life together.

I feel that I am at the edge of a tremendous precipice now, facing a hurdle that is unimaginable in scope. I am making decisions that will affect the remainder of my years . . . by myself. I am anxious and scared, but I am also optimistic. I have to be. I know I will carry the love I shared with Marc with me for eternity, which gives me great comfort and joy. I look at my future without him now not as the next chapter, but as a whole new book in my life: Volume Two.

I miss the man I loved with all of my heart and soul. The emptiness is so very real and powerful, but so is the fullness of the love we shared, and I know I will be okay.

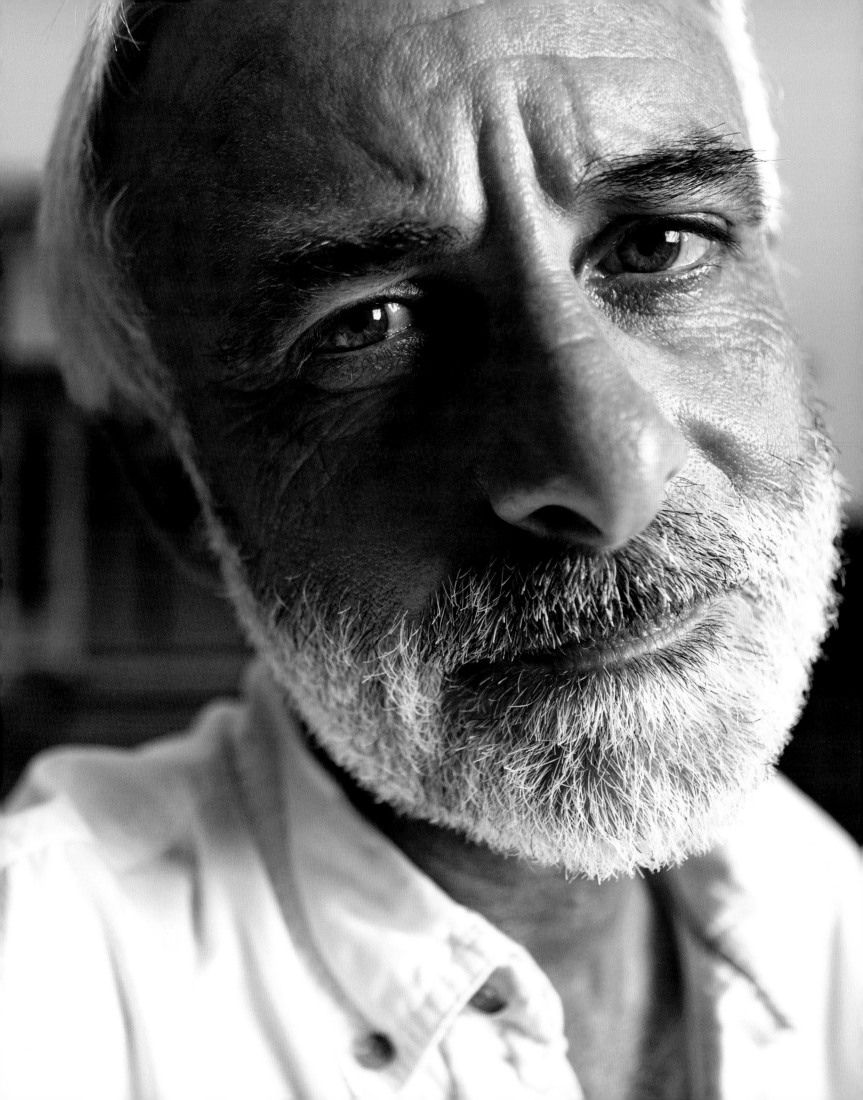

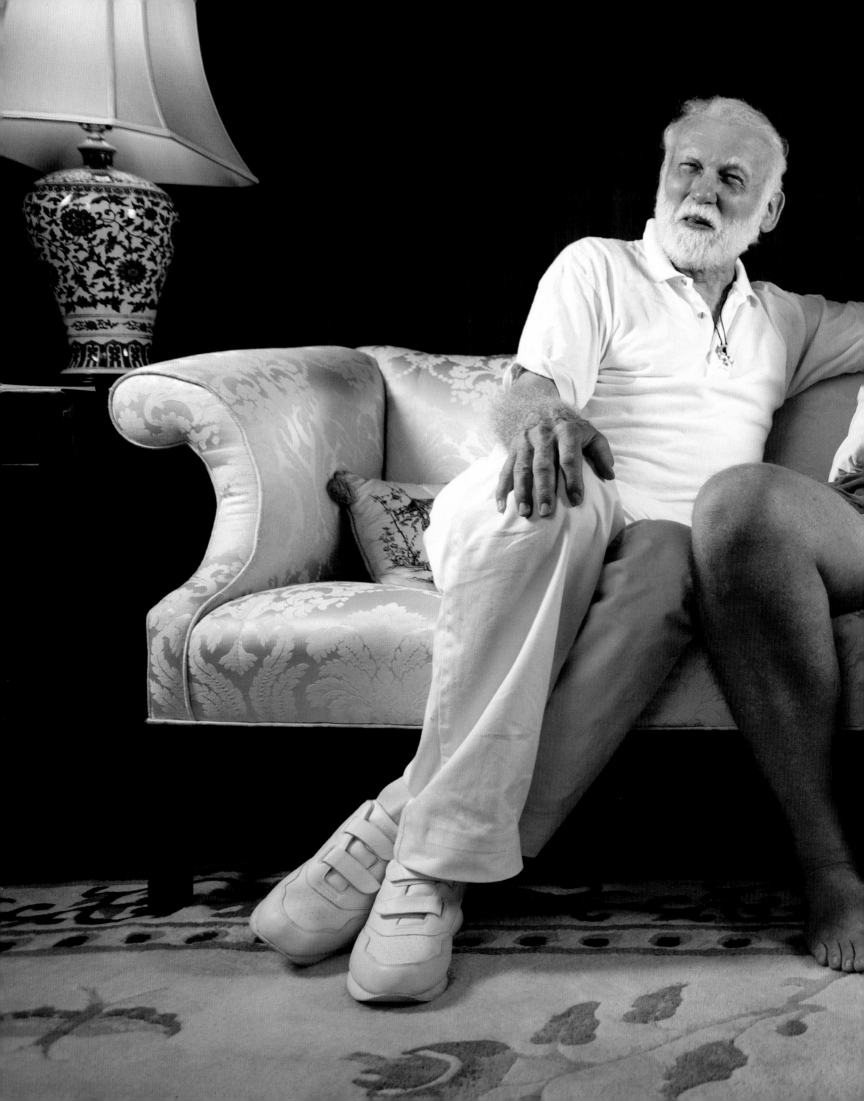

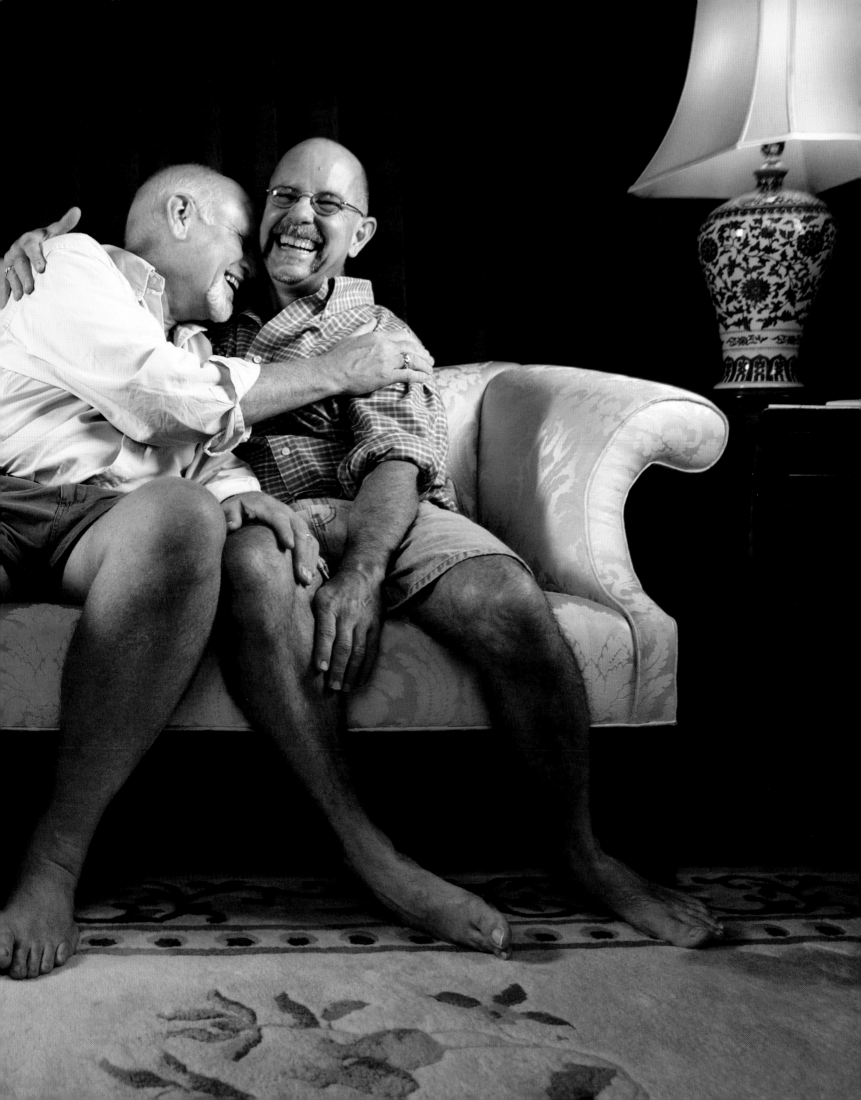

ROBERT, RICHARD & DALE Savannah Georgia

When I was a schoolboy in Pennsylvania, I never thought geometry was going to help me understand my love life at age sixty-four. The desire in any "triad" relationship is that of an equilateral triangle and not of an isosceles triangle. But, as we are human, the lines are always changing. The key in maintaining an equilateral triad is open, truthful communication on a regular basis. When that fails, tension rises and threatens the triad's delicate balance and the entire relationship is jeopardized.

Our first serious triad attempt lasted about a year and a half and ended after this photograph was taken, when Dale left for greener pastures. Much of what precipitated the breakup was Dale's inability to openly communicate his feelings, negative and positive, for me and Robert. Once Dale did leave, it opened the floodgates of understanding, and Robert and I now have a stronger sense of what will work and what will not. On paper, the perfect man to complete our triad in the future is one who is strongly sexually compatible with me—and Robert, to a smaller extent—enjoys antiques and gardening, and works in massage therapy or hospitality.

Robert has been HIV-positive since I first met him, and therefore our physical relationship is more affectionate than sexual. He has always kept me as the "china doll" on the shelf and will not do anything to put my health at risk. On top of that, he is not jealous, which is another key to a good triad relationship. Robert is happy for me to have other lovers.

I am a full blown romantic. Robert is not. I would describe him as a "classicist." He believes romantic love is bullshit and has no time for it—now that isn't to say I can't get him to cuddle a bit now and again. But he is not that kind of person. Robert was very active sexually in the pre-AIDS era of New York City when you could enjoy anonymous sex in the parks any time of the day or night. To him, sex is not emotional. Robert's feeling is that as gay men, we are out of the box to begin with—so why do we have to pattern our gay relationships and families after the straight community, which has failed miserably?

Robert is the first man I lived with as an openly gay male. We have been together for the last sixteen years. In late spring of 2003 we decided to cash out of our lives in New York City and move somewhere else. I wanted to move to a place that had palm trees and lizards. I figured we would move to Ft. Lauderdale because I wanted to work in massage and I needed a large gay community to serve. However, my mother raised me to believe that Florida was "God's waiting room," and Robert and I really did not wish to relocate there. Before we made any decisions, two men called Robert within ten minutes of each other and both recommended Savannah, Georgia. As a Yankee, I had no interest in moving below the Mason-Dixon Line and certainly not to Georgia—a curse worse than death. But as a spiritual man, I saw these two recommendations as the universe sending us a message. We visited Savannah for about four days and were sold. That December, we moved to Savannah lock, stock, and barrel and haven't looked back. This city truly is a state of mind, full of beauty, elegance, and grace along with a fantastic gay community.

My growing up was all about men with shirts off and muscular torsos, like Steve Reeves and Tarzan. I found bookstores in downtown Pittsburgh at an early age that sold used and new physique magazines to supply my secret

masturbation life. But as I was raised a Roman Catholic, I would occasionally feel guilt, and purge my magazine collection. My guilt generally lasted less than twenty-four hours.

As a young man and now, I always came across as fairly straight. When I went to an all male college in Pennsylvania in 1965 and joined the theater group, I met and got close to gay men. The problem was that they were mostly flaming queens. I wasn't like that, but knew I liked men and the male body. If a very masculine male, such as a football or soccer player, had come on to me in college, I probably would have come out then. In my senior year I applied to ten business schools for my MBA and one master's program in theater at Smith College. I was rejected by all the business schools and accepted to Smith. But it was 1969, and Vietnam was hot and heavy. The last thing I wanted to do was to be "cannon fodder" for our government, so my stepfather very gracefully got me into the National Guard, and I then moved to New York City and joined Morgan Guaranty Trust Company.

I didn't fully come out until I was about forty. At that point I was a respected husband, father, churchman, and businessman living in Pelham Manor, New York, trying to be a good guy. But once I came out sexually, I returned to my late teens and needed to grow up as a gay man. I took to male sex like a duck to water. I would visit the old raunchy Times Square in New York City, get all the male porn I desired, and visit the various theaters and baths. (Today Times Square is pristine and Disneylike.) I would fall for single gay men, but they would push me away because I was married. They did not want to be the cause of a family breakup.

I did not deliberately come out to my former wife, Carol, but I did leave a porn magazine lying around one day, and the "genie was out of the bottle." She was very calm and intelligent about it, though she wrestled with my orientation quite a bit. After my coming out, we stayed together for about six years and she permitted me my freedom.

But one evening, while having dinner with my now long-time partner Robert at Café Sha Sha in Greenwich Village, he showed me three incredible co-op apartments, all next to one another in Hudson View Gardens in the Washington Heights neighborhood. He said, "Wouldn't it be great if these three apartments were bought by gay men and we could all be neighbors?" I went home to Carol that night and thought about how I would probably never be able to participate in anything like what Robert had proposed. After I got into bed that night, Carol turned over and said, "You are itching to leave again, aren't you?" I agreed and she said, "I think it's time. I think it's best for both of us if we part." I had been released! Carol and my two wonderful children are very close to me and Robert today.

Periodically, the straight world communicates that we—gay men—are too sexually focused. Well, sexuality is the best thing about being gay. To be able to make a sexual connection to another male—whether it is through a relationship, a lover, a casual encounter, or through my massage practice—is extremely powerful and fulfilling. Sexuality is something I am gifted with and one of the reasons I am here on this Earth, and I feel no shame in that. Without sex, being gay is meaningless to me. I mean, otherwise you are just a eunuch.

GARY Columbus Georgia

Being an openly gay man here in Georgia can be a little challenging but I make it work. I grew up here, and Columbus leans more towards the conventional—there are many in the Bible Belt who are too righteous for their own good. But there are some individuals like myself who are less traditional and live openly and honestly no matter what.

Being that my family is of Latin and Caribbean descent, they had some issues with my choice to come out initially, but once it became clear that I was still the same person and wasn't going to become some over-the-top stereotype, they were much more at ease.

I think my accomplishments and good nature have made people realize that being gay isn't a choice and we are not all queens or degenerates. I love meeting new people, and I love dating. I tend to date guys from other areas since the mindset is a little unaccepting here and the options are limited.

Fashion and beauty are my passion, and my long-term aspiration is to leave Columbus and open a salon and boutique in a larger city.

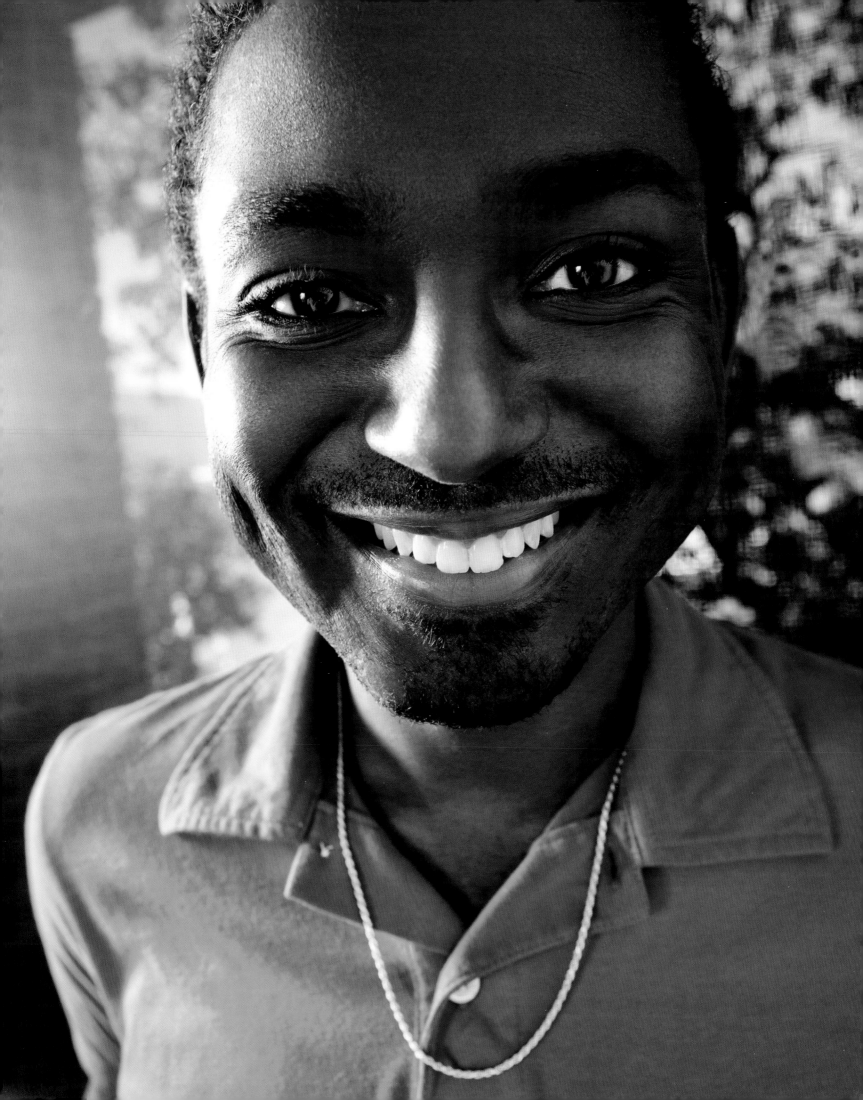

MICHAEL & BERNARD
Maui Hawaii

I am a physician living on Maui with my partner of twelve years, Bernard. In our family, we have three Chihuahuas, a Great Dane, a Cockatoo, a pond full of fish, and an African Gray parrot that burps and says "god damn it."

I was born in Taiwan and moved to America when I was twelve. I was completely closeted until the age of twenty-six. Having always been attracted to men I felt different from other boys. At the time when I came out, I was entering medical school, and someone told me, "The world is your oyster, why would you ever want to be gay?" They did not understand, being gay is not a choice, it is who you are.

Bernard grew up in Montreal in French Canada. His coming out was somewhat less traumatic than mine. As he puts it, "I was out when I came out of my mother's womb."

We met in New York City and our backgrounds and personalities are polar opposites. I came from a conservative Chinese family where traditions are stressed; Bernard came from a somewhat bohemian upbringing, living on his own since the age of fifteen and working in the antique and art business.

I have a job that luckily allows us to move anywhere in world. We were seduced by the allure of "aloha" and the promise of paradise, and moved to Maui four years ago. We don't advertise our sexuality, but we are out openly in our everyday lives. Anyone who knows us knows that we are in a committed, loving relationship. We have never been ashamed of being who we are. To our delight, our governor, the honorable Mr. Abercrombie, recently signed into law the Civil Union bill, guaranteeing the equal rights and protection of same-sex partners in Hawaii.

Our relationship has outlasted many of the marriages of my straight physician colleagues. Maybe our relationship has endured because we are constantly bickering. At least we are always talking and having lively conversation. Our "children" certainly keep us very busy. I am not sure if we would be considered "normal," or the typical couple next door, but I imagine we are at least on par with *The Simpsons*.

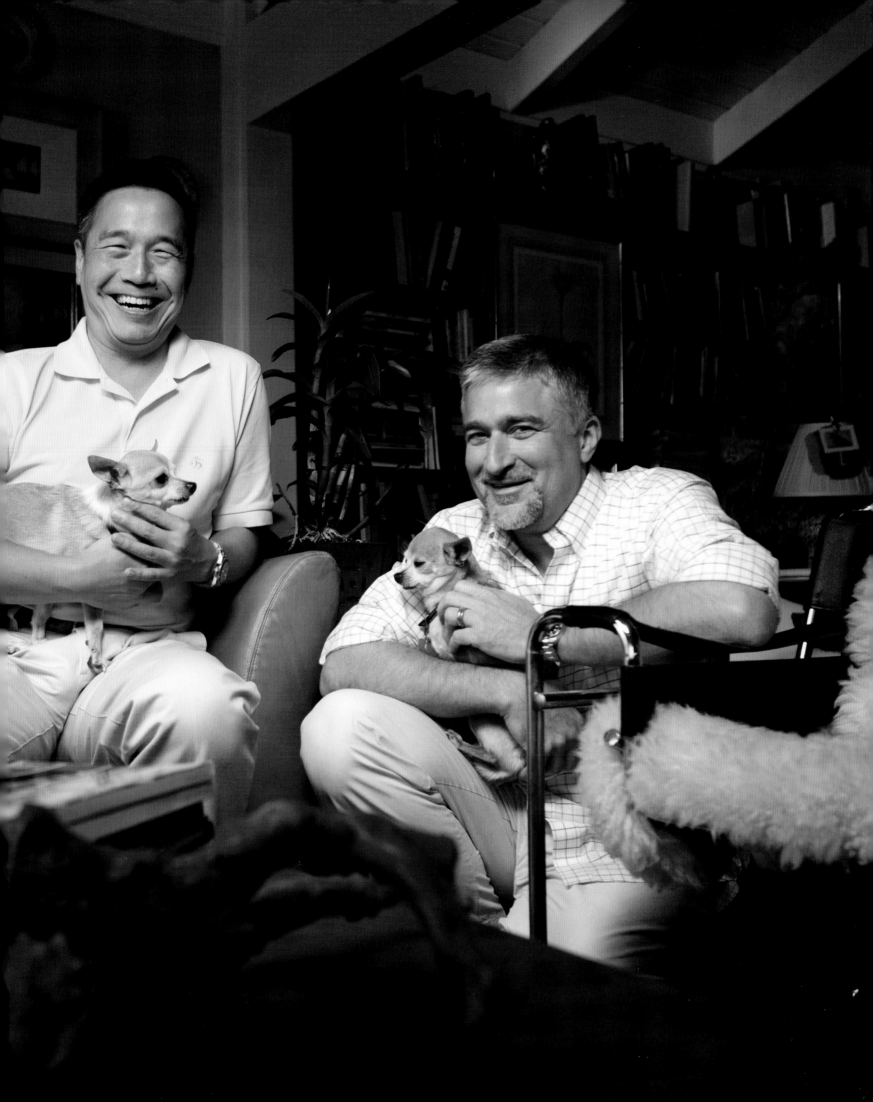

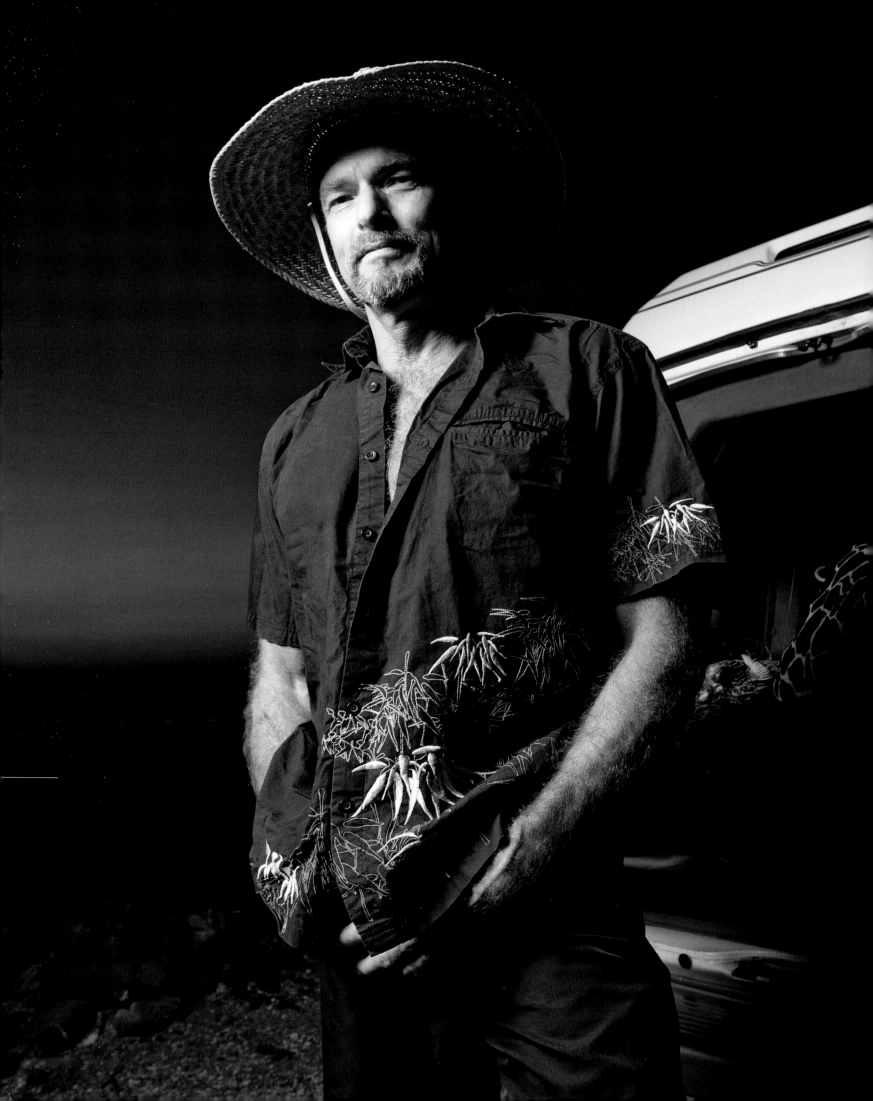

JONNY Kailua Kona Hawaii

Ten years ago I thought I was living the American dream in Spokane, Washington, with a successful business and a beautiful home. I had all of life's accessories but I was spiritually stagnant. So I took off for the islands, camped on the beach for four months, and when I returned I realized that all I really had was just "stuff." I put everything up for sale, and I've been having the time of my life ever since.

I moved to Hawaii's Big Island and lived in a geodesic dome in the rainforest for a while. I had an amazing seventy-foot waterfall for my shower, a twelve-volt battery for my power, and life was great. I did some humpback whale research; there is nothing like looking at a fifty-foot gentle giant eye to eye. I made some dolphin buddies that I swam with on a regular basis. I played with octopuses and watched lava flow before my feet.

I eventually got my captain's license and have sailed most of the Big Island's coastline. I've always been clear to my crew and my friends about who I am, and even though I do not wear my "gayness" on my shirtsleeve, I know it is important to be a good man and break the stereotypes that are pretty rampant here in Hawaii, especially within the boating industry.

I live a very simple life. I have no debt, no credit cards, and for the most part live in my travel van and just see where the road takes me. I never get island fever, but when that wanderlust kicks in and the "travel account" is flush, I'll take off on a new adventure. I've hiked the desert in Palm Springs, sailed the Sea of Cortez, and enjoyed the people of Puerto Vallarta. I can truly say that the phrase "I wish I had done that" is not part of my thoughts anymore.

SAM Ashton Idaho

Most of my friends know that I'm gay, but I don't exactly fit the typical stereotype. I'm fine with that. I've traveled to many places in the world and can tell you that a gay bar in Barcelona is no different than one in Sydney or Atlanta. So I don't spend much time hanging out in clubs, walking in pride parades, or taking gay cruises. I find I get on better with my straight and macho gay friends.

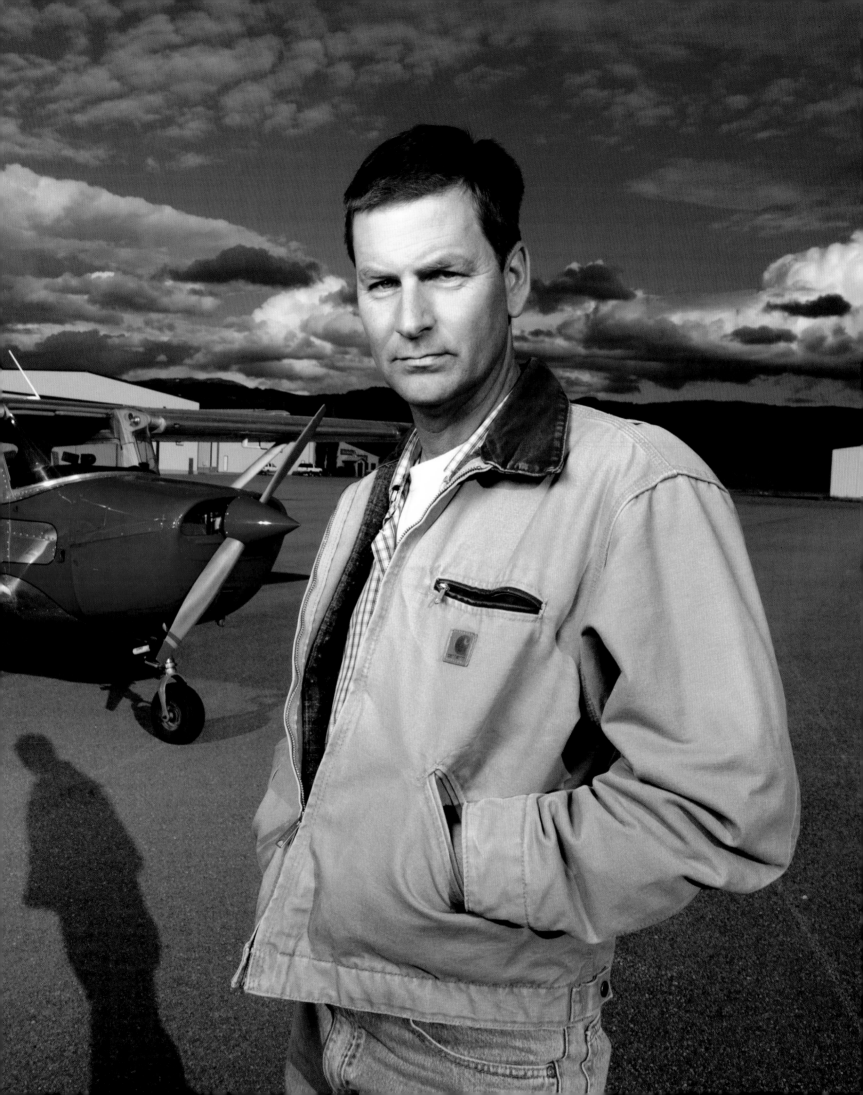

DEAN Boise Idaho

I felt sexual about guys before grade school. The more I wanted someone, the more impossible it was for me to bring up the subject. Words like "queer" and "fairy" began entering my friends' vocabulary, and they were not used in kind ways. I found myself afraid of the boys I lusted for the most—afraid of being beat up, of being bashed. Inside I was running scared, a coward digging my hole, as addicted to talking myself into rejection as any heroin user watching himself cook up another pipe. Making cowardly decisions is not something one walks away from. I carried them with me the day I graduated from high school and moved to Los Angeles to become a movie star. With a bag of clothes and a hundred dollars, I stayed at the downtown Y before moving to a seedy neighborhood and walking several miles to a job on Sunset Boulevard.

Then I spent three years hitchhiking around the country, sleeping under bridges and taking rides from anyone who stopped. I've been in bars where it was so dark your only sense was touch, and walked through the streets of lower Manhattan at four in the morning. Yet I was always a coward, avoiding the crowd if I could, letting my fear of being bashed get in the way of my freedom.

Over the years I'd crisscrossed many amazing places in this vast association of states, but at the age of fifty-six the Alaskan Highway and a good dose of the northern lights had still remained unseen by me. I took off and headed north. On my way I stopped at Watson Lake, a lumber community with several hotels and an equal number of bars, just over the Yukon border. Settled in and full of dinner, I made my way to a bar. I began chatting with a handsome man in his late twenties, a lumberjack fresh from hauling logs, out drinking to get the weekend started. The beer flowed and the bullshit flew and everyone was glad to give me pointers on the roads and the attractions and their travel stories.

Hours later I ran in to the young man in the bathroom and made a decision. I came on to him, but immediately knew better, and was out the door. I finished my beer and decided to check out another bar. I got as far as the parking lot, and heard some sounds behind me. I was aware I was being hit. I put up my arms to protect my head; I knew I needed to stay on my feet. I kept walking, and suddenly it was over. I turned and the lumberjack was in the doorway of the building, saying, ". . . And don't come back!"

I was lucky as a guy can get. A swollen side of the head and a lost hat, but my glasses still fit and nothing was broken. I pressed on, and spent two glorious nights watching huge sheets of light wafting across the sky. I took the ferry on my return from Alaska, and it was there I realized that I had confronted my most awful fear—being bashed for being queer. I was finally free from a childhood dread that had been gnawing at me my entire life.

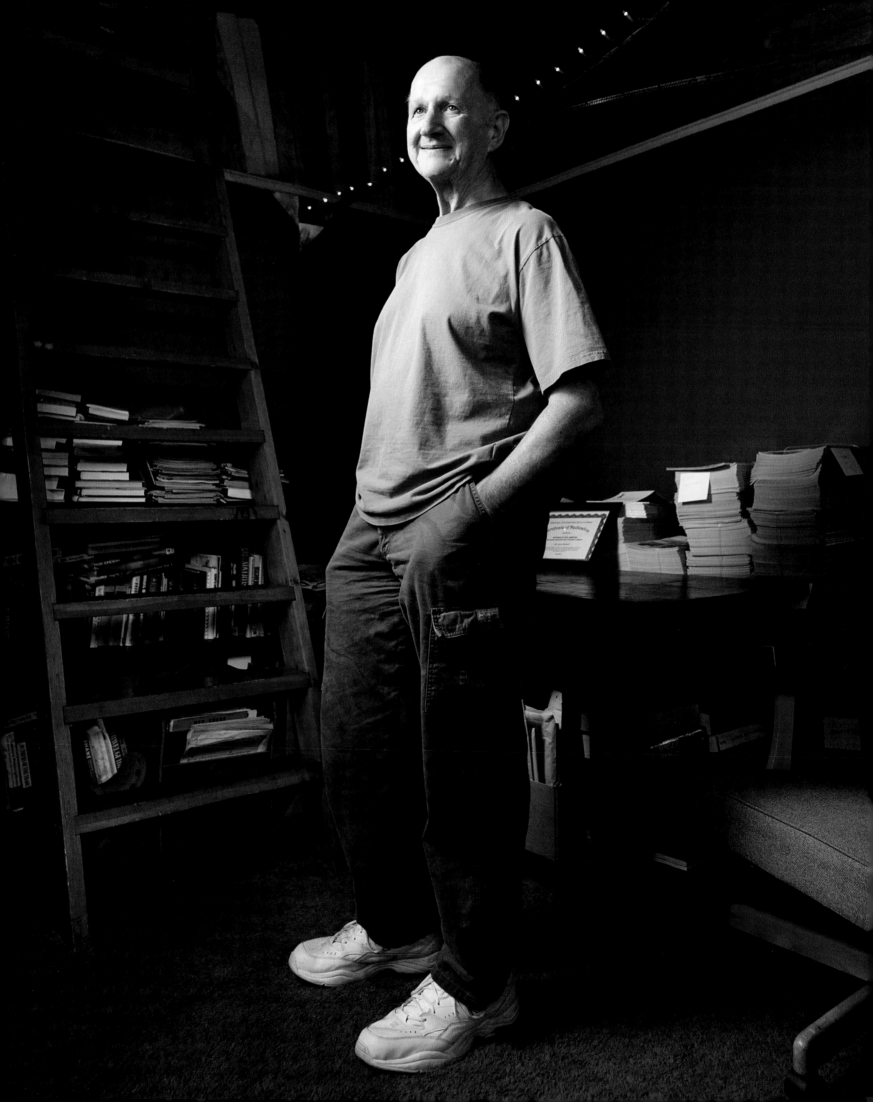

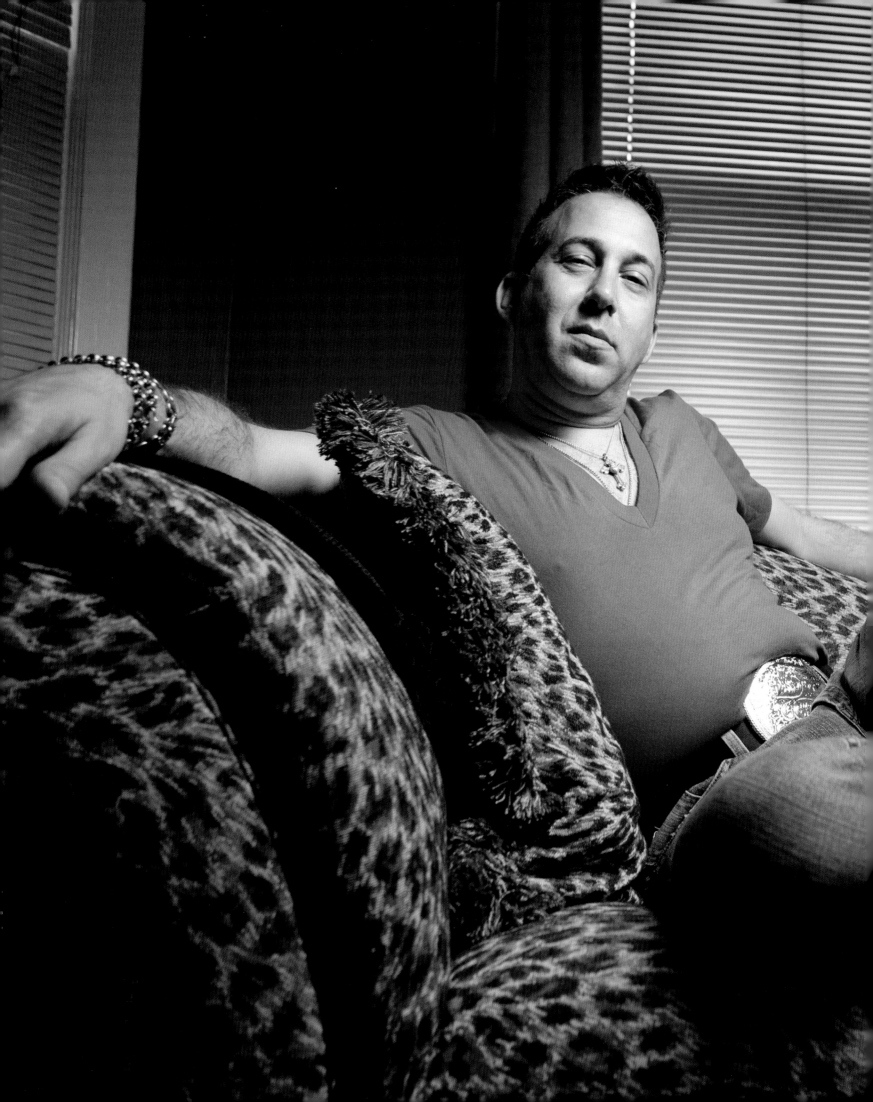

KEVIN Chicago Illinois

I am an entire season of *Oprah* all my own.

I was a victim of molestation, a product of a divorced home, and a gunshot victim—all as a child. I witnessed my father's cheating and my mother's suicide attempts. I would wake in the morning to shattered glass strewn from one end of the house to the other, the results of the previous night's fight between my parents. I saw my father put my older sister through a wall once, and go after her in a rage with a broomstick another time. I saw him strip both my sisters down and beat them with his western belt and buckle until they were bruised.

Both my sisters died young, one from complications brought on by anorexia, and one by committing suicide. She is the one who shot me; it was an "accidentally on purpose" scenario. My life is my life. I don't view my childhood as tragic; it's all I knew. I came out in my early twenties but then went right back into the closet and married my best friend. I had no dating prospects, and neither did she. We thought we would take care of each other into our old age. I am now in the process of getting a divorce and easing myself back out of the closet.

I have managed to hold it together all these years, and I continue to work on becoming stronger and better. I want to believe there is someone out there for me . . . they just haven't found me yet.

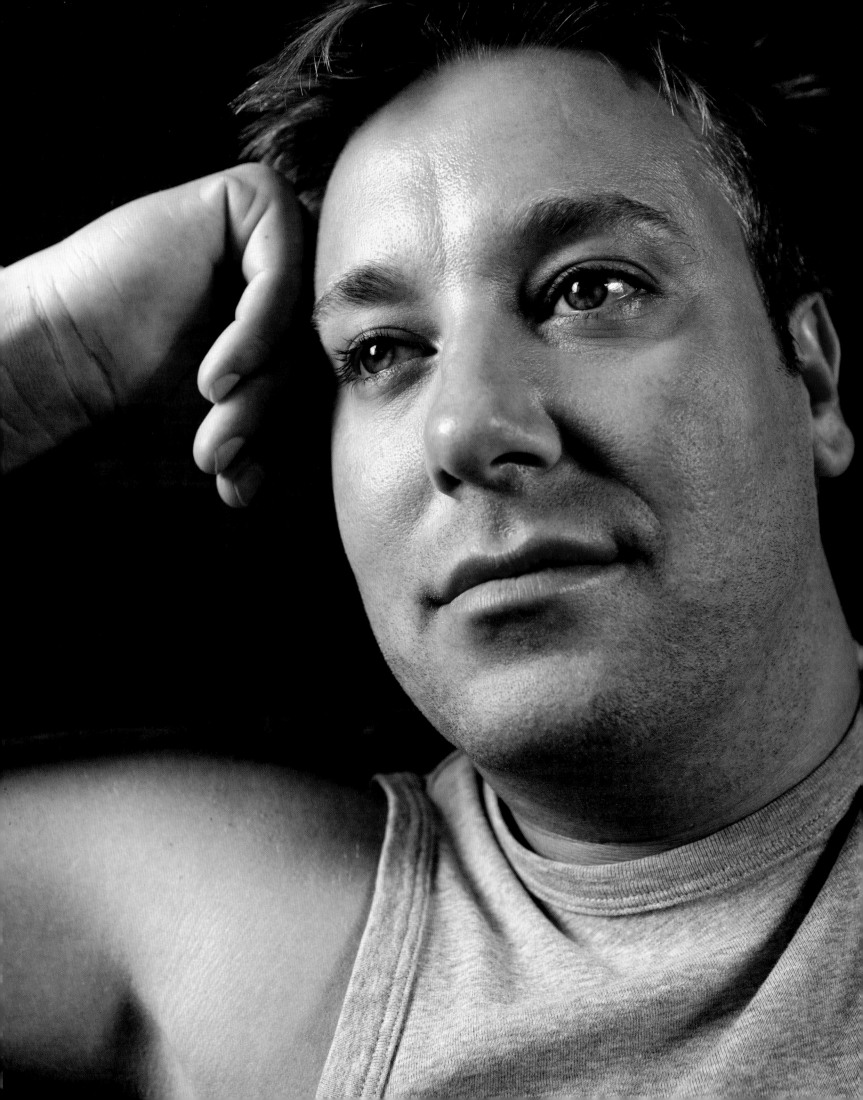

ERIC Noblesville Indiana

My childhood was not easy. I was raised by a very religious mother, and I still struggle with issues regarding my faith to this day. A small part of me is scared that I actually will go to Hell. I try to convince myself that no God would make me this way and then send me to that place. I avoid going to church. I don't have anything against Christians, but I mostly feel that religion is for people who can't really think for themselves. I know what is right and what is wrong, so I just try to do the right thing and enjoy my life.

JOE Sioux City Iowa

I come from a single-parent home, raised by my loving and caring mother, who has always supported me (she was even my business manager and travel companion when I won the title of Miss Gay Iowa USofA at Large). I was often tormented as a child for being gay. I didn't know what it really meant to be gay because I didn't know anyone who was. I knew even as a child that I was attracted to boys, but believed if I lived a small, quiet life that these desires and thoughts would eventually go away. When finally faced with the choice of staying in the closet or living an open and proud lifestyle, I chose to be open.

I never thought I would be a drag queen. I was not thin, pretty, or very outgoing. I watched from the corners of the room. The first time a friend painted my face and placed a wig on my head, a new personality was born. Fearless and outspoken, I was larger than life, ten feet tall, and bulletproof. In addition to this newfound personality, there also came a sense of community. When I first ran for Miss Gay Iowa USofA at Large, I wanted it because it was shiny and pretty, and it gave me a sense of accomplishment. Once I won the title, I found it gave me a stronger voice to encourage people who had been victims of bullying or felt like outcasts to stand up and be proud of who they are.

In my nine years of performing, I have raised approximately $100,000 for charities, including AIDS, cancer centers, humane societies, children's charities, homeless shelters, food banks, and even one to save a park. My experience as a drag queen taught me to embrace who I am, to love myself, and to respect others for the similarities and the differences that make us unique individuals. I am proud of my accomplishments, and I am proud of who I have become.

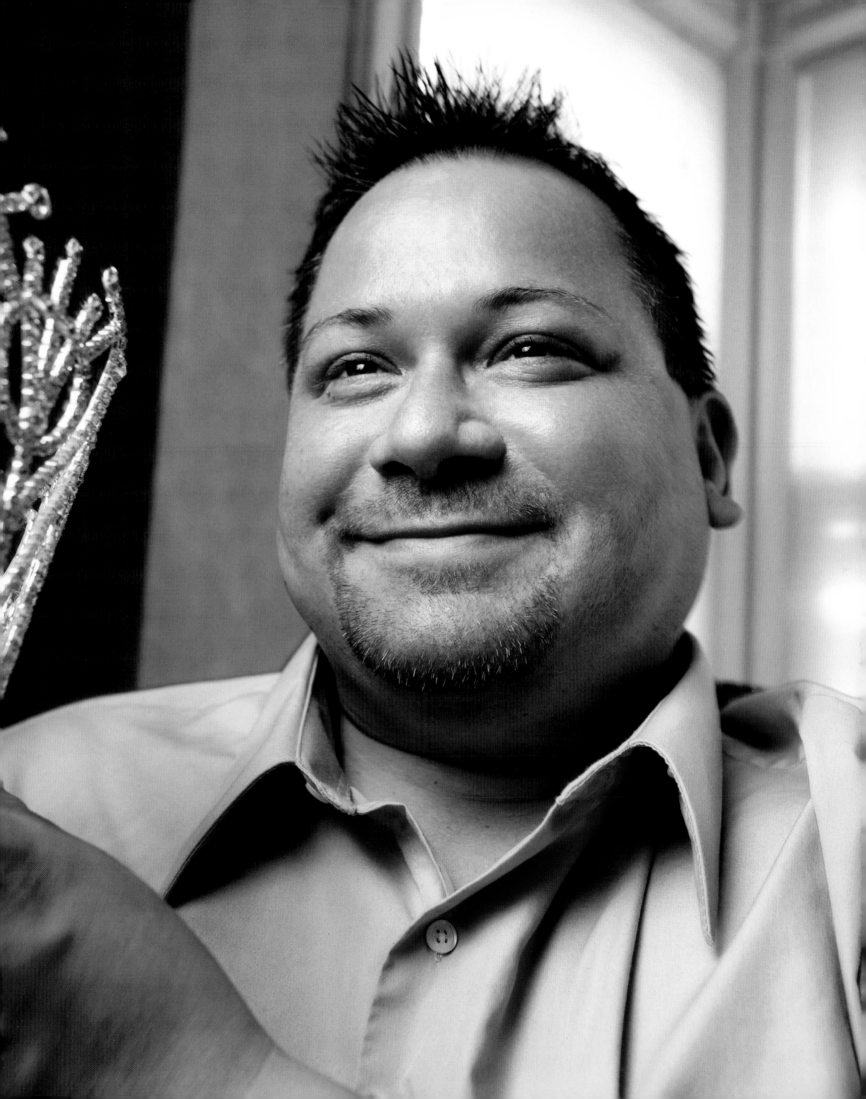

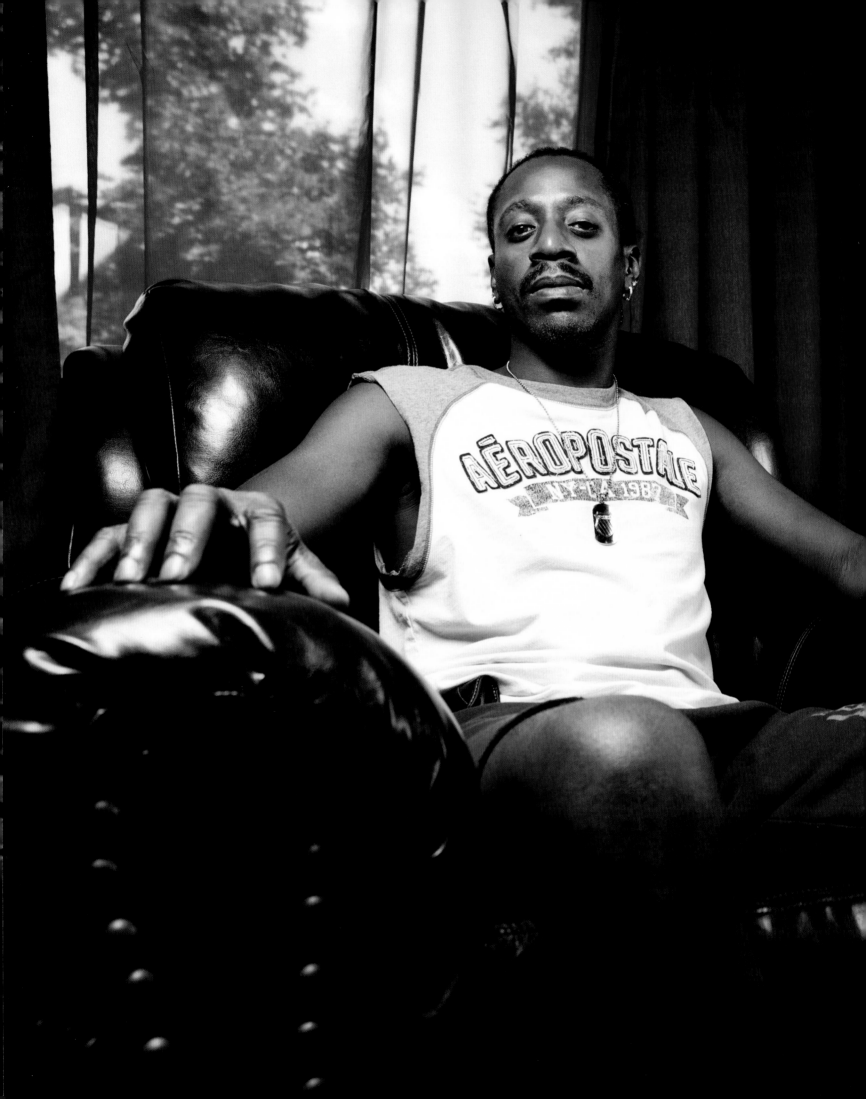

STEVIE Wichita Kansas

Being a gay man in Wichita isn't a bad or good thing. It's the largest city in Kansas, so tolerance is relatively high, and we're evolving into an even more accepting city. We have an annual event in mid-October that is a platform for HIV/AIDS awareness. Wichitans come out in big numbers to buy art and expand their awareness of the gay community's influence and presence. We still have a long way to go, but our path is clear.

Being an openly gay black man, I have had mostly positive experiences since coming out when I was eighteen. Since then I have always been open in public, in jobs, and in social settings. I have learned that how people carry themselves dictates how other people treat you most of the time. I lead with my personality rather than my sexuality. As a result, I believe most people look at me as a black gay man with respect. I also choose to surround myself with people who are positive and don't carry a negative energy.

Within black culture, being gay still carries a large stigma, so there is great reluctance to come out. Like anything else, with more education, I know that will start to change, too.

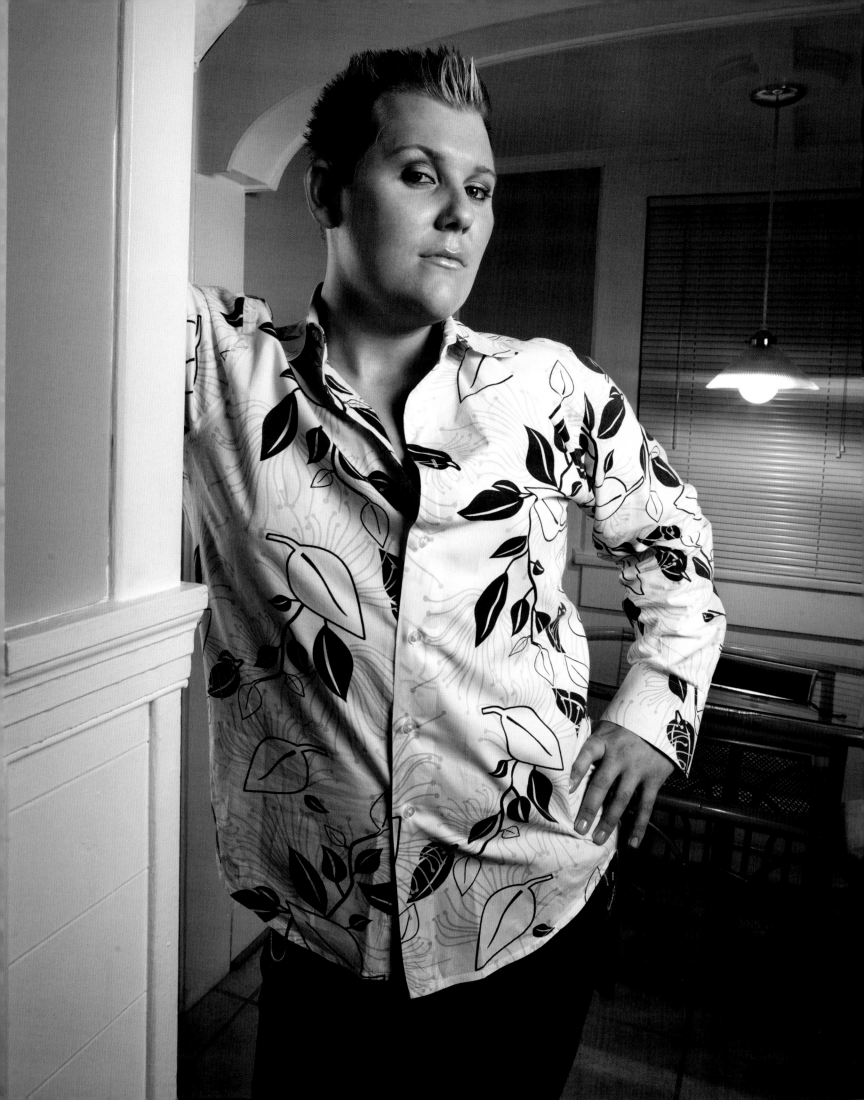

JT Lexington Kentucky

I just came out of the womb looking feminine. I don't have any facial hair, and I have the most beautiful skin in the world. People mistake me for a woman even when I have a baseball cap on. There are hardly any men in the family—just tall, blond glamazons. I come from a line of beauty queens. My aunt was the first person to open a high-end spa in Lexington. No throwing the football around for me; it was always about makeup and fashion. I was sixteen years old when I told my mom I was gay. She pretty much knew, everyone knew. I think they were waiting for me to grow up so they could hear it from the horse's mouth.

I dated a much older man when I was in high school, and that devastated my family. It brought havoc into my life. At the age of twenty-one, I took off for California. I was ready to spread my wings. I went to live with my aunt in Laguna Beach. I got into the makeup industry and worked my way from the bottom to the top. I have been so fortunate to work in Los Angeles because I have met everyone I've ever idolized. The day I saw Whitney Houston, I got weak in the knees—she's gorgeous. Everyone knows she's my number one. My bedroom wall is covered with all the headshots of people I've met. They motivate me because I want to be a star like Whitney or Oprah. I would love to be a fashion journalist for a television channel. I know it'll take a lot of work, but I'm going to get there.

Even though Lexington is one of the most gay-friendly cities in the United States, I stick out like a sore thumb here. I have one of those faces you can't forget. People tell me I'm like a white Grace Jones. The tragic thing is that no one here has ever heard of Yves Saint Laurent. When they see me walking through the mall in my limited-edition leopard-print loafers, they are tacky enough to ask how much I paid for them. When I tell them, they say, "Oh, I'd never pay that much for a pair of shoes." People can't believe I walk out of my front door looking the way I do.

In my downtime I help my aunt with her beer cheese company. I go with her to trade shows, and sometimes she says, "JT, can't you tone it down a bit?" That's the only time disapproval of my looks hurts my feelings—knowing it could hurt a business. This is why I absolutely have to get back to Southern California. The economy is horrible right now, but the beauty industry is always pumping. If I'm going to be famous, I have to live among the most beautiful people in the world.

CHAD Lexington Kentucky

I **was around twenty-one when I fully came out.** My friends were all okay with it, which was really surprising, because a lot of them were pretty redneck for this area. Some knew, and said, "Thanks for finally telling us," and others were like, "We didn't know that you were all the way gay, we just figured you were just really friendly, or very liberal." It's kind of unusual for such a backwoods area to be so cool with it.

When people say things like, "Oh, that's so gay," they think nothing of it because they probably don't realize they know someone who is gay. When I first came out I would go to parties or weddings, and people would always ask random questions about being gay, or think that one person who's gay knows everybody that's gay. But I'd rather answer all kinds of crazy questions than have people assume the wrong things.

In my spare time, I play online games. Certain games have players who get together and play as groups, called guilds. Some games actually have gay guilds, where everyone who is a member is completely out and open. Gay players get the same amount of harassment that anyone will get online. I was in a guild that wasn't gay, but I was out from the beginning with them because I didn't want to sit in the background and bite my tongue if somebody started badmouthing gay people. I let them know up front so that if they didn't like it, they could go ahead and kick me out. You're playing a game for entertainment and joy; you don't want to get harassed there like you might anywhere else.

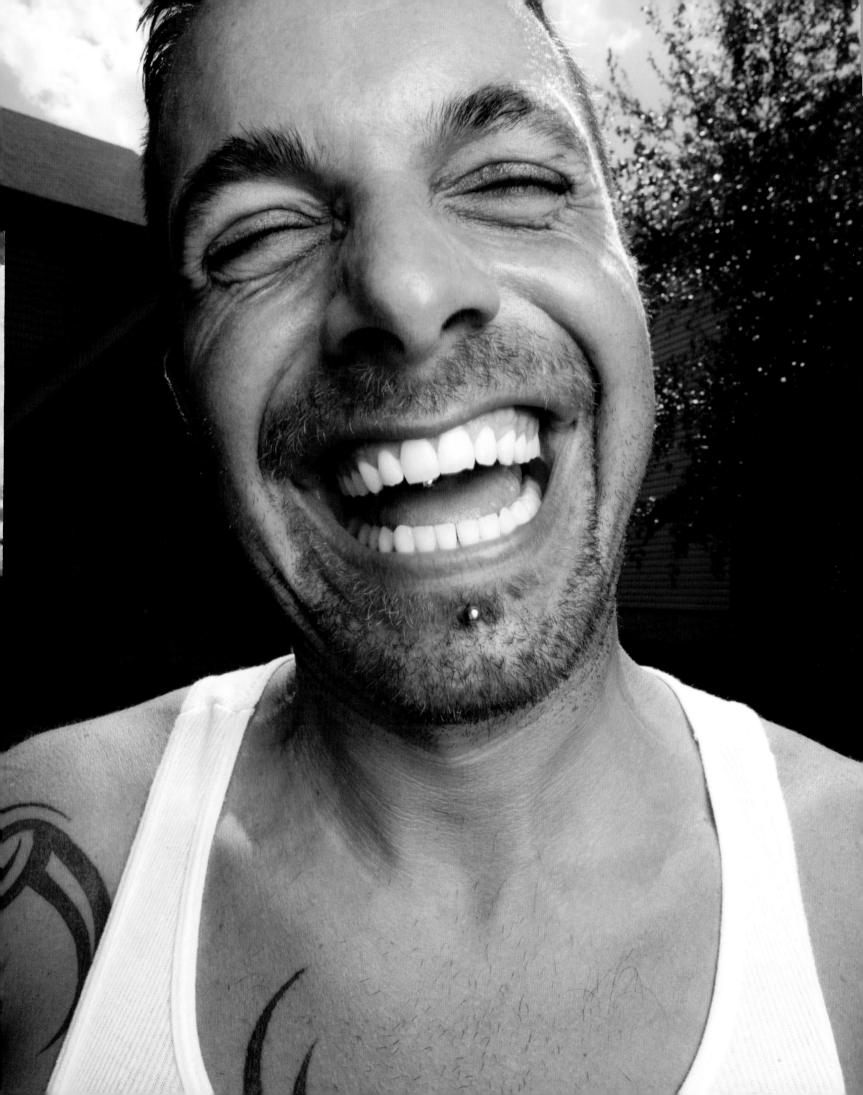

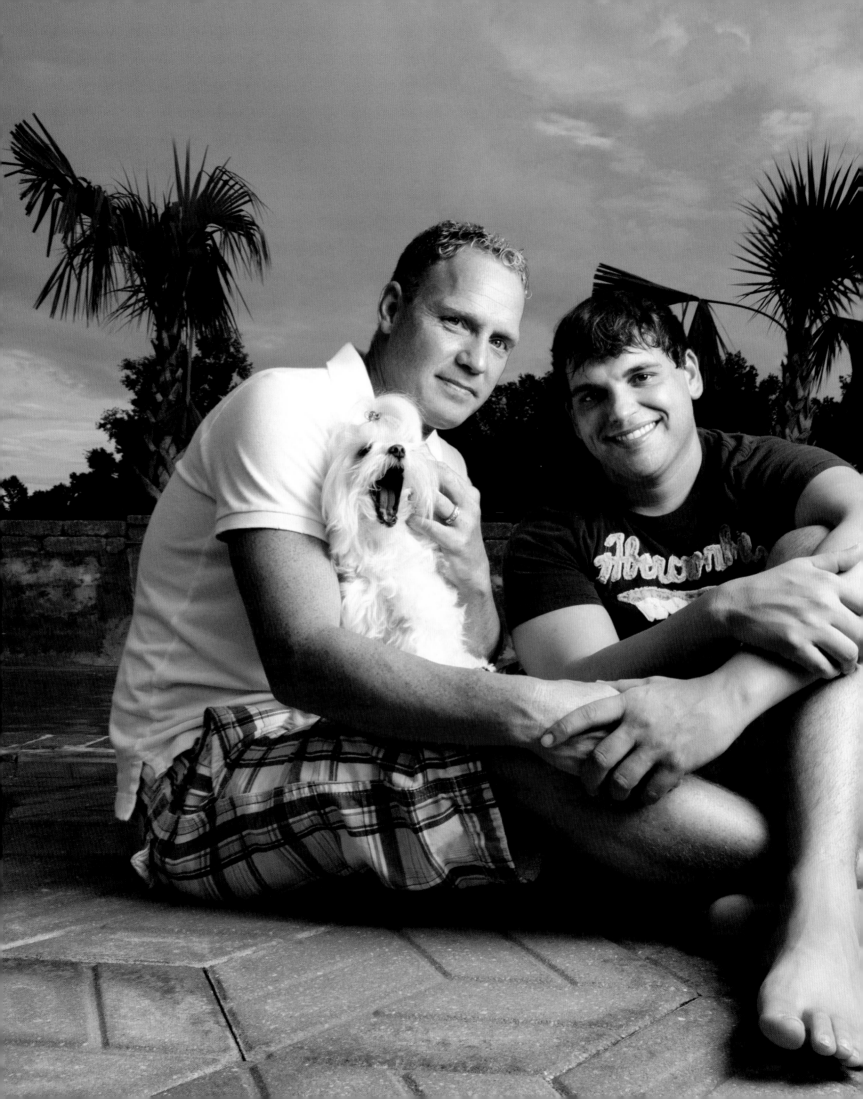

BRENT & CHARLIE
Loranger Louisiana

We were both born and raised in south Louisiana. Brent was raised on a dairy farm in Kentwood, and I was raised about twenty-five miles south, in Hammond. We have worked in this area our entire lives, and our family and friends are located nearby, so it made perfect sense to put down our own roots here. We chose Loranger because it is right in between both our hometowns.

It is difficult to be out in the South. People here have the hospitality and politeness thing going, but behind closed doors it's a different story. We vowed to always be open and honest with people, no matter what their opinion of us might be. We often hear things like, "I love Charlie and Brent, but I just can't accept their lifestyle."

We were raised Christian, and it's difficult for us to believe that six verses in the Bible can tear relationships apart all over the country. Especially as many of our friends have been divorced, committed adultery, and so on. The Bible speaks to those issues in the same manner as homosexuality, but we are viewed differently. As a couple, that is a hard pill to swallow because we're in love. It has taken many years for us to come to this conclusion: God made us and loves us just the way we are or he wouldn't have made us this way. This probably sounds obvious to most people, but given our background and the parade of people telling us it's wrong to love each other, it was a hard journey.

TED Peaks Island Maine

've worked full time as an artist my entire life, struggling to keep my finances above water. When I was losing my studio to a condominium project in Newburyport, Massachusetts, I decided to make a change and move to Maine. When I first approached Peaks Island's bay by ferry, the magic was instantaneous for me. The island is a treasure of spectacular views and light and enchanting cottages from times past.

I was outed before I even arrived. My cousin, a gay hairdresser in Portland, decided to share my story with a client. This client happened to be the grand dame of the social circle that mingled around the yacht club, right across the street from my soon-to-be house. On an island word travels faster than the speed of light, and everybody knows everybody else's business. But as people met me, I melded into the community, which I have become a strong part of.

My house is named Joy. It faces west to the water with spectacular sunsets over the Diamond Islands. Above the lookout tower is a meditation room with a skylight pyramid fabricated by my friend Moss, a Radical Faerie from Vermont. He built it with a crystal he brought back from a Brazilian temple site. There are twelve small stained-glass windows at the base of the space representing the twelve major religions of the world. The space has evolved into a learning center called the the Center for Sensational Living. Its purpose is to teach the oneness of us all.

Because of the size of the house and my nature, Joy has become home to many wayward travelers and friends. Literally hundreds of people have stayed with me, all ages, all genders, all types, recognizing a special process, purpose, and experience of living that is maintained in my home.

JOHN & CHRIS Portland Maine

We both come from wonderful, albeit different, families. Growing up trying to figure out being gay is never easy, but the love and support we got never made us think that we couldn't have happy, normal lives.

Always individualists, people seemed surprised that we chose to have a traditional wedding, but we never saw our commitment as different from any other, gay or straight. After years of dating and living together it was just the natural progression. We got married in July 2010 in a Connecticut park before close family and friends. Sharing that day with the people we care about the most brought us all together in ways we never anticipated. I have never felt so much love in one place.

We recently relocated to Maine from New York City with our dog, two cats, and a turtle. It's a wonderful place for our little family to begin its next phase together. Maine probably isn't the last stop, but it's a good place to hang out and daydream with my husband about where life will take us next.

KEVIN & JOEL Dayton Maine

Both Joel and I grew up in Maine—I've never lived **outside the state.** We don't define ourselves by our sexuality. A few years back, when Maine had a ballot initiative to repeal an equal rights law, I was talking to my mom. In the course of the conversation, she said to me, "I don't think of you as gay, just as Kevin." At first I was angry, insulted. If she didn't think of me as gay then how could she value the twenty-five-year relationship that I have with Joel? But then it came to me, my mom sees me as I want to be seen: "Just as Kevin." Not as Kevin, her gay son.

Joel and I believe in personal responsibility. We both got where we are today through our own hard work, sound financial decisions, and commitment to each other. In our opinion, the major functions of the federal government should be national security, interstate commerce, and infrastructure. We prefer capitalism over socialism. Public schools should be a place to learn a basic set of knowledge and not a place for social engineering. Affirmative action has done its good, but now needs to be cut back and eliminated. I would never want a position in a company to be given to me simply because I am gay. However, I wouldn't want to lose a job opportunity because I am gay either.

This election season, we lost a few of our gay friends for being political conservatives. We have been called self-loathing. When we became the first openly gay male foster parent couple in Maine in 1992, our gay friends accused us of trying to be straight. The white picket fence, two kids, dog thing. That is how we were both raised. It wasn't in the news, but when we adopted our son we silently set the precedent that allowed the law to be amended to permit unmarried people to jointly adopt in Maine.

We find it interesting that the people who have discriminated against us the most are those who are supposed to be part of the "enlightened" crowd. As parents, we have faced discrimination by the school districts, the Department of Human Services, and a so-called liberal residential treatment center for children. I worked there, and it was the only place in my professional career that I did not feel comfortable being out.

A few years ago, we took up competitive same-gender ballroom dancing. When we attended our first competition in Philadelphia in March of 2007, Joel and I were disappointed that the MC of the evening gala was a fifty-year-old drag queen named Miss Pumpkin. Wasn't there a local gay celebrity who could have hosted that wasn't a drag queen? We didn't bother going back the following year.

We both enjoy physical activities of all kinds, from tennis to tap dancing. Joel loves to garden and putter around the house. I crochet, play computer games and I am learning to play the piano. Joel attends the local church with his family. I used to attend occasionally when our son was at home. It is a rather fundamentalist church, but we are accepted with open arms. We even get invited to the annual Valentine's Day couples' dinner.

We just celebrated our twenty-ninth anniversary, and are looking forward to spending the rest of our lives together.

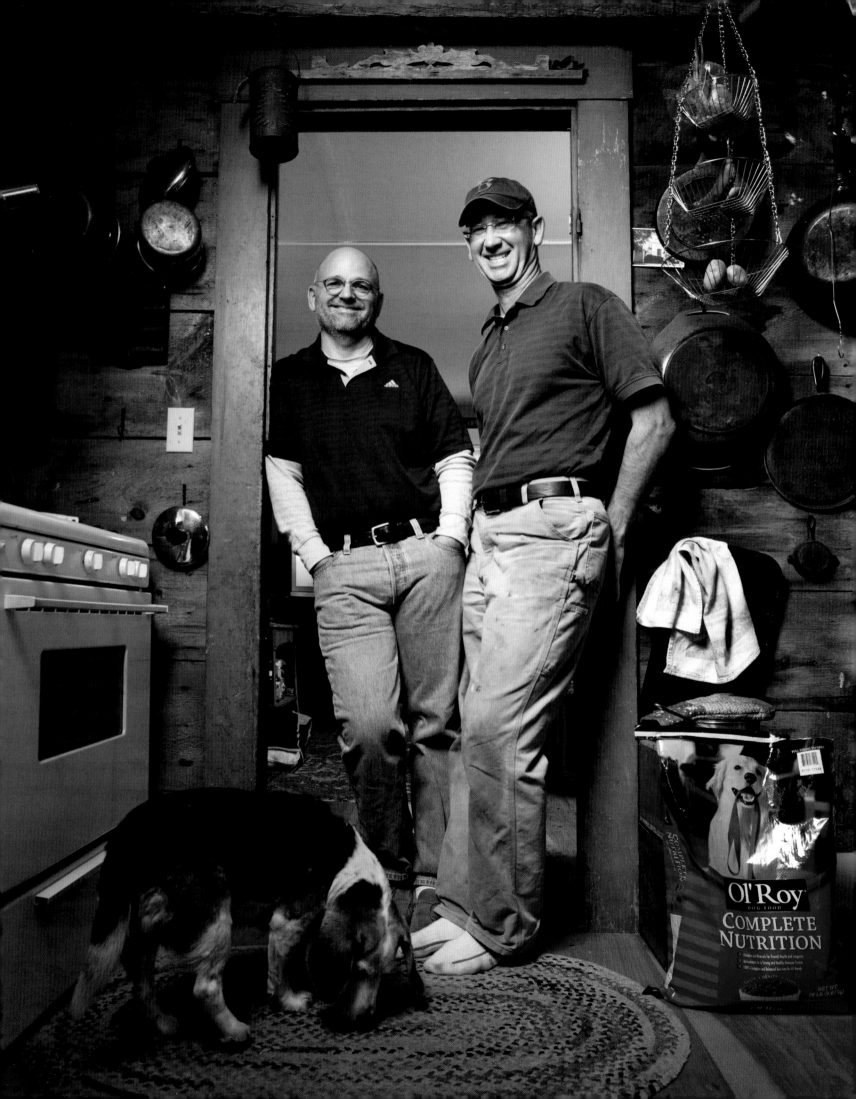

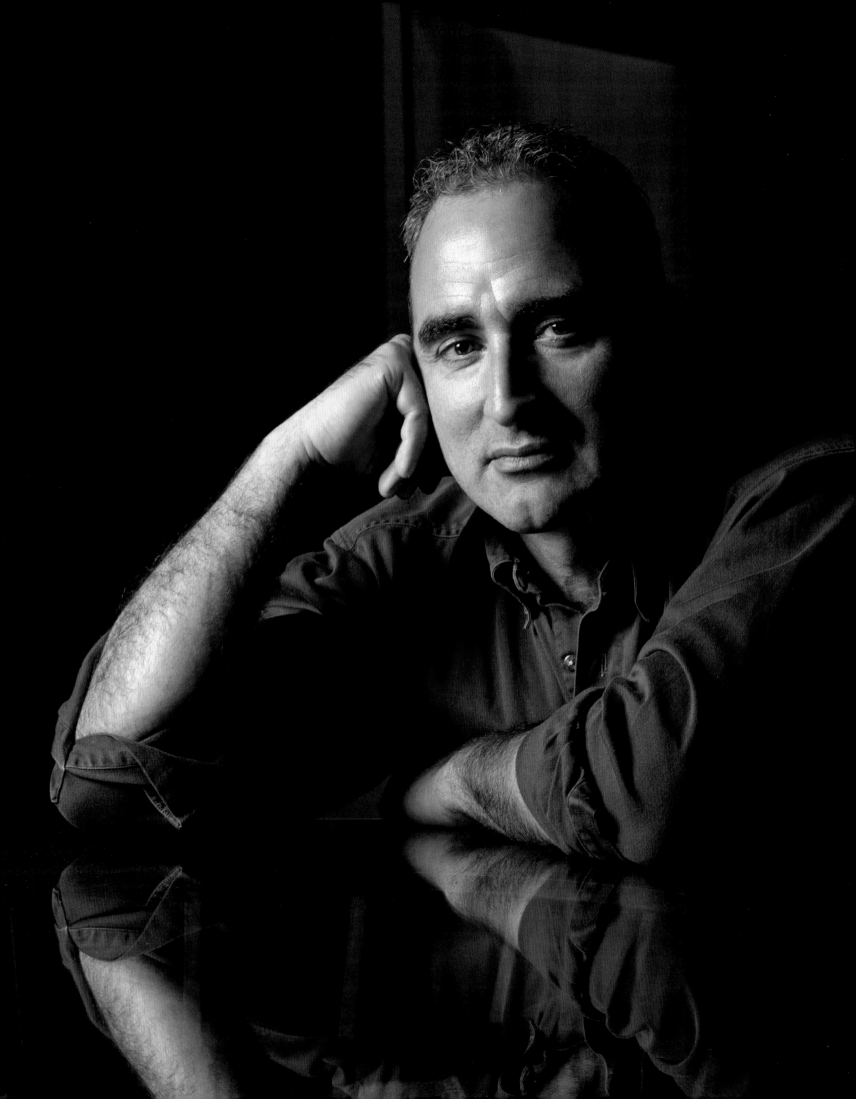

BRYCE Turner Maine

I left my hometown when I was young and moved out of the state in my twenties. I never expected to come back here, but it was exactly what I needed for my personal life's journey, and for my recovery from addiction. It's been a powerful and unexpectedly affirming experience for this gay man to be welcomed back to small-town America. I've experienced more tolerance for alternative lifestyles some thirty years later, as well as more self-acceptance of my sexuality.

A few years ago I had a harrowing experience with crystal meth and alcohol. I realize in retrospect that I flirted with addiction for many years before it finally got me in its clutches at forty. When it did get me, it took me down fast. Addiction is a monster, and I lost everything to it. It was, ironically, the strength of character I developed from growing up gay that helped me survive my fall.

I don't believe it to be an accident that I came home to rebuild my life. I needed to slay the demons that dogged me, to shatter the isolation that I had felt because of my sexual orientation, and also to reconnect with my roots. I have a true-blue Maine pedigree: my grandfather was a lighthouse keeper and a lobsterman and came from a long line of boat builders and fishermen. My summers and school vacations were spent at my grandparents' house on the ocean. The other side of my family was of farmer stock. I've experienced a lot of richness and self-discovery living here at this time in my life.

I now have a partner and we are planning our commitment ceremony (Maine does not allow gay marriage). I've had relationships in the past but never never wanted to settle down. The growth and self-acceptance I've experienced as a result of coming back to Maine has allowed me to embrace my life with Michael, who is my lover, my partner, and my best friend. And it helps that he loves Boxers, of which there are now two.

I know the saying goes, "You can never go home again," but that's just what I did. And it was going home that healed me.

MARTIN & PETER Bath Maine

I'm the principal of a local high school. Most everyone in town, including the students, knows they have a gay principal, and no one really cares. I moved here to Maine with my partner Martin, whom I've been with for almost twenty years.

Martin contracted Hepatitis C in 1971. At that time they didn't know what it was, so for most of his life he lived fairly normally. Eventually his liver enzymes became elevated and he attempted treatments but was non-responsive. Martin's health continued to deteriorate, and several years ago he prepared to move to Pittsburgh, where he once lived, because Maine is one of the worst regions for organ availability. That meant leaving me in Maine and waiting up to a year for a possible transplant, with no guarantee he would receive a liver before he died. That's when I decided to try being a living donor.

I gave two-thirds of my liver to Martin. There was only a thirty percent chance of compatibility, but I went through a series of tests and, as luck would have it, I was a perfect match. I even had an extra vein in my liver that only twenty-five percent of the population has, which they used to make the connection between the two livers even better. As far as our clinic knew, we were the first same-sex couple to have this procedure done. Martin started treatment again, and after twenty-four weeks the virus appeared to be gone.

Six months later, his doctors called out of the blue and told us that the virus had come back. There isn't much more we can do except wait for the day when Martin will need another transplant. So many events in our life together seem to be fated, and I believe that I was meant to meet Martin and that I was meant to save his life. We'll keep muddling through as we always do, and hope for the best.

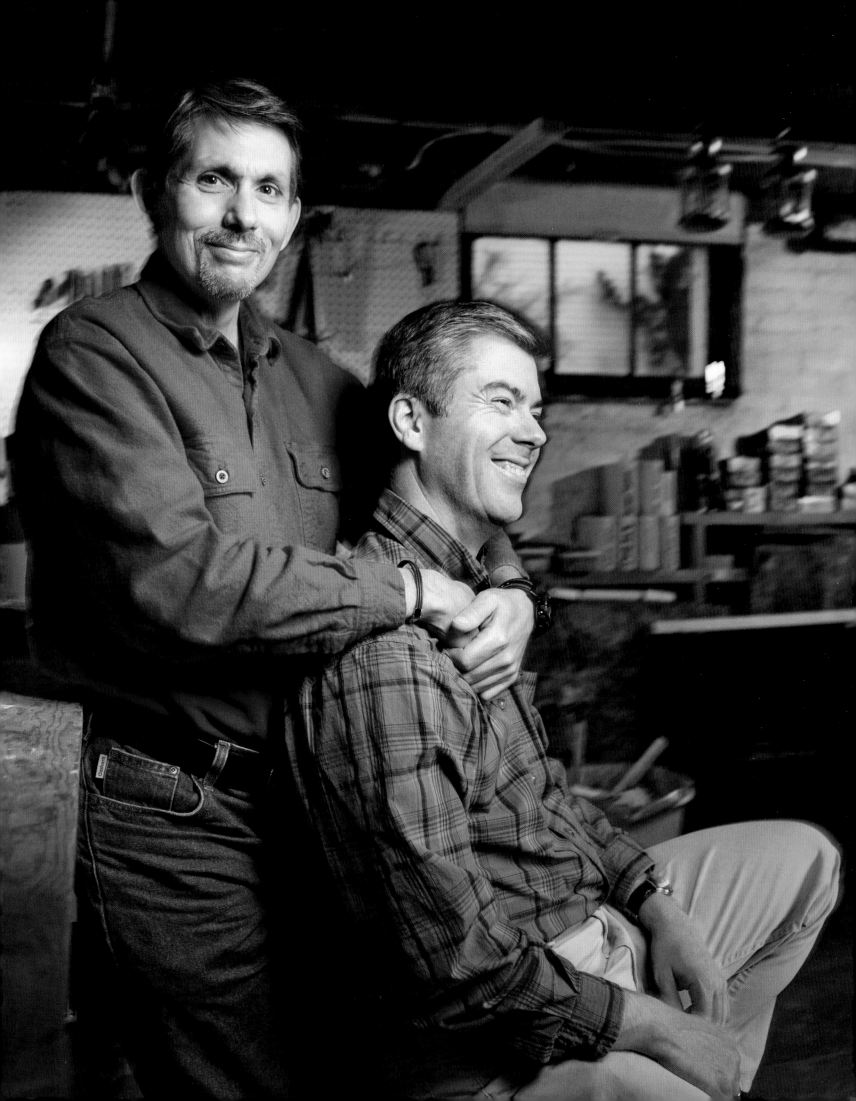

SHAWN Baltimore Maryland

don't act "gay." I'd rather jump into a mosh pit at a Nine Inch Nails concert then see some musical. I've got a bit of a belly on me. I'm poor as a shit-house rat, my apartment is crap, I don't wear designer clothes. I've been locked up for an extended amount of time. I used to be a junky, but now am proudly clean.

I'm into breaking stereotypes.

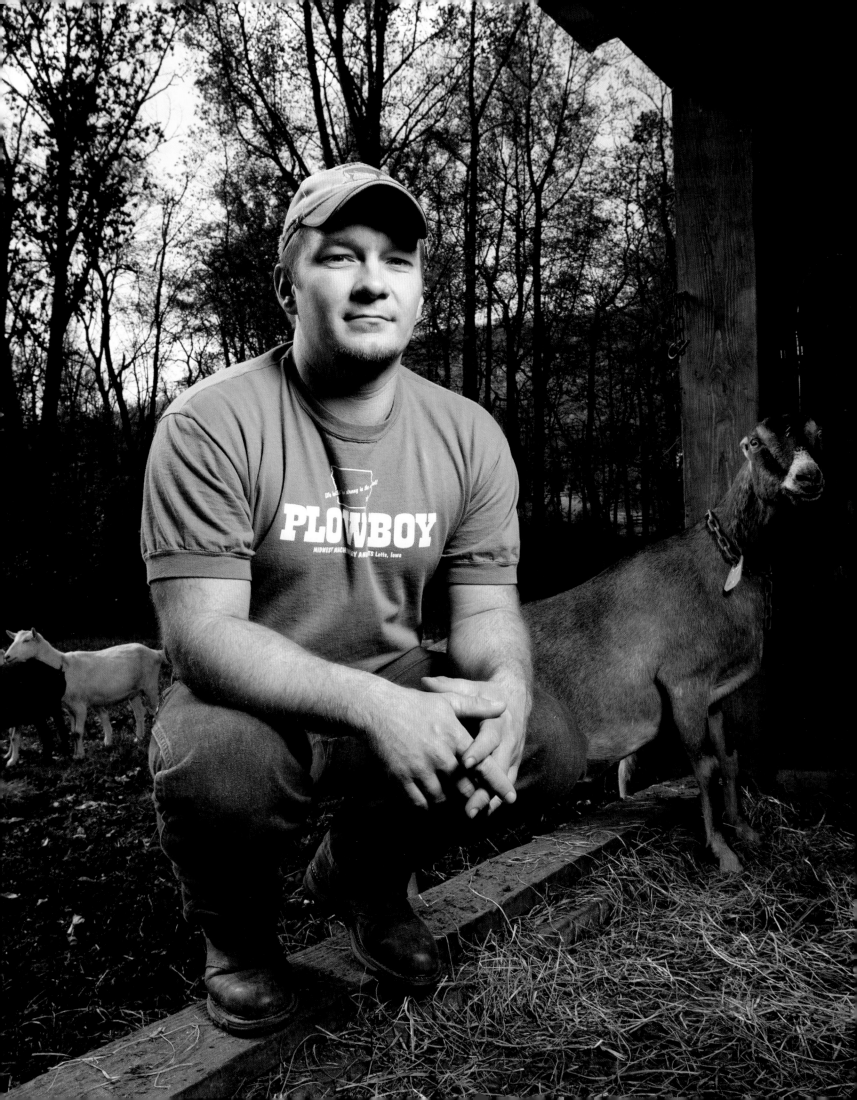

KEN Brunswick Maryland

My friends say I'm a true gay redneck. I was born the youngest of eight boys in southern Missouri. We are simple people, family means everything and money means nothing. My parents taught by doing, not by saying. They have an unbelievable work and family ethic. The night before I was born, Mom was out in the barn milking so Dad could finish up cutting the hay down in the fields. Then early the next morning I popped out, and three days later Mom was back in the milk barn doing chores, with me. I was brought up in the very typical Southern ways: never back talk an elder, hold the door open for people, always say "Yes sir," and "No ma'am," do with what you have, or do without. My parents' famous saying to us kids was, "If you want help from someone, first you have to help yourself—and you better thank them after they help ya."

I was raised to work on the farm, but only after schoolwork was done. My afternoons were spent doing chores. It was basically a requirement to join FFA (Future Farmers of America), just like my father did, and most of my older brothers did before me. I was on state judging teams, and competed as well, often winning first place. That was time Dad and I spent together, judging heifers with flashlights the night before a competition. It made us closer, and is something we still talk about, like how so-and-so grew into the cow that we thought that she would when she was younger.

I met Kevin, my partner for nine years, through FFA. My senior year of high school, Kevin and I were both Area Presidents. We met at a convention in Columbia, Missouri. I was just seventeen at the time; I did not know how to date,

or honestly what I was doing looking at another guy in that way. I kind of knew what I liked, but that was something that was not to be talked about in the family. You don't discuss dating, sex, and God forbid, being attracted to other boys. A couple of months later Kevin called and asked if I was going to a meeting back up in Columbia that weekend. He offered to drive me as I didn't have my license, and we went together, and that was the way it worked all summer. He would come pick me up on Friday night, and we'd drive four hours to the meeting. We got to be great friends. He would show up at livestock shows that I was competing at, and would ask all kinds of questions. I still thought he was hot as hell, but never considered the idea of dating him. Hell, I'd never even had a date. I stayed on the farm all the time. Finally, the last meeting of the summer came around, and that was the day that my whole world changed.

About halfway to Columbia there is an overlook. Kevin pulled in, shut off the car, and sat sideways in the seat facing me. He said, "Now this is very hard to ask, as I know it might ruin what we have, but . . . I just have to know something." And me being me, I had no damn clue. He waited a little bit and kept starting to say something, but then stop. This went on for a bit until finally I just said, "Hell, go on with it . . . It can't be that bad." He looked at me and asked, "I have to know, do you see anything happening between us or am I just dreaming it up?" I still had no idea what he was talking about—what was supposed to happen between best buds? He saw the dumbfounded look on my face and said, "Let me put it this way . . . Can I date you?" At that moment, I didn't even know that I was gay or anything. I was just me,

nothing more and nothing less. I do remember looking at him, smiling, and saying, "Only if you will hold my heart forever in yours," and then thinking, "Did I just say that out loud?" Kev looked at me and smiled. I don't know how or why, but we became a couple after that. We had not kissed, held hands, or even talked about anything like this before.

Our summer ended with that final meeting in Columbia, and we were off to school together. I was still lost about what any of this meant, but the one thing I knew was that Kev was by my side all the way. It was six months before we did anything sexual—and by that I just mean kiss; it was much longer before the good stuff! We were meant to be together, one never took a step ahead of the other.

Life went on, we graduated school, and talked about our future. Kevin wanted to get his master's degree in advertising, and I was set on becoming a veterinarian. We wanted a good school that offered both, and chose the University of Wisconsin. We moved to Madison, and life was grand. Kevin graduated in 2002, and I was still in vet school, which was a much longer program.

We always celebrated our anniversary the 19th of August, since that was right between our birthdays—his on the 18th and mine on the 21st. We were typical men—we couldn't remember the actual date to save our lives. On our ninth anniversary in 2003, we went to a romantic restaurant in Madison for dinner, then stayed out late walking and talking. When we finally got in the car to go home, I took the driver's seat because Kev was tired and I didn't trust him to drive. We did our normal thing at that time and stole a kiss before I started the car. I took the same route I had taken many times

before, and Kev fell asleep like he had many times before. I pulled up to a stop sign and leaned over and gave Kev a kiss and told him we were almost home. He started to wake up and smiled at me, and I went though the first stop sign, then got to the second one and stopped. I looked both ways and turned onto Route 69. All I remember was the yell that Kev let out. A drunk driver had broadsided us. There in the middle of Wisconsin, with the nearest family member over 600 miles away, I was losing the one I'd learned to love, the one who made me whole, the one who showed me that it was okay to be myself. I was losing him. All I could do at that point was pray. I was praying for him to make it, praying that I should have looked a second time, that I would wake up the next morning to find myself next to him in bed. I prayed that it was me in his place, that he was too great of a man to die. I prayed that someone would come and make him better. That was all I could do, just hold him and pray for him. I grabbed on to him and held him tighter than I have ever held anyone, and said, "You're my one, you are my only one, I will not love anyone as much as I love you."

Kev was killed on impact or shortly thereafter. As they laid him on the road, I fought to get to him. I had to see him one last time. I prayed that he would be safe, that he had not gone in pain, that he would remember to meet me when my time came. I prayed and I prayed.

They took him to the University Hospital in Madison. That was where my life really changed. We were not partners in the eyes of the state. I was denied the right to see him or fill out any of the paperwork, because I was not family. I can say that I really came out there—to myself and the world. I

was not going to be able to go on without seeing him one last time. I tried everything I could think of to convince them. Finally I looked at a nurse and yelled, "Damn it, let me see my boyfriend!" Right there, standing in the hospital, I knew I was gay. Up to that moment we were just together and it was not a big deal. I never thought of him as my boyfriend, even though he was, the whole nine years. But never once did I introduce him as that. It was just Ken and Kevin or Kevin and Ken. I never thought about putting a label on it.

The nurse must have seen something in me then, and she agreed to take me to him. When we got to the room where Kevin was, she looked at me and held my face in her hands. Then all I remember is getting the best hug of my life. You know the type that only a grandmother can give, that warms you to your core and makes you feel so safe, that you wish would never end. I wept in her arms. I wept, and she just kept hanging on. I wept, till my eyes hurt. That was the first person I came out to, some complete stranger in the hospital. From that moment on, Kevin was my boyfriend, not just a friend. I had opened my life to the whole damn hospital floor, but from that moment on I knew who I was. I was gay and I was proud.

After that night, I had to do the hardest thing I've ever had to do in my life. I called Kev's family and told them what happened. His mother knew we were a couple, and she answered the phone that morning. I just busted out crying, and all she said was, "I know, you don't have to say it. Please don't make yourself say it." The hospital had already called her earlier that morning.

Then it was time to call my folks. I never will forget that phone call. My mother answered. "Oh, dear God," I thought, "why not Dad at least? When he gets mad, he just stops talking." But it was my mother. I got up enough nerve to tell her that Kevin was killed in a car wreck. I was in tears, trying to be strong, and she said, "Ken, it's hard to let someone go that you love with your whole heart, but he is in a better place." Right there I knew she knew, but how? Who told her? She said she knew years ago, the first time he stepped into the milk barn. "I knew you were going to fall in love with him, head over heels, and there was nothing I could have done to stop it. So I just stepped back and watched it happen." She told me to take my time, and to open my heart when it was healed, but not any sooner.

I still live by this advice. Eight years later, I have been on a few dates, but not many. I've found that I am just not ready. I still love Kevin. I don't know if I will ever love someone again the way I love him. Here I am, thirty-two years old, with just one boyfriend and a couple of dates under my belt, and I don't think I am missing a single thing in life. I have friends who are the best in the world, whom I would do anything for and they would do the same for me. I have an amazing family who may be strange at times, but would hold out their hands to support me any time I needed them.

My family taught me that the real meaning of life is not what you make of your life, but what you make others' lives like. That is all the human race is, just one big family. Perfect strangers, holding you in the hospital till you are well, making you feel cared for. Perfect strangers who remind you that you are valuable, just as you are.

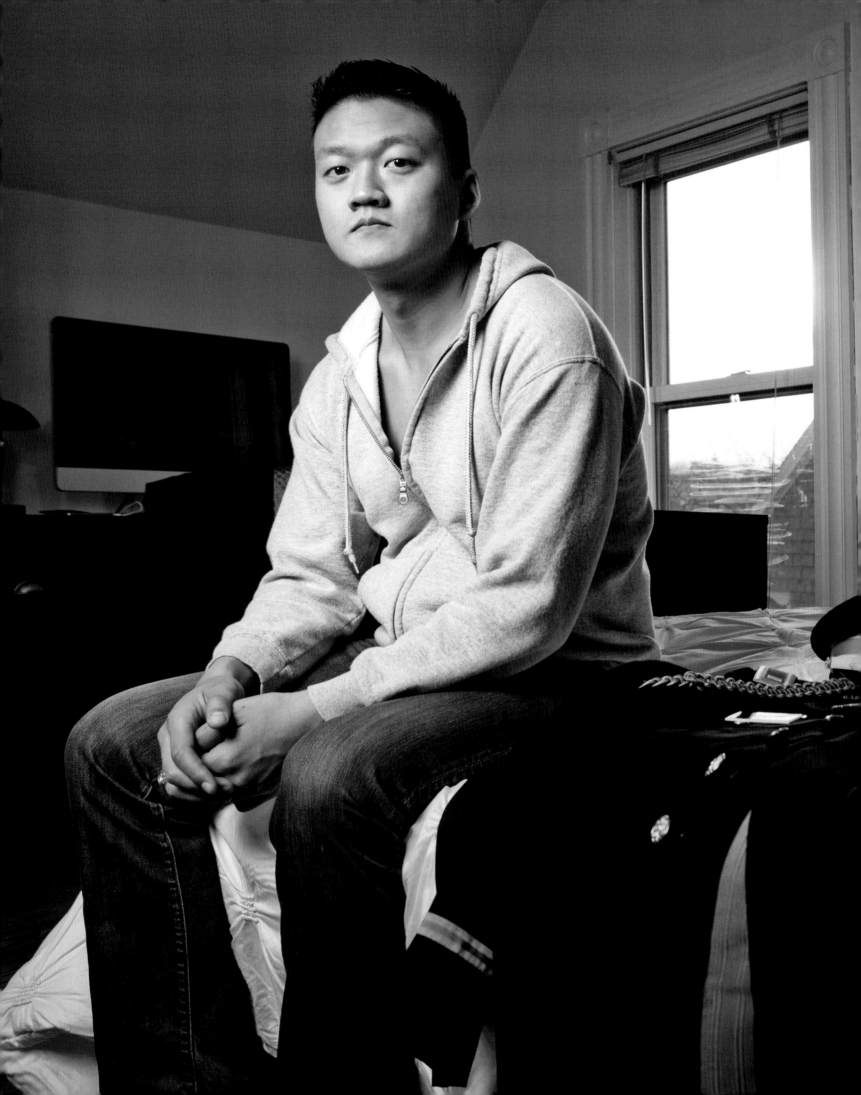

DAN Cambridge Massachusetts

I decided to serve my country by going to college as far away from my Southern Baptist Korean American parents as possible. My mom refused to pay application costs for any college outside of California, so I applied to all the military academies. Knowing I was gay but vowing to keep it a secret when I entered West Point about 3,000 miles away, I suppose you could say I was a bit nervous. But after watching the Steven Spielberg film *Saving Private Ryan*, I was encouraged by the military ethos of teamwork, sacrifice, and selfless service. From our first moments at the military academy we took the Cadet Honor Code to heart: "You will not lie or tolerate lying." At chapel, reciting the Cadet Prayer was just as powerful and uncompromising: "Never be content with the half truth when the whole can be won."

Perhaps because I never understood romance or intimate love while growing up, I felt that lying and hiding the whole truth of my identity was no problem. Perhaps because I was running from the effeminate stereotypes of both gay and Asian men, I decided to play rugby, train as an infantry officer, give commands with as loud a voice I could muster. Perhaps. The truth is, I loved serving in the military because it was a place to hide from my truth. I even thought at times: "Don't Ask, Don't Tell is great! I'll never have to tell my Southern Baptist minister father I'm gay!" Better yet, I thought, "I'll never have to explain to my mom that I won't be marrying that Korean girl after all." Everything seemed like it had neatly worked itself out.

After coming back home from Iraq and finally falling in love, the equation was severely unbalanced. How could I lie about my boyfriend and deny the love that completed my existence and dignity? The scale tipped toward the foundations of my training. In Iraq, we knew that complete honesty and integrity were not just codes we memorized in books; lives depended on it. If I translated Arabic incorrectly, it would erode trust in any negotiation. If I reported inaccurately, it could cause mission failure. But if I lied about my love life, what heartache would I cause my boyfriend, who would never be notified of my injury or death, never be honored at my funeral?

I finally realized the full power of love. When you fall in love, you realize the fullest meaning of service. All other values are increased in meaning. Life is worth living, and you realize why we join the fight to begin with. Because among all the rewards or values worth fighting for, despite all of its consequences, like termination from your job or punishment by your country, despite the hatred from former friends, despite the awkward moments at home and church, despite the difficulty of the journey— love is worth it.

Love. That's what it means to be gay in America.

KRIS Quincy Massachusetts

with nephews Daniel & Jonathan

I am a thirty-eight-year-old gay man living my life out in Quincy, Massachusetts. I came out at twenty-one, and a few months later I entered a relationship that lasted fourteen years. Not long after we broke up, my sister moved to Mississippi to take care of some personal issues, and her two teenage sons, with issues of their own, were left in my care.

Most gay men might view the raising of two teenage boys as "baggage," but I am so proud of them and what they have become. The boys were very supportive of me and helped me through a very tough time in my own life. Being a single, gay "soccer dad" gave me the opportunity to change two young lives and at the same time regain my own. I am also proud to provide an example and environment for my nephews that allow them to develop into who they are and will become.

I am blessed to live in Massachusetts, where being out is not a problem, even living in a small neighborhood filled with retired people in their seventies. They have all embraced me.

In addition to a diverse and accepting community, the Boston area has a definite advantage when it comes to medical resources.

In 2009 I went to the doctor thinking I had some some sort of stomach virus or kidney stones, and left seven days later with fourteen inches of my intestines removed, and my life completely changed by a colon cancer diagnosis. I had recently reunited with my ex-partner, and would not have made it through that time without him. I have tremendous support from so many people that it is overwhelming at times; I don't have a religious bone in my body, but it has redeemed a belief in karma.

I know that I will overcome this new obstacle, as I have so many others. The last few years have taught me so much, but nothing alters your perspective on life like the threat of losing it.

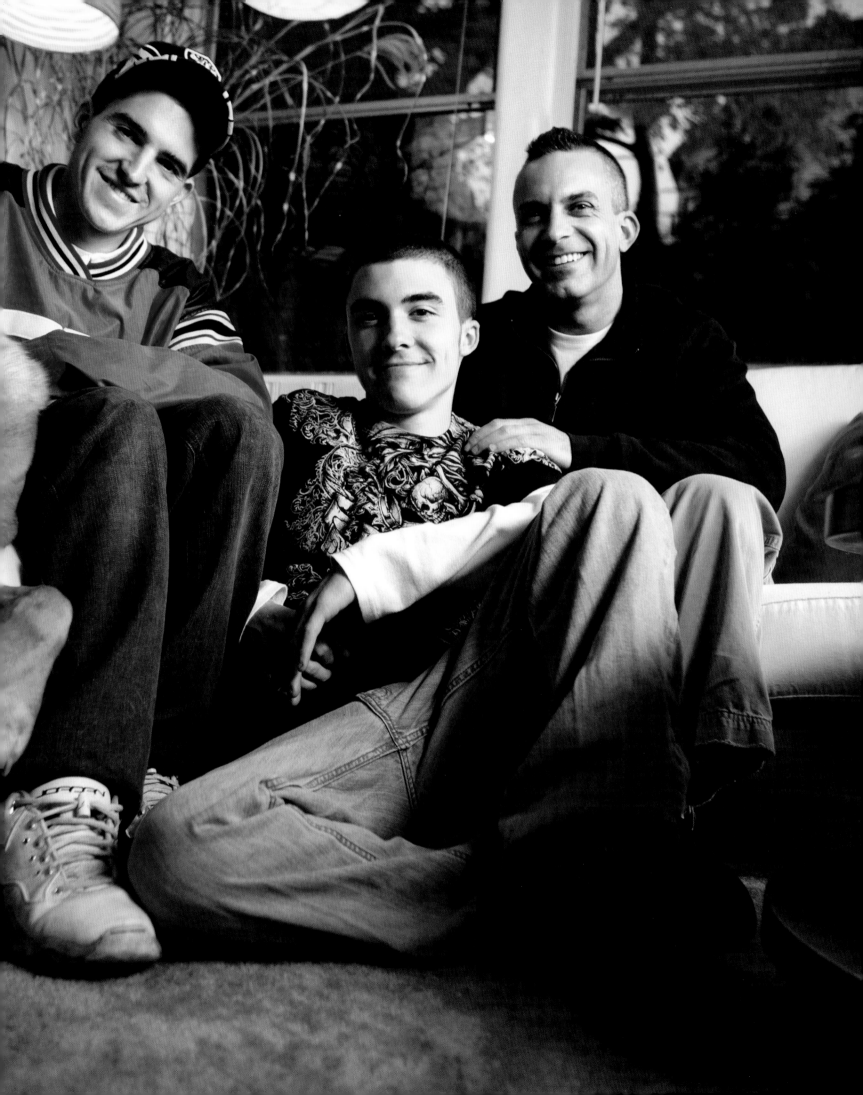

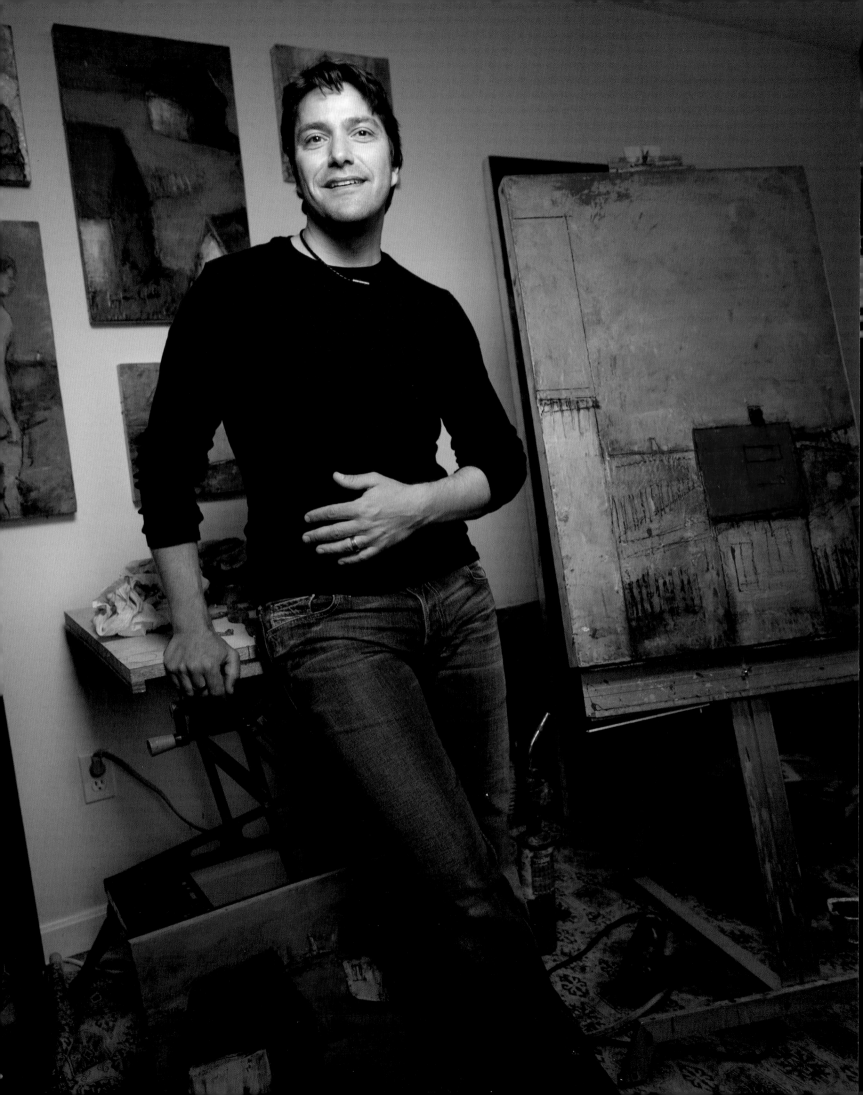

MARC Truro Massachusetts

I was in the closet until I was thirty. I lived in San Francisco as a "straight" man in the mid-eighties, at the height of the AIDS epidemic—at least in terms of fear. I met my partner in the process of coming out in Minneapolis. After three years together, and shortly after his mother's death from cancer, we decided to follow our bliss and move to Cape Cod. We abandoned our professional lives to just be where we wanted to be and pursue our dreams.

The Provincetown area is historically open to and accepting of others. There's a freedom to be yourself out here that I haven't experienced anywhere else. It's why artists and writers, both gay and straight, have found it such an inspiring place to work. As a gay man in a long-term relationship, I've found that being here has relaxed the way I interact with my partner in public. There's a casualness that straight people take for granted in the way they physically interact—walking down the street together closely, hands occasionally touching, sitting on the same side of a table in a restaurant—the body language that says "we're together." And that's what I get to experience here with my partner. You lose the self-consciousness of being gay. It spoils you for the rest of the world. We're not aware of it anymore until we leave and find ourselves in an airport or city, and that sense of cautiousness creeps back in.

My partner and I built a life together for ten years before the Massachusetts Supreme Court decision opened the door to same-sex marriage. We had talked about the possibility of getting married over the years and felt it was something that even if we could do, we wouldn't bother—we'd done all the legal work, had our medical powers of attorney, owned our home together, and so on. But when my partner asked me to marry him in the middle of a crowd of our friends celebrating my birthday at a Provincetown restaurant, it felt absolutely right, and of course the answer was "Yes!" Because that's exactly the point and beauty of getting married—the full public acknowledgment, embrace, and support of you as a couple by your friends and family.

After you go through the experience of a wedding and see that room of friends and family who have traveled miles to be there with you to celebrate your relationship, you see it differently. I think it adds an extra strength. It's no longer a kept secret—which same-sex relationships can feel like—but something that is part of a bigger community.

However, legally it doesn't mean much outside of Massachusetts. And in fact it can be a bit confusing. An example that I find really troubling is that in Massachusetts we file our taxes as a married couple and get to acknowledge our marital status. On federal tax forms, we're basically told we have to lie—we're supposed to say we are single. I find that pretty insulting.

LIAM Canton Massachusetts

I am a spirit medium living south of Boston in the suburb of Canton. I provide private readings and public demonstrations to anyone who wishes to reconnect with loved ones who passed to Spirit. My clients are gay, straight, bisexual—anyone in search of healing. I try to show them that life and love are continuous, that after we pass from this life, life and love do continue on, and the soul constantly evolves.

Gay men are so often labeled as being sensitive, and as a medium, that definitely rings true for me. The only time being gay truly impacts my work is if a communicator in Spirit has issues with my sexuality, because if they did in life and still haven't moved past it, they won't talk to me at all. I have experienced that in readings before; it can be an obstacle, but thankfully it's rare.

I'm truly blessed with an unbelievable family. I'm the youngest of seven kids. I come from an Irish Catholic family. My father, brothers, sisters, and my mother in Spirit have been extremely supportive of my pathway. It is a great gift to me that I can still maintain a loving, ongoing relationship with my mother since she passed. I communicate with her on a regular basis; she's always around me.

I am simply a conduit, a vehicle for Spirit. I love my work. I love opening people's minds to greater possibilities. If I can alleviate some of their fear, pain, or worry, I've succeeded. It's a service I feel truly blessed to provide.

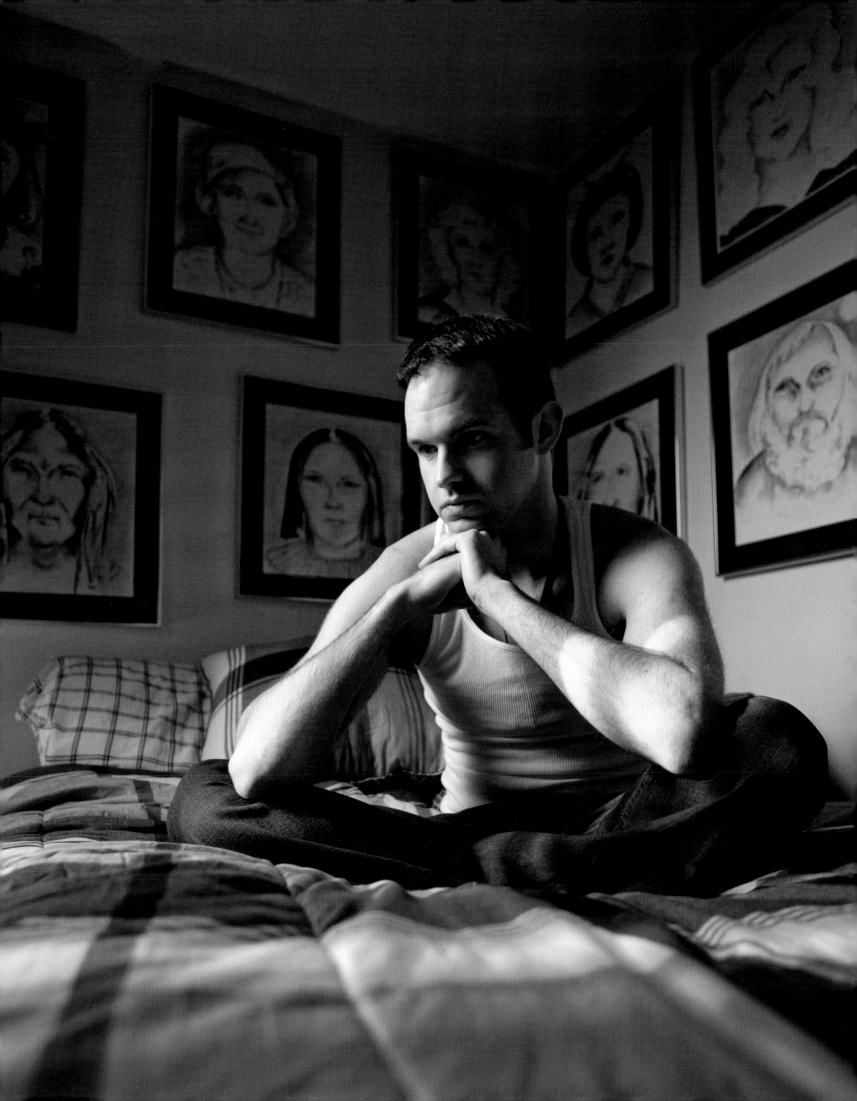

MARK Ferndale Michigan

During my ordination in 1997, my sister Lynne proudly told a story about when I was five years old and was asked, "What do you want to be when you grow up?" I replied without hesitation, "A preacher!" But reconciling my emotional and physical feelings toward men with my calling to be a minister was not always possible.

When I came out in 1988 as a gay man, then married with two children, I was emphatically told not to return to my Southern Baptist church; there was no place for my kind of Christian there. So I found a church where they would allow gays to be members, but we could only participate in pastoral worship. Gay congregants weren't allowed to teach, pray, or preach; they could only attend, listen, sing, and of course contribute to the offering each Sunday. For a while that token involvement seemed enough, but I sensed inwardly that my calling to preach was still there—alive, vital, and insistent.

I eventually discovered the Metropolitan Community Church of Detroit (MCCD), part of a worldwide denomination for LGBTQ people. I remember driving around the building several times before getting up the courage to go in. As I entered the church that memorable Sunday I heard the choir sing, "Blessed Assurance, Jesus Is Mine!" I sat there deeply moved, singing along to the words I knew so well by heart. I cried long pent-up tears of joy. I was home.

In 1993 I became the church's interim pastoral leader, and, following my ordination, its pastor. I have finally reconciled being gay with being a minister. God loves us just as we are, gay or straight. At long last the five-year-old boy was made whole. Today, as Senior Pastor of MCCD, I feel I'm one of the luckiest people in the world. I have two beautiful grown children, Brian and Amy, who accept me as I am. In fact, on a Sunday not long ago, with my son back from four years serving his country in Iraq, both my children attended the service. I am out and proud, and I know my calling is a blessing to me, my family, and my congregants.

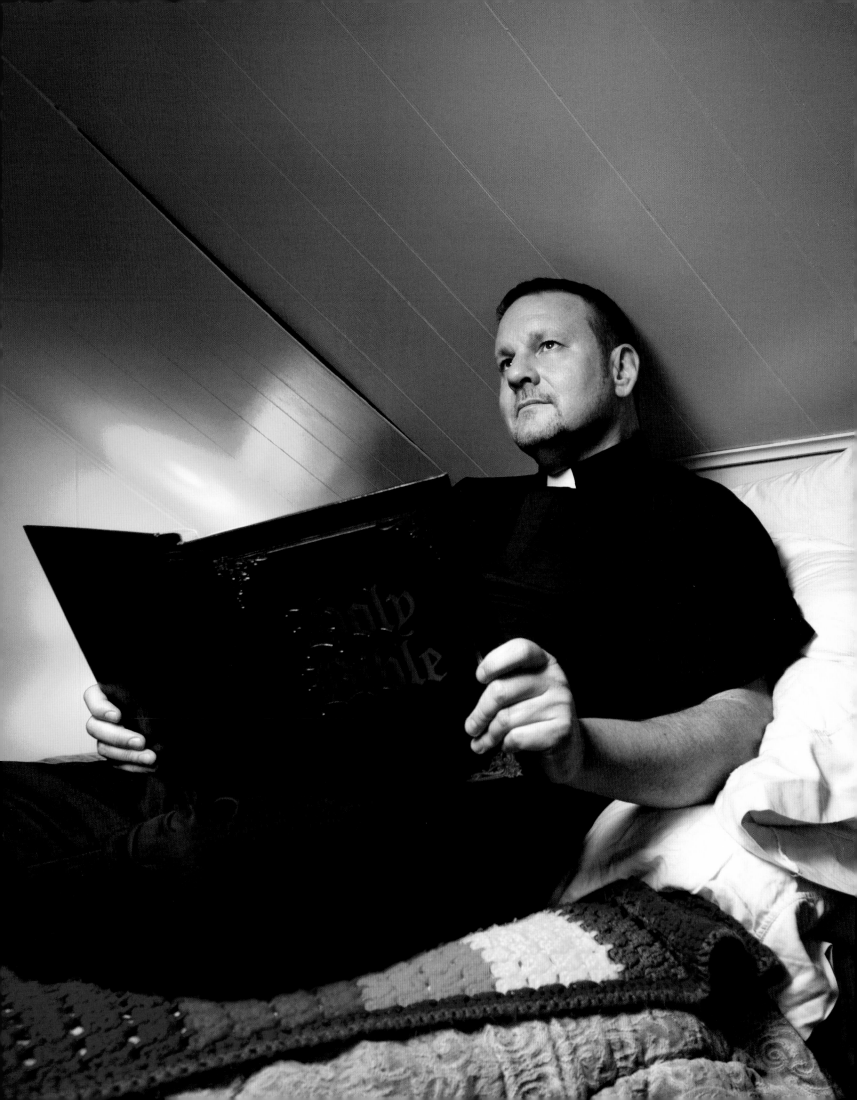

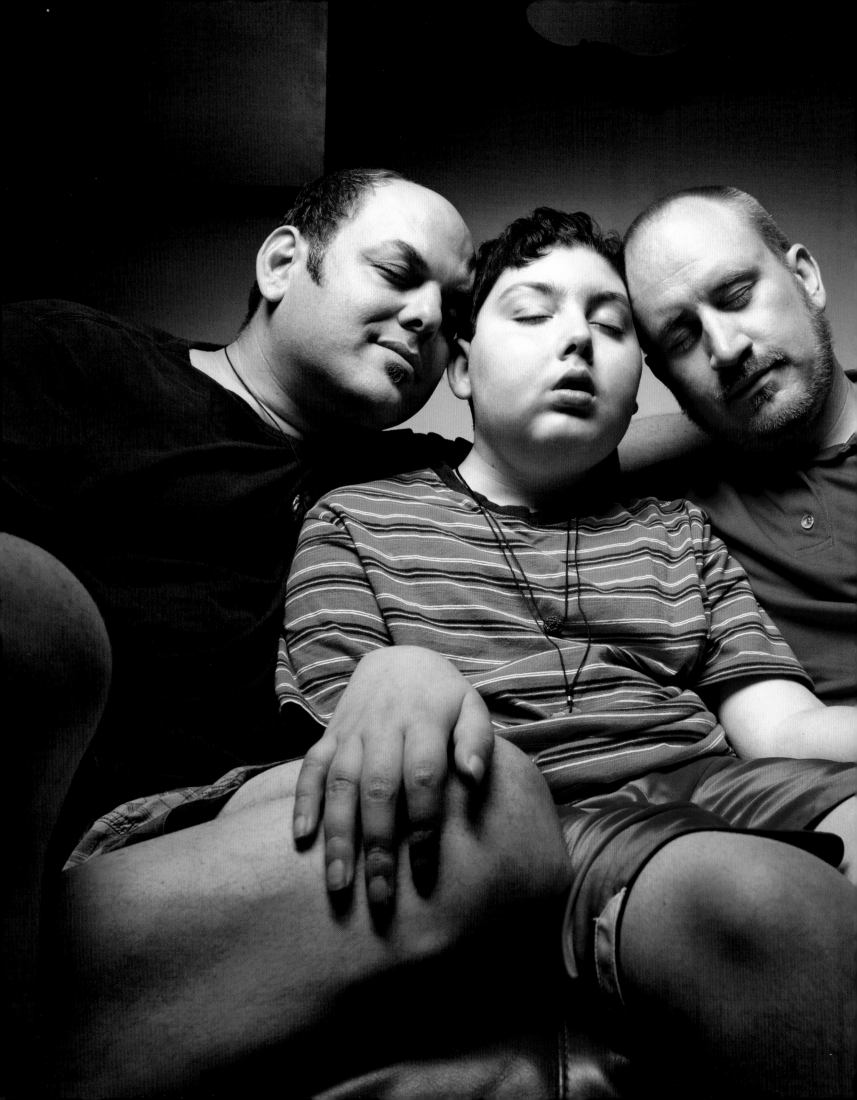

HENRY & SCOTT
Minneapolis Minnesota
with Henry's son Cameron

I am forty-two, a father, and a cancer survivor. I have lived in Minneapolis for fifteen years. My father was a United States diplomat. I grew up all over the world, exposed to the full spectrum of humanity from an early age—I learned what a drag queen was at my first Carnival while living in Brazil. Though I came out in 1984 at age eighteen, I married a woman in my mid-twenties. We had a son, Cameron, and divorced when he was three. I started dating men again soon after we separated, and had a few meaningful relationships over the years before meeting and marrying my ex-husband Scott. We were legally married in St. John, New Brunswick, Canada, where we sailed on Rosie O'Donnell's R Family Cruise in 2008, with my son present. We had his full blessing; he even signed the marriage certificate with us, making it extra special.

Cameron and I were always very close; he never had any hang-ups about my sexuality. When he was diagnosed with brain cancer, it was devastating for me. He fought it for over two years. After exhausting all conventional means of treatment, we tried Eastern medicine, traditional Chinese and Ayurveda, to help his body cure itself, but ultimately nothing could save him.

A few months after Cameron's passing, Scott left our marriage unexpectedly. I still don't know exactly what his reasons were, but I am grateful for the time he was present, and his leaving doesn't invalidate that. He was kind to Cameron, and I think our marriage may have helped make Cameron's transition a bit easier, knowing that I would be cared for and loved after he was gone. It took some time, but I am okay now, and have been able to put the pain of being left behind me.

The final two years of Cameron's life were so surreal, but I am thankful that he is now cancer-free, rid of his broken body, and still inspiring so many people with his message and vision.

J.E. Moorhead Minnesota

Gay life here in northern Minnesota was not good **when I first came out.** Due to that and my family, I didn't come out until I was in my forties. I had married and fathered a son by that time, and it was hard living two lives. When my wife figured it out, I thought she might throw me out. I went to Minneapolis, but after a few weeks she asked me to come back. We talked it out and decided to stay married.

My wife had two children when we married, and we sat all three kids down and told them that I was gay. At first my son had a hard time with it, but as he got older he came around. He and his girlfriend have been to gay bars with me, and he's met all my lovers. He's a people person like his father.

I have always had long-term relationships—one-night stands are not my thing. A few of the men I've been with have spent time at my home, and we all get along well. My wife sleeps on the second floor and I stay on the first. We all eat together, go to shows, shop and all of that; my family stands behind me.

Life is funny at times. I never thought things would work out this way, but all it takes is the truth and long talks. It was damn hard telling friends I was gay, and I did lose a few when I came out, but I guess they weren't really friends to start with. I would not undo one thing about my life.

126

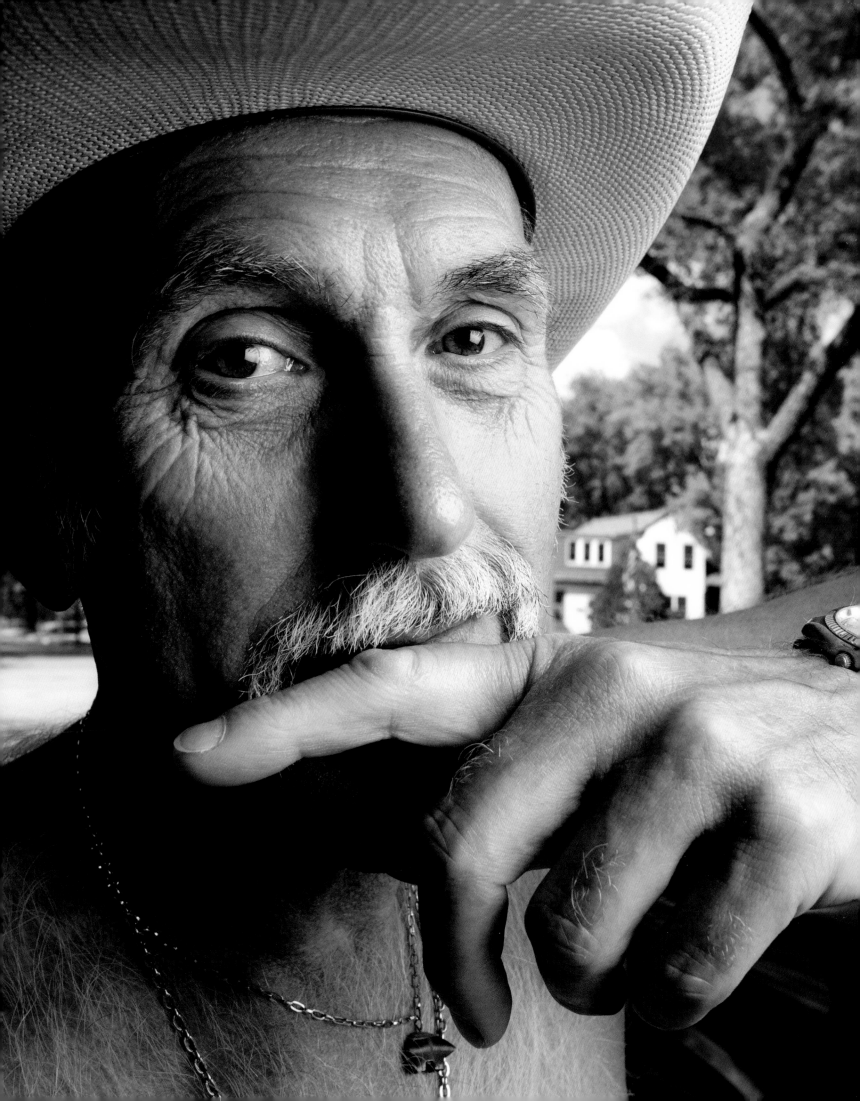

JOHN Tupelo Mississippi

I **live in a rural area between Verona and Shannon, Mississippi, both south of Tupelo, home of Elvis Presley.** I've always tried to keep low-key and hidden about my sexuality, as I work in a warehouse and am quite possibly the only gay male in the building. However, I had to come out when I appeared in a documentary that highlighted Shannon as being the smallest town in America with a gay bar, Rumors. I was interviewed and my comments and image were aired on the big screen and television. Talk about coming out big. It was only a day later when someone told me they had a friend who thought they saw me in the documentary, my partner draped over my shoulder, giving an interview about being a closeted gay male in the Deep South. With hesitation and fear I said it was me and that I was gay. Instantly, a great burden seemed to lift off my shoulders.

Being gay is not all that I am, it is only part of me. I am also a comic book collector, an avid sci-fi-movie watcher, a computer geek, a photographer, a graphic designer. I am a son, a provider, a caregiver, a supporter, an actor, a singer, an Episcopal, a comedian. But to those who barely know me, I am just "the gay." To those who hate me, I am a "faggot." I am used to the whispers, the stares, the jokes I never hear but can feel behind my back. I tell myself that I am a better person than they are. I constantly remind myself now that only I determine how I feel; nobody else has the power to make me think less about myself.

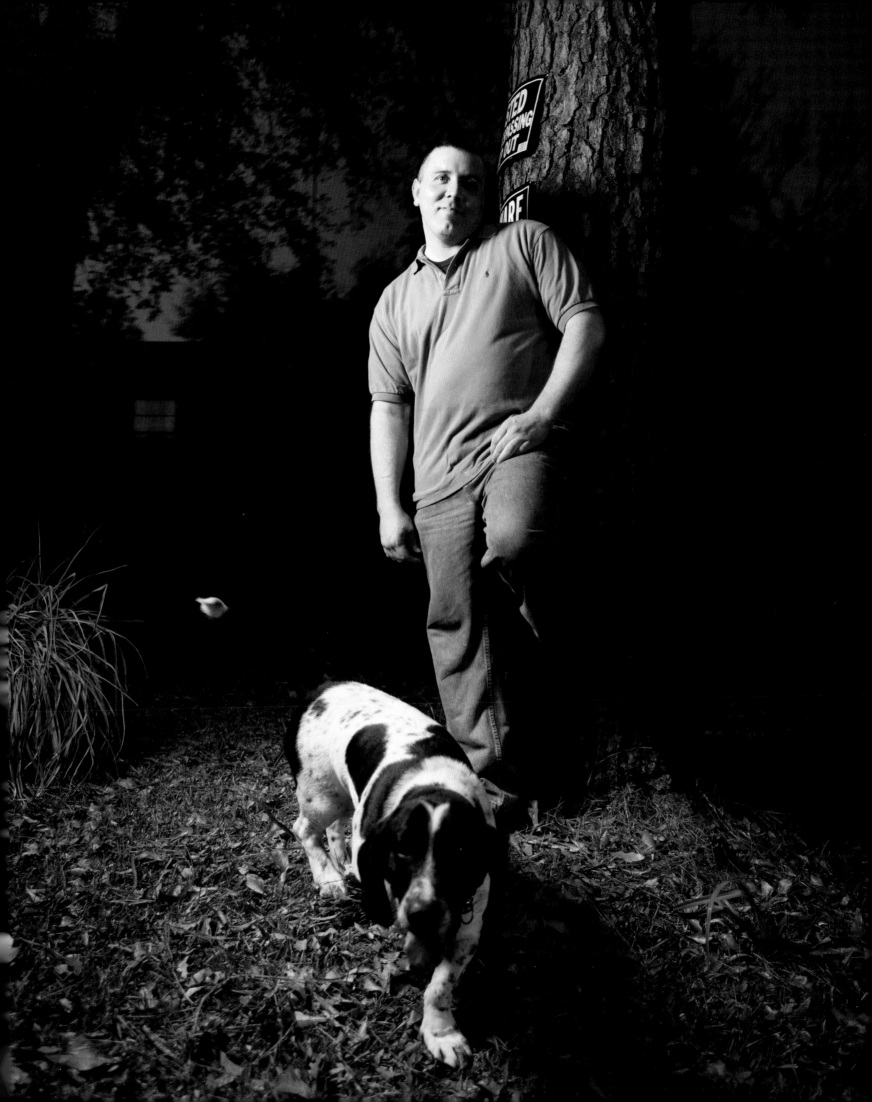

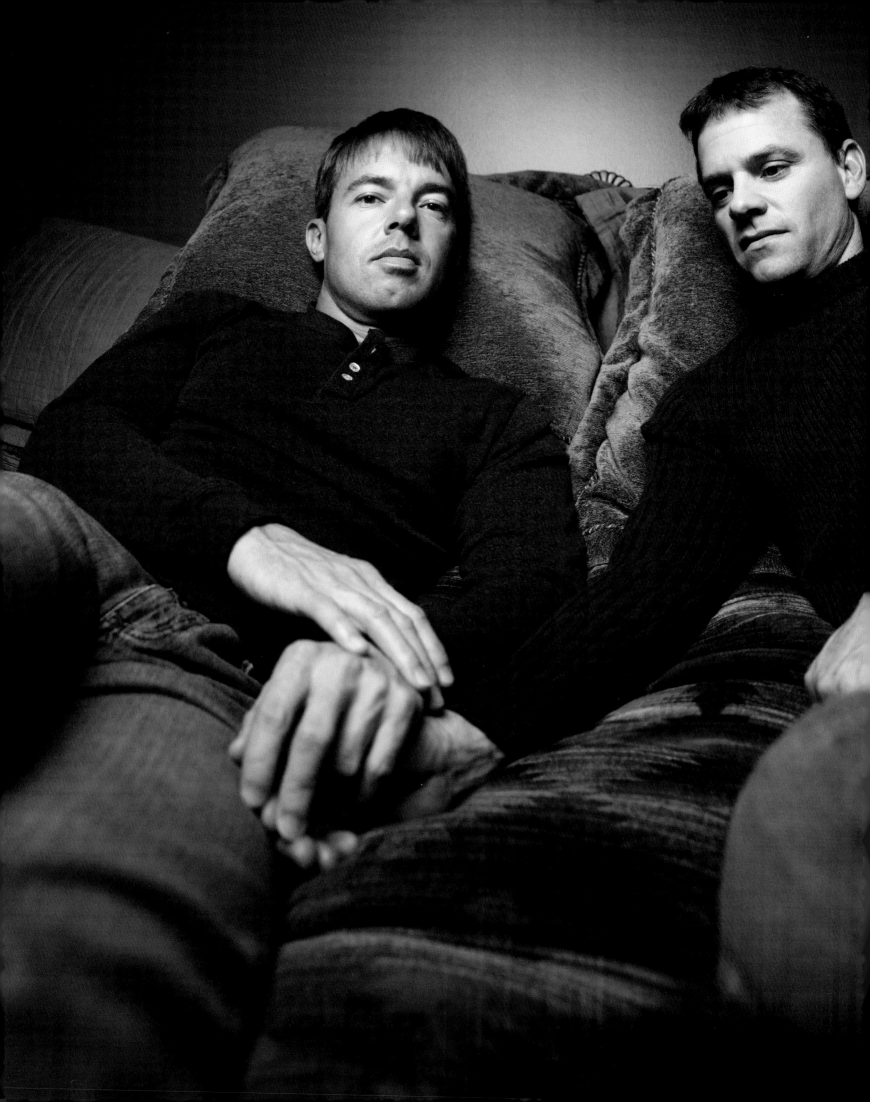

KEVIN & MARK
Kearney Missouri

Our story, my boyfriend Mark's and mine, began with death and love. It was the passing of someone we both cared for deeply that brought us together.

In 2008, I was forty-one years old, recently divorced, and just beginning to admit to myself that I was gay. I was a late bloomer. In fact, I had been married for fourteen years and have three children. I met a man online named Chris, and we started seeing each other fairly regularly. As we spent more and more time together, we shared our histories and stories with one another. Chris was not a very talkative person, but I learned that he had been tormented in high school and again when he was in the military; then the worst thing possible—his parents and brother were not accepting of his lifestyle, though fortunately his sister was. Chris had what I called an "old soul." He was aged far beyond his twenty-six years by the hardships he'd experienced. I believe this is why he was attracted to older men. I was almost fifteen years his senior, and he told me his other boyfriend, Mark, was thirty-eight.

I began to fall in love with Chris. He wanted a long-term relationship more than anything, but he was torn between me and Mark. I forced the issue and told Chris he had to choose, thinking he would pick Mark because they had been together longer. He chose me! I told him that I felt I had found the right man and that I was ready to come out. Soon after that he started meeting my friends, and then I introduced him to my kids.

A few weeks later, Chris was spending the weekend at my house with me and the kids. He slept in the basement to try to get the kids used to the idea of him staying at the house without the additional stress of him sharing Daddy's bedroom. While I was mowing the yard one afternoon, he went out for a motorcycle ride. Two minutes later he was dead from a crash.

The week following Chris' death was filled with deep sadness. I met Chris' sister for the first time and we bonded instantly. She shared with me that Chris had told her he was finally happy now that he was with me. Hearing that warmed my heart. After the funeral I spent the weekend alone at home, just trying to stay busy. In the back of my mind I kept expecting a friend to call and see if I needed some distraction, but I guess they felt I wanted time alone. They were right, but eventually I decided I needed to get out of the house or I would go crazy.

I went out for a few drinks. I was standing by the dance floor of this club, fairly close to a very handsome guy. We started talking and it turned into a wonderful conversation. After a while, he asked me for my name. When I replied, he asked if I knew Chris Fry. It finally dawned on me who this man was. Mark and I had never met before. We both started crying right there in the club. The odds were astronomical against us bumping into one another at random; yet we did. We decided then and there that Chris must have meant for us to meet.

We took things very slowly. As we got to know each other, we spent hours talking about Chris, sharing stories, and remembering him; we still do sometimes. There may be those who think that what we are doing is wrong, or that we are on the rebound from Chris' death or blinded by grief. I've thought about all of that and more. But I kept coming to the same conclusion: that I am a reasonably intelligent, emotionally stable, mature man who sees the potential for something beautiful to come out of something so tragic. I could not let it pass unexplored. Mark's and my relationship, although young, has far exceeded any expectations I've ever had. And for the first time since I fell in love with Chris, I can once again see great happiness in my future.

Chris had already been photographed for this project before he died. It meant so much to him; he was so proud. We just had to be part of it, too, to honor his memory and the gift that he was to both of us.

CHRIS Mission Kansas

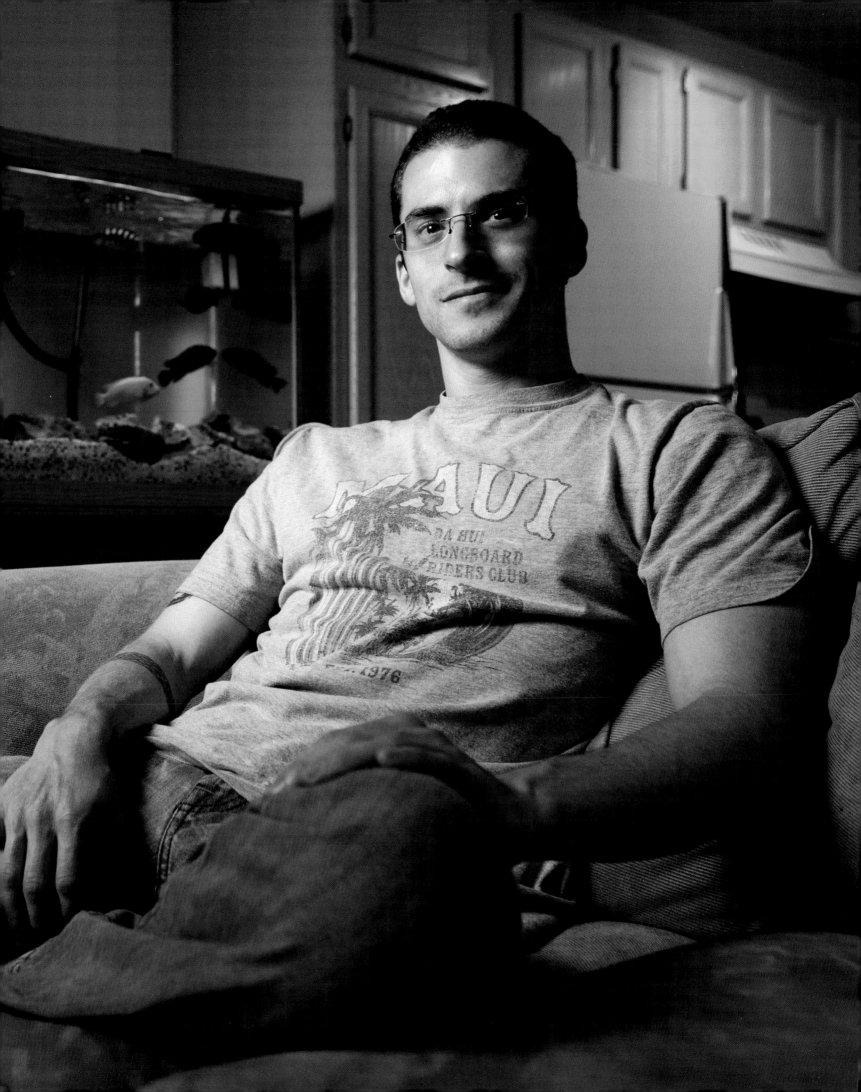

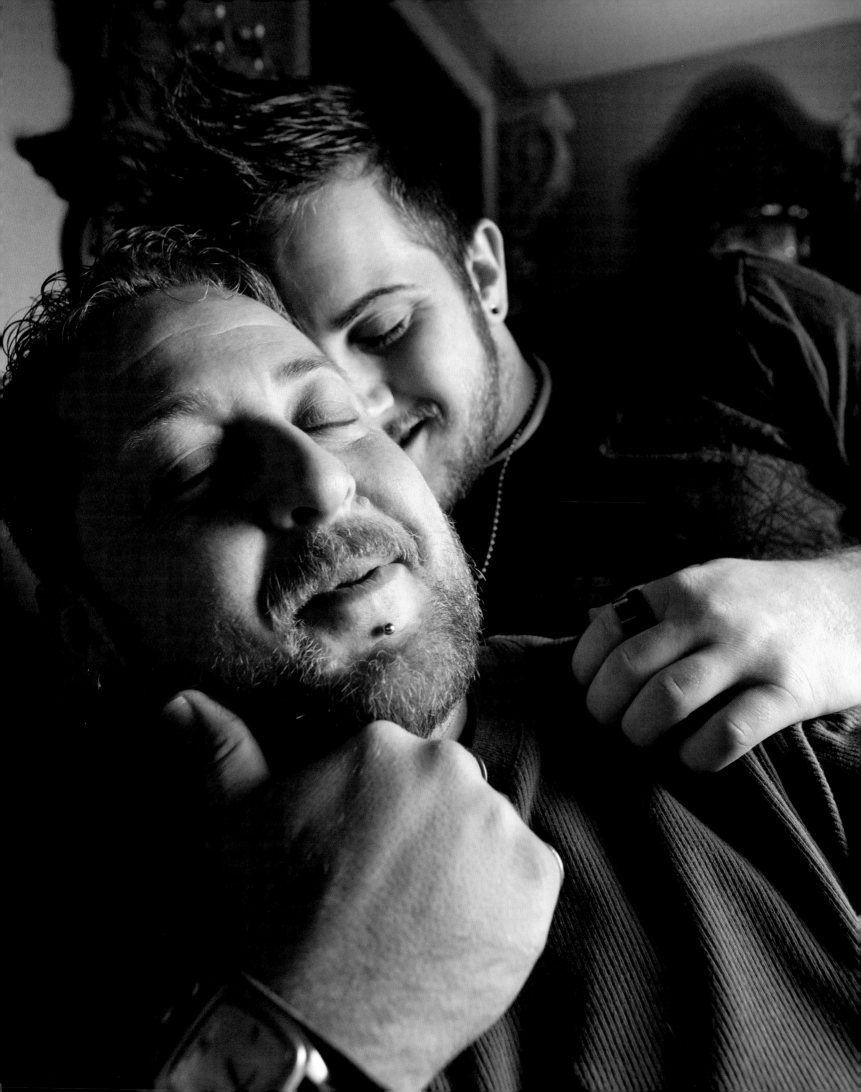

ROBERT & RYAN Kansas City Missouri

I grew up in Kansas City, but left to see the world for many years before returning to finally go to college and settle down in my mid-thirties. Ryan is your typical small-town boy from Osage City, Kansas, who went off to a state college (where we met) and came out of the closet. He's nineteen and I'm thirty-seven, but we are really two old souls, wise beyond our ages. It's funny to think that it has only been a year since we first met—it seems like a lifetime.

Ryan and I run an independent film company that we are starting from the ground up, while finishing our degrees in film and photography. I'm also working on a book about my life called *In & Out of the Closet*—I was married twice before I came out for good. We have both modeled (though we are far from professional model types) and acted in film and theater—Ryan is presently in an independent film called *Crush*. He even got our Jack Russell, Luna, her first walk-on part in the movie.

Kansas City is an amazing place, full of life and history. This time of the year the fountains are roaring, the theaters are buzzing, the jazz music is playing, and the BBQ is cooking. I think like most cities, gay life here is full of ups and downs. It's certainly not like New York or San Fran where being gay is not considered unusual. Walking down on the Plaza here, or even in Westport, it's hard to find to men or women hand in hand. Don't get me wrong, it's a great place to live, but it's still the Bible Belt, and we have a long way left to go.

Ryan and I met through mutual friends the first week of college. A group of us were hanging out at my place and everyone was winding down. Ryan claimed to be straight, and I remember thinking, "your eyes tell a different story." Ryan and I sat next to each other on the sofa and talked for hours. I finally decided to make a move. I knew either I was going to be right or freak out a freshman, but I took a chance. I put my arm behind him and took my index figure and slid it down his and relaxed my arm back. Within seconds his index finger slid down mine. We looked into each other's eyes and that was it. From that point on we have been together. We live every day as a couple and are building something bigger than either of us ever imagined.

It's wild—two people who didn't believe in love, who thought it was nothing more than a four-letter word. We fell for each other from the very first touch.

JON & GREG Whitefish Montana

I am actually a native New Yorker living in Montana with Jon, my partner of ten years. It has been an incredibly empowering experience to move to and come out in Montana—and quite an adventure. I feel more at home here than anywhere else I've ever lived.

Jon and I spend lots of time catching Phish shows across the country, skiing powder, and hiking the backcountry. Jon is an avid collector of antiques, music, and art. I teach Reiki and Yoga and am a certified BodyTalk practitioner. My private practice keeps me busy here locally, and I travel internationally to teach. I see clients with just about every health issue you could imagine. Basically my job is to create the climate for spontaneous healing to arise, and watch miracles happen.

We are about to begin construction on a new home that will sit on ten pristine acres here in Whitefish. The land will serve as our sanctuary, but also a place where our community can visit to relax in nature surrounded by art and the healing arts. As we become stewards to this land, we recognize the awesome responsibility it holds and are excited by the opportunity to create a place for gathering.

It is a blessing to call Montana home and to pursue our dreams in such a special place on this Earth.

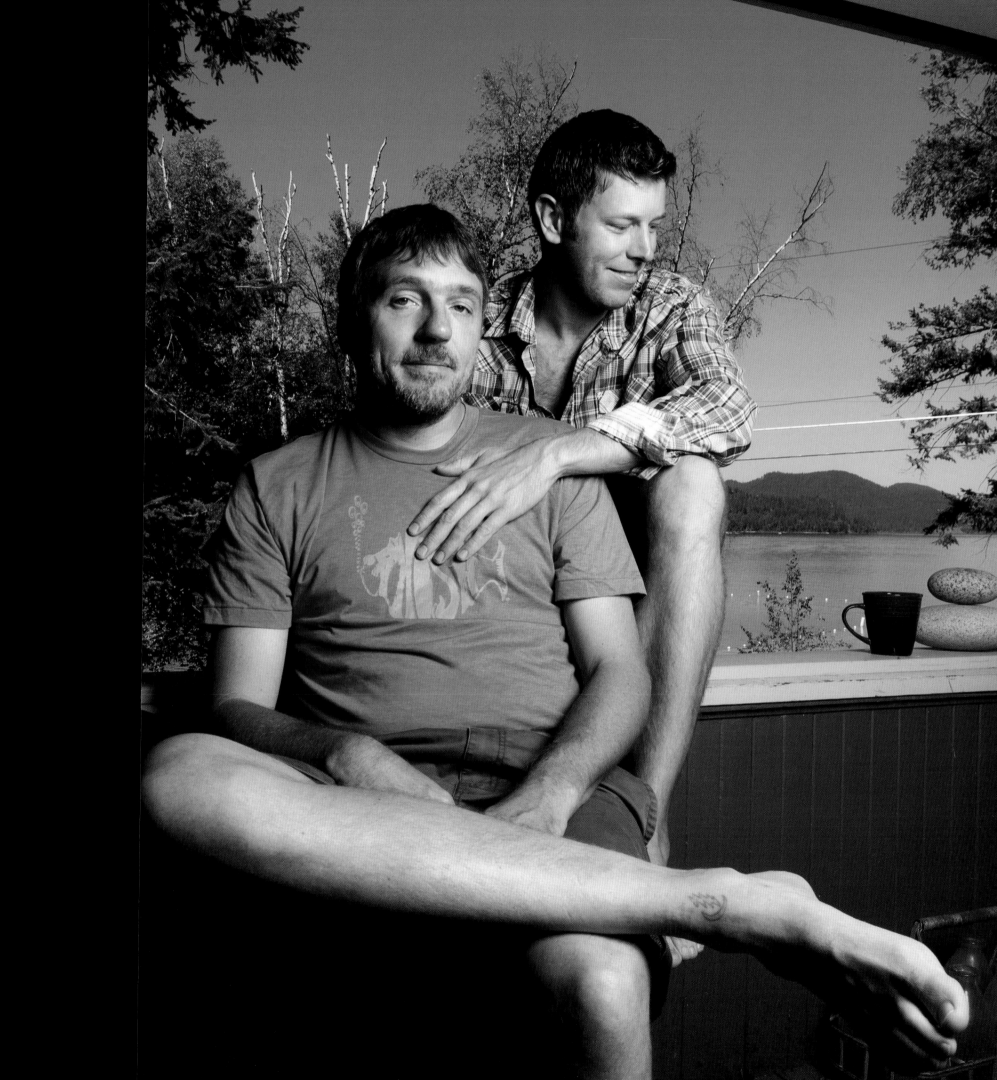

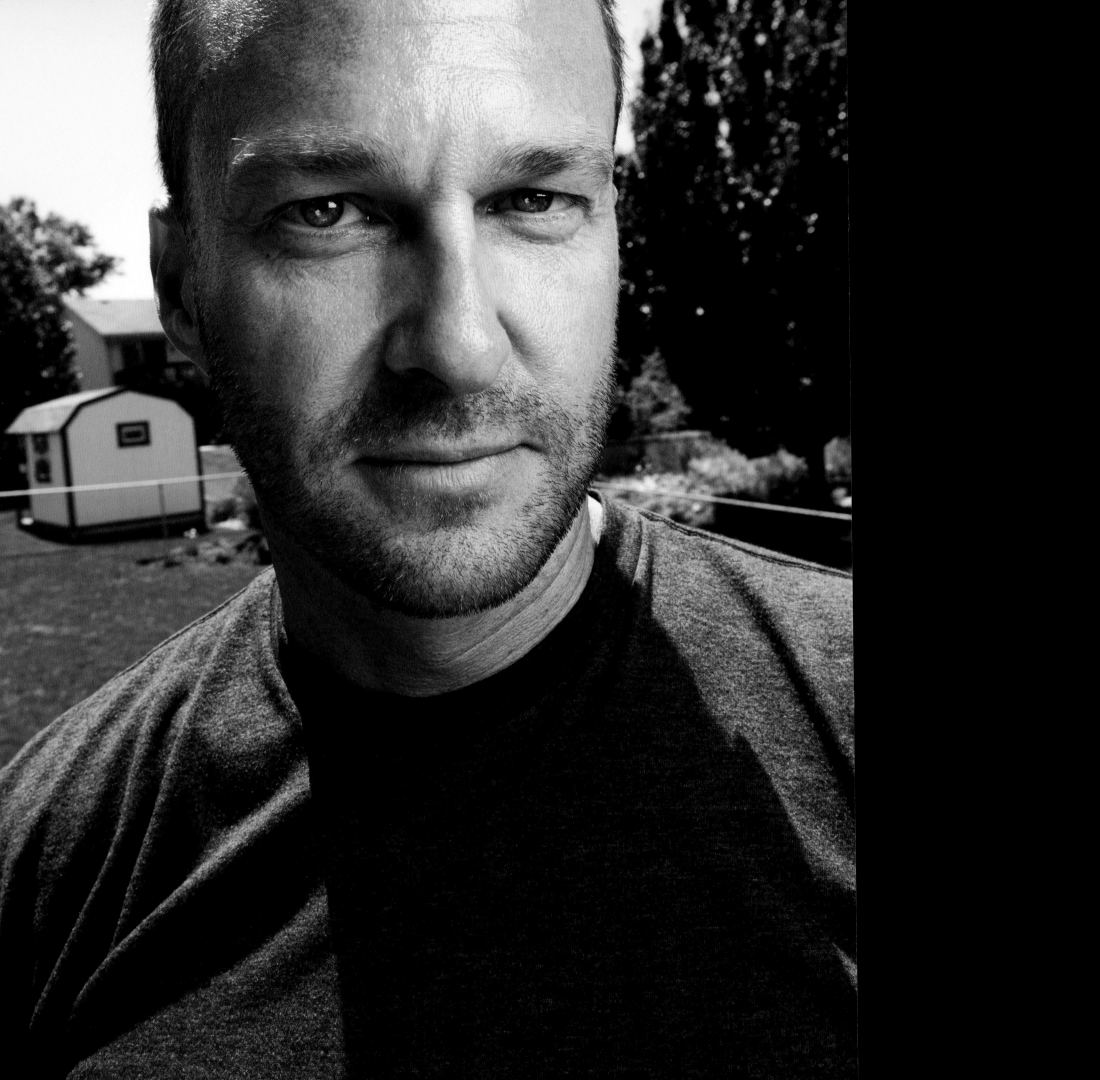

JOHN Omaha Nebraska

'm divorced and have been out for four years. I was married for eleven years, and I have two amazing kids who are the center of my world. I was raised in rural Nebraska and have nine brothers and sisters, including one brother who is also gay.

It has taken me a long time to get to where I am now, but it was so worth the journey. I grew up feeling I was different from the other boys but didn't understand why. I was the kid who was always made fun of on the playground, chosen last for any game, called names, pushed around and beaten up by the tougher kids. I didn't know what gay meant. I just remember feeling an attraction to the men in the JC Penny underwear catalog, and I was sure if I told anyone they'd think I was a freak. I was right. About a year later my brother, who was ten years older than me, came out as a gay man. And to put it mildly, it didn't go over so well. Looking back, I'm sure this pushed me even further into the closet.

My one job on this Earth is to be the best dad I can be, and part of that comes from being true to myself. I remember telling my kids at a very early age that no matter what, they can come to me and tell me anything, that our love is unconditional and it will never change. Then I got to thinking I better practice what I preach. I did as much research as I could on the subject of coming out to your kids. I nervously sat down with them for a family meeting in the living room on a Friday night. About halfway through my coming out speech, my son, who was ten years old at the time, came over, squeezed my shoulder and said, "Just a second here, you are still my dad, right?" I said, " Yes, of course." He then said: "Well then, what's the big deal?" Wow! That was all I needed to hear. Love wins!

At first I found the gay world very strange. I didn't think I really fit in anywhere. I was just a suburban dad raising two kids with a mortgage. I'm happy to say that today I'm in a happy, loving, and caring relationship. I have found the one for me. He completely gets who I am, for better or for worse. We live a very average life. The kids are with us half the time. We sit down to dinner, do homework, talk, and laugh together. Both kids adore him. They each connect with him in different ways.

I have been able to "pay it forward" by helping several other dads go through the coming out process. It is rewarding to help them see that there is a light at the end of the tunnel. Things do get better, and in time things can get great. Looking back at this journey I remember one of the dumbest things I had ever said. While coming out to one of my brothers I said that no one would choose to be gay, and if I could take a pill and it would make me straight I would do it. Man, was I wrong. Today I couldn't imagine my life not being gay—it just wouldn't be the same. Being gay has been a blessing. It has made me who I was meant to be.

MIKEY Las Vegas Nevada

I **am native to Las Vegas—it's a pretty unusual and fun place to grow up.** I can remember when the mob ran the place; we always knew it was time for school to start again at the end of the summer, because a dead mobster would wash up on the shore of Lake Mead about a week before Labor Day like clockwork. Frank Sinatra, Sammy Davis Jr., and Tony Bennett all sang at my Boy Scouts events, and Siegfried and Roy always gave out the best candy at Halloween. We used to see Joan Rivers bargain shopping at Woolco, and Charo buying shoes at the mall. Tina Turner once sang here for less than ten bucks, and that included two drinks! Funny, only in Vegas could you ever become personally acquainted with the celebrities you admire.

I'm forty-four, and while I think I am quite normal, my life has been anything but ordinary. Living in Las Vegas, I've had every job from the ridiculous to the sublime. Singing telegrams, phone sex operator, instructional video actor—you name it. I even worked in the music industry in the eighties, as a reporter for Billboard. I can hardly believe that I survived it all. Many of my friends did not. They either succumbed to drugs, drinking, or AIDS. Those experiences introduced me to my altruistic side. I worked for a decade as a therapist at a post-acute neurological rehab program. The process of re-teaching people their names and how to tie their shoes helped form the cornerstone of my "grab life by the balls" philosophy.

I've recently started a new career as a "professional dick"—an insult-waiter/entertainer at a theme restaurant, where I routinely find new ways to be a jackass and make people laugh. I tell crude jokes, make stupid hats, and have given thousands of lap dances. It is the "yang" to ten years of "yin" as a rehabilitation therapist. For me, this is therapy in reverse.

I am out, gay, proud, and about a 6.8 on the Richter scale of fabulosity. My life is happy and fulfilled; I'm single at mid-life and content with where I am. I have a great circle of friends and family all around me. I love my life!

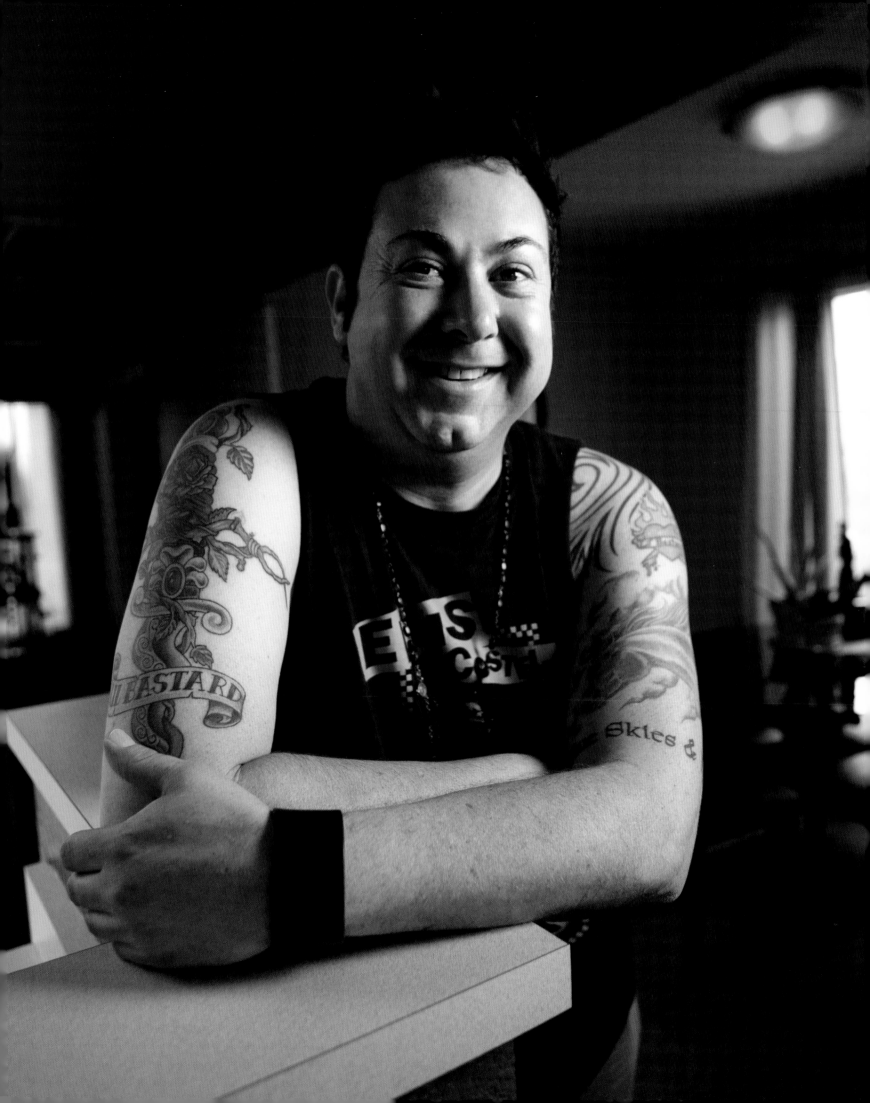

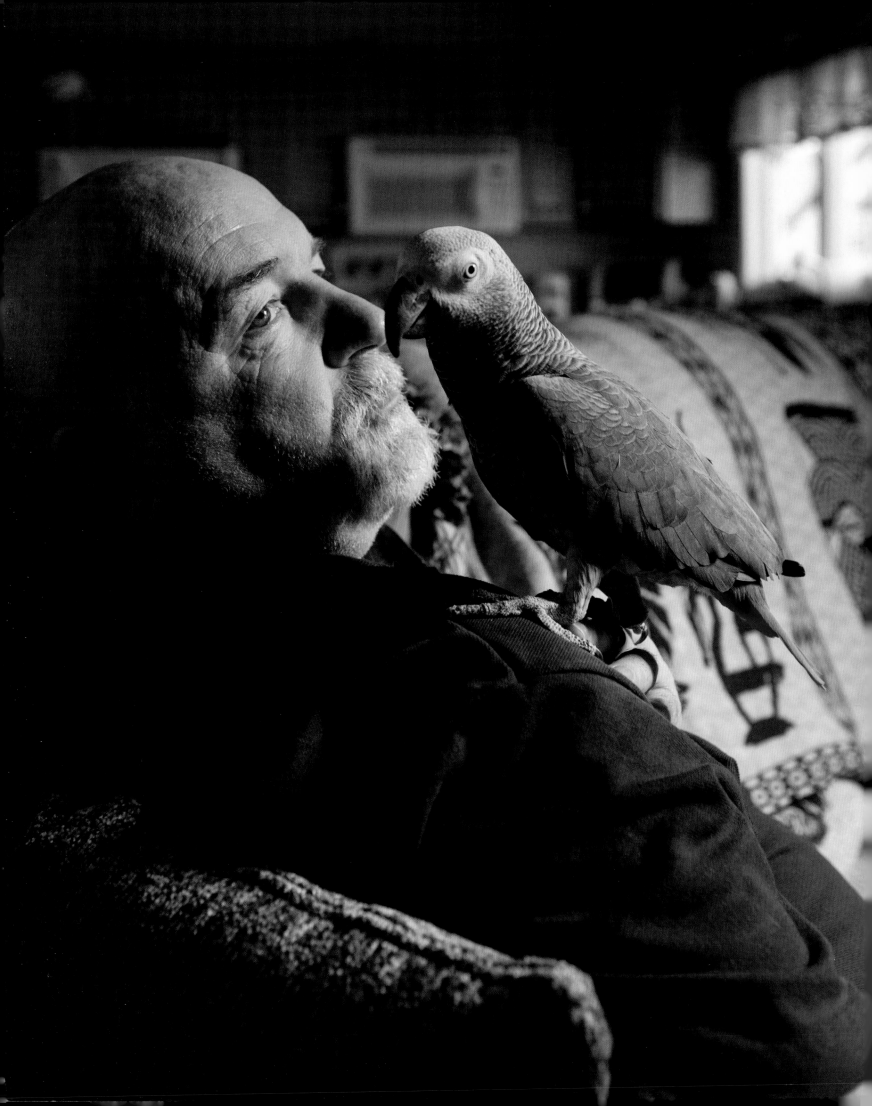

MIKE Colebrook New Hampshire

No model material here. I am just a fifty-two-year-old single gay man living on the New Hampshire/Vermont border in the town of Colebrook. My bird's name is Richardo and he is very spoiled. I was born and raised on a dairy farm—up early in the morning and to bed early at night. At an early age I knew who and what I was, but due to family values and my upbringing, I attempted to do what was expected of me.

I got married and I am the father of two great kids. My daughter is the result of my ex-wife's first marriage. When I first met my ex, her little girl was about three weeks old. She was thinking of giving her up for adoption but once I met the baby there was no way that was going to happen; I was hooked on her. As time went by we had a little boy who was born three months early. He never left the intensive care unit in the nine months of his life. That was the biggest loss in my life. I didn't plan to ever have another child, but then along came my son, who is now an adult and a dad himself. He was also born three months early, weighing in at two pounds, three ounces. Today he is a sergeant in the armed forces as well as the dad of a daughter and a pair of twins—a little boy and a girl. And we have found out there is one more coming!

When I finally decided to leave my wife, I told the kids my story. I didn't want them to find out that I was gay later in life and not want to live with me. They chose to be with me. I was very proud of that. So from that time forward, I worked hard and raised my kids the best I knew how. Today they are both very close to me and totally behind the choices I make in my life.

I'm still single, but that's okay. I was too busy raising the kids to worry about my personal life back then. It must have been tough for my kids, but they never complained or mentioned anything about being harassed in school. I do believe from rumors I heard that my son did get harassed, but he never once came home and told me a thing about it.

I work in the purchasing office at a furniture plant and I also bartend and wait tables. Yeah, I am lonely at times but I would not trade the kids for anything or go back and change a thing.

MANNY & BRIAN Paterson New Jersey

I am a Cuban American who got to New Jersey by way of New York City. My partner, Brian, is a former Jehovah's Witness, and was born and raised here. Coming from that background there are a lot of issues for him about being openly gay. But he does what comes naturally to him, and he is the most gentle and sincere man you will ever meet. Brian was also born deaf, and has overcome many challenges related to his hearing loss.

As for me, I abandoned all ties to my family when I came out in 1971 at age seventeen. They wanted me straight and married, and I would have nothing to do with a fake heterosexual life. I'd seen what that did to my parents—my father was a closeted gay.

I was molested as a child by the father of my younger brother's friend. I was invited to the beach with his kids, but his kids never came, and I never saw the beach. When I was twelve, I was forced into incest for five years by a first cousin, right under my parents' noses. And while visiting my aunt here in Paterson, I was raped by a group of people who were tenants in her house. They asked me to drink alcohol with them and then they overpowered me. After several failed attempts at taking my life, I gave up on that routine. It never worked for me, so I guess it's my lot in life to live with the past and deal with my present. And the present is good. Brian and I live happily together and have been married for two years. Sometimes it is still difficult to keep from looking over my shoulder because there are pieces of my soul that will always be damaged. But I keep on trucking. I cannot change the past, so I continue to re-invent the future.

After twenty-seven years in the hairdressing industry and speaking with many of the men I've worked with, it came to my attention that early rape was part of the history of many of my gay contemporaries. It was never something they spoke of freely. I hope men who hear my story will feel safe to share their own without fear or shame.

Today I concentrate on my art and host lots of dinner parties for my close friends. I also like gardening, photography, sculpture, and other things that pique my interest. I have a tendency to stay with a partner until they either toss me or they die. I think this one is for the long haul. Unlike my family, who had little ambition for bettering their lives, I have found a perfect niche.

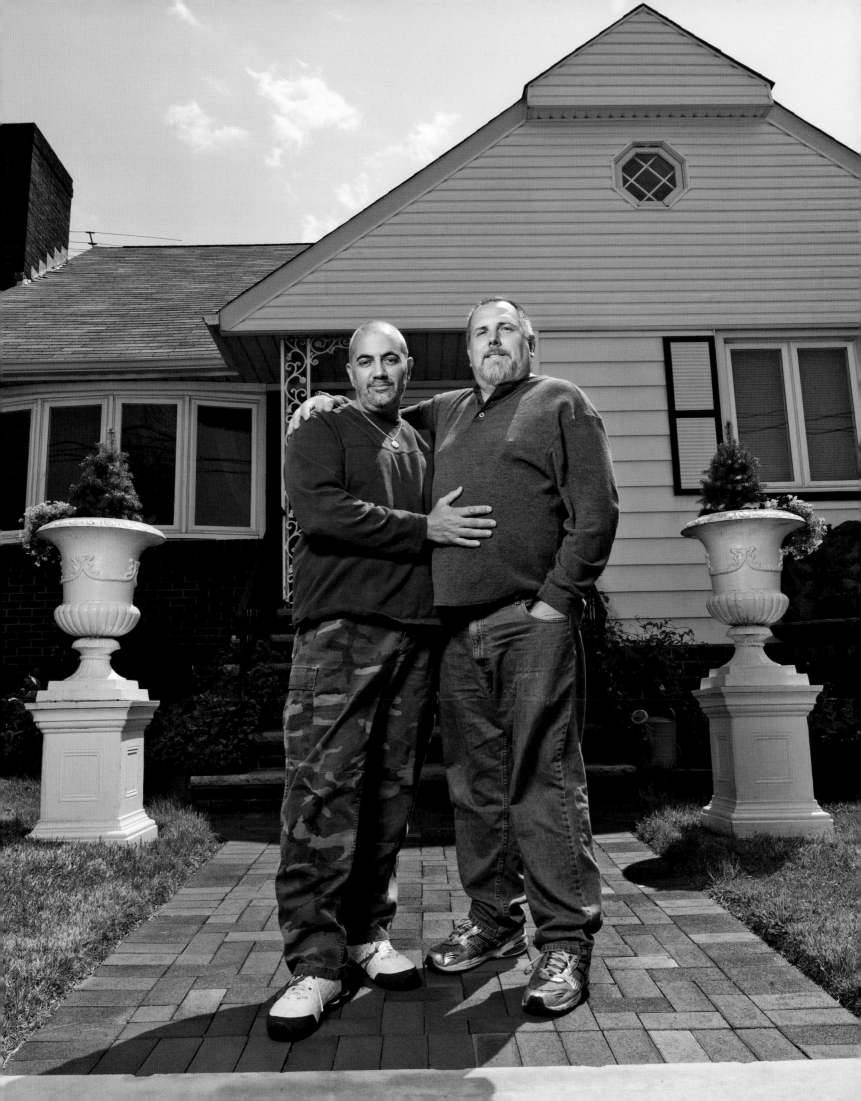

CARL Carlsbad New Mexico

grew up in a small town in the hills of southern New Mexico, and went to college at the state university. I came out during my first semester, the same year Matthew Shepard was murdered—he was my inspiration.

After school, I escaped to the "gay mecca" of San Francisco for two years, and worked at a Catholic-based agency serving the homeless. I encountered an entirely different set of gay-related obstacles in San Francisco than I did in New Mexico, and realized people will have problems living anywhere if they're not true to themselves. I obtained my master's degree in social work in 2005, and by a strange mix of events, including a suicide attempt, found myself back in New Mexico a few years ago, where I currently work as a counselor at the local mental health clinic in Carlsbad.

I am grateful for the life I've been given, the gifts I have, and the obstacles I've overcome. I live my life as a journey with the conscious understanding that we are always pulling apart the weeds from the wheat. My biggest challenge in being gay has been balancing a Catholic and gay identity, and gradually gaining a greater understanding of my spiritual self. I could go on forever about what it means to be gay, but I would probably sum it up by saying it's a gift that comes with responsibility. That is especially true in rural America, where I am very much a minority. I struggle with things like dating and social support, as well as advocacy and educating others about diversity. There are times when I want to blend into the crowd and not feel like the token gay, but at the end of the day, I have a very good group of (mostly straight) friends and family who love and support me.

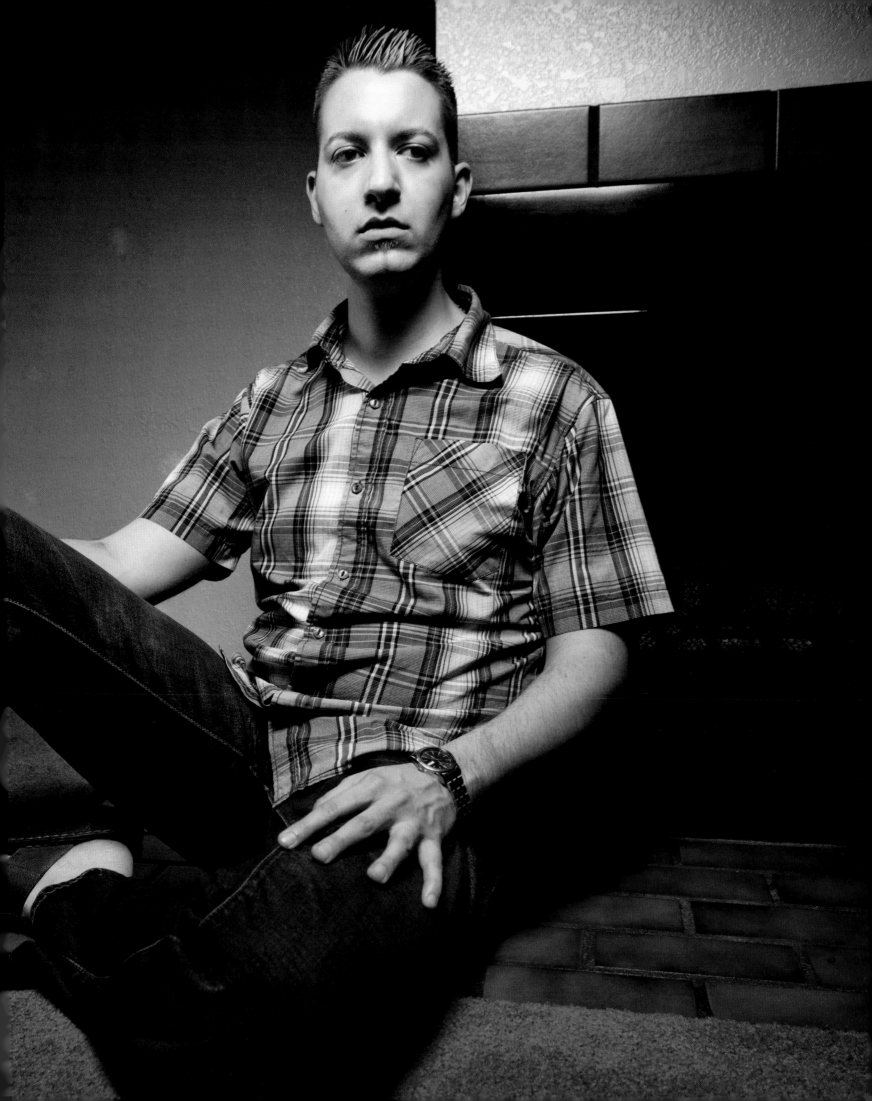

NEOBOY Albuquerque New Mexico

I am a visual artist, poet, and performance artist. I'd describe my work as a virulent and healing bag of memories, photographs, found objects, and luck. If I can provoke whimsy in people when they look at my art and put them in more than one place in time at once—I have done my job. I love the Southwest, but I'm not a regional artist. I respect the Hispanic and Native American traditions, but I don't feel like I have to own them in my art. Still, you can see traces of my background in much of my work. I think that by looking at my art anyone could easily guess I'm gay.

I've had a full life and known some very colorful people. I met photographer Joel-Peter Witkin, for instance, in 1980; we lived around the corner from each other in Albuquerque and we both drove Karmann Ghias. I modeled for him a few times, and some of those pictures became very well known. We met up once at a Halloween party where I was dressed like Charlotte Rampling in her *Night Porter* cabaret drag outfit crossed with black Klaus Nomi face makeup. I looked hot and dark. I was just twenty-three. Joel really liked it, and that costume became the inspiration for his famous "Bee Boy" image, which made me the poster boy for his first Paris show, in 1981.

I have been on this Earth for fifty years now. I'm HIV-positive and healthy. I am also a vegetarian. I enjoy working out, hiking, going to art galleries and museums, and hanging out with friends. I have a huge vinyl LP collection. I love all animals, including humans. I am a part-time caregiver for the elderly, mostly Alzheimer's patients.

I sometimes forget the simple things that make me happy. I get caught up in my own angst and feel separated from my precious life and connections. I live to be me, not to achieve a social status, not to be an angry artist, not to create bad karma or please my every little greedy desire. I love nature to the fullest; Mother Earth is precious to me.

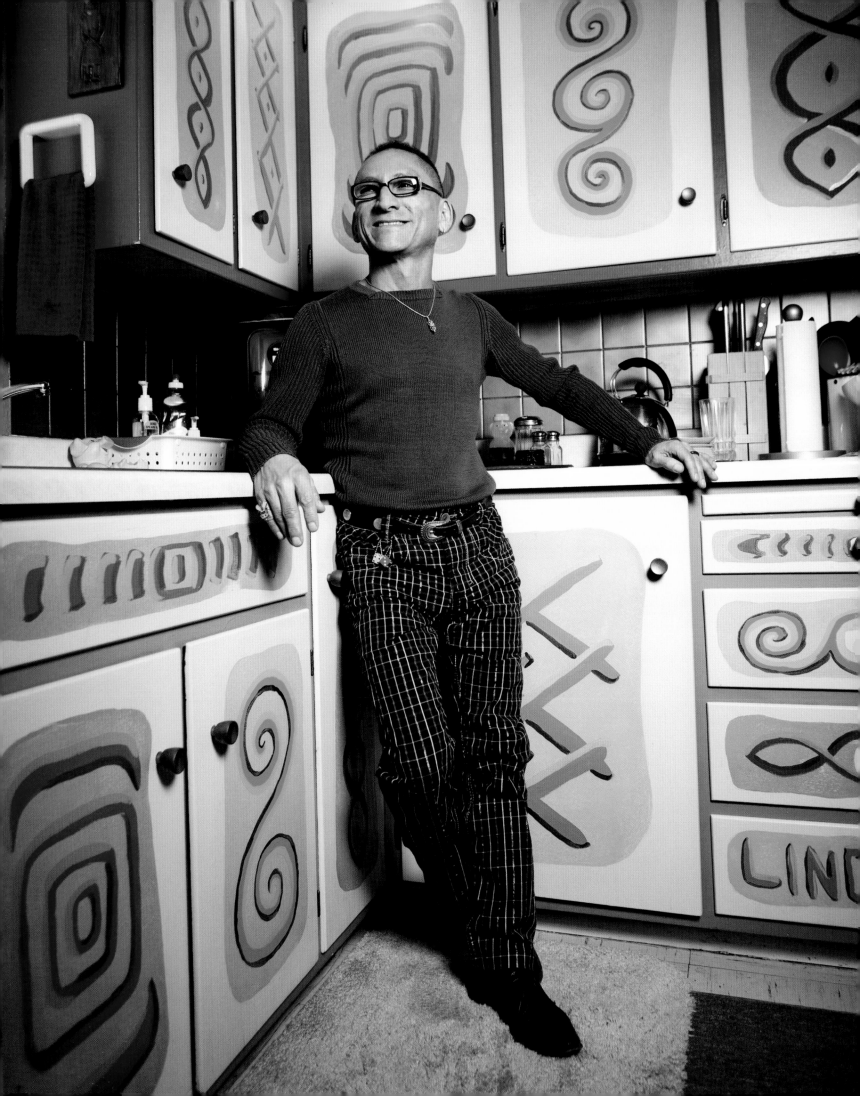

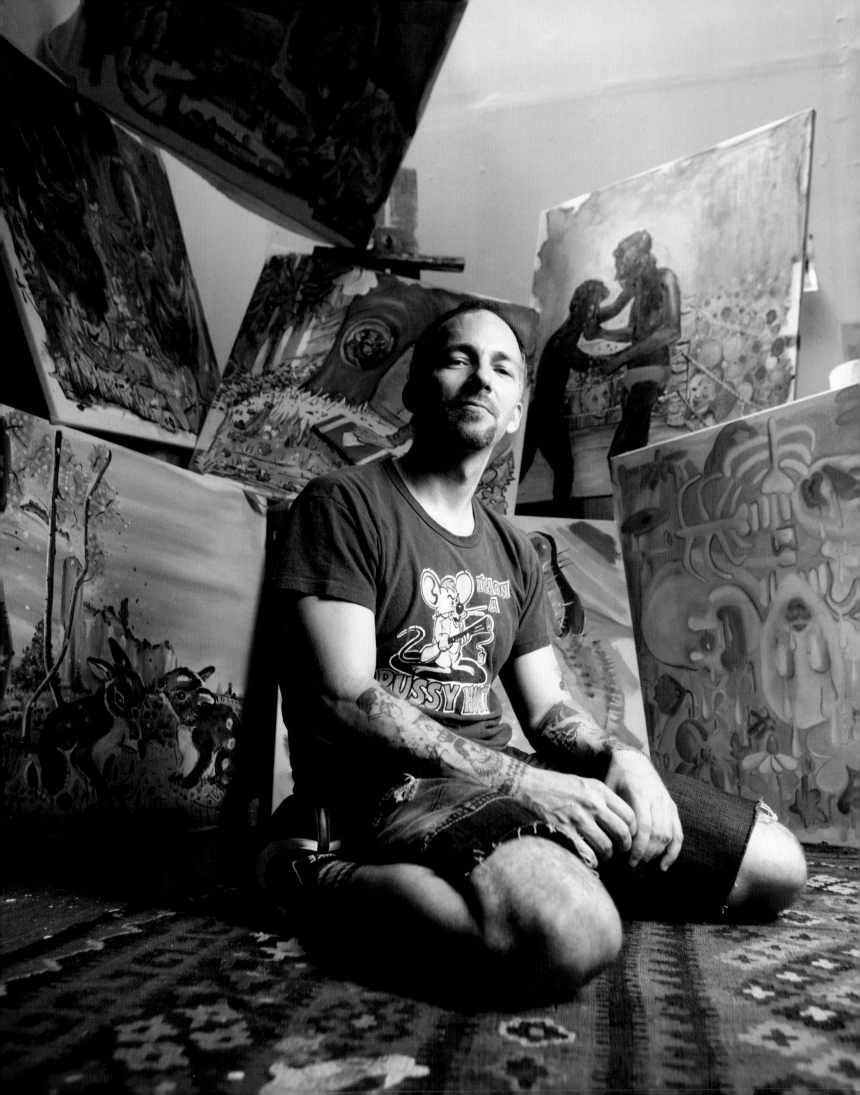

SCOOTER New York New York

I **had a difficult time growing up gay in New Mexico.** There was a lot of bullying all through my school years. I felt really out of place and was consistently made fun of for being different. I contemplated suicide on more than one occasion. Coming out was very awkward. Even though I come from a very artistic family—my mother is an actress and a musician with many gay friends—they still had a hard time with my homosexuality initially. I kind of felt like Chaz Bono. Thankfully, today my whole family is very accepting of me and is proud that I've chosen to live my life exactly the way I want to—as a gay artist. Life is too short not to.

I moved to New York and the opportunities started coming in. This city is where I should have been all along. The style of my art is a mixture of Golden Books meets the Dutch masters meets the abstract expressionists, with twists and turns along the way. I live every day with anxiety and try to explode it onto the canvas, out of my head and through my hands. Sometimes I have a very soft touch, and sometimes I paint very aggressively, depending on my mood. I paint in heavy, lush oil colors mixed with linseed oil and turpentine on canvas. I keep it simple. I make my art for myself. I don't think about pushing anyone's buttons, I think about what makes me excited and what I love and am inspired by. Sometimes I'm inspired by the sparkles in the sidewalk, by mold that grows on the walls, or by teddy bears I find on the street. Sometimes I'm inspired by the back room at a gay bar, my sexual experiences, and my sexual fantasies. If I can express this in a visually appealing, original way, and in my own language, then I am ecstatic.

I work every single day, often into the early morning hours. I never take a day off. I try to exercise and do yoga every day as well. I don't sleep that much, and I don't eat a lot—very simple foods like black beans out of the can with tortillas, or a can of soup. I feel like putting all my energy into my artwork means having no regrets at the end of my life.

I've had several relationships since I moved to NYC, all lasting for about a year, and all ending in disasters, but I'm learning and growing from each one and am currently in the healthiest and loving relationship I've been in thus far. I have a very supportive man in my life who I love very much and would do anything in the world for.

JAMES Sag Harbor New York

work as an officer on a private yacht that calls the charming town of Sag Harbor in Long Island its home port in the summer. The family I work for is not famous or well known. They are incredible people, who are more family to me than my own. We spend our winter in Saint Martin and Saint Bart. Life is not bad. I often jokingly and affectionately refer to my boss and his wife as my Sugar Daddy and Momma. Doesn't every gay man wish for both!

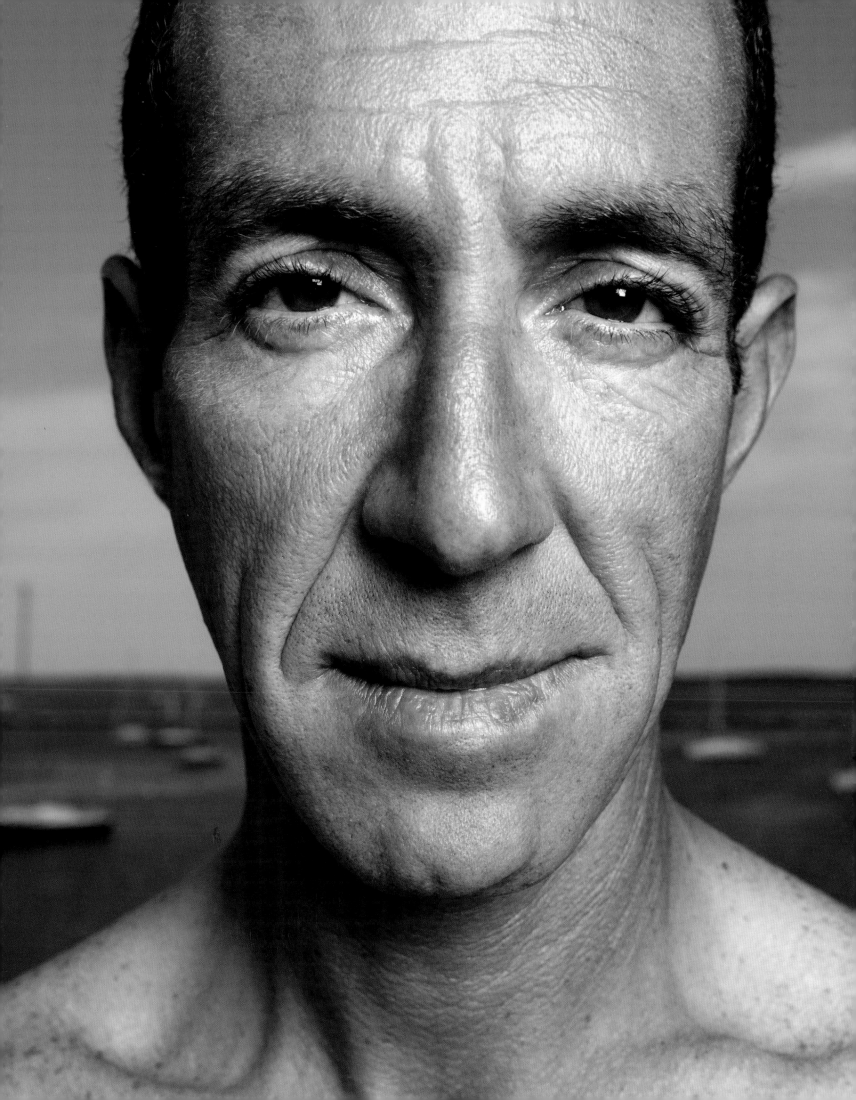

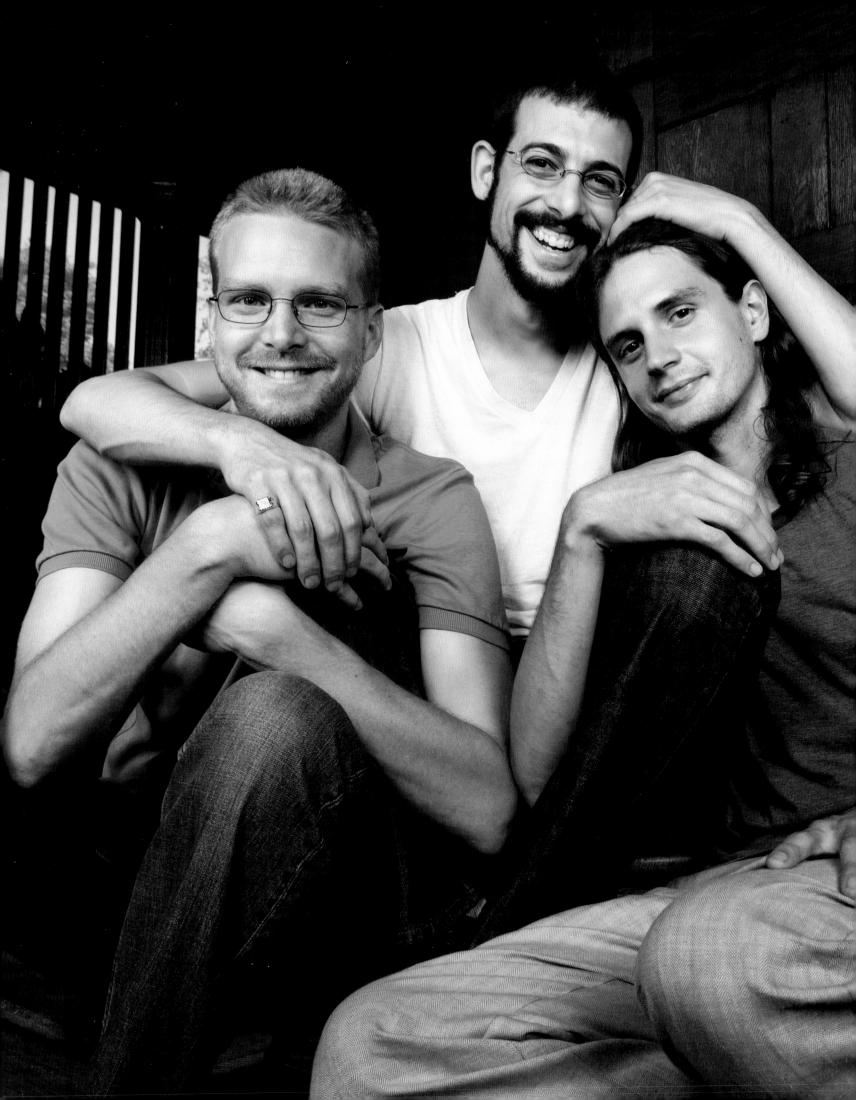

TERRY, PAUL & MATTHEW Buffalo New York

We have been living together as a monogamous threesome for seven years. We are twenty-seven, twenty-nine, and thirty-one. We bought an old house in the historic Linwood district of Buffalo and spend a lot of our time working on it. Eight years ago Terry and I met Matthew through a chance encounter with a mutual friend. He stayed over one night and wore our clothes because I was allergic to his cats and ferrets. The next week he moved in and the three of us started a beautiful friendship that led to love.

People are always curious about how we handle jealousy and other potential conflicts. It's easy. We share everything, from our house down to our bed and even our underwear, much of which our moms bought for us. We aren't jealous of each other's affection, and our situation keeps us safe from the unsafe. There is always someone's shoulder to cry on and an arbitrator for every argument. Our pet tortoise Basra completes our family. While we have heard of plenty of gay threesomes out there, we have never met any other serious triads—but we highly recommend it!

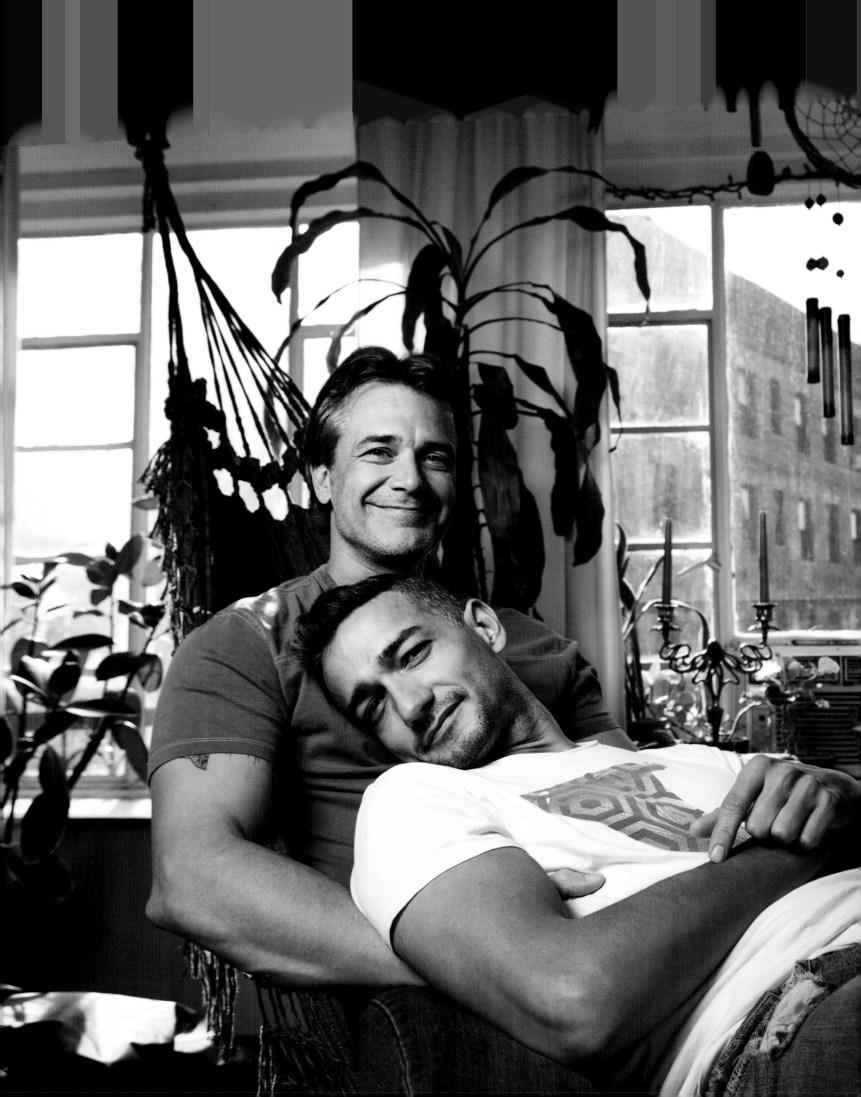

CHIP & GABRIEL
New York New York

Gabriel and I took Holy Communion from his father, a Lutheran minister in Misiones, Argentina. Afterward, we had a nap in the parsonage—Gabriel and I together in a double bed across the hall from his parents in twin beds, our bedroom doors open to each other's in order to share the air-conditioning.

Last November, we had Thanksgiving with my family, my mom and stepdad across the hall in my nephew's bed; we slept in the trundle bed of another nephew, down the hall from two sisters, a brother-in-law, and my nieces. These are images we cherish, and they represent the importance of our families in our lives. Gabriel and I take our roles as uncles very seriously, and we feel being out is vital to the open communication we have in all our relationships.

I am a poet, a romantic who believes love holds up the stars, so meeting Gabriel in Vermont in 2009, the man I know I was destined to "galvanize" with, was the fulfillment of a long-wished dream. Not only did we quickly fall comfortably in love, both of us are from warm, tropical climates, and we shared similar life plans to extend summers by switching every six months to the opposite hemisphere, and to start our own family. Now we live together and work together and split the year between New York City, northern Vermont, and Montevideo, Uruguay. We see a dog and kids on the short horizon.

JOHN & JOHN New York New York

I **fell in love with John one holiday season when I visited his picture framing shop.** He had fashioned a mantle and Christmas stockings with people's names on them out of hand-carved wood. His creativity, imagination, and almost childlike love of the holidays were a very powerful aphrodisiac. John's world, at that time, was based solely in the West Village, while I had been traveling all over the world and felt very attracted to a simpler, more wholesome life.

It came at a time in both of our lives when we felt ready to settle down and commit ourselves—heart, mind, and body—to each other. I think that after having survived the eighties and nineties as gay men, both of us losing many friends to AIDS and other casualties of the gay experience, we were ready to create a safe haven for each other and to celebrate monogamy and sanity (well, as much as two gay men living in New York can be "sane").

We really try to keep it local in all aspects of our life. John's shop is four doors down from our apartment, and I have a design studio two blocks away and a retail store one block away. As gay men it is important to us to have a sense of community and a neighborhood where we all know each other, say good morning to each other, and support each other's businesses. Where else but in the West Village of New York City could you hold a "gay dog wedding" and raise $6,000 for a local animal shelter? (John and I were the proud parents of one of the grooms.)

Both John and I had pretty easy coming-out experiences. I actually came out to my parents when I was a senior in high school, and although there were some growing pains, they and all of my immediate family have been open, accepting, and loving from the get-go. I feel very lucky, as I know this is not the norm. John came out after college and was also welcomed with open arms by his family and friends.

We both support the Trevor Project, which provides a safety net for young teens and youth struggling with their sexual identity. We feel so very fortunate to have always been able to express who we are. Our quest is to continue to define what it means to be a man in our culture, and to keep learning from and leaning into each other.

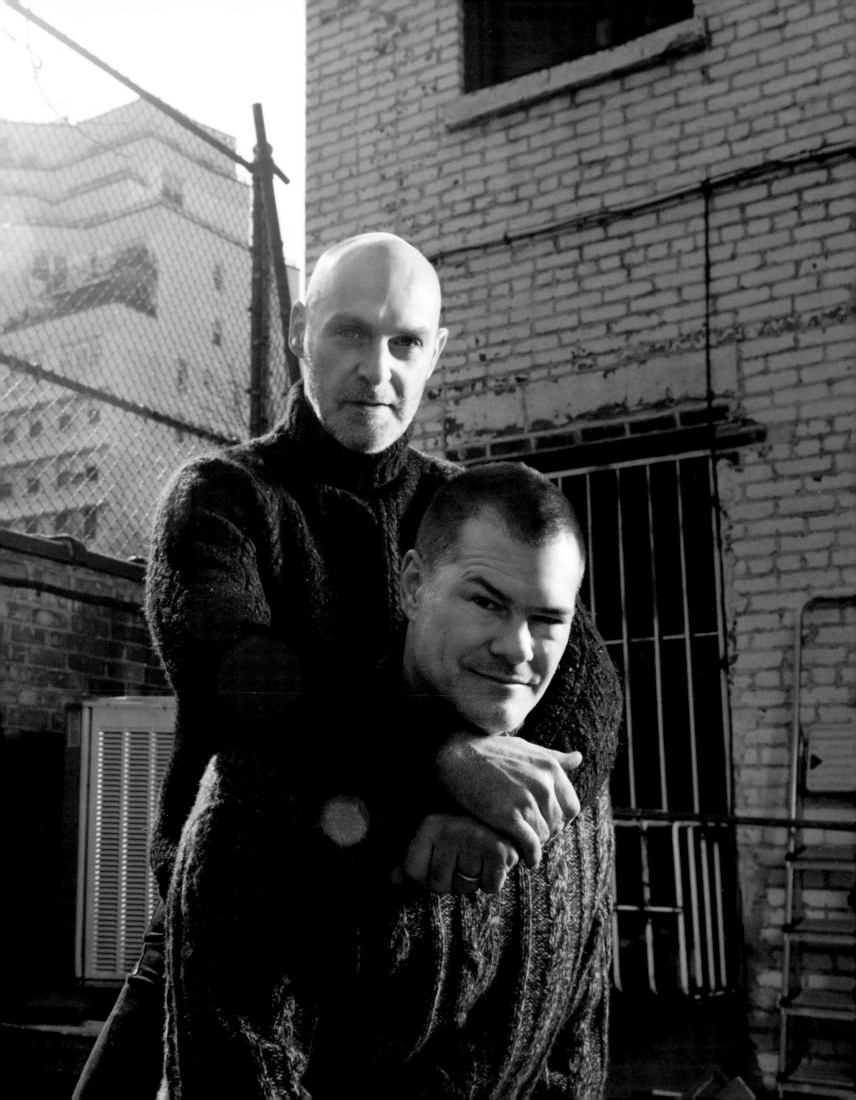

KEITH & BLAINE
Charlotte North Carolina

I live with my partner Keith in Charlotte—at one time seen as the buckle of the Bible Belt. Many areas in the South are less than open to new ideas or lifestyles. Charlotte is very much a cosmopolitan city trying to grow in a state that holds tightly to tradition. Although Charlotte isn't the capital, it gets the most attention of any city. It tries to strike a balance, and gay rights are often the last civil liberty to be brought to the forefront. The South, in general, is ground zero for issues of discrimination and, hopefully, eventual acceptance.

I was in a relationship with a woman when my son Brice was born. When we split up, Brice's mom started to see a younger man. Brice got in the way of their relationship, and she spent very little time with him. She built another life that didn't include him, and ultimately he moved in with me full time. I hate that I can't change things for my son, but his mother is who she is. Eventually, she packed up and moved to Texas without telling us. Brice found out through someone else. Their relationship is strained, to say the least. She blames him for the distance, yet she doesn't acknowledge his birthday or Christmas, and didn't attend his high school graduation.

When I met Keith, I knew he was everything I wasn't and everything my son Brice needed to be. Keith is grounded, rational, driven, focused, and sane. I am an artist, so quite the opposite. My son deserves to have Keith as an influence and guiding force. Brice, now twenty, recently enlisted in the Air Force, with the long-term goal of being a police detective. As for my son's experience being raised by two dads in the Deep South, he recently got a tattoo on his arm of a heart with the words "My Dads" in the center. He flashes it proudly.

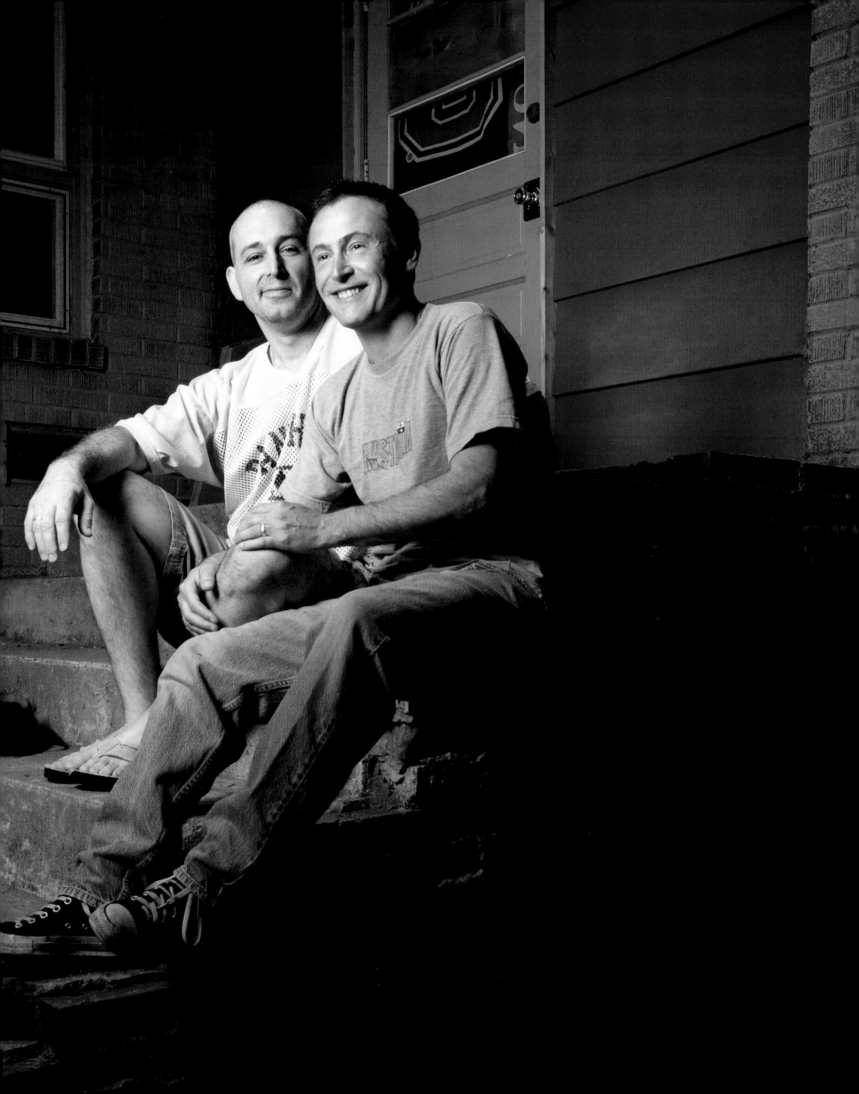

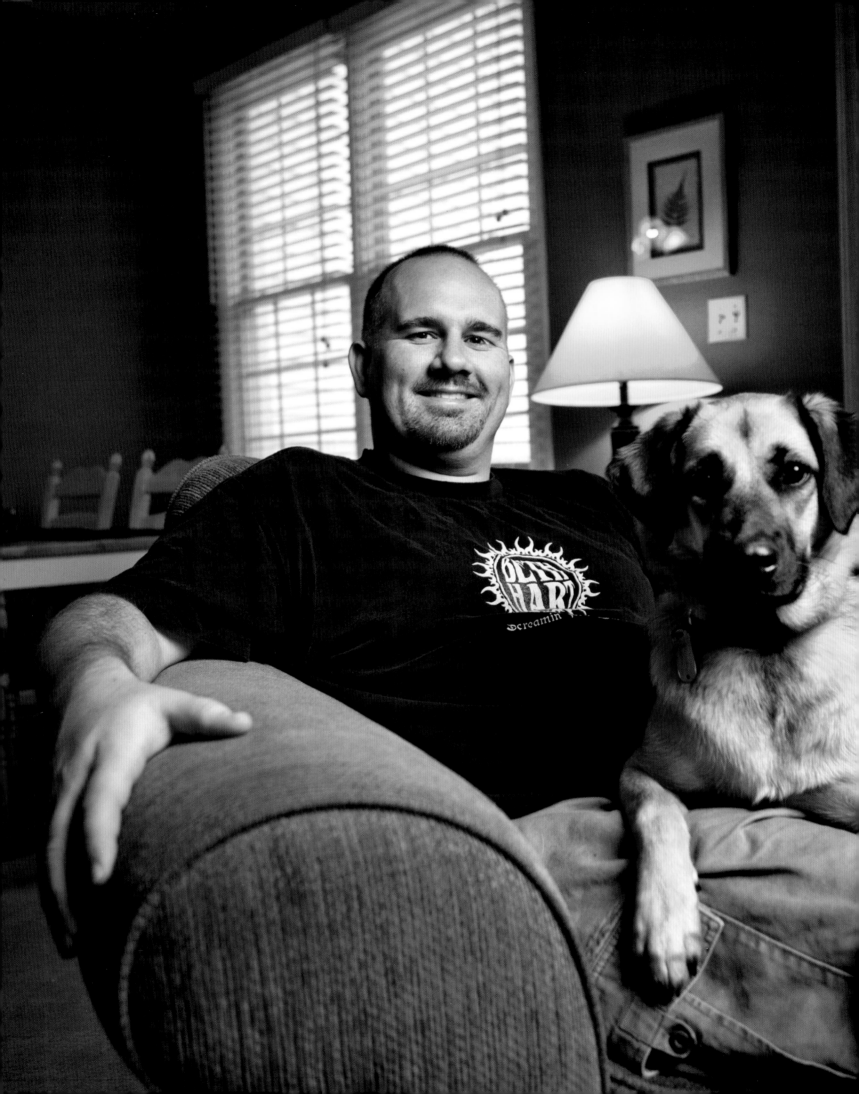

CHRISTIAN Raleigh North Carolina

I grew up outside of Washington, D.C., before going to college in the mountains of Virginia, where I got a degree in health science. Fifteen years ago, I moved to North Carolina to attend graduate school for counseling and student development. At that point in my life, I was completely on my own; I had a car, a job, and felt like it was either time to come out or end it. I told my friends and some family, and overall it was a very positive experience. My parents were really concerned about me being out and gay in North Carolina because it's the South and part of the Bible Belt. But I've never had any problems.

I work as a paramedic and have been involved in EMS for seventeen years now. I'm out at work, and I believe that it's important for folks to see that not all gay men are like the ones that they see on TV and in movies. My coworkers have been very supportive and are quite protective at times.

I don't wear my heart or my sexuality on my sleeve. I believe in working hard, being honest, and treating people with respect. I'd probably be considered a "bear" type. I'm a big music fan and enjoy rock, alternative, metal, and country. I love beer, cars, and trucks, and I don't dress well. I don't really care for shopping and I'm not great at decorating. I've been in a few relationships over the years, but haven't found exactly what I'm looking for yet.

ROBERT Leonard North Dakota

I **am a forty-four-year-old, gray-bearded bear.** I have been letting the beard grow out for more than the year since my dad's death, so it's bushy even for me, but it's kind of fun to let the wind blow through it. I live in a small town about thirty-five miles outside of Fargo. I moved to North Dakota in 1989. I am out, have been for a bit. I came out to myself in 1992 and then to my folks five years ago. I am out at work and anywhere else too. I am not what most folks picture when they think of a gay man. But there are a lot of us, and we are all around.

A lot has changed for me over this past year. Probably the biggest thing is that I found out I have diabetes. I can't say I was shocked to hear the doc diagnose me; anyone over 300 pounds would have to live in a fantasy world to be surprised by that. It was a wake-up call. Since then, I have lost somewhere in the neighborhood of sixty pounds and weigh a slim 284 now! Folks are just starting to notice, or at least say something. My goal is to get down to about 230. It'll probably take another year, but doing it right is the important thing.

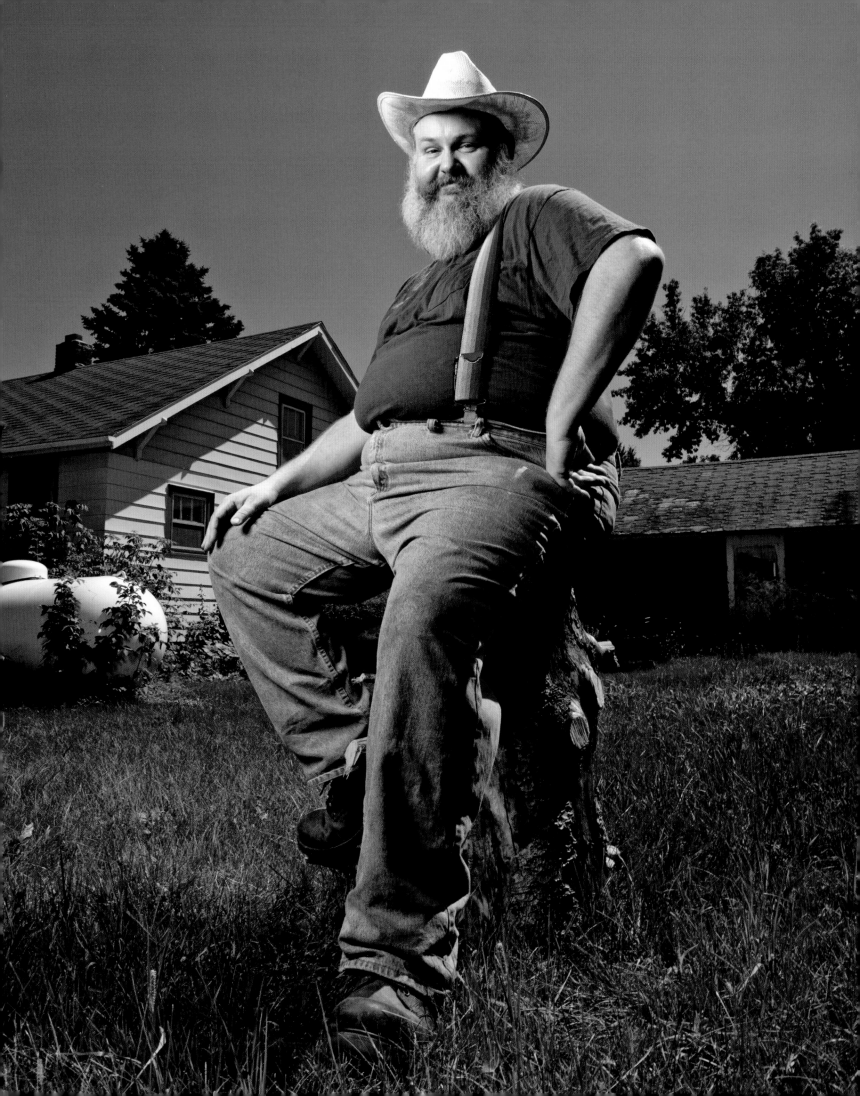

JONATHAN & PAUL
Columbus Ohio

'**ve lived in Ohio since I was fourteen, and have been out and proud since I was eighteen.** I'm forty-four and a sober alcoholic. My partner, Jonathan, and I have been together twenty-one years. We have three boys with a lesbian couple from Columbus—six-year-old twins and a ten-year-old. Jonathan is the biological father of the twins.

I work at Ohio State University. I have a passion for social justice and organize diversity workshops and presentations on sexuality and society's perception of gender roles. Through my volunteer work with the Columbus Stonewall Union I give "Gay 101" presentations to area businesses, high schools, and colleges. My passion for social justice extends beyond equal rights for LGBTs to those across the country and the world who are economically and/or politically disenfranchised. I was in Queer Nation and Act Up and have been arrested twice for pro-peace activities.

Over the past couple of years I have concentrated more on local activism. I coordinate a group of colleagues to host a lunch once a month at a family shelter, I make pancakes twice a month for a drop-in facility for LGBT youth, and I cook once a month for another youth group at a center for homeless and runaway kids.

Jonathan is the more stable, secure, and responsible one in our relationship. We met in 1986 while students at Ohio State. It was a combination of love and infatuation at first sight. We've had to overcome quite a few obstacles to be together. It hasn't always been easy. He's a dedicated father and takes his commitments very seriously. He's a great role model for our kids and for me.

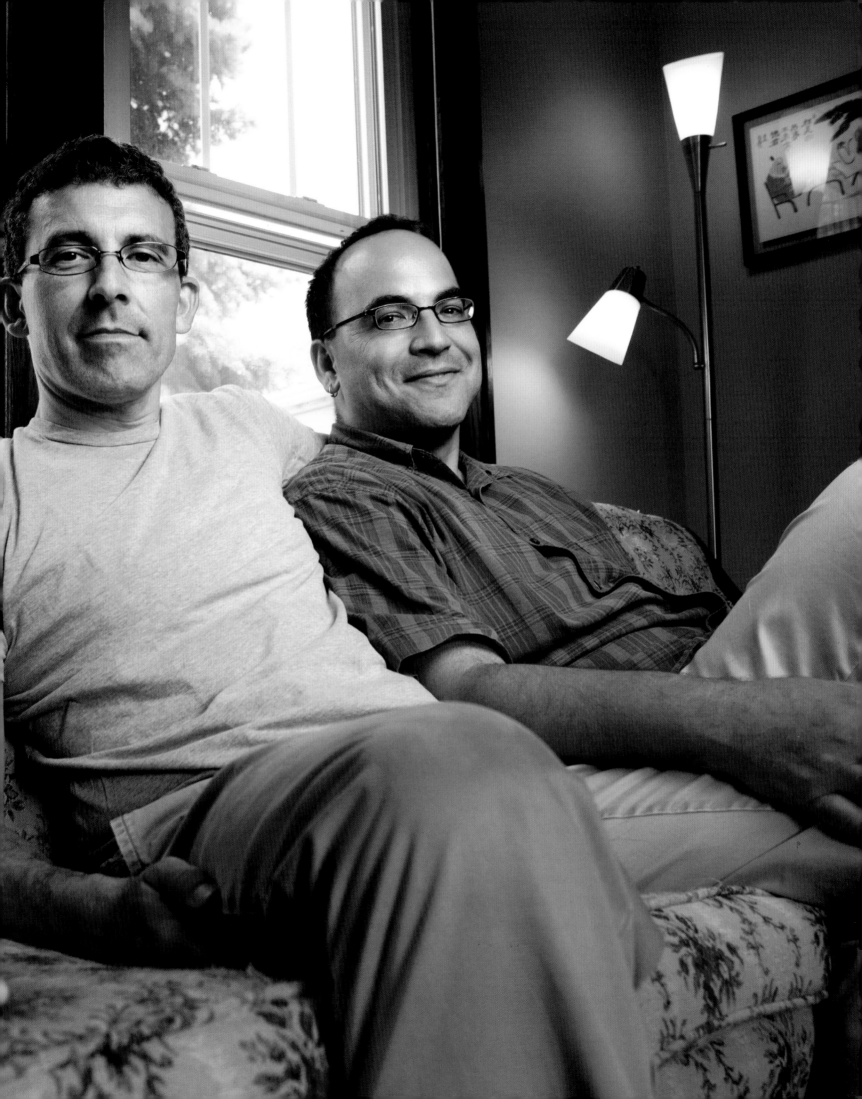

ROGER & SCOTTY
Tulsa Oklahoma

I came out when I was seventeen years old and a junior in high school. It was a bit of a shocker to family and friends because I didn't fall in to the category of what people thought of as gay. I was popular in school, had girlfriends, played sports, and was generally a guy's guy. My partner Roger came out at twenty and also told his parents about that time. His family is supportive of him.

My brother is just a few years younger than me. When I first came out he was very upset and angry, though I didn't know why at the time. It turned out he was gay, too. We were always close, and he really looked up to me, so he thought he'd be labeled as a copycat if he revealed he was gay after me. I didn't know the reason for his reaction until he came out at sixteen. We finally sorted through it all and are still very close.

My sister is seven years younger than me, and she came out when she was twenty. She was a tomboy growing up. She liked the guy stuff—playing sports, getting dirty; she wasn't afraid to play with the guys. We were close as kids and still are now. She lives in Florida, and my brother lives here in Tulsa—as do our parents. We each have very unique personalities, yet we do share a very special bond that's different than most siblings.

Our parents are very supportive of all of us. It may seem unusual to have three out of three kids be gay, but for my family, it was normal.

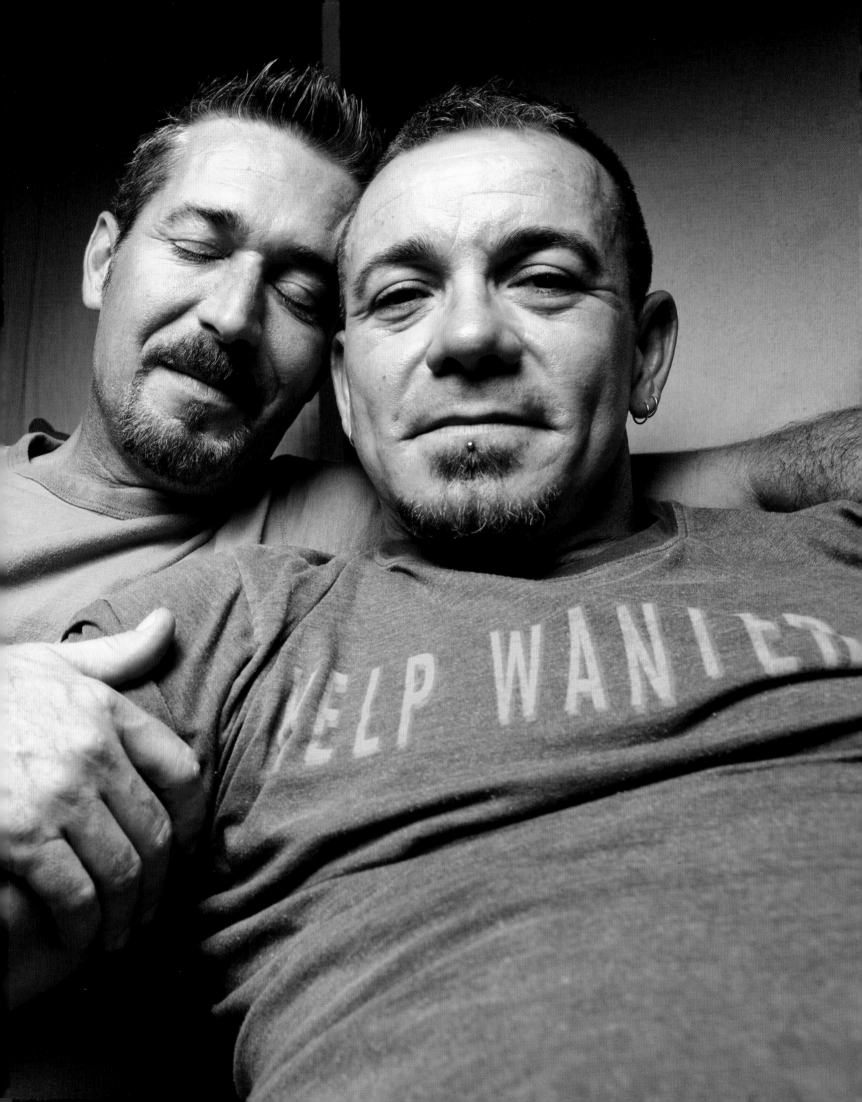

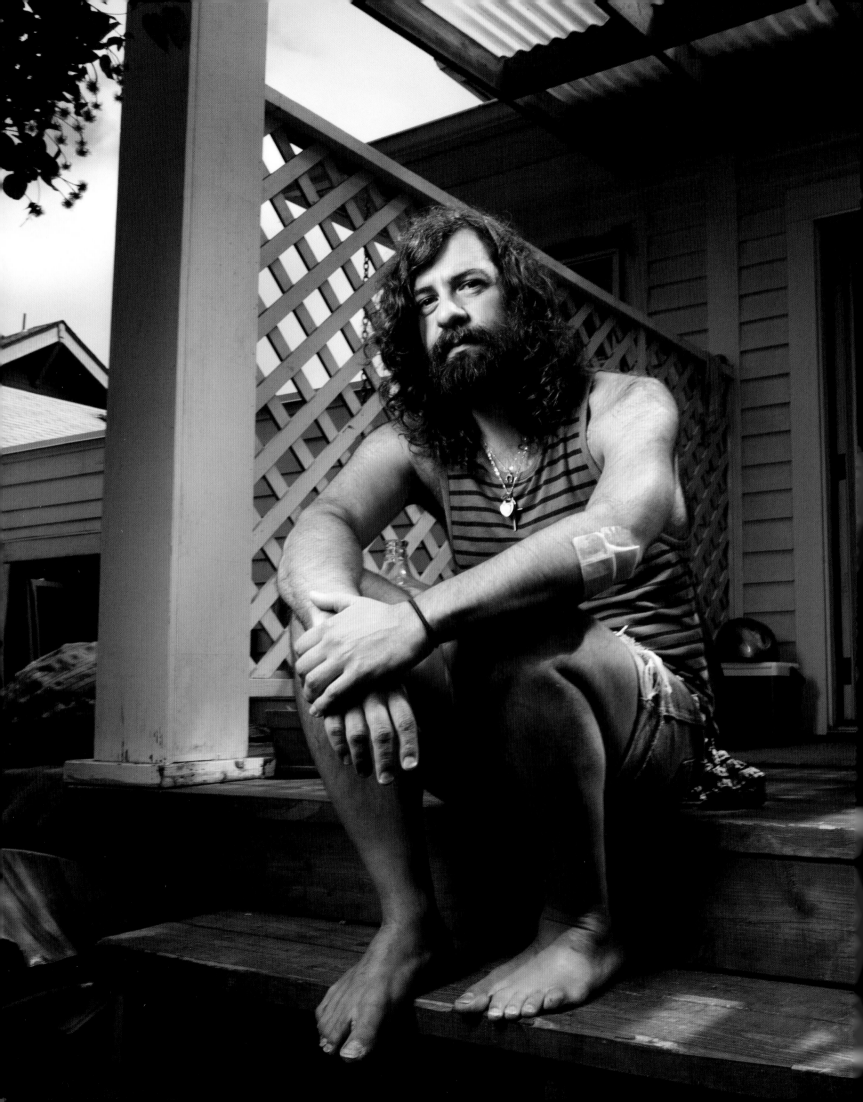

FRANK Portland Oregon

I came out at thirty-six, on my mother's birthday. I didn't do it to hurt my mother, though now my actions seem selfish. Coming out more than once felt unfathomable and it was the rare occasion that my family would all be together. Dinner was interrupted many times by me going to the bathroom to give myself a pep talk. I just couldn't get up the courage.

After dinner, my step-dad went to the living room to watch the game. It was now or never. I stepped into the living room and asked him to come into the kitchen because I had to "Tell everyone something, I had to tell them that I was gay." He patted me on the back and said "Come on."

At forty-five, I find myself unemployed, single, and sort of homeless. It wasn't my plan to be here at this stage in my life. After losing my job I spent several months sending out resumes, checking job sites, and furiously contacting everyone I knew looking for work. When nothing materialized depression set in, followed by going out every night, and wasting a lot of time. Then I had an epiphany. There's absolutely no work and there is just no way I can afford to live in New York City now, when will I ever have so much freedom again? So I sublet my apartment and began traveling—Mexico, Europe, Morocco, and finally Portland. Unemployment has actually been liberating and exciting, a real life-changing experience.

There is a big part of me that loves having a home and all the things that surround it, the notion of being settled and the simplicity. But another part of me is quite different—it loves socializing, getting dressed up, and going dancing. I feel like I'm shy and somewhat of a loner, but I also love people. I'm always being told that I know everyone and it's kind of true. As a child, I wanted to live in the city or country. It was about extremes. The middle seemed boring.

So why do I like Portland enough to consider moving here permanently? It's the most middle place I've ever been, except for where I'm from. It offers cultural stimulation when needed and the opportunity to explore the outdoors, which has been sorely lacking from my life. Portland feels like a place I could call home. But I still have a lot of wanderlust, and I'm fighting my urge to make plans.

MICHAEL Portland Oregon

I **was raised in Texas by a musician mother and lawyer father.** It was a fairly normal environment, including the typical strained father/son relationship because of my sexuality. I did the normal things—acted out and misbehaved—but was always a creative child. I went to ballet school, art school, and twirling classes (yes, I took baton). Catholic school didn't agree with me much, so after fifth grade I transferred to a performing arts school and studied dance and theater into my twenties. From those early years I learned many lessons, some good, some not. I had a few relationships that led me down the wrong path into drugs, alcohol, and even drag. Nonetheless, I started my own restaurant when I was twenty-six with the help of a partner and went on to work in interior design after being noticed for the look of the restaurant.

I began to seek some form of spiritual life, and investigated chanting and Buddhism. I went on a Buddhist retreat where I told the teacher I had been having dreams of a beautiful place for two years. At our next meeting he brought two hundred photos he had taken during his travels. I looked through the pile and randomly picked out seven images. This enlightened man turned over each one, and on the back of all of them was written "Portland, Oregon." He instructed me to get on a plane and go to Portland as quickly as possible. I asked him, "What am I supposed to do when I get there?" His answer was simply, "You are supposed to be there." I went out of sheer curiosity. When I arrived, I got in a cab and asked the driver to take me someplace beautiful. He took me to the Japanese Garden and I fell in love with the city.

I visited six times, desperately wanting to move, but I was unable to let go of the life I had built in Texas. I had lived my entire life within a sixty-mile radius of my family home and the hospital I was born in. I had a boyfriend, a beautiful home, a successful business, and a lifetime of friends. How could I leave? How could I just start over and make new friends and create a new business? But I became more and more drawn to the Northwest and ready for some sort of adventure and change. I chanted and meditated about my dilemma and all the things that made me feel trapped. And then something incredible happened: on September 13, 2008, my whole life changed. My home, my store, my office, and sixty percent of my client base were destroyed by Hurricane Ike in Galveston, Texas. After five months of trying to put my life back together, I moved to Portland.

I love it here. I've made new friends, established my business, and I'm working on a book. I have a new boyfriend who is amazing, and my crazy Pomeranian who rode out the hurricane with me. I am chanting, dancing, and working on my artwork every day!

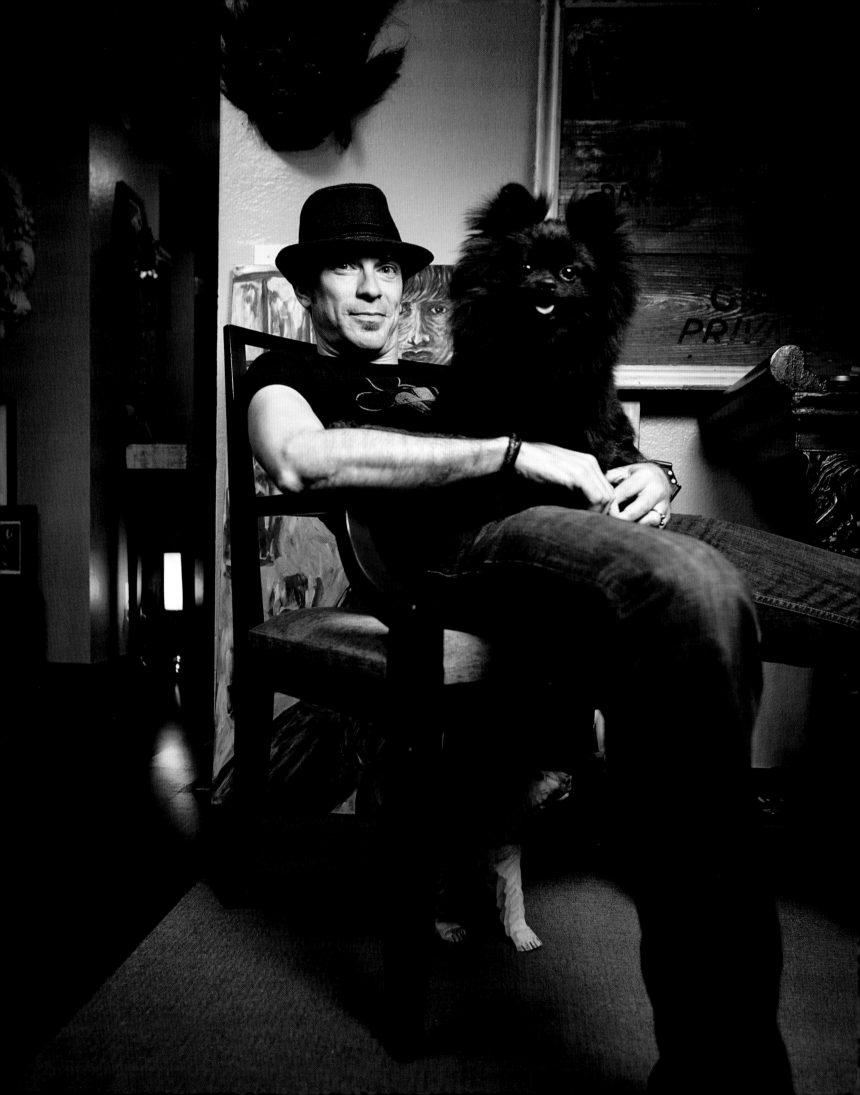

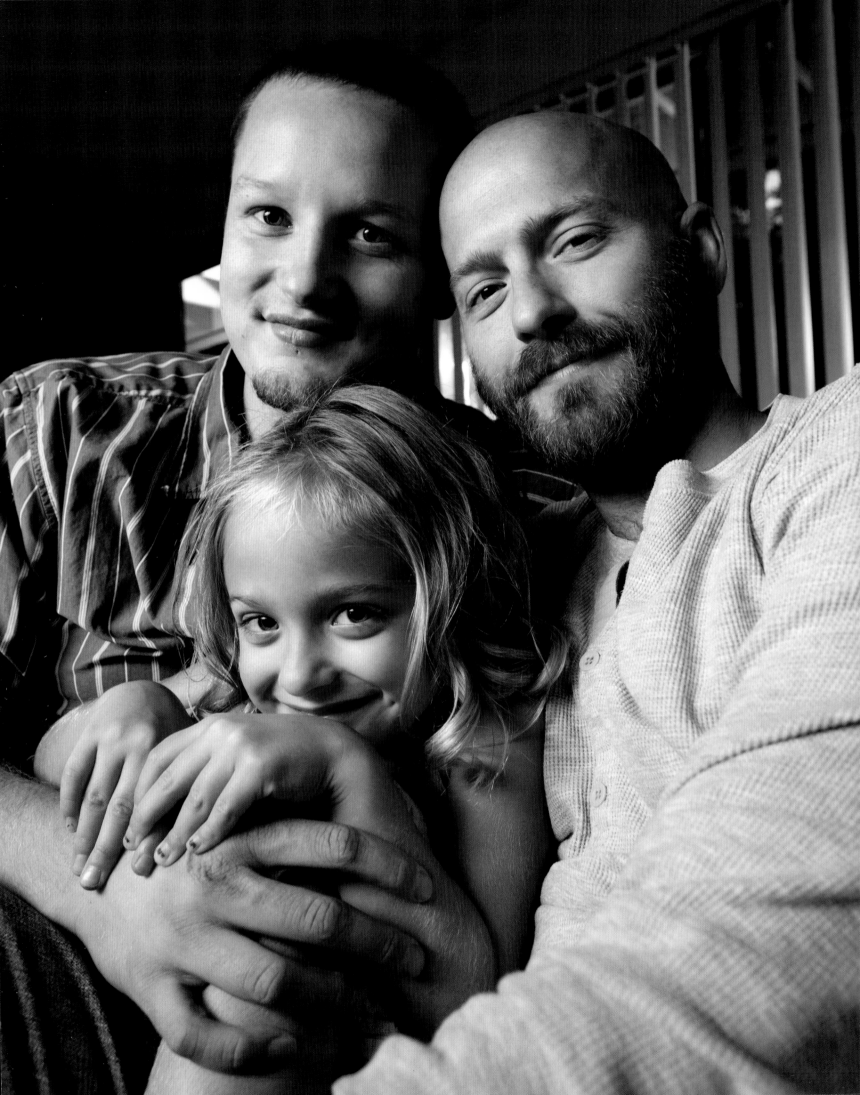

JOSH & JOSEPH Eugene Oregon

with Joseph's daughter Sabin

JOSH:

I'm the fifth of six boys, of whom only three are now living. My coming out was less than anticipated by everyone but my mother. She told my family I was gay when I was three, then asked me if I was a homosexual the first Christmas after I graduated high school. I grew up in a home filled with drugs, alcohol, and abuse of every kind. My first goal after moving out and coming out was to live a life that didn't reflect my upbringing. For the first few years, I struggled to find my own identity as both an adult and a gay man. Growing up in Kinsley and Pretty Prairie, Kansas, I found it difficult to identify my homosexuality with the small-town mentality I was raised with. So I dove in headfirst. I moved around a bit trying to find a "gay place" to lay down some roots and call home. After living in Los Angeles and Nebraska, I landed close to home in Wichita, Kansas, of all places, just a short drive from all the things I was trying to escape.

It was only a matter of time before I found myself immersed in the glorious world of sex, drugs, and late night bar-hopping. I finally felt I met all the "gay criteria" to be part of the "in" crowd in my neck of the woods. I was involved in LGBT advocacy, and had a large group of gay and lesbian friends, but the endless supply of going-nowhere relationships left me feeling empty and longing for more than a Saturday night number. After being diagnosed with PTSD, I decided it was time to clean up my act and escape the chains of my childhood. I quit doing drugs, stopped partying, and started concentrating on my health. A year after cleaning up my act I met Joseph and quickly fell in love. A year later, we moved to Eugene, Oregon, to be with his daughter. Instant family, just add water!

So now we live your typical "vanilla" family life. Work, school, playdates, dinners, homework, PG movies, and the occasional glass of wine. And I wouldn't trade it for anything. The normalcy and redundancy that so many people take for granted—we have the same worries, stresses, joys, and loves as everyone else and I can't imagine being happier.

JOSEPH:

I was raised as a missionary kid in Taiwan and had very little exposure to the "real world." When I reached about thirteen and realized that I felt a strong attraction toward the same sex, I became withdrawn and fearful of what my family would think. Isolated and with nowhere to turn, I buried my gay feelings until I got to college.

Slowly, I began to lift the veil of fear and explore my sexuality. Unfortunately I was attending a conservative, Christian university and the result of my exploration was only a deeper sense of guilt. Ultimately I fell into a destructive pattern of self-sabotage. I clung to the false hope that I could change and turn "straight." If only I could truly commit to the path of "righteousness" I could then live the life I was raised to believe was right.

Shortly after graduating college I met the woman that would become the mother of my child. Our marriage brought with it acceptance from my family, acceptance from the church, and for a time, acceptance of myself. Forsaking my true path I found myself living my life for everyone around me while secretly I knew the truth—that I could never feel honest romantic or sexual fulfillment from a woman. Rather than being set free I had only become more deeply entangled in the lie. It would take seven more years for me to finally stop running and accept the truth.

Though I may have taken a lengthy detour, I owe who I have become today to the choices I made in the past. Today I am proud that I am gay and would never choose to hide it. I am a loving father with a beautiful daughter and wonderful partner in Josh. In the end, I really believe what didn't break me has only made me stronger.

KEVIN & TRACY
Pendleton Oregon

I grew up here in Pendleton, Oregon. It's a pretty roughneck area known for its world-class rodeo, the Pendleton Round Up. My partner, Tracy, was raised on a cattle ranch in Idaho and moved out here about twelve years ago.

We are out, but we don't wear our sexuality on our shirtsleeves. We love the small-town life and are well respected in our community. We have many straight friends in town who have never known a gay person before, and have commented that we don't fit the typical stereotype. They tell us we've led them to see gay men in a different light. We love to hear that!

The community is pretty redneck, but open-minded and accepting at the same time. It's great living here, and we are always trying to get other gay men to check out the town, but usually they're not willing to leave the city for the quiet life. That's okay, though, because it just means there is more of it here for us.

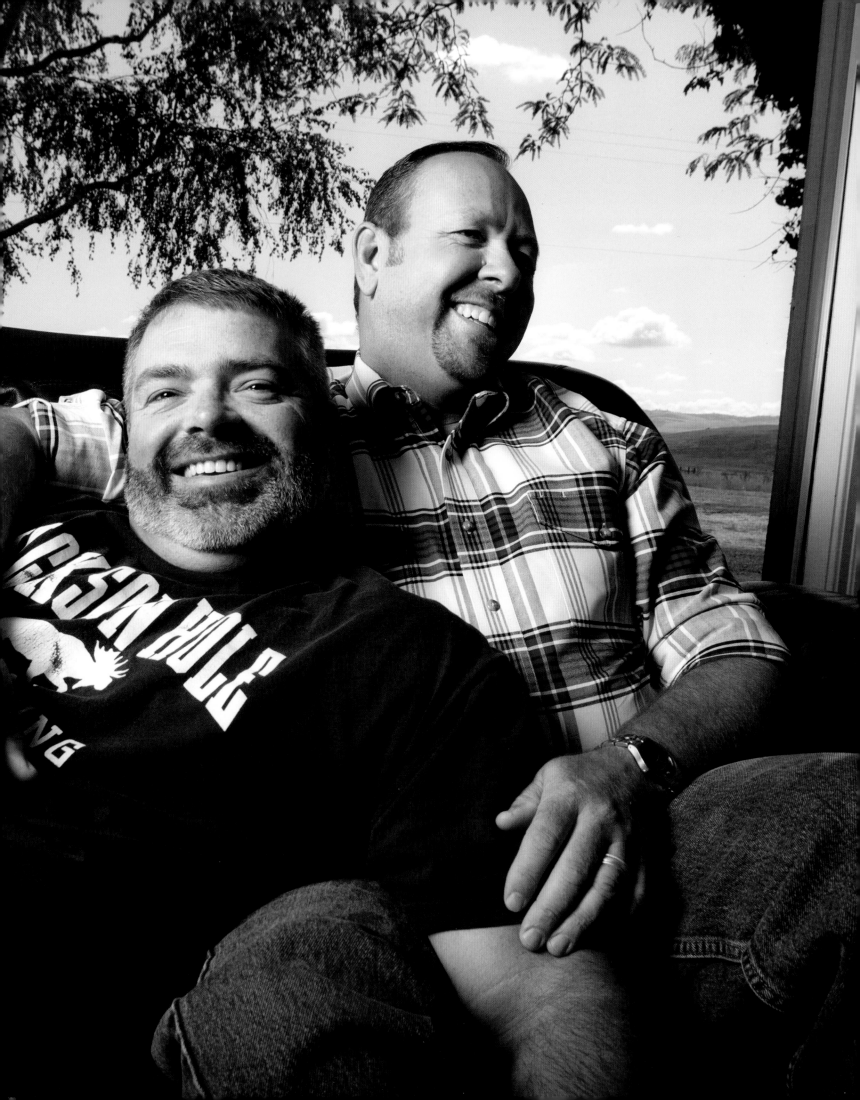

RON & KEN Easton Pennsylvania

Ron and I have been together eight years now, after meeting one lucky evening back at New York City's Eagle Bar. We fell in love, bought a house, and started a magical life together. We got married before our entire family and a huge group of loved ones on the front porch of an old farmhouse in upstate New York. Neither of us are from Pennsylvania—I'm originally from Texas and Ron's from Florida—but there's no doubt that Easton has become our home. We're involved with our community on many levels—from spearheading local art projects and leading the way toward more neighborhood gardens, to just being out and proud about our love and life to all we meet.

We create together. The unique connections, chemistry, and perspective we share fuel this creation. It's been that way since we met. Music, art, life. We've transformed an average suburban yard into a Technicolor wonderland, crab grass and concrete into a garden that feeds us and our community, a dilapidated house into a cozy home, broken bits of crayons into beautiful sculptures, and dreams of independence into a business that energizes both of us. These are only a few pebbles on a path that's filled with this kind of life force.

It's difficult to put into words this energy that fills our life together, makes us smile, and keeps us moving. It's created by the unique combination of us. It's probably a blessing that it can't be articulated eloquently, but I can tell you one thing that can be: The butterflies we felt in our stomachs the moment we saw one another eight years ago have never stopped fluttering.

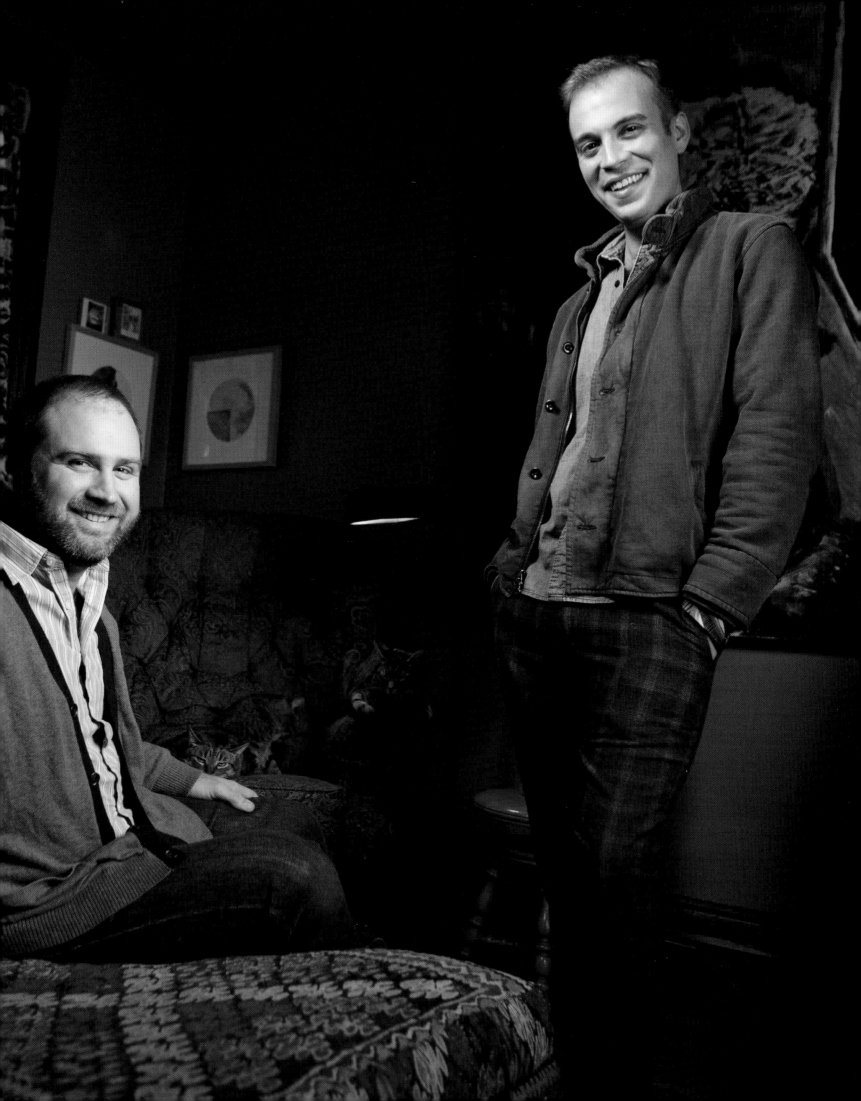

KOLAJO & BOBBY Providence Rhode Island

BOBBY:

We met at a club in D.C., where Kolajo and I both lived and worked for most of our twenties. We dated for a few months and things started to get serious, but Kolajo had already decided to leave D.C. and attend graduate school prior to us meeting.

KOLAJO:

As soon as I got my first acceptance letter, I began to suspect our relationship was more than just a fling. I decided on Harvard, where I am now working on my doctorate in education. After experimenting with a long-distance relationship for about a year, Bobby decided that he liked me more than he did living in D.C. He got a job as a campus planner for Brown University and moved to Providence. I similarly decided that I liked Bobby more than living in Cambridge, and I now commute to school by train, three to four times a week.

BOBBY:

We find Providence to be a city of glorious contradictions, as is New England in general (think pleasant summers and almost unbearable winters). It has a small-city charm, a robust art scene, great restaurants, affordable housing, generally progressive politics, and a strong local food culture. It also has all the grit and unemployment you would expect from a former industrial capital. Its gay population is large for the city's size, the bars are plenty and varied, and the folks are friendly. Our neighborhood, the West Side, could most accurately be described as a gentrified mix of artists, hipsters, college students, families, immigrants, and long-term residents.

KOLAJO:

Bobby and I spend a lot of time keeping our nineteenth-century Victorian home from falling apart. We consider ourselves to be amateur cooks, and spend many nights executing recipes from all our bibles of modern cookery. We are proud members of our community garden, though Bobby is the one with the green thumb.

BOBBY:

Kolajo, on the other hand, spends most of his time dissertating, while I keep myself busy in my-third floor studio with canvas and oil paints. We have two dogs: Lou, a loving eight-year-old standard poodle, and Albey, an incorrigible four-year-old smooth collie.

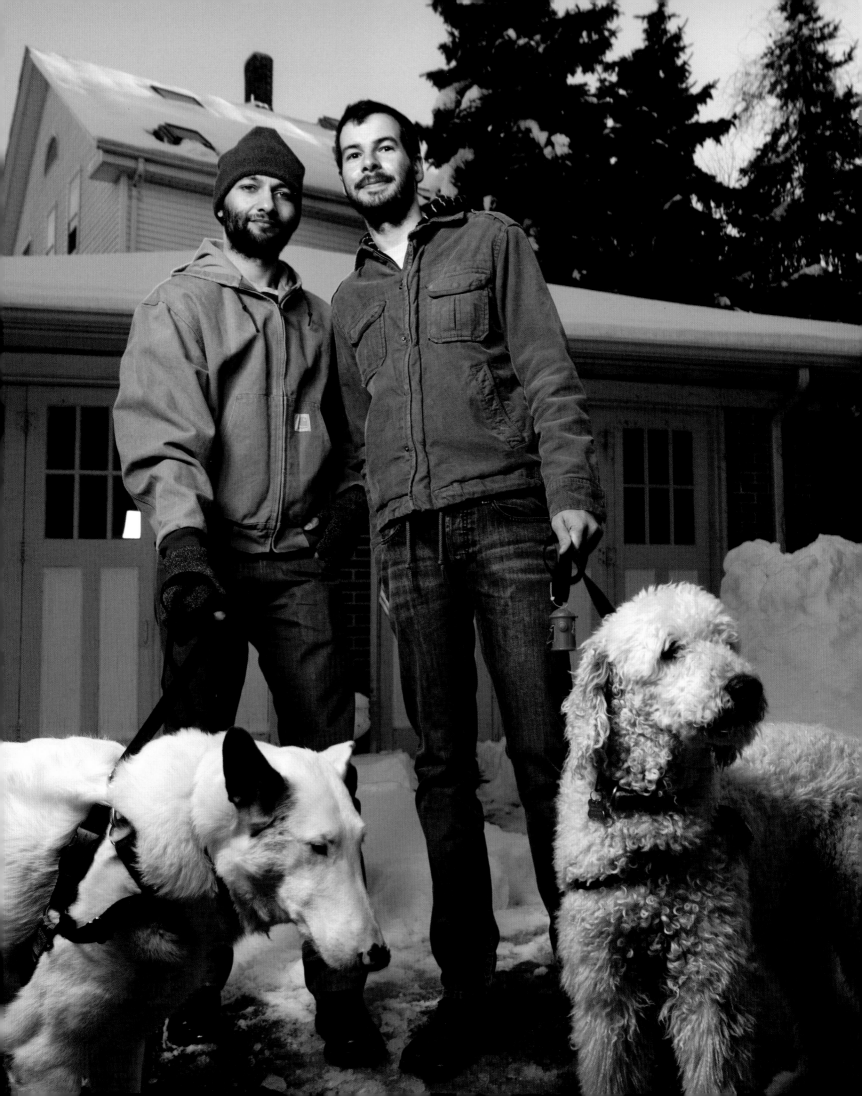

BEN Columbia South Carolina

n the end, I look at my life as an open book, and I
no longer care what people think of me. I am a strong,
driven, independent, normal man who just happens
to be gay.

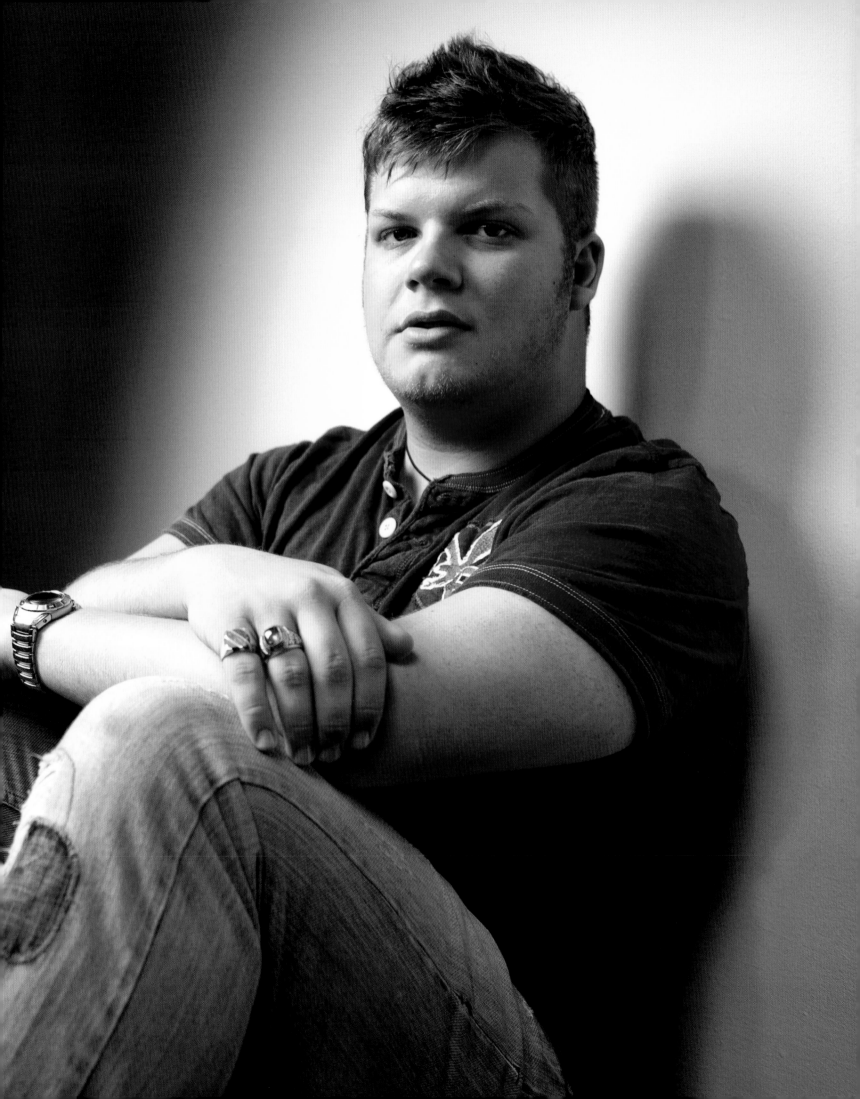

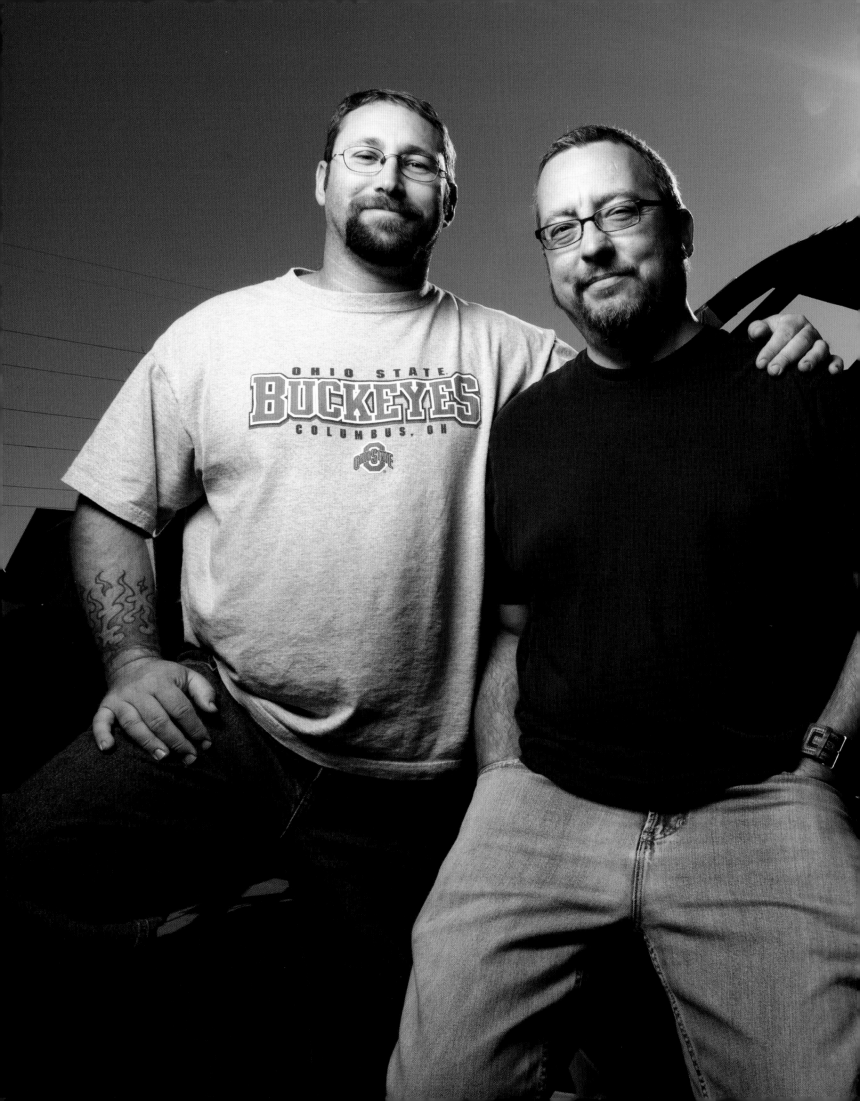

KEVIN & ERIC Spartanburg South Carolina

My partner Kevin and I have been together for almost seven years. We have a thirteen-year-old son who is Kevin's biological child. Our son lives with us full-time since his mother deserted him when he was two years old.

Kevin and I own a house together, have three dogs, two cats, and about fifteen tropical fish. Our house is often a wreck, but we'd rather be doing things we care about and enjoy than spend every waking moment trying to keep fur off the floors.

We love reading, traveling, cooking out, playing cards, and spending time with friends. Our biggest passion is our interest in 1960s and 1970s muscle cars. We have a 1967 Dodge Coronet that we are just beginning to restore.

Another one of our more unusual hobbies is demolition derby. If you are not familiar with derby, it's a contest where drivers in reinforced cars compete by smashing into each other.

I am more of a spectator, but Kevin has driven in derbies for over ten years. Three years ago he won first place at the state fair and since then he has won second place twice. He's very talented at it.

KEN Charleston South Carolina

When I was seven, my family moved from D.C. to Florida to increase my father's quality of life. He had quadruple-bypass surgery when I was four. Less than a year after moving, he died of a heart attack. His death was not something that was discussed openly in my family, so I buried my feelings and put my attention to performing well at school.

After graduating high school, I moved to Charleston to study culinary arts at Johnson & Wales University. I wanted to be a chef. I got a great job during my second year of school at a French restaurant called Restaurant Million. I learned from a European culinary master and spent the next decade working in Charleston restaurants.

Leaving Tampa and my family behind at eighteen, I had decided not to hide who I was and live an openly gay lifestyle. The hospitality business was very welcoming to all types of people, so it seemed like a perfect fit. Still hiding the pain of my father's death, I focused on studying food. Though it brought me a great wealth of culinary knowledge, it also gave me a lot of stress and an unhealthy lifestyle, which included smoking, excessive drinking, and drug abuse. The substance abuse was due in part to my father's death, but also as a way to deal with the confusing messages I was getting about being gay. Many coworkers and peers were quick to welcome gay men and women to the table, but professional kitchens are very competitive, male-dominated, egocentric cauldrons, so there was always an undercurrent of homophobia.

The need to constantly prove myself to compensate for my queerness also stoked a fire of egotism that challenged my relationships. Publicly I was celebrated for my talent, but personally I was never really one of the gang. A missing piece I discovered many years later was the lack of any gay role models for me. There are successful gay men and couples who live in Charleston, but the need to remain closeted here keeps them unavailable as examples to the young population.

Over time, this claustrophobic environment rendered me constantly tired, often depressed, and overweight. Realizing the need to change, I took up yoga simply as exercise and a way to relieve some of my stress. That is where my life turned around and began an upward spiral. I practiced yoga daily and met many of the people I had been looking for, people who were truly accepting and loving, to whom I didn't need to prove myself or excuse my gayness.

Through the many relationships that have since developed, being gay has become a part of my life I can now celebrate. I have grown into a man who is very proud of who he is, faults and all, and I want to let others learn from my experience, and be the example I didn't have.

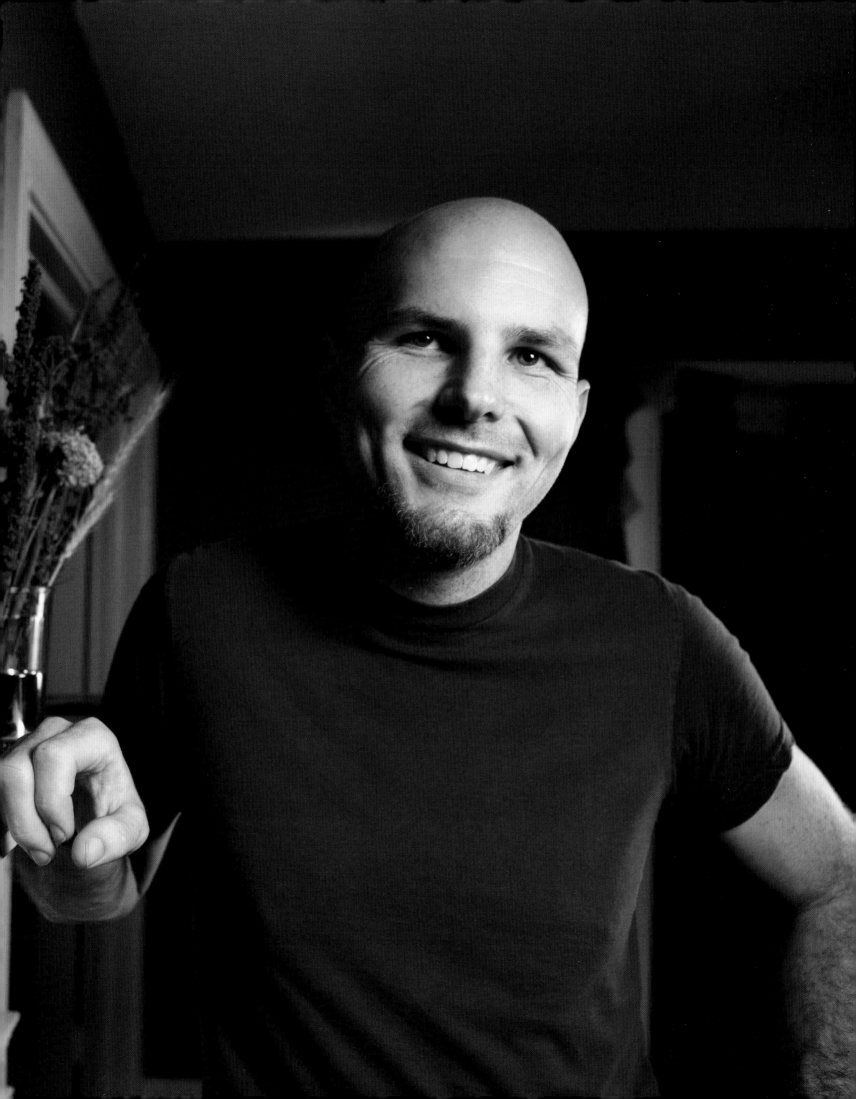

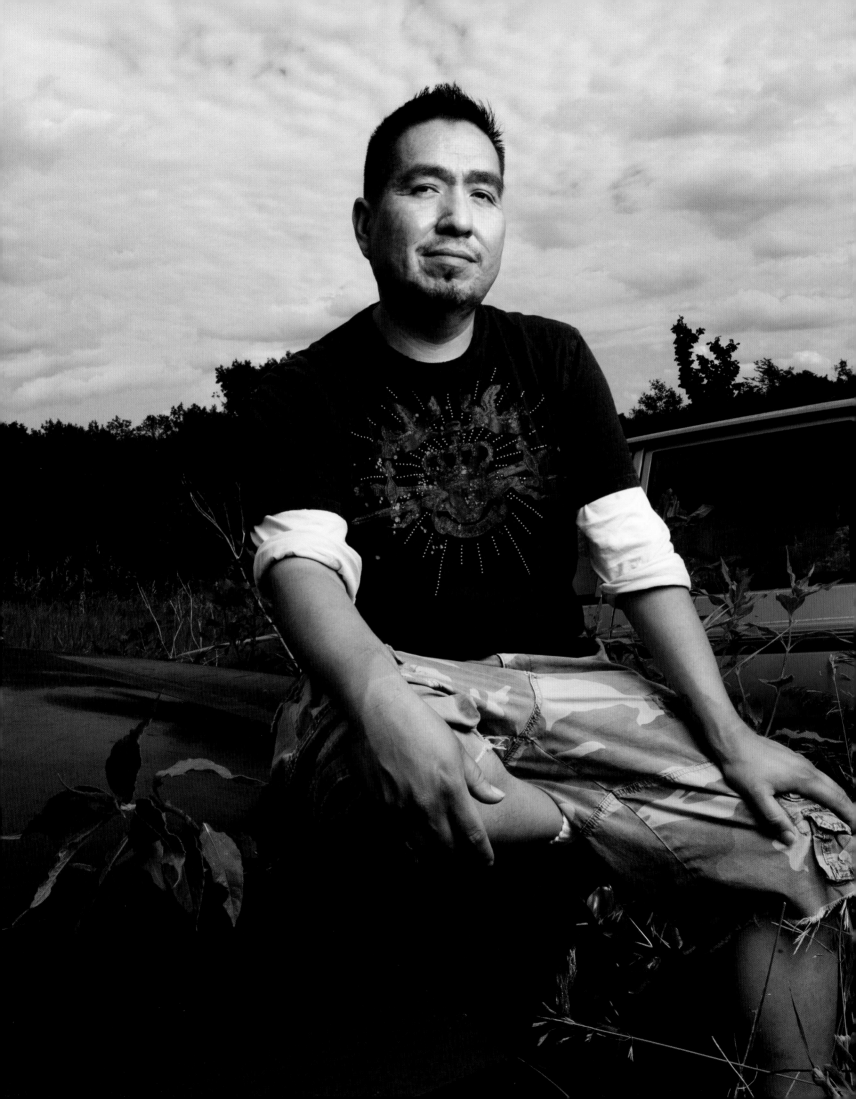

STACE Sisseton South Dakota

I **am a gay Native American living out and proud on the reservation.** I have lived here almost my entire life. I even went to college here. It taught me so much about my culture and history.

Traveling off the reservation is always a good feeling, but I truly love it here. The Dakotah way of life is dear to me; I am who I am because of where I'm from. My people have always looked at homosexuality as a person having two souls, a male and female. Hence, gay people are considered to have the gift of seeing things from both a man's and a woman's perspective.

My relationship with my family is awesome. My brothers and sister and I all get along very well. My mother is very supportive and loving. She has sacrificed much to give me a good education, which she fiercely believes is important to have.

There are always people who hate gay men, anywhere you live. I do go through a lot of issues. It is difficult to get a job because people know I am gay. And there is so much inequality. Despite that, I still love it here. I live my life as best as I can, and try to always treat others with respect, even when I've been disrespected.

HARRY & NEIL
Dale Hollow Lake Tennessee

My partner Neil and I have been together over **seventeen years.** We met at a nightclub. We bought each other drinks, got to talking, hit it off, and moved in with one another within days of meeting. We've been together ever since.

I was raised on a cotton farm in rural Mississippi. I worked on the farm from an early age, did well in school, and joined the Navy after college. Neil was raised in the Missouri Ozarks and is a self-proclaimed hillbilly.

Our rural childhoods led us to the nudist lifestyle. We enjoy the outdoors, nature, and the freedom being nude gives us. It's relaxing. When we decided to start working for ourselves, we sat down and thought about our ideal job. Key requirements were being our own boss, control of our daily experience, ability to work from home (preferably nude), and being together as much as possible in the outdoors. We both enjoyed camping, and Neil had some past experience with a campground business. So we set our goals, worked hard, saved, planned, and made our dream a reality.

After eight years of building and running a successful business, we wanted to downsize, so we sold the business and moved to Tennessee. We had survived a house fire, I had been diagnosed with Crohn's disease, and Neil's mom, who lived with us, passed away. We were ready for a change. Our best memories of the business are the connections we made with guys like ourselves from all over the world, with our neighbors, and the closeness that working together allowed our relationship.

Tennessee has great natural resources, wildlife, no state income taxes, great housing prices, and our county has the smallest population in the state. We found a rustic rural cabin a few minutes' walk from the lake, simplified our lives greatly, and left those stresses behind. We have built a life together despite society's issues. We live our lives as men who love one another and find no shame in that. We're living a new dream.

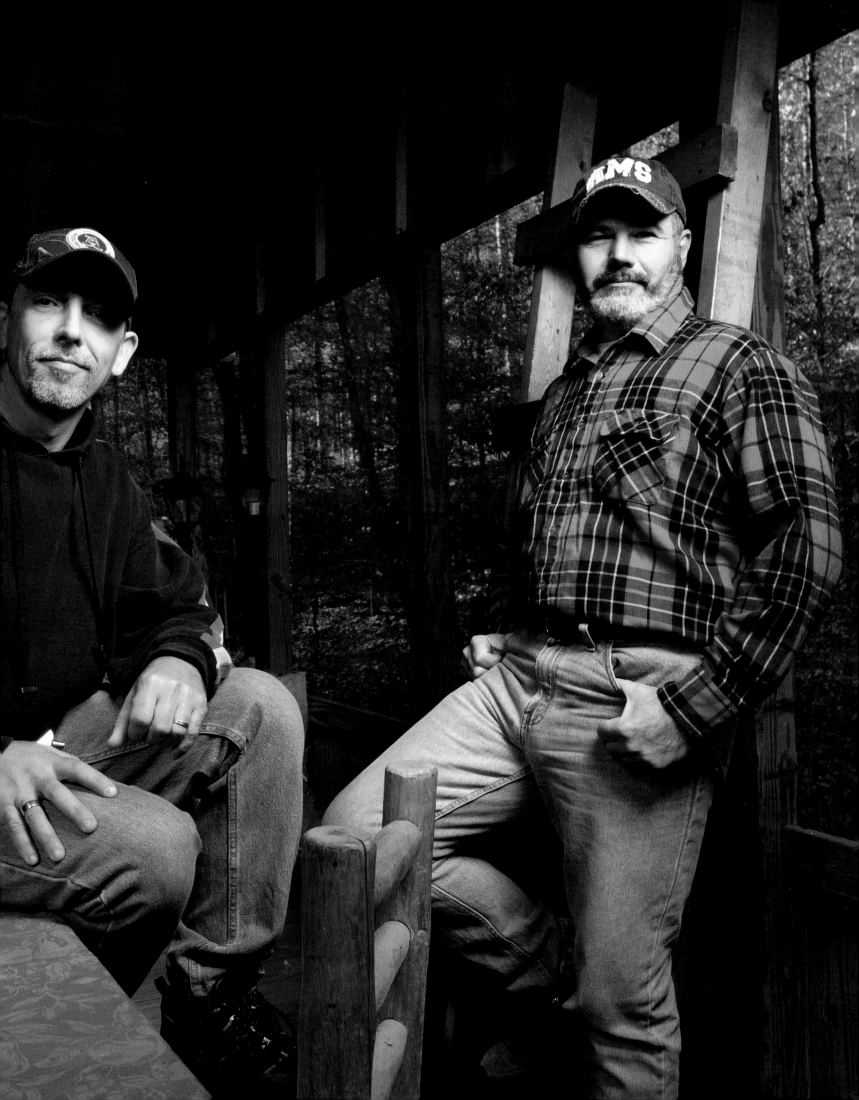

GENE Conroe Texas

From the time I was a little boy growing up in a rodeo family in south Texas I knew I was different than most kids. I always stood up for what I believed in, and I followed my heart when pursuing my dreams. If I wanted something, I went for it, even when someone said I couldn't or shouldn't. I grew up with all kinds of strange pets; as long as I took care of it, my parents let me have it. Today, I live on my ranch outside of Houston along with my horses, a menagerie of pets, fish, and birds, and a pair of white wolf hybrids.

I was the subject of a documentary about my life as a rodeo cowboy who happened to be gay. It was a life-changing experience. Filming meant coming out and a lot of publicity, but it let me represent a segment of society that for many years has gone unnoticed. It let me represent gays and lesbians who want to be recognized for their God-given talents and not their sexual preference. And it let me represent all Americans, straight or gay, who believe in fulfilling their dreams when others say you can't, or shouldn't, do something.

One thing I learned about being gay is that if you are always hiding with your hands over your face, then people are going to treat you as such. Since I have come out publicly, I no longer feel as if I have anything to hide. It's like the weight of the world has been lifted off my shoulders. I love myself now like everyone should, openly and honestly.

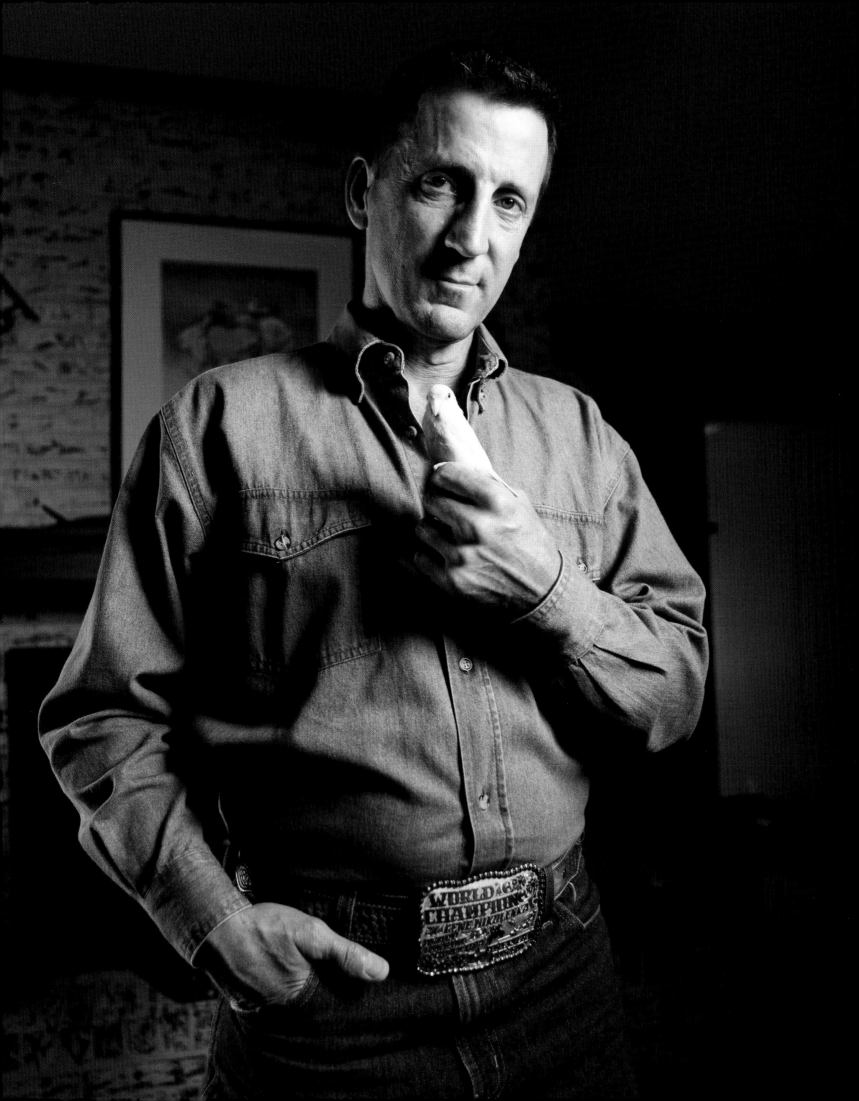

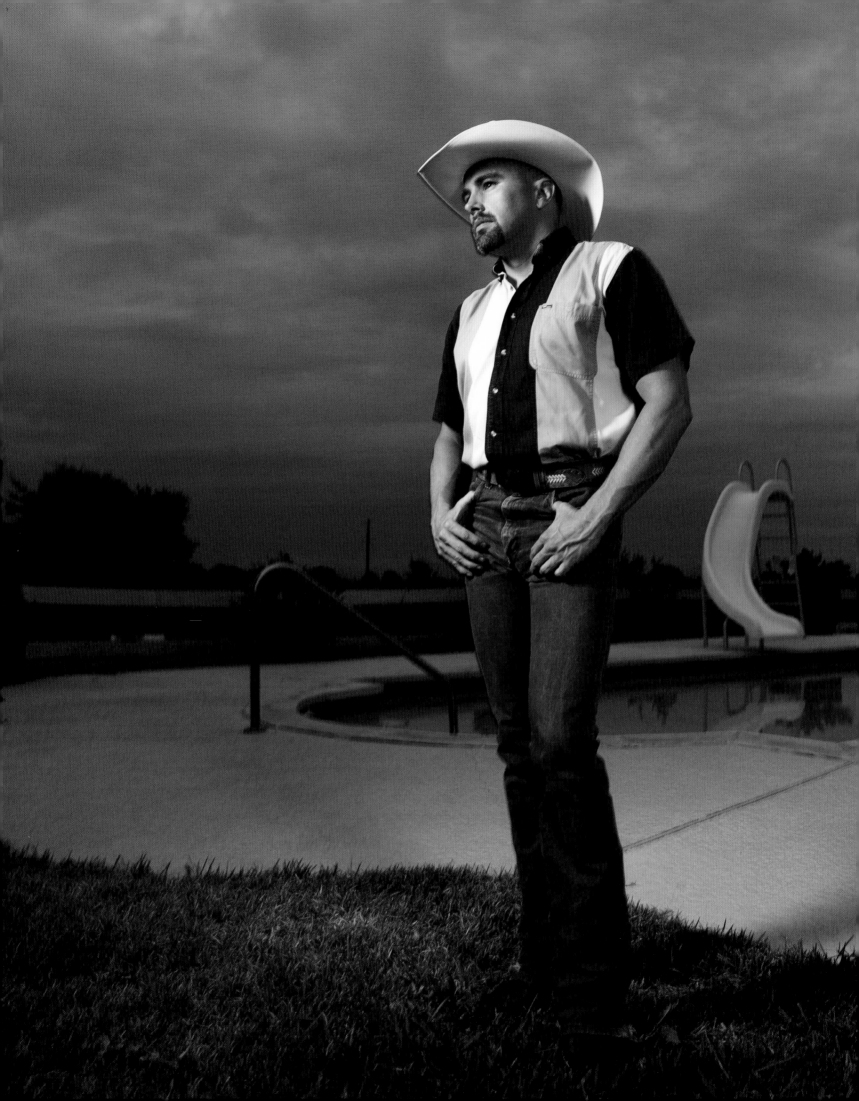

BRIAN Austin Texas

I'm a bit of a maverick, a roamer, and a wanderer. The most stable time in my life was my childhood. Growing up in the Sierra Nevada Mountains in the small California town of Twain Harte, I spent all my time playing in the forest. We had miles and miles of woodland around us. As an adolescent I resented where I lived—it was too remote, too far from my friends. Now, as an adult, I envy those who are able to live and thrive there.

I left home at eighteen and spent a few months in southern Oregon before returning to California to attend college, where I came out. After I graduated, I moved to San Diego, and learned all about computers and corporate life. I was young and eager to conquer the world, but after five years of living the gay lifestyle I longed to be back in the country. I found that just because I was gay didn't mean that I had to conform to the city culture of gay life. San Diego had become too big for me and was not fulfilling on a spiritual level. I met a couple while on vacation who were moving to Austin and they suggested I take a look as a possible place to live.

Texas was *hot*, but there were rolling hills and the people were friendly. I was living on four acres outside of Austin with a couple of friends, enjoying both the country and the many comforts that come with city life. Ultimately we lost the ranch to foreclosure, but I was able to turn what some saw as a tragedy into a dream come true.

A few weeks before losing the house I bought a fifth wheel RV. I moved myself, my three dogs, and my cat into my escape pod. It has been two years since I made that move, and I have never been happier. I am now free to roam the country, taking my family and my home with me where ever I go. Native Americans had the right idea keeping their lives so mobile. There is nothing more liberating than coming home one day, hitching up the house, and moving on to another town miles away. The scene outside my windows changes regularly and I love the mobility. There truly is a different way of life for each of us, and I have found mine.

BRUCE San Angelo Texas

I **have the usual stories of growing up closeted gay in West Texas in the fifties and sixties—from the elastic-strapped, plastic high heels at the five and dime, to the troll dolls with their fabulous hair.** By the time I was in high school, I saw graduation as the pinnacle of one's youth, followed by reality. My father told me on graduation night, "Son, you're leaving for college, and I think you should search the campus for a little lady to marry and settle down with." That was when I told them I was gay. My mother shook her head and said, "No, don't say it," while my father sat there in his chair. It was not pretty. I left that evening for Houston where I was pre-paid for one semester at the University of St. Thomas. Hello city, hello sex, drugs, and rock 'n' roll.

I worked and finished three semesters, shocking the priests and staff with my colorful costumes and behavior. I played poker with Alice Cooper and drank with Bonnie Raitt at Liberty Hall. A housemate purchased 350 acres in northern Oregon, so I dropped out and moved with him to the farm. It was totally raw, never a dull moment. I dropped acid and watched how similar the hogs were to people at the dinner table. After four months I really wanted to see electricity and disco again, so I packed up my baby blue convertible and moved with a friend from Houston to Mill Valley, California. I went to beauty school during the days, and babysat for my friend, Ruth, at night. While I was in Texas for some dental work, Ruth burned the house down. No one was injured, but it was a total loss. I transferred to beauty school in Austin, where I graduated.

After finishing school I landed a job as an apprentice to a bunch of Vidal Sassoon stylists in Dallas. The salon did not fare well, due to the fact that Sassoon wasn't doing big bleached Texas hair. But the group introduced me to the Kim Dawson Agency, who styled for major fashion. I met fabulous models and still keep in touch with them to this day. I moved to Chicago, but grew weary of the weather and wound up in Key West, Florida. I did odd jobs: cleaning, backyard haircuts, running the lights at some disco. I was still in Key West when I received a telegram from my father saying the doctors were giving my mom three months to live. She had been battling cancer for eight or nine years.

So I moved home, back to San Angelo, to be with my mother. I figured I could comfort her for a few months and be with her when she passes, and then move on to New York. Well, I will be goddamned, but Zada Rose lived five more years. Her baby had come home and she couldn't go. She was in her early sixties when she did pass, almost the age I am now. During those five years I opened several salons and today I have a remarkably distinguished clientele. I dabble in the arts: painting, theater, cooking, decorating and redecorating. I just can't slow up. My motto is "Life is too short. Order dessert first."

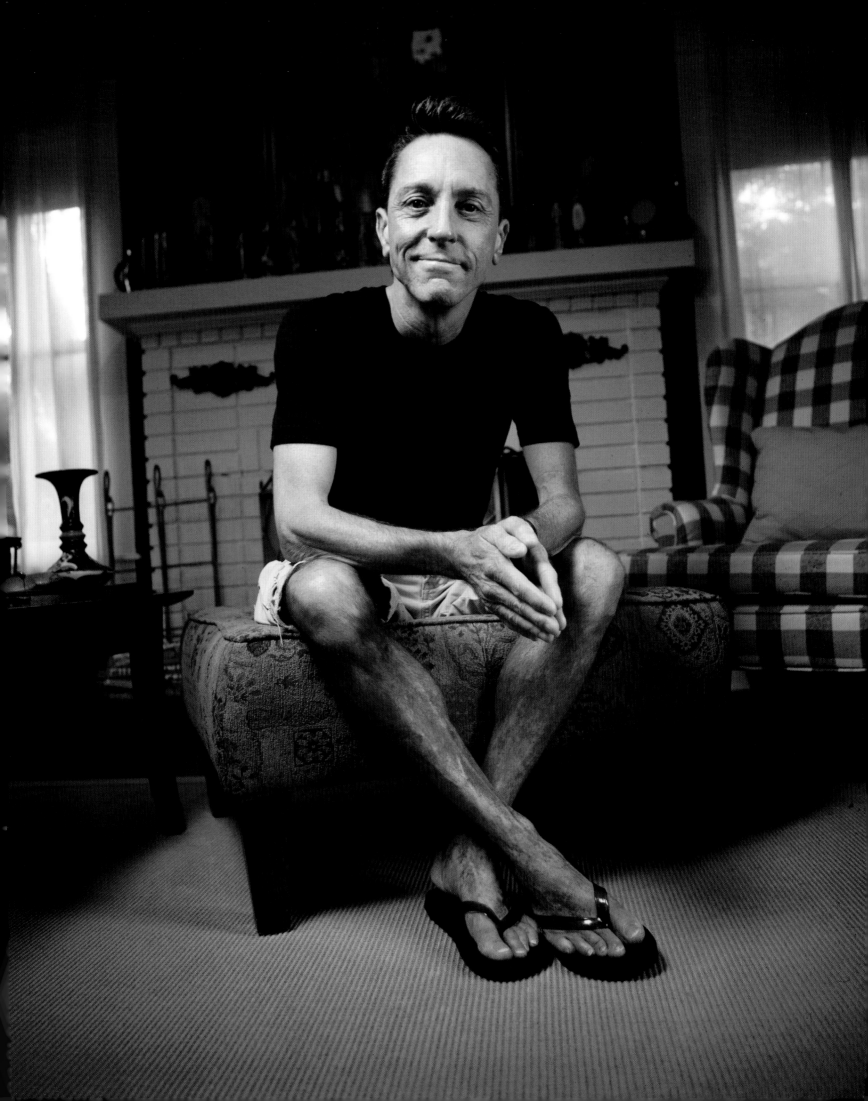

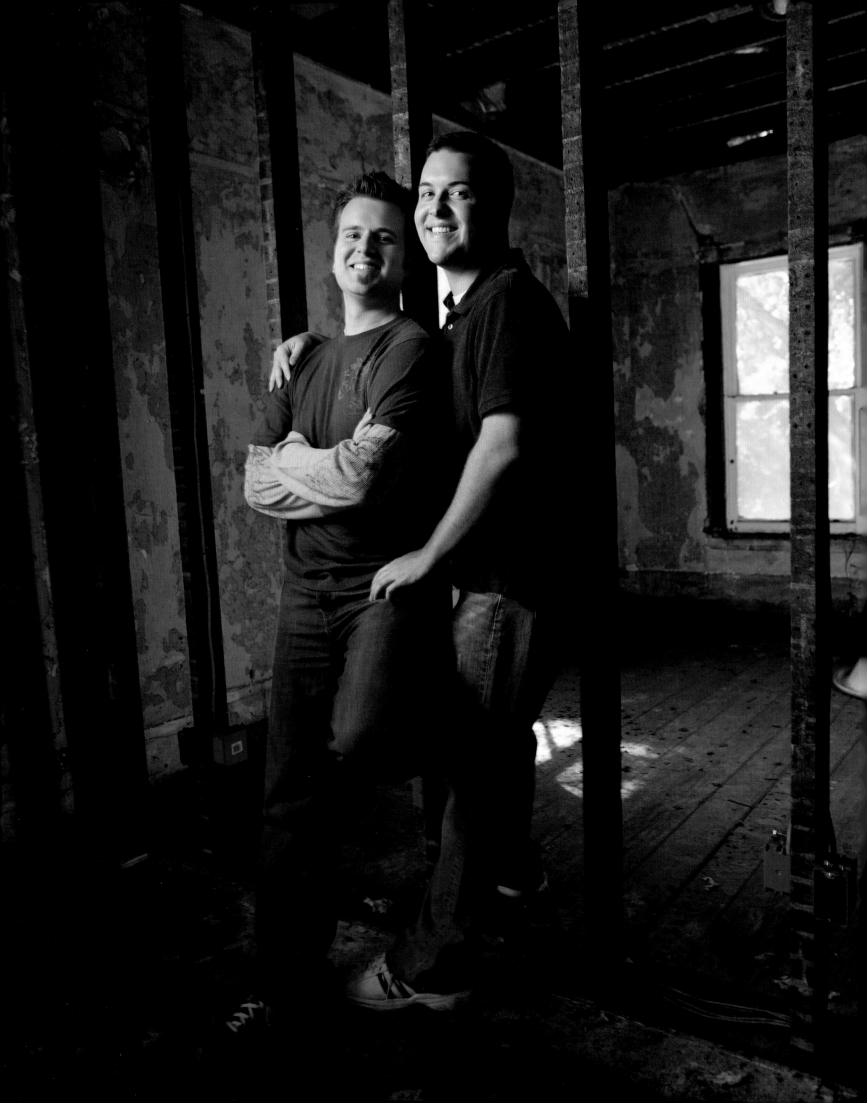

NICK & PATRICK Salt Lake City Utah

'm a gay Mormon. I live with my partner, Patrick, whom I've been with for seven years. I came out ten years ago, right after my junior year of high school.

I'm an only child. My parents did the best they could with my coming out. It wasn't pleasant or easy, but we have a great relationship now. I have a large extended family that is very religious. My parents were never the most devout Mormons (fortunately), but their families are. Most of my relatives have responded well to my being out; with the rest, it's just not a topic that's brought up for discussion, though they all know Patrick and ask about him when he's not at family gatherings. Mormons work very hard to "love the sinner, hate the sin." It's an incredibly aggravating attitude, but it could be a lot worse, so I'm grateful.

Patrick's family, on the other hand, practically threw a party for him when he came out. They welcomed me into their family immediately, and there was never an issue—even with his grandparents, who are in their mid-eighties.

We know we're lucky.

Patrick and I hope to have children someday, somehow. We are renovating an ancient, dilapidated house in central Salt Lake City. I love it here. Sure, it can be politically aggravating, but on the other hand, it's beautiful, the people are friendly and real, and the quality of life is incredibly high. We have great friends, good jobs, and there's better nightlife and culture than anyone ever thinks. I spent my high school years dreaming of escape, but now I can't imagine living anywhere else.

CHARLIE Montgomery Center Vermont

I grew up in a Norman Rockwellian sort of town in Massachusetts, right on the ocean between Boston and Cape Cod, where my mom's family has lived since the boat landed, with an amazing family that supported every endeavor I ever went after. My friends used to make fun of me for being a "parent's wet dream"—I rowed crew, I was an Eagle Scout, on the advisory board for the town's high school, active in the community and church. I was the perfect kid. So the last thing I wanted to do was ruin that—to cause what I expected would be a disappointment to my family—by coming out.

I've known I was gay since the first day of seventh grade, but I didn't actually come out to my friends until I was almost finished with college, and not to my family until I was twenty-four—long after I'd moved out and was on my own. I guess it's one of my only real regrets in life, not sharing all of me with the people I was closest to earlier then I did. My fear was always that if I came out I would be defined by being gay, and not by anything else that made me who I was—my hopes, my dreams, my passions. I was afraid that label would take over the conversation, I'd get put in a box and no one would ever look at me the same way again.

Growing up, the only gay role models I had were on TV—characters like Jack from *Will and Grace*—or what I could dig up on the Internet. They were people I had no connection with, even though at the time they more or less defined my concept of what it meant to be gay. And I didn't really want any part of that. I was a guy. Not a fag. It was something I wrestled with all through high school and well into college in Vermont where I studied forestry. It was all chainsaws and timber, Carhartts and hard hats, grease and dirt. Tall trees. Tough men. Straight stuff. Definitely not gay. But it was what I loved. So I lived for a while stuck there between two worlds trying to reconcile how I could possibly fit into both of them.

That's when I started to realize I probably needed to change my definition of what it meant to be gay—because in the end I was really the only one it mattered to. If other people wanted to define me by something that probably means more to them then it does to me, then fuck 'em. I didn't need to compromise who I was in order to fit a prefabricated person. There was no "if this, then that," only whatever I wanted out of life, and whatever I was willing to go after.

After college I went to work in the Adirondacks with a big timber investment company, administering logging operations and developing forest management plans, and—with a bit of hard work and a whole lot of dumb luck—I ended up where I am today, moving back to Vermont to take over a company here. So for the past three years, northern Vermont is home once again. Being outside, making a living essentially getting paid to play in the woods—it's pretty much the best job in the world. While I'll never get rich doing it, I can say for certain that my life is richer because of it. It's the most beautiful place on Earth—not just physically, with the mountains and forests, but the people here. Our town is nestled up near the Canadian border with only about 900 residents so, yeah, it's small, but the sense of community here is bigger than you'll find in any city in the world. Next to skiing (with the best in the East right up the road), the town's favorite past time is to party, so it's a sort of a wonder anything ever gets done around here. It's paradise for anyone who loves to be outside, and who doesn't want to know the definition of a desk job.

But there are days I look around and wish my pond was a little bit bigger, with a few more fish in it. Days I wonder what it would be like someplace else, with a slightly different story to tell. I still can't say I honestly know what I want to be when I grow up, or where I may be ten years down the road, and I might never have that one figured out. Maybe that's the fun part. The one thing I do know is that right now, I'm happier than I ever have been. And I guess that's a start.

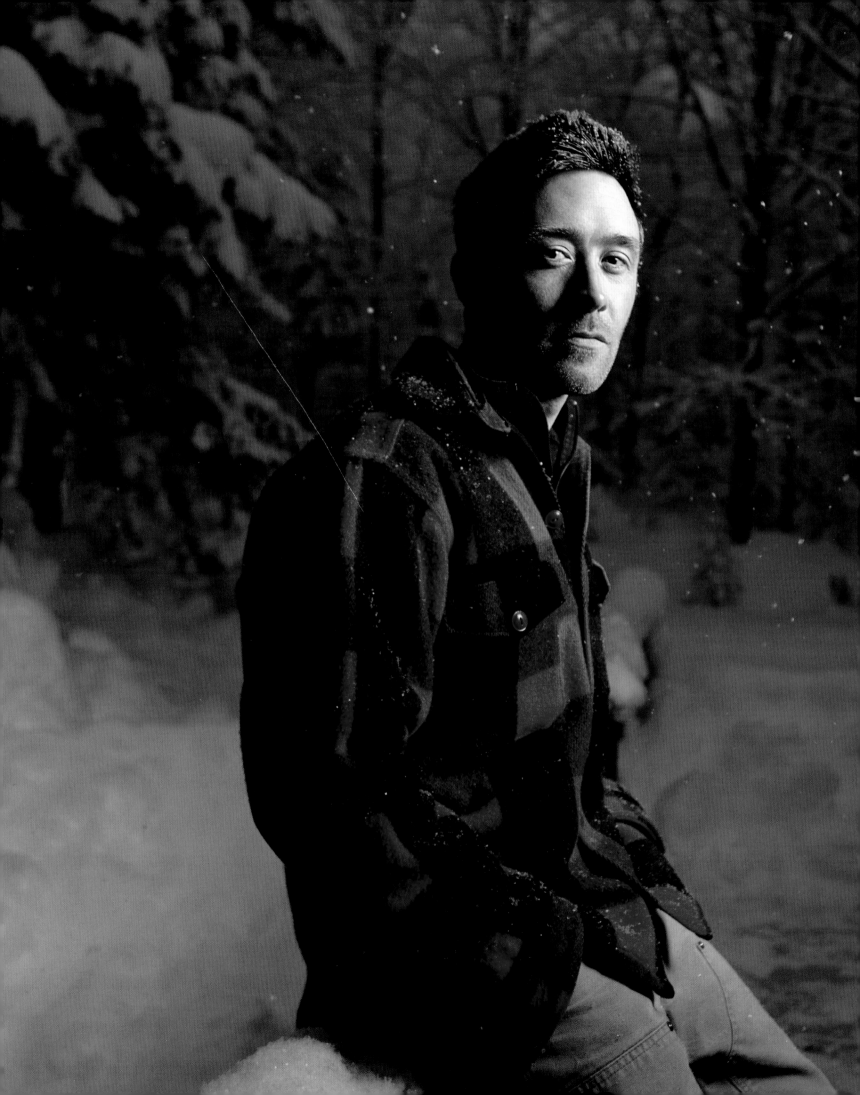

WILL Burlington Vermont

I contracted HIV in 1991, at the height of my career as a classical musician. I had come a long way from the Vermont dairy farm I was raised on. I knew I was gay from the very start, so life with Dad was pretty rough. I discovered in school that music was my passion. It liberated my soul and physically liberated me to the Curtis Institute in Philadelphia. I left Vermont with pleasure, never to return, I thought.

After I contracted HIV, my confidence eroded over the next ten years to the point where I had no choice but to quit music altogether. It was devastating. I moved back to Vermont, which was also devastating. But something happened here. I found out who I was again. I slowly regained a sense of self by walking, talking, swimming in the magic waters of Lake Champlain, working out, eating, and loving my nieces and nephews. I began to see HIV and all my pain like the scars of a gladiator, to be worn proudly.

Although scared to death of failure, I decided to go back into music. I went to Venice, Italy in search of an appropriate instrument and found the double bass, the instrument I had always dreamed of. I thought getting my chops back would be like climbing Everest, but not so. All the pent-up joy and passion during my years of not playing exploded, and I was flying around the bass like never before. It's been unbelievable. I'm so in love. To lose the thing you loved and to find it again is the greatest gift. I'm so incredibly blessed.

CHRIS Chester Virginia

I've always been known as the big kid, the one people befriend mostly out of pity.
When I began exploring my sexuality in junior high school, kids told me they expected
it of me because I was so big that I couldn't get a girlfriend, and being gay was a last
resort. I always brushed off the jokes and taunts, but I wondered if it was true.

A good friend of mine convinced me to tell my mother. When I tried to explain my
feelings, she reacted terribly and threatened to kick me out. She couldn't fathom having a
gay son. After not speaking for a night, I told her I was joking and just said it for attention.
It hurt to lie, but I couldn't bear the awkwardness between us. The following year I started
high school. I wanted a clean slate, to just start over. But the thing about high school is, kids
are vicious and persistent. They will rub you raw until they hear the information they want.

For the first two years, I tried to ignore the teasing and name-calling. I tried to suppress
the rumors by dating girls, but I was only hurting them by pretending to be something
I wasn't. It seemed that more and more of my friends turned against me. That's when
I decided to turn to the one person people said would never help or accept me: Jesus
Christ. I started to attend church regularly. I met a youth pastor who turned out to be not
only my savior, but also my guiding light. She helped me feel accepted. I was shocked,
because any time I thought of being gay, I thought about burning in Hell and never being
accepted by Christians.

I joined a program similar to Habitat for Humanity known as Impact Virginia!, spending
time worshiping and building houses for the less fortunate. It was a place for Baptist teens
to make friendships with the Lord and each other. I mostly went to bond with my youth
group and hopefully make friends with them. One night we had a guest speaker tell us
a story about how his brother was gay and how he would never stop loving him for it.
He could never bash his brother for his lifestyle, even though he had seen so many other
fellow Christians do the same. He went on to say that our sexuality didn't define us in
God's eyes, it was our acceptance of Him that did. I was dumbstruck. It was as though he
had read my mind. At that moment it seemed like years of doubt and denial had came
flooding toward me and knocked me breathless.

After the speech was over, my group sat down near our rooms and began to chat. I
looked at all of them and simply said, "I love all of you and can understand if you don't
want to be my friend after this, but . . . I'm gay." They all kind of looked at me like I'd thrown
up. Then one by one they stood up and began to hug me. I couldn't help but laugh—I was
so surprised. I expected them to go running for the hills!

Since then, I've been on two mission trips and I volunteer at Bible school. I recently
came out to my mother, only to have her apologize for the way she originally reacted.
Before my experiences, I never knew what the word "comfortable" meant. I thought laying
in bed was being comfortable. Now I know that it means being who you are and showing
your true colors. I'm not afraid to be a gay teen in America. I pride myself on the fact.

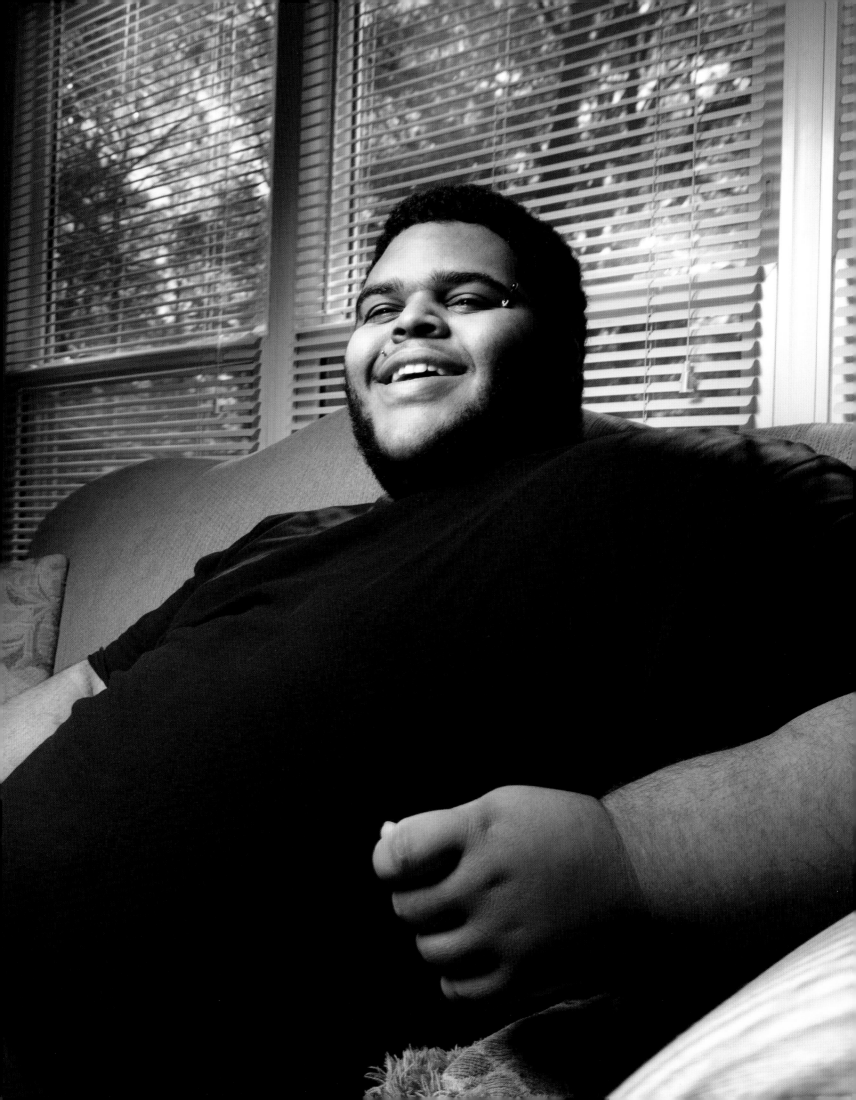

JAKOURY Chester Virginia

I live in what I would call a "retirement" town. There are lots of elderly people, everyone here is pretty conservative, and there are very few activities for people to do. When I entered high school I had just moved here from Atlanta, and it was an extreme change of pace for me. Everyone was quiet and tightly compacted into the stereotype of what was acceptable.

I always knew I was gay, and in Atlanta I was slowly beginning to show it. I told my mother before we moved away and she was fine with it, but I was afraid to tell my father. He was a military man straight out of the country; I doubt he had ever come into contact with a sexual minority, let alone spend time with one. When we moved, we left my mother behind. They weren't quite divorced and they weren't quite together. I guess they assumed that moving away from each other would help them realize what they really wanted.

When we got to Virginia I was excited about the fresh start; I could just come into school gay, no need for a back-story, no need to make friends, I could just be myself. I quickly found that being out of the closet wasn't going to go over easy. Everyone in town was a carbon copy of each other. All the kids wore the same clothes and looked exactly the same. I forced myself to fit in, even carrying on relationships with girls from time to time. I was upset I had to act this way, to put up a front.

During a visit to my mother, I told her how unhappy I was. She explained to me that if the people at my school couldn't accept me as gay then they really weren't my friends at all, and that I wouldn't know those people ten years from now. She said I shouldn't be something I'm not just to impress people. On the way back to Virginia I decided I would be an out gay male, probably the first my town had ever seen. It was a long ride back, and I told my father everything. At first he was uneasy, but he told me he was going to love me regardless.

When I returned I cut my hair into a mohawk, got rid of all my masculine, loose-fitting clothes, and became more fashion-forward. I was on a high; I loved being myself. Unfortunately, other people didn't. I was ridiculed, mocked, bullied, and harassed. People called me a faggot, wrote "fudgepacker" on my locker, and even threw things at me. Every night I would cry. I was so miserable. I got into fights and was beat up a few times. Someone vandalized my house, writing "faggot" across my front door. My father had enough. He put me in boxing classes and told me to stop being so passive. I spent the whole summer learning to defend myself.

On the first day of tenth grade I got in a fight and made an example of the kid. If anyone insulted me I would curse them out so bad that they'd never want to utter another word to me. I became a bit of a bad-ass, but I was happy because people stopped bullying me and started looking up to me. More and more, boys started coming out of the closet, and became examples of how happy gay teens could be. I started a small gay student association at my school and became actively involved in a youth group for teenagers in the city. I'm not worried about fitting in anymore.

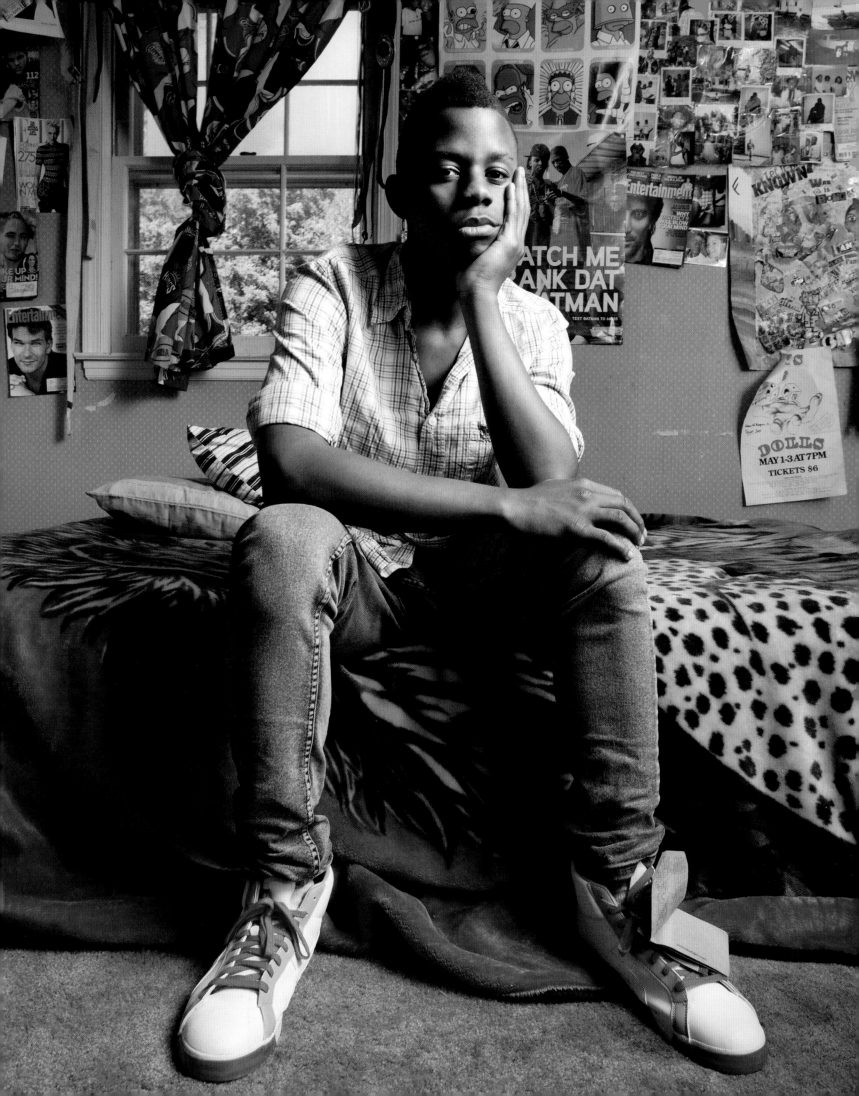

HARNIK & PAUL Seattle Washington

I met Paul at a Human Rights Campaign fundraiser. We had both become content with our lives as single men, but deep down the fantasy of romance had never really faded. That night was a kind of reawakening. Our love is one of mutual education. It is always a process of compromise, understanding, caring, and communication.

Our cultural balance is ideal, to say the least. I'm East Indian, born in New Delhi, and always aim to strike a balance with the best of both Indian and American culture. I'm a Sikh, but more spiritual than religious. Paul is also very spiritual; we can pray to God together and remember Him without there being any conflict in our beliefs. We've gone to church and to Gurdwara together. We value family, food, and friends, and share a deep respect for others (especially elders). While we are an interracial couple, we share in our histories of oppression and our cultural values.

We are proudly gay, but it doesn't consume who we are, and we don't fit the media stereotype of "gay." We value our masculine and feminine attributes, and don't flaunt either, and love others who choose to flaunt it at the same time. There are things we will never have in common. Paul is a software engineer, the coolest and hottest geek I've ever met, with a love of cars, video games, and *Star Trek*. I'm a project manager working in international public health, the social butterfly of the relationship, interested in travel, fashion, and shopping. Paul is practically a chef, and I am in charge of cocktails and dishwashing at dinner parties—it's a perfect balance.

We have everything we could want, especially in each other. We have ideal contrasts and perfect complements, unconditional love with a commitment to communicate with each other along this crazy path we call life. We recognize our blessings because we have both been without them. But in the end we know everything in life happens for a reason.

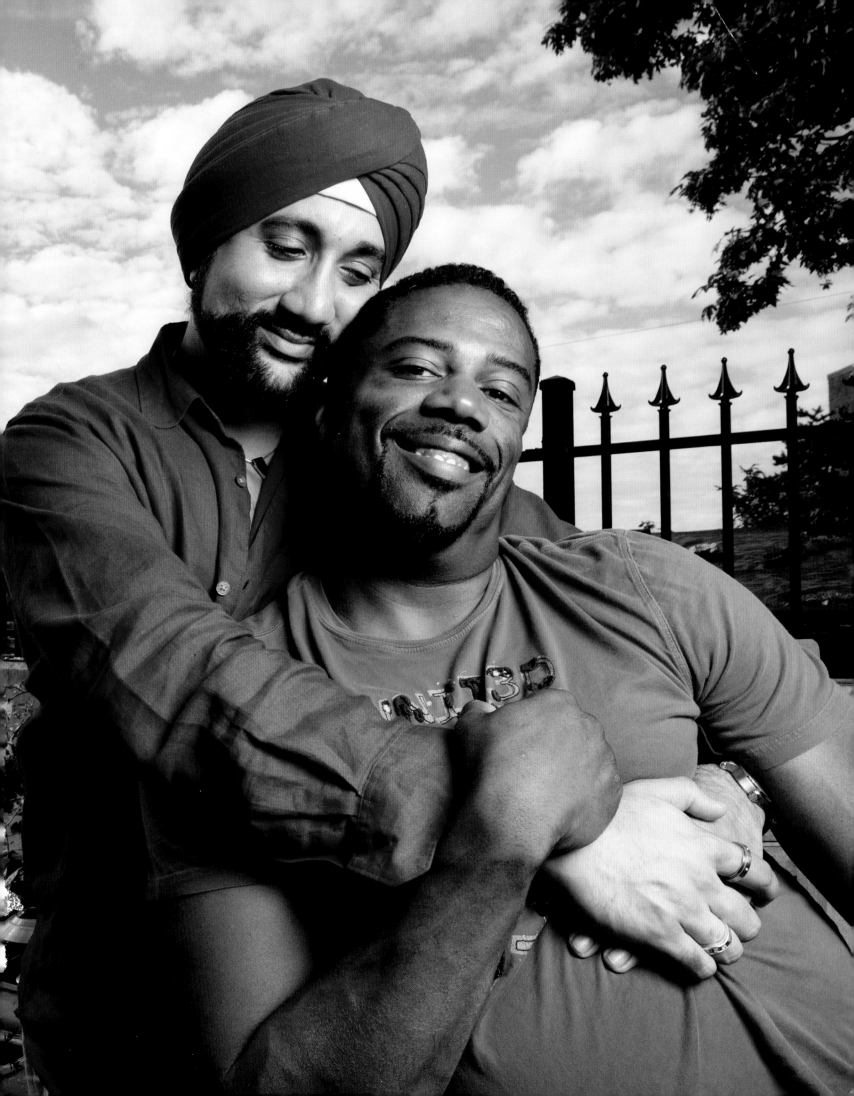

ANTHONY & KEVIN Kennewick Washington

I was raised in a very small town, in a very religious family. I knew I was different from an early age but had no idea how to identify what it was that made me feel that way. I followed all the rules society told me to, but it never seemed quite right.

When I was in college I met a woman who went to my church, and I believed marrying her was what I was supposed to do. It wasn't until I was twenty-six and met a man at my gym that I truly discovered what it meant to be gay. It was like discovering the last missing piece at the very center of a puzzle. When that first relationship ended shortly after it began, I was devastated and went deeper into the closet. I made my family move away from Seattle to a smaller city where I thought I could just be normal. We had two children, and I remained very unhappy and closeted for another seven years.

When Anthony and I met in the late nineties, we were part of a growing number of gay married men coming out of the closet due to the opportunity provided by the Internet. I know many men who found solace in the ability to connect online with other men in similar situations. It opened up the closet door slightly, and a few brave ones kicked that damn door down. A few friends told me that I came out of the closet so fast I had hangers stuck in my hair!

My partner's coming out was a little bit rockier. A doctor, Anthony had moved from Syria to the States in the seventies, and due to professional and cultural pressure he hid his sexuality and married a woman, with whom he had four children. He was flying his son across the country, and when his son asked him for a book to read, he handed him one from his bag called *Gay Fathers*. His son didn't say anything at the time, but told his mother about the incident.

A few months later Anthony was on his way home from a trip to Seattle, and his wife called and told him he was not welcome home, and that she was divorcing him. The next year was a very difficult time, and I am so glad we met and were able to understand what the other was going through.

Anthony and I moved in together in 1997 and have been together since. That fall I was fired from my job because someone told my supervisor that I was gay and living with another man. We did not have the same laws to protect us in Washington state that we do now, and even though I talked to a lawyer, he made my case sound so terrible I decided it wasn't worth it to fight, and ended up switching careers.

Since then our lives have changed. Our kids have grown to be well-educated, open-minded, accepting adults. We are very proud of the positive impact we have had on our six great kids. We are both out in our lives, at work, and in the community. I have been the president of the board for the local LGBTQ youth center. We created it so that kids could have a safe place to go and not be judged. We wanted to cut down on youth suicide in the gay teen demographic. We've succeeded, and have helped launch gay pride in this small, relatively conservative city. We are opening minds, one at a time!

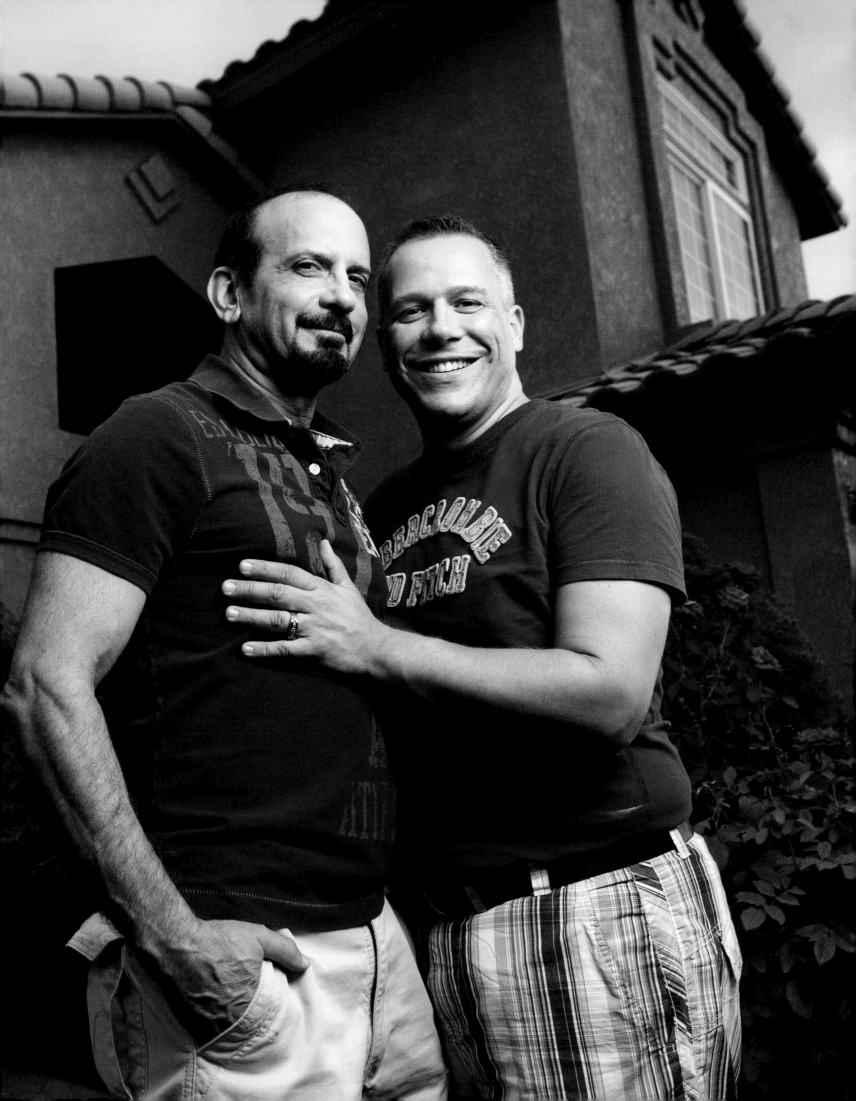

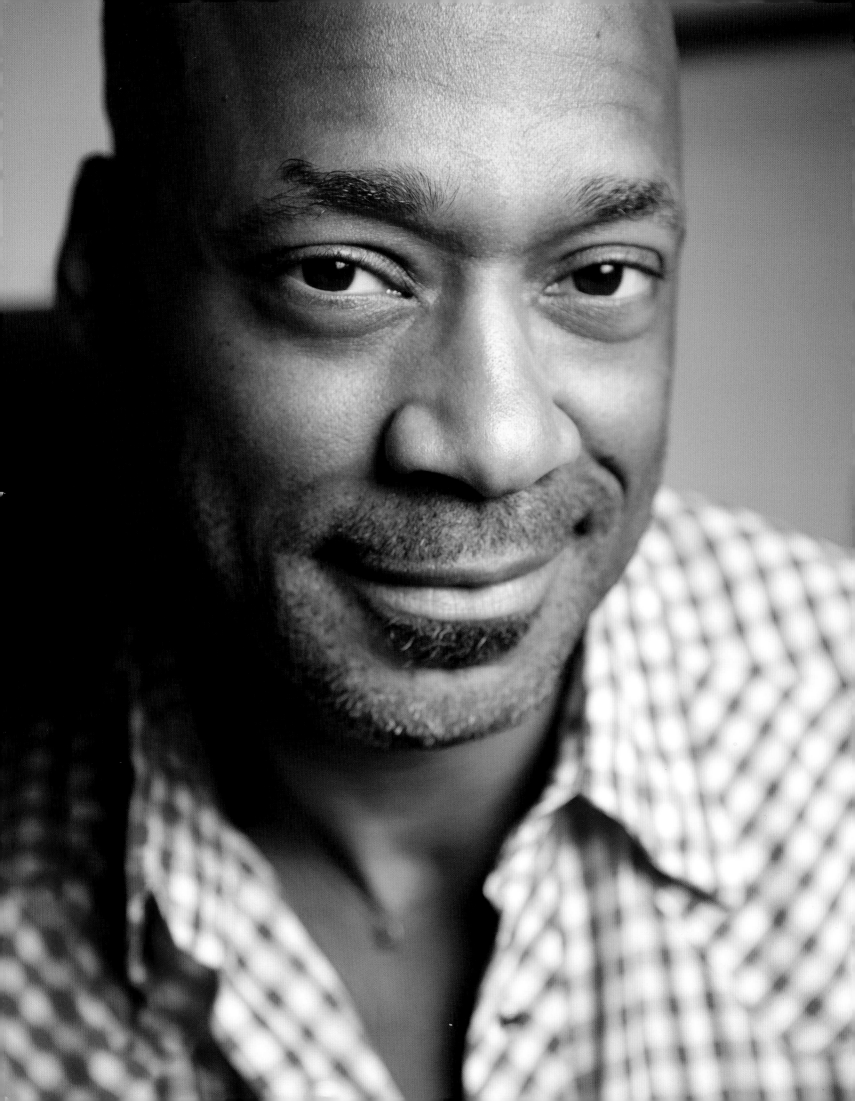

BRACE Seattle Washington

My approach to life is not about being gay. Being gay has to do with my sexuality, not with who I am as a person. I have never appreciated nomenclature that works to group people together based on expected identities. Like animals, our simplest needs are satisfied through food, drink, sex, and play—essential needs that define my person more than being male, black, gay, or American. I am a person who searches for love, friendship, and a sense of belonging, just like everyone else.

The challenges of being gay in Seattle are no different than anywhere else in the world. Some places are more accepting than others, but ultimately the challenges we face, individually and collectively, have as much to do with our internal environment as our external. I discovered this when I lived in Berlin and realized that my feelings would follow me no matter where I was.

A few years ago, I came up with four words that I truly enjoy: respect, responsibility, honesty, and love. If we make room for these things to exist in our external environment, it will hopefully reinforce our internal one. But we have to be willing to work at it—when animals want to eat, they have to work for it, otherwise they wither away and die.

I eat slowly to enjoy every bite, allow for idle time and reflection, walk, ride my bike, and work to stay present in each moment, no matter how much I would rather be elsewhere. My effort is to always be in my skin.

ANTONIO Morgantown West Virginia

My middle name, Q'ran, was chosen by my father. He was into black power and Malcolm X at the time I was born. I was exposed to many different religions growing up. When I was little, I was raised by my grandmother, who's Southern Baptist, like most of my family. My father was always the outspoken atheist, and after living with him, my views moved toward agnosticism. My opinion is that since there are so many religions in existence, who's to say which one is real or true? Why worry about it, if we'll find it out when we die? Just live in the now.

I've been gay for as long as I can remember. I recall pseudo-sexual play with other boys as early as seven years old. It's just who I've always been. There wasn't one big day where I was like, "OMG, I like boys." Being gay is just another part of being alive for me. My homosexuality doesn't define me, though. I'm more than just gay. I'm a son, a brother, a friend.

Over time, I've heard a lot of really epic coming out stories. Mine was never on par. In fact, I never really came out. I just was. I think a lot of my family knew before I did.

All I ended up doing was changing my MySpace orientation to "gay." About two weeks later my mom saw it and asked me about it. When I told her, she bought me some condoms, and that was that. The rest of my extended family (uncles, aunts, cousins) know but don't mention it. I was always the golden child who could do no wrong, and they still try to think of me in that way.

I'm in the middle of getting my bachelor's in Spanish, and I work at a gay bar here in town. When I get the chance, I like helping out Caritas House, a local charity that provides for people in northern West Virginia who are affected by HIV and AIDS.

After graduation I see myself traveling abroad. I want to go to Spain, Israel, Turkey, Ireland, everywhere. I want to see the sights, eat the food, and immerse myself in other cultures and the languages. I have a feeling that once I go away, I'll probably want to stay. I just want to get out there and have fun, no matter what I choose to do.

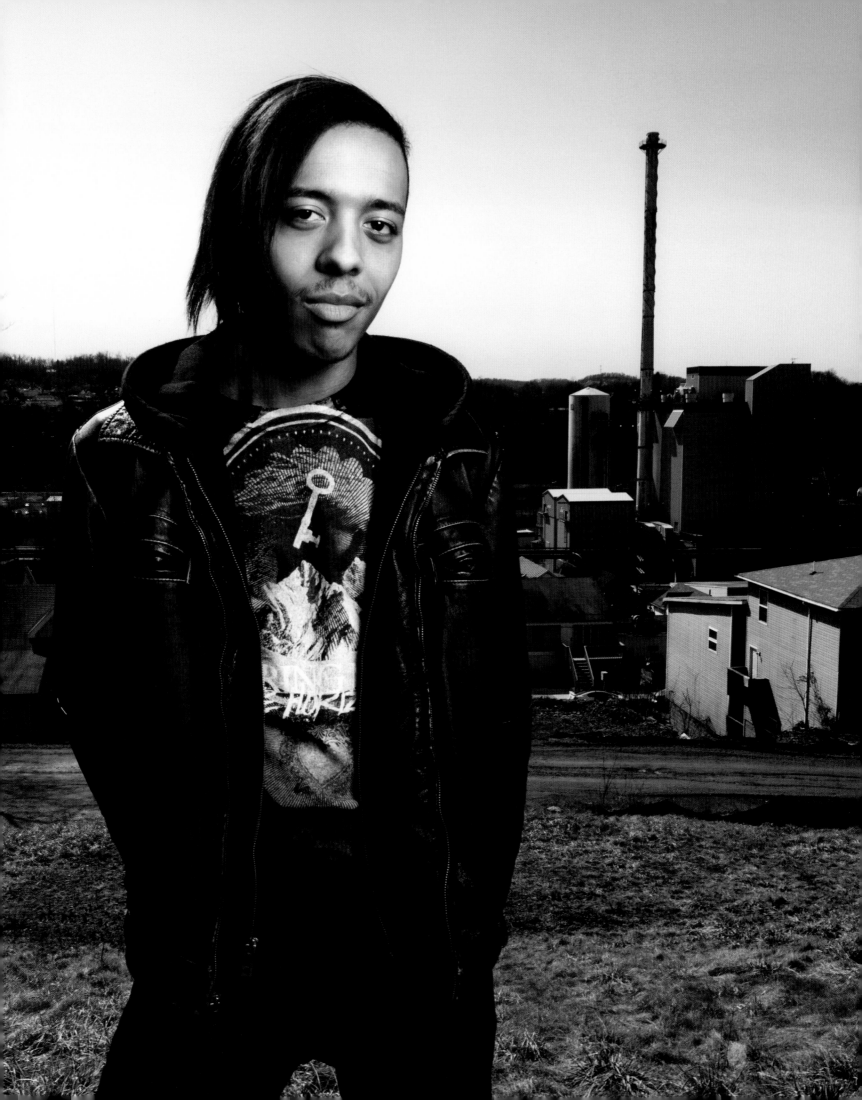

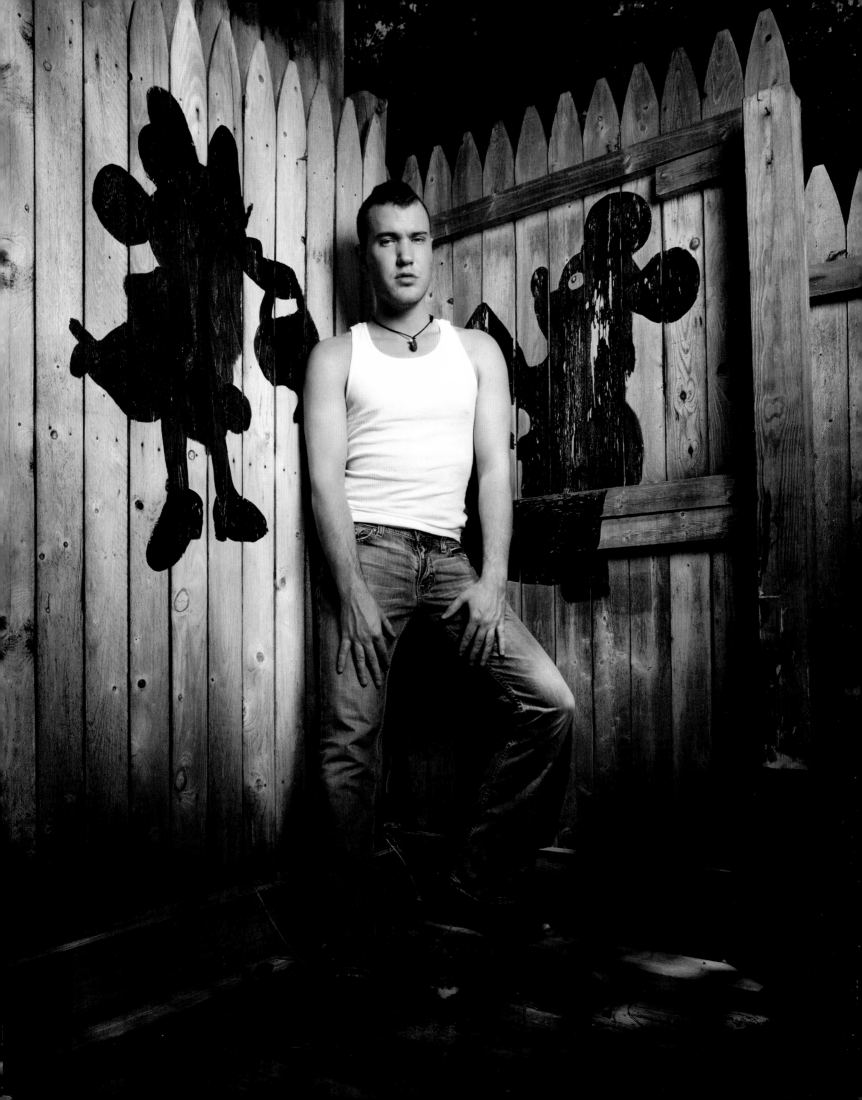

NICK Charleston West Virginia

My mother is a woman with little common sense, and my father, a man without a conscience. They divorced when I was three. He moved to Texas where he became wealthy and tan and still lives and golfs today. I was shuffled off to the 'burbs of Charlotte, West Virginia, during the nineties when urban busing was politically popular, and I ended up being one of four white students in my class at a predominantly urban black school. I never made the track team and always felt inferior in gym, but even today I don't fear black people in large groups.

My parents remarried. My mother divorced the nineteen-years-young Marine she had left my father for, and married a tower-crane operator and habitual abuser. My father married a leggy blond fresh off her first marriage to a plastic surgeon, the prospecting type, who days after exchanging vows asked if she was in the will yet. I overheard that and it was the end of my relationship with my stepmother.

The relationship with my stepfather was tragically closer. He was a true sadist and probably more than a monster. He beat my mother, and when I tried to intervene he beat me too, and locked me in a dog kennel. And, of course, he touched me. My maternal grandparents would always come pick up the pieces. Then, like some Lifetime movie melodrama, my mother left him and moved us to Savannah with assumed names. My mother was always afraid, and this made me unsettled no matter where we were.

I came home from school one day and my stepfather was there, and it was like I got punched in the stomach. She moved with him back to West Virginia when I was fourteen. My grandfather later confessed that my father knew all the sordid details, and that he declined my grandfather's offer to testify against his daughter if he would only bring a second custody suit. He never did, and I never forgave him.

I started high school in West Virginia, where I finally made the track team for the first time, had a strong academic record, and was president of the student council. I volunteered with HRO and Equality Forum; I wanted to understand more about what the implications of being gay were. I was dismayed that there was no real established gay history, so I had to learn about it and piece it together on my own. I came out when I graduated.

I won scholarships to West Virginia University, and got my BS in advertising during the recession, when work was hard to come by. Of course, the only solution to these sorts of situations is to get a master's degree, which I did, in social work. As a social worker, I fight for the rights and dignity of other people every day, and, as it turns out, fighting is what this hill-jack mountain queer is damn good at.

ERIC Milwaukee Wisconsin

've lived in Milwaukee my whole life. I've been out to my family since I was
sixteen. My mom went from sending me to a priest for guidance to leaving the
Catholic church because it isn't accepting of gay people. Now she's very involved in
PFLAG (Parents, Families, & Friends of Lesbians and Gays).

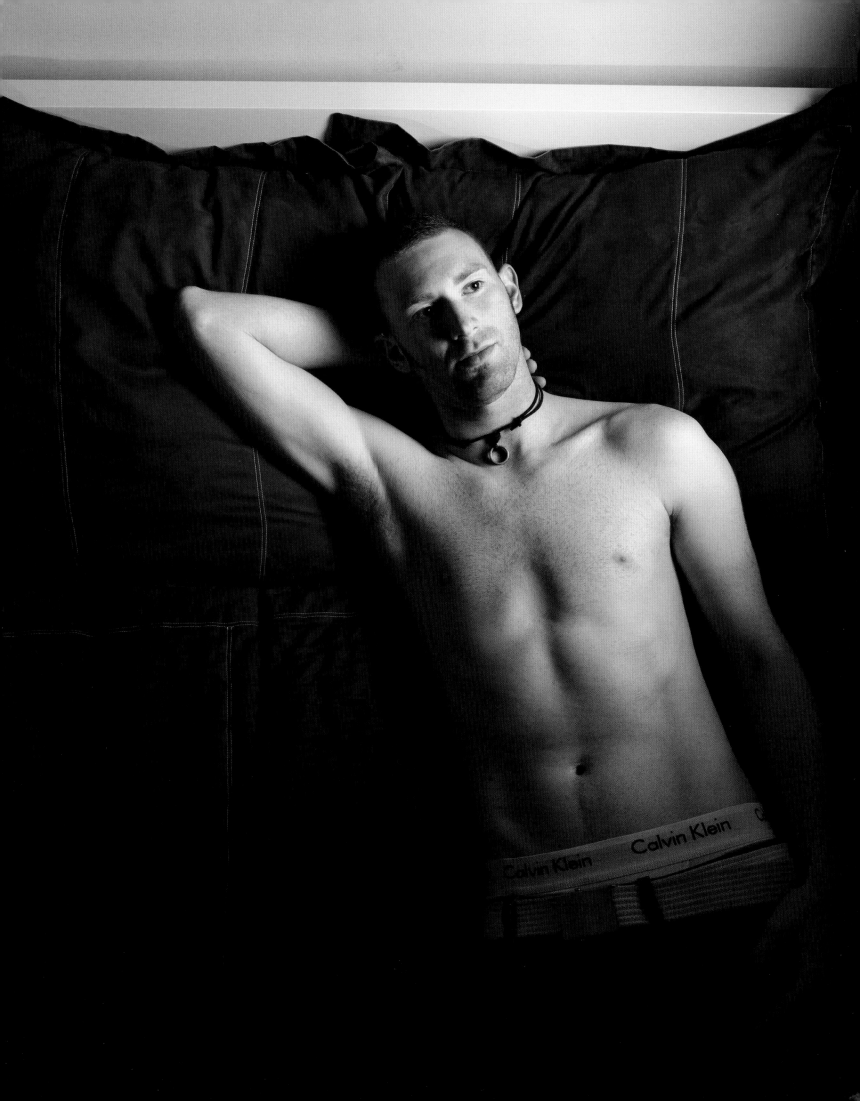

PAUL Laramie Wyoming

I **was born and raised in Wyoming—about a hundred miles from Laramie, where I now go to college.** Growing up here may have influenced who I am as a person, but had little to do with my sexuality.

The first fourteen years of my life were pretty typical. I was in Little League, I played with my friends at the park, I went to birthday parties and sleepovers, I was a Cub Scout until I lost interest. I learned to hunt with my dad and worked at a movie theater. School was always a constant.

My best friend's parents were like second parents to me and figured out at some point that I was gay. When I was a high school senior, they told my parents. It felt like such an invasion of my privacy, and I resisted talking to my parents about it, even though they tried. I felt that if I had been ready, I would have gone to them and not the other way around.

My mother, I suspect, had known for some time but was in denial. My father, on the other hand, didn't seem to have any idea. They were truly supportive, but they were naturally also worried about me, I think what they still struggle with is their own mores and conventions. They were raised so differently that changing suddenly, even for the better, takes a lot of time.

No one's experiences are ever the same, but being out in Wyoming, after the stigma of high school, has never been difficult for me. Being gay is not my most defining characteristic, but it is an important part of me.

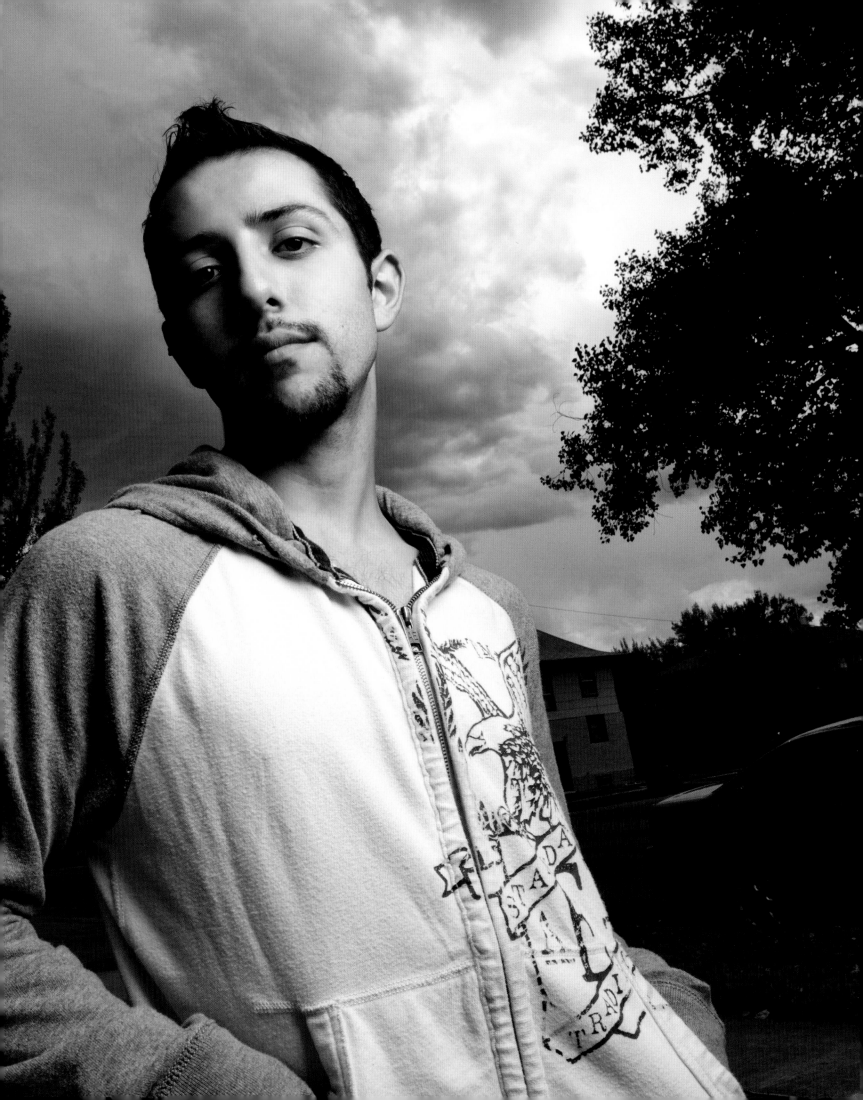

INDEX

ACKNOWLEDGMENTS

Without you all, this project would never have been possible . . . or as much fun. Thank you.

First and foremost to Nick Barletta, for being there every step of the way.

Lena Tabori for believing in the project and me, and taking the risk. I am forever grateful. Gregory Wakabayashi for such amazing designs and an incredible eye. Katrina Fried and Gavin O'Connor for dedicating themselves to getting the stories right. You both did a beautiful job. To everyone else at Welcome for their help and attention to detail. And to Jeff Debevec and my sister Jennifer Hess for helping get this into Welcome Books' hands.

The incredible men who have contributed to this project. Dan Choi for taking such a strong and eloquent stance against the military's DADT policy; you are an inspiration. I am so proud to have you on the cover. Tom Kirdahy and Terrence McNally for lending their wisdom and words to this. It means so much. Michael Musto and Simon Doonan for their enthusiastic early praise and support.

I have been so impressed by those I met along the way. John Bartlett and John Esty, your love for each other is inspiring, thanks for being a part of this. Scooter LaForge for your moving art and for the honesty in all you do. Chip Livingston for your beautiful poetry and sharing your love with Gabriel for all to see.

Callie Schneider at Chroma Visuals for helping me keep my sanity with the realities of digital imagery and getting these photographs to look their best. Carol Morgan and Andy Reynolds for their publicity savvy and passion. Alan Rapp for his guidance and help with my initial proposal. Mike Savel for his early editing work on so many stories, helping me make sense of it all. Paul Soulelis and Erik Vrielink for their selfless help designing my sample book. Peter Berberian and Ryan Speth at Gotham Imaging for their beautiful prints. Lesli Klainberg, Ben Garcher, and Jennifer Steinman for helping create such a great video trailer. Tommy Boy Entertainment and Matt Alber for the use of his brilliant song "Monarch." Mary Virginia Swanson for her excellent early advice. Reid Callanan and the Santa Fe workshops for their inspiration and support though the years. Newfest Film Festival for their support and help in spreading the word.

Trevitte Willis, Maria Cataldo, Joan LeFosse, Rachel Clift and Kareem Mortimer for their help in pushing the boundaries of the project. I still hope we go there.

Aaron McQuade and Sharda Sekarran at GLAAD for their brilliant advice and interview. Sonia Montalbano for her excellent legal eagle help. Loni Efron and Naomi Harris for their support.

Michael Werner and 2WayLens, HomePageDaily, and AfterElton for their early online stories and blog posts about the project.

Robert Whitman for your help in so many ways; I am forever grateful.

Platon for all the lessons you've taught, and the inspiration and encouragement you've given. Not to mention, one fantastic portrait!

The family and friends that put me up and supported me along the way, you all made it so fun, thank you! The Pasfield clan in NC, Debbie and Steve White, Suzanne and Lew Pringle, Kelly and Steve Maguire, Rebecca Brown and Tom George, Kriss and Jeff Marsh, Debra Dawson and Norm Robinson, Jason Hopper and Rob DeWalt, Grace Berge, Katherine Kett, Osman and Penny Rodas, Wendy and Marc Norton, Kathy Plunkett, Ginka and Chuck Poole, Missy Fite and Richard Caldwell, Suzanne, Alan, and Danya Singer, Joe Delate, Justin and Sarah Pasfield, Jeanne and Scott Germann, Mark Maiorano and Roy Brown, Mary Boss, Mark Okean, Sonia Montalbano and Grant Raddon, Deborah Nelson and Keith Donahue, Gary and Jen Pasfield, and Laura and John Cannon.

To many of the men I photographed for a place to crash, a meal to eat, or a tour to give, you guys were great and made it so special. Thank you.

My heartfelt thanks and apologies go out to all the subjects that we could not fit in the book. I wish we could have included everyone. I will always treasure your stories and photographs, and the project would not have been the same without you.

Valerie Cihylik for her tireless cheerleading and friendship.

My mom and stepdad, Evelyn and Jim Fosella, for their love, support, and acceptance always.

And last, but certainly not least, to whoever's running the show up there and to those guiding me along the way, thanks for everything. — **Scott Pasfield**

Gay in America by Scott Pasfield

Published in 2011 by Welcome Books®
An imprint of Welcome Enterprises, Inc.
6 West 18th Street, New York, NY, 10011
(212) 989-3200; fax (212) 989-3205
www.welcomebooks.com

Publisher: **Lena Tabori**
President: **H. Clark Wakabayashi**
Editors: **Katrina Fried** and **Gavin O'Connor**
Editorial Assistant: **Emily Green**
Designer: **Gregory Wakabayashi**

Library of Congress Cataloging-in-Publication Data on file

ISBN: 978-1-59962-104-3

First Edition
10 9 8 7 6 5 4 3 2 1

PRINTED IN CHINA

For further information about this book please visit online:
www.gayinamerica.us

For further information about the photographer:
www.scottpasfield.com